SIN NOMBRE

SIN

Hispana and Hispano Artists

NOMBRE

of the New Deal Era

Tey Marianna Nunn

UNIVERSITY OF NEW MEXICO PRESS

ALBUQUERQUE

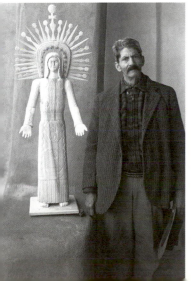

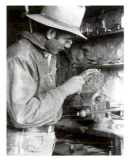

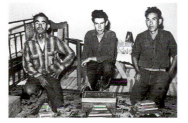

SIN NOMBRE
Hispana and Hispano Artists of the New Deal Era
Tey Marianna Nunn
University of New Mexico Press
Albuquerque

Library of Congress Cataloging-in-Publication Data

Nunn, Tey Marianna.
Sin nombre : Hispana and Hispano artists of the New Deal era / Tey
Marianna Nunn.—1st ed.
p. cm.
Includes bibliographical references and index.
ISBN 0-8263-2399-5
1. Hispanic American art—New Mexico—20th century. 2. United States.
Work Projects Administration. I. Title.
N6538.H58 N86 2001
704.03'680789'09043—dc21
2001002650

Design: Mina Yamashita

Printed in Hong Kong

DEDICATION

Para los artistas del Diablo a Pie

Muchísimas gracias por sus obras y sus cuentos.

y para mis abuelos:

Washington Antonio Rebolledo and

Esther (Tey) Vernon Galindo who experienced

the New Mexican New Deal first hand.

TABLE OF CONTENTS

Acknowledgments

THE MOST MEANINGFUL ASPECT of this research has been locating and meeting the artists, their family members, and friends. The entire experience is something that I will never forget. It will always shape the manner in which I approach future projects because without their kindness and trust, I would not have learned so much. It is one thing to conduct research in archives and libraries and an entirely different thing to sit in an artist's living room eating the best apricot pie in the world (off a WPA-era table!) and listen to their stories: their voices.

From the bottom of my heart I want to thank those who provided valuable information and shared priceless photographs as well as works of art. To Eliseo and Paula Rodríguez, and Abad and Emma Lucero who let me into their homes, their lives, and their families: you are my heroes. You have had a profound influence on my life and I love you very much.

Many other family members and artists also gave their time, stories, and encouragement. They, along with the Nuevomexicano community, embraced and supported this project. I am deeply touched by their participation. The list is long but this book would never have happened without input from the following individuals. Mil gracias a Matilde Archuleta and her daughter Teresa Archuleta-Sagel; Luis Barela, Sr., Carlos Barela, Luis Barela, and Patricia Barela; Debbie and Paul Brehm (and the rest of the Aragón family); Mary L. Cervantes (and the Cervantes family in Cincinnati and elsewhere!); Arlene Cisneros Sena, her mother, Elsie Martínez Cisneros, and the two tias from Costilla: Celsa Quintana and Otilia Martínez; Marcella Falvey; Mary Ellen Sánchez Ferreira; Ruben Gonzales; Jacqueline and Ernie Gutiérrez; Floyd Lucero; Angelina Delgado Martínez and Rita Younis; Vicente Martínez, Nino and Nancy Padilla, Thane Padilla and Tasha Riggins, and Margarita Padilla Lyngen; Ernestine Rodríguez, Victoria Rodríguez; May Romero; Priscilla Roybal, Eleanor de Roybal and Victoria Sosaya; Rose Segura; Luis Padilla and Cecil F. Stark, Jr.; Jo Ann Tejada Lerma, Pluma Louise Gonzales, and Loren and Vikki Tejada. Also, Jane Blumenfeld, the daughter of Holger Cahill, and her late husband Art, gave wonderful support and motivation.

Sin Nombre is based on my doctoral dissertation ("Creating for El Diablo a Pie: The Hispana and Hispano Artists of the Works Progress Administration in New Mexico," 1998) at the University of New Mexico. I want to thank the following professors on my doctoral committee for supporting me, and the artists. Un abrazo muy fuerte para: Holly Barnet-Sanchez, Robert Himmerich y Valencia, Enrique Lamadrid, and Donna Pierce.

Financial support for my dissertation was provided by many institutions, including the National Hispanic Scholarship Fund, Hispanic Culture Foundation and the Arturo G. Ortega Fellowship, Smithsonian Office of Museum Programs, Smithsonian Office of Fellowships and Grants, the Latin American Institute, and the University of New Mexico.

The exhibition portion of *Sin Nombre* was generously funded by the National Endowment for the Arts, the Rockefeller Foundation, the McCune Charitable Trust, Wilson and Company, Engineers & Architects, the International Folk Art Foundation,

and the Museum of New Mexico Foundation. A phenomenal number of private individuals also provided financial support for the exhibition. Due to their understanding of the necessity of this research, the artists whose lives and works are featured on the following pages got the recognition they have long been awaiting.

My gratitude also goes to all lenders to the exhibition. Without their cooperation and sense of noble purpose, I would not have been able to assemble this collection of masterworks, many of which had not been seen in New Mexico since the 1930s. Lenders to the *Sin Nombre* exhibition included Albuquerque Little Theater (Larry Parker), The Albuquerque Museum (Jim Moore and Ellen Landis), Amarillo Museum of Art (Patrick McCracken), Franklin Delano Roosevelt Presidential Library and Museum (Tex Parks), Georgetown Special Collections (Marty Barringer), Harwood Foundation (David Witt), Museum of Fine Arts, a unit of the Museum of New Mexico (Stuart Ashman and Joan Tafoya), National Hispanic Cultural Center (Michael Miller), Newark Museum of Art (Amber Woods Germano), Oklahoma City Art Museum (Jayne Hazelton), Palace of the Governors, a unit of the Museum of New Mexico (Diana DeSantis), Panhandle-Plains Historical Museum (Michael Grauer and Mary Moore), The Portland Art Museum (Prudence Roberts), Roswell Museum and Art Center (Michael Riley and Laurie Rufe), Sheldon Memorial Art Gallery and Sculpture Garden at the University of Nebraska–Lincoln (Daniel Siedell and Sharon West), Spanish Colonial Art Society, Inc. (Donna Pierce and David Rasch), and the Taylor Museum of the Colorado Springs Fine Arts Center (Susan Conley and Cathy Wright). Individuals who loaned objects for the exhibition and/or book include Ray and Judy Dewey, John Dillon Fillmore, Nino and Nancy Padilla, Thane Padilla, Jonathan Parks, Penny and Armin Rembe, Barry and Arlette Richmond, and many other private collectors.

The following kind-hearted souls allowed me into their archives and collections and provided photos for the book: Bridget Carlin at the University of Colorado Art Galleries, University of Colorado at Boulder; Teresa Ebie, former curator and registrar at the Roswell Museum and Art Center; and Barbara Stanislovski of the National Park Service.

Many thanks to the research staff at the Library of Congress and the National Archives for putting up with me for long periods of time. Mary Jebsen at the Museum of Fine Arts Library and Arthur Olivas at the Museum of New Mexico Photo Archives provided valuable information and photographs. Angie Manning at Coronado State Monument in Bernalillo, New Mexico granted access to records and files. A very special thanks goes to Judy Throm, Liza Kirwin, and the gang at the Archives of American Art of the Smithsonian Institution for allowing me to poke through everything (and I mean everything!) in the Holger Cahill Papers and other collections at AAA. They not only became great supporters of the project, they became friends.

In the fall of 1998, a grant from the McCune Charitable Trust in Santa Fe allowed me to hire two Latina graduate assistants in an attempt to get more Latinos/as involved in museums. Feliza Medrano and Rosalía Triana went above and beyond research assistant duty. They proved highly capable and indispensable. Their dedication, excitement, and intense hard work was more than any project director could hope for. Barry Richmond, a devoted volunteer, enthusiastically participated in the planning and research of the *Sin Nombre* exhibition and this book. Lisa Mayer also cheerfully helped at all the crucial junctures of the project.

My colleagues at the Museum of International

Folk Art, Charlene Cerny, Jacqueline Duke, Deborah García, Robin Farwell Gavin, Aurelia Gomez, Joyce Ice, Rene Jolly, Linda Landry, Barbara Mauldin, Laura May, Judy Sellers, Paul Smutko, Tamara Tjardes, Chris Vitagliano, the Guard Staff, and the Board Members of the International Folk Art Foundation never failed to support me. Jon Freshour, former Museum of New Mexico Registrar, always had the answers during the exhibition process. Thanks also to Blair Clark for his good humor, patience, and photographs.

Additional thanks go to Ana Pacheco, publisher and editor of *La Herencia,* who allowed me to make my first plea for information; Kathy Flynn, New Deal Detective and former Assistant Secretary of State; Reggie Sawyer of Hanging Tree Gallery in Albuquerque, Cam Martin and Linda McGee of Dwellings Revisted in Taos, Murdoch Finlayson of Santa Fe, and Richard Ahlborn and Lonn Taylor at the National Museum of American History.

I will never forget what Dana Asbury, former editor at the University of New Mexico Press, did to make this book a priority. She immediately embraced it for the important and emotional project that it is. Thanks also to Evelyn Schlatter, Dawn Hall, and many others at UNM Press for rushing *Sin Nombre* through and among other things, cleaning up my footnotes! My hat is off to designer Mina Yamashita for making this book a beautiful testimony to the artists.

My wonderful and amazing parents, Tey Diana Rebolledo and Frederick M. Nunn, guided me where I had not gone before. Throughout my life they have provided me with different experiences as well as the strength to navigate the ups and downs of this world. They have pulled me through the toughest of times. My stepparents Michael Passi ("the only good dissertation is a 'done' dissertation") and Susan Karant-Nunn (my cohort when it comes to antiquing) have always cheered me on. Jessica Nunn, my little "stister," kept me supplied with bubble baths for stressful times. My love and gratitude goes to all of my family and friends who have either cheerfully dealt with my "absence" from real life or listened to me speak endlessly on this topic. No one could ask for more.

Finalmente, my husband James Ross has seen me through the many manifestations of what has, and will be, an ongoing quest. His endless support and daily encouragement helped us create a history together. He is the most amazing person I know. Te amo mucho, Jim.

—Tey Marianna Nunn

Preface

Buscando a los artistas del Diablo a Pie:

The Search for the Hispana and Hispano Artists

of the Works Progress Administration (WPA) in New Mexico[1]

FOR MANY YEARS I HAVE BEEN FASCINATED with the dynamics and cultural politics occurring in Mexico during the 1920s, 1930s, and 1940s. Thinking that surely there must have been Nuevomexicano artists who may have gone to Mexico during this time or painted in New Mexico as participants of the Santa Fe and Taos arts "boom" of the early part of the twentieth century, I searched every available book on New Mexican and American art of that period, but found only a handful of Spanish surnames. These names belonged to a few santeros and the Mexican muralists.

Where were the Hispanos? Why, at a time when there was an intense focus on Mexican and Latin American art and culture, as well as on Spanish-speaking people in the United States, were there no Spanish surnames listed as "artists" in the volumes on New Mexican and American art of the period? As I began my research, I would tell people—including librarians, archivists, and many scholars—that I was researching the "Hispanic" artists of the WPA in New Mexico.[2] Across the board, their response was the same: "You're not going to find anything."

I was pleased to discover that they were dead wrong. I found the artists (and the answers as to why they were missing) buried deep in archival repositories. I rarely found them under the category of "art." Rather, their names and information about them appeared under the categories of "craft" or "labor." They had been forgotten, relegated to invisibility because of their ethnicity and their art. That they had been "forgotten" and treated as the "stepchildren" of American art speaks to the historical context in which these artists and other New Mexicans were excluded on many levels.[3] Yet, it is also relevant to today's Hispano, Hispanic, Chicano, Mexican American, and Latino artists who are continuously excluded and faced with situations of racial and artistic discrimination, the latter based on a lack of aesthetic sensitivity.

The primary documents and photographs that I found in the various local and national archival repositories were the central resources for my social art historical methodology. Historical photographs taken during the WPA and "revival" eras provided the impetus for this recovery project. Many of these photos of the vocational school and WPA art activities were taken as a means to propagandize the "success" of these programs. They were then sent to the national WPA program offices in Washington, D.C. These images are now scattered throughout other facilities such as the National Archives, the Library of Congress, the Archives of American Art, and the State of New Mexico History Library. They provide an invaluable tool to research the Hispana and Hispano artists and their art despite the fact that the artists and works are rarely identified.

By combining references and numbers on the images with official WPA records in the National Archives in Record Group 69 and other archival collections, I was able to find names and references to artists. Each day I spent in the archives was like finding a small clue to a long-unsolved mystery. Over time, this "undocumented" story emerged.

In 1998, the years of research and the supposed "lack of information" turned into my 440-page doctoral dissertation titled "Creating for El Diablo a Pie: Hispana and Hispano Artists of the Works Progress Administration in New Mexico," written at the University of New Mexico. The dissertation then evolved into a major exhibition at the Museum of International Folk Art in Santa Fe. On June 6, 1999, *Sin Nombre: Hispana and Hispano Artists of the New Deal Era* opened to a record crowd. Among those in attendance were surviving artists, their families, and family members of many of the artists who had died before we could publicly acknowledge their contributions to American art.

Although I have identified and researched only a few of the thousands of Hispana and Hispano artists who worked for the WPA and during the "revival period," at the time of this writing many are still alive and in their late eighties and early nineties. I conducted interviews with surviving artists and family members. In the process, it became even more apparent that these artists have not been given all the recognition they deserve. For example, I learned from Eliseo Rodríguez, a fine painter with formal art training, that he was "encouraged" to take up the traditional art of straw appliqué. He was also instrumental in developing the silk-screen process for the WPA's Federal Art Project in New Mexico and he helped produce portfolios of Native American blanket designs and images of santos with Louie Ewing for the Laboratory of Anthropology in Santa Fe. Ewing is given sole credit for the work of serigraphs.[4] Additionally, Marie Cervántez, the wife of Pedro Cervántez, a Texico painter whose work was exhibited at the Museum of Modern Art in New York, describes how her husband not only assisted Russell Vernon Hunter with the murals in the Ft. Sumner Courthouse, he actually painted portions of the wall scenes.[5] Yet nowhere is his artistic contribution to a national legacy mentioned as anything but being Hunter's "assistant." Illustrative examples such as Rodríguez and Cervántez testify as to how, in many ways, the Hispanas and Hispanos who worked for the various WPA arts programs were "encouraged" to abandon the "fine" mediums and develop skills in the areas of "handicraft." As a direct result of Eurocentric aesthetic values, art historical categories, and racial prejudice, these artists were pigeonholed and stereotyped into utilizing only traditional Hispano "folk" art materials and thus relegated to the level of "craftsmen." Obviously, the mass popularity of Mexican muralists far overshadowed that of their New Mexican colleagues. While the names of Orozco, Siqueiros, and Rivera are

synonymous with art of the 1930s and 1940s, the names of Cervántez, Chávez, Rodríguez, and Romero de Romero, all "New Mexican" painters and muralists, have been waiting for inclusion.

The recognition of these and "other" WPA artists is long overdue. This project is by no means over. It has only just begun. New information surfaces daily, testimony to the important body of knowledge about these artists that remains to be uncovered and documented, revealing artists who blazed an artistic path that others could follow.

It has been my research goal that I retrieve enough information to change perceptions that these Hispana and Hispano artists of the New Deal era were solely engaged in producing what has been dismissively referred to as "handicrafts." Quite the contrary. Their contributions to the art and cultural history of New Mexico and the rest of the United States were, and are, impressive. From this point forward, their masterworks should be equally discussed and exhibited alongside other fine art of the early twentieth century.

—Tey Marianna Nunn
Albuquerque, New Mexico
January 2001

Notes

1. In New Mexico, the acronym "WPA" was often referred to in Spanish as "El Diablo a Pie (Devil on Foot)," a tongue-in-cheek play on the English acronym and thus a commentary on the group of government programs.

2. For the purposes of this book and the time period it addresses, I will use the term "Hispano(a)" to describe Nuevomexicanos during the depression. The historical term that Anglos applied in the 1930s and 1940s was "Spanish-American." The term "Hispanic" did not exist and therefore is not appropriate to apply in this context.

3. I have used the terms "forgotten artists" and "stepchildren" of American art based on George Sánchez's use of the terms "forgotten people" and "stepchildren of a nation" throughout his book, *Forgotten People: A Study of New Mexicans* (Albuquerque: 1940; University of New Mexico Press, 1996). His intention was to address the unique situation and identity of the "adopted" Spanish Americans of New Mexico. Sánchez concentrated on factors that dealt with education and integration of New Mexicans, as he referred to them, into greater America. In applying his use of terms to art and American art history, I am simply expanding on Sánchez's ideas.

4. Interview with Eliseo and Paula Rodríguez, 19 March 1997, Santa Fe, New Mexico.

5. Don McAlavy (Clovis, New Mexico) to Kathy Flynn, former Assistant Secretary of State for New Mexico, 8 December 1995. Letter courtesy of Kathy Flynn.

Historical Introduction

"Can we change the arts from things to be looked at from afar to things in which we can participate here and now?"[1]

—*Holger Cahill, WPA/FAP Director*

WHILE MUCH ATTENTION has been given to both colonial and contemporary Nuevomexicana/o artists, little has been written and researched concerning the Hispana and Hispano artists in the various Works Progress Administration (WPA) programs of the 1930s and 1940s during the presidency of Franklin Delano Roosevelt. With few exceptions, these artists and their works of the depression era, have been left out of the volumes that address and applaud the artistic achievements of early twentieth-century American and New Mexican art history.

The hundreds of Hispana and Hispano artists who created works that include paintings, murals, sculpture, fiber arts, mixed media, metal work, and furniture during the WPA and New Deal era, did so through a variety of federal and state supported programs such as the Public Works of Art Project (PWAP), Federal Art Project (FAP), Civilian Conservation Corps (CCC), and the National Youth Administration (NYA). Additionally, a number of retail ventures helped these artists sell their art at both local and national levels.

The broad impact of the New Deal programs (especially those that contributed to American art) in the United States is far-reaching. The complete history of relationships, objectives, and cultural dynamics of the New Deal and its arts programs is scattered throughout the fifty states and the District of Columbia. The archival record is incomplete because state offices were often directed to sell their excess paperwork for scrap or to destroy portions of "unnecessary" records. Nevertheless, the Hispanas and Hispanos who participated in New Deal programs have been overlooked. What has been uncovered to date provides insight into the enormity of the New Deal programs and also an integral historical backdrop for the rest of this story.

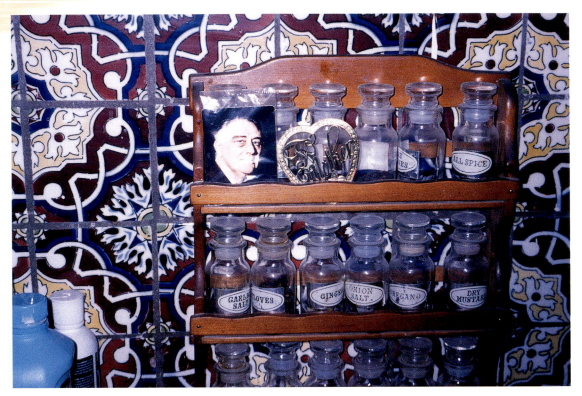

"Political Sentiment in a Spice Rack" (1998). Home of Eliseo and Paula Rodríguez, Santa Fe, New Mexico.
Photo by Tey Marianna Nunn.

FDR'S New Deal

During the 1930s and 1940s, Franklin Delano Roosevelt's New Deal programs provided relief from the country's economic depression in the forms of infrastructure work and creative expression. In a massive and progressive attempt to revitalize the American economy, citizens were put to work improving the country. The New Deal programs were responsible for thousands of physical improvements including roads, bridges, buildings, and other structures that still stand. A large number of the New Deal relief programs also included artistic components.

The "New Dealers" believed that all Americans would benefit, in one way or another, from the social and physical enhancement of their country, state, city, or village. In May 1933, the Federal Emergency Relief Administration (FERA) and the National Recovery Administration (NRA) were formed to allocate supplemental funding to state and local relief efforts. In New Mexico, such efforts varied from different construction projects to tree-planting, and from mural painting to soap-making. Later that same year, the Public Works Administration (PWA) and the Civil Works Administration (CWA) were created and provided funding for projects such as airports, playgrounds, parks, roads, and schools.

The Works Progress Administration (WPA) began in 1935 and was reorganized and renamed the Works Projects Administration (WPA) in 1939. During the New Deal Era, the Hispano population of New Mexico often referred to the Works Progress Administration as "El Diablo a Pie," or "The Devil

on Foot," a play on words referring to the acronym "WPA." The multi-layered meaning of the phrase can be interpreted as both humorous commentary about, and social criticism of, the role played by the United States government and its federally funded programs in New Mexico.

Due to the fact that the WPA was one of the largest and longest of the New Deal programs, its name and WPA initials are often used to refer to all of the relief-oriented depression-era federally funded programs. New York City's LaGuardia Airport and Washington, D.C.'s National Airport are examples of some of the nationally WPA-funded facilities, while the planning and overhaul of Chicago's Lake Shore Drive and San Antonio's Riverwalk are illustrative of the federal and local enhancement projects. In New Mexico, the Albuquerque Community Playhouse (now the Albuquerque Little Theater), Carrie Tingley Hospital in Hot Springs (now Truth or Consequences), the Monte Vista Fire Station in Albuquerque, the state fairgrounds, and a number of University of New Mexico buildings, including Zimmerman Library, were erected with WPA funds.

Not since FDR's New Deal has there been such a major system of programs to build the nation's art centers, bridges, buildings, dams, fairgrounds, firehouses, fountains, golf courses, highways, hospitals, museums, parks, police stations, public housing, schools, sidewalks, sewer systems, stadiums, streets, subways, swimming pools, tourist destinations, tunnels, universities, and zoos, to name some of them. Still other projects that benefited from federal relief funding included archaeological excavations, archival inventories, landscaping, library book repair, malaria control, map-making, mattress-making, rodent eradication, soap-making, surveying, and tree-planting. These do not include the numerous art projects meant to provide visual and literary pleasure and respite from

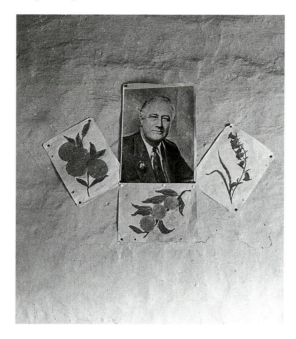

"Political Sentiment in Spanish American Home" (1943), Taos County, New Mexico. Photo by John Collier for the U.S. Office of War Information, Library of Congress, neg. no. 17273.

the day-to-day traumas and troubles of the Great Depression.

The New Deal programs were filled with idealism and dreams. Yet as idealistic as they were, the programs were emblematic of the U.S. government. They were complex, confusing, multi-layered, constantly changing, and generated mountains of paperwork. The intricacies, complexities, goals, and administration of these programs are part of the reason that Hispano participation has remained unrecognized for so long.

Mexican Roots for Government and the Arts in the United States

Federally funded art programs were first suggested to FDR by George Biddle, an artist who was influenced by the government-sponsored mural program in Mexico, which flourished during the 1920s. In May

1933, Biddle wrote to Roosevelt:

> There is a matter that I have long considered and which someday might interest your administration. The Mexican artists have produced the greatest national school of mural painting since the Italian Renaissance. Diego Rivera tells me that it was only possible because [Mexican President] Obregón allowed Mexican artists to work at plumbers' wages in order to express on the walls of the government buildings the social ideals of the Mexican revolution. The younger artists of America are conscious as they have never been of the social revolution that our country and civilization are going through; and they would be eager to express these ideals in a permanent art form if given the government's cooperation.[2]

In this pivotal piece of correspondence to FDR, Biddle went on to say how the murals would visually portray FDR's ideals and that he was convinced that should such a project take off in the United States, it would provide, for the first time, "a vital national expression."[3] The artistic stars at the center of the Mexican Muralist movement, Diego Rivera, José Clemente Orozco, and David Alfaro Siqueiros had worked in the United States and exposed the population to social realism through visual imagery. Biddle offered the theory that the citizens and artists of the United States felt an inter-American connection with Mexico because of the Mexican muralists. Furthermore, the American population saw in Mexican art truly "American" aspects. The Mexican mural movement developed a visual vocabulary of symbols that depicted Mexican history, landscape, customs, and *arte popular*. More importantly, the murals depicted working-class participation in everyday life as well as their struggle. It incorporated precisely the same elements that the art world in the United States was seeking. American art needed to be recognized on its own merits, away from its European roots.

Much as Mexico created a sense of "Mexican-ness" and acknowledged *indigenista* aspects of *Mexicanidad,* the United States government, through its sponsorship of art projects, set out to foster and acknowledge a distinctly American artistic identity. The New Deal art programs emphasized subject matter of the "American scene"—the rendering of American values in landscape, culture, history, folklore, costume, and art.

Revivals and Revivalism

The 1930s and 1940s also witnessed a massive revitalization attempt: a world-wide movement toward "reviving" and "preserving" traditional "handicrafts" and folkways—cultural elements thought to be in danger of disappearing because of industrialization and rapidly encroaching civilization.

Both the "handicrafts revival" in the United States and the New Deal arts-related programs were modeled after other programs already in place in other parts of the world, most notably the social and public arts programs in post-revolutionary Mexico. In the United States, both movements searched for what was truly an indigenous expression of America before all such creative manifestation disappeared. The movement was also fueled by wealthy "fine" art collectors such as Abby Aldrich Rockefeller and her son Nelson, who actively collected both modern and indigenous expressions of creativity that eventually formed the core collections of not only the Museum of Modern Art in New York, (MoMA), but those of Colonial Williamsburg. Popular arts—art for the people by the people—were beginning to be seen as both indigenous and ingenious forms of artistic expression.

The revivalists and the New Dealers converged and overlapped during the 1930s and 1940s. In New Mexico, a number of the Hispana and Hispano artists

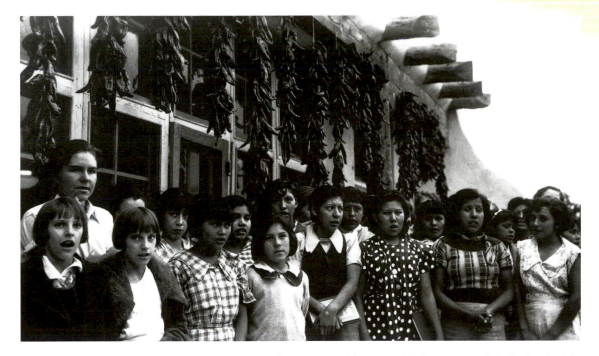

WPA Children's Choral Group (ca. 1930s), New Mexico. Photo courtesy of the National Archives, neg. no. RG-69-N 12016-C.

who worked for WPA-era arts programs also worked for state-supported vocational schools that taught the "traditional" arts of weaving, tinwork, and furniture-making to Hispana and Hispano students.

New Deal Art Programs

American New Deal art was created under the auspices of a variety of different federal programs during a ten-year period between 1933 and 1943. The Public Works of Art Project (PWAP), Treasury Section of Painting and Sculpture (SECTION), Treasury Relief Art Project (TRAP), Federal Art Project (FAP), Farm Security Administration (FSA), National Youth Administration (NYA), Civilian Conservation Corps (CCC), and the Division of Women's and Professional Projects, oversaw arts-related projects. Many of the smaller components of the various New Deal government programs also contained "arts and crafts" elements. Although these so called "alphabet soup" terms,

or entities, are now generally bundled together and referred to under the umbrella term of "WPA," these federal programs contained key differences that separated them in artistic objective. While each encompassed some type of art or "craft" component, some were more successful than others.

The rolls of the New Mexican arms of these programs read like a who's who of the Anglo-oriented Taos and Santa Fe art colonies and those who shaped the identity and regionality of what is known as New Mexican art. Names such as Kenneth Adams, Jozef Bakos, Teresa Bakos, Gustave Baumann, Charles Berninghaus, Oscar Berninghaus, Emil Bisttram, Ernest Blumenschein, E. Boyd, Gerald Cassidy, Manville Chapman, Howard Cook, Randall Davey, Maynard Dixon, Fremont Ellis, Louie Ewing, Joseph Fleck, William Penhallow Henderson, Allan Houser, Peter Hurd, Raymond Jonson, Gene Kloss, Gisella Loeffler, William Lumpkins, Lloyd Moylan, Willard

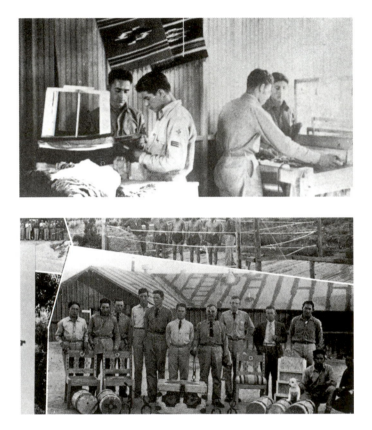

Civilian Conservation Corps (CCC) Weavers, Camp SCS-3-N at Española, New Mexico. Photo from the Official Annual . . . 1936 Albuquerque District 8th Corps Area, Civilian Conservation Corps. Baton Rouge: Direct Advertising, September 1936.

Civilian Conservation Corps (CCC) Furniture Artists, Company 833 at Santa Fe, New Mexico. Photo courtesy of the Official Annual . . . 1936 Albuquerque District 8th Corps Area, Civilian Conservation Corps. Baton Rouge: Direct Advertising, September 1936.

Nash, B. J. O. Nordfeldt, Jesse Nusbaum, Sheldon Parsons, Bert Geer Phillips, Olive Rush, Eugenie Shonnard, Will Shuster, Dorothy Stewart, Carlos Vierra, Cady Wells, and many others appear in profusion throughout the archival documentation. At one point, even Georgia O'Keeffe was thought of as worthy of relief funding and federal support of her art.[4]

In New Mexico, the administrative positions in the WPA art programs were occupied by Anglo artists and administrators who involved their Anglo colleagues and friends (whether they were financially needy or not) in the arts projects. Such networking further discouraged the inclusion of Hispana and Hispano artists. Throughout the documentation, names of Anglo artists and intelligentsia overshadow and disregard *en masse* the artistic contributions to American art by artists such as Patrocinio Barela, Pedro Cervántez, Clem Chávez, Eduardo Arcenio Chávez, Margaret Herrera Chávez, Francisco Delgado, Ildeberto Delgado, Estella García, Felix Guara, Felix Gutiérrez, Elidio Gonzales, José Dolores López, Abad Lucero, Ben Luján, Santiago Matta, Alfonso Mirabal, Samuel Moreno, Max Ortiz, Emilio Padilla, Eliseo Rodríguez, Esquípula Romero de Romero, Ernesto Roybal, Juan Amadeo Sánchez, George Segura, Domingo Tejada, the National Youth Administration artistas of Camp Capitán, the Works Progress Administration weavers of Costilla, the Civilian Conservation Camp muralists of Roswell, plus many others, yet unidentified.

Public Works of Art Project (PWAP)

Funded with money from the Civil Works Administration (CWA) via the Treasury Department, the Public Works of Art Project was the first but all too brief attempt by Uncle Sam to support the country's artists. The objective of this project was to "give artists employment at craftsmen's wages in the embellishment

of public property with works of art."[5] Its guidelines stressed that "artists were to improve the craftsmanship of furnishings" of public buildings, embellish federal, state, and municipal buildings and parks, and make pictorial records of such national projects as the Civilian Conservation Corps camps and Boulder Dam.[6]

Under the direction of key New Dealer Harry Hopkins, the PWAP ran for six months (December 1933–June 1934) and was divided into sixteen regions, each with a committee. New Mexico and Arizona comprised Region Thirteen of the PWAP, whose regional committee was chaired by Jesse Nusbaum and was comprised of Mary Austin, Kenneth Chapman, New Mexico Senator Bronson Cutting, John Gaw Meem, Caroline Thompson, and Gustave Baumann. Headquarters for the New Mexico PWAP were located in the Laboratory of Anthropology in Santa Fe.

Many believed the PWAP to be the "first genuinely democratic movement that has ever been started for the employment of the artists and the support of the Arts."[7] In a speech written by Holger Cahill, then an exhibition manager for the PWAP, these ideals were expanded upon:

> A great Democracy has accepted the artist as a useful member of the body politic, and his art as a service to the state. It has taken the snobbery out of Art, and made it part of the daily food of the average citizen. It is, I believe, a distinct setting up of our civilization, a new conception and definition of public works—a recognition that things of culture and of the spirit contribute to the well-being of the nation. It has elevated the artists to the rank of artisan—has recognized him as a laborer worthy of his hire.[8]

During its short existence, the PWAP employed approximately 3,521 artists nationwide who created

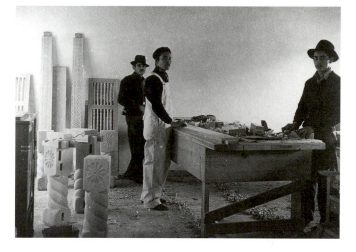

Furniture Artists Constructing Conference Table (1938), National Park Service, Old Santa Fe Trail Building, Santa Fe, New Mexico. Photographer unknown, photo courtesy of the National Park Service.

over 15,000 works of art that included lithographs, etchings, watercolors, oil paintings, murals, and sculptures, as well as "products of various crafts" under the general theme of the "American Scene." The PWAP was not considered to be a relief program; rather it gave employment to those with "recognized competence" rather than financial need.[9] One observer described the PWAP in Region 13 in the following words:

> One of the most diverse regions is that directed by Mr. Jesse Nusbaum, (New Mexico and Arizona), since the artists employed by him represent the Indian, the Mexican, and the American races. Mr. Nusbaum is employing Indian artists and craftsmen as well as other artists in New Mexico and Arizona. All of the artists he said were so filled with enthusiasm to complete their work that they "would be glad to carry on even if the Project should conclude before their work was completed."[10]

A number of New Mexico artists figured prominently in the PWAP program as both administrators and artists. Amid the numerous, and now famous, names of Anglo artists of the PWAP are only four Hispanos: Francisco Delgado, a master tin artist from Santa Fe; José Dolores López, an innovative wood sculptor from Córdova; Emilio Padilla, also a talented sculptor; and Esquípula Romero de Romero, an academically trained painter and muralist from Albuquerque.

Treasury Section of Painting and Sculpture (SECTION) and Treasury Relief Art Project (TRAP)

The Treasury Section of Painting and Sculpture, or, simply, the Section of Painting and Sculpture was in place from October 1934 until October 1938 under the direction of arts administrator Edward Bruce. From October 1938 to June 1939 it was renamed the Treasury Section of Fine Arts and also directed by Bruce. Operating parallel to both these projects was the Treasury Relief Art Project (TRAP), which supported artists from July 1935 until June 1938. Both programs focused on "high" art and awarded commissions and projects only to artists considered to have a higher degree of skill. These programs later evolved into the Section of Fine Arts of the Public Buildings Administration of the Federal Works Agency, which functioned from April 1940 through June 1943, also under Bruce's direction. TRAP ran concurrently with the FAP and the other art programs of the WPA for three years.

Despite constantly changing titles and dates, the various manifestations of the Treasury Department's fine art programs held a commonality in their project objectives. All works, most of which were murals, sculptures, and paintings, were created solely to enhance and decorate federal buildings such as post offices, courthouses, and other larger governmental edifices that were under construction at the time. Artists employed by this project were not on relief or necessarily in financial need. They were awarded the commission based on the results of a competition. Over eleven hundred post office murals and sculptures for federal buildings were created through TRAP.

Existing documentation offers no Spanish surnames as recipients of TRAP mural or sculpture commissions in New Mexico. This is not to say that Hispana and Hispano artists were not involved in the projects; rather, that despite their artistic skills, they may have been employed only as assistants to the artists with winning designs. The lack of Spanish surnames on mural projects in New Mexico certainly seems an anomaly when compared to the greater historical and cultural history of muralism in the United States at the same time. The Mexican mural trio of Rivera, Orozco, and Siqueiros along with other artists such as Rufino Tamayo, had instigated an artistic fervor throughout the United States and Mexico, and their murals from California to Detroit to New York received widespread attention.

Works Progress Administration/ Works Projects Administration (WPA) and the Federal Art Project (FAP)

Harry L. Hopkins directed the national Works Progress Administration, whose name was changed in September 1939 to the Works Projects Administration. Together, the merged "WPAs" were in effect from 1935 to 1942. Federal Art Project Number One was the artistic division of the enormous WPA entity and the most ambitious of all federally supported art projects. Under the umbrella of Federal Art Project Number One were national units encompassing painting, sculpture, murals, graphic arts (including silk-screen), photography and films, museum support, technical

projects, art exhibitions and federal art galleries, art education, community art centers, and the *Index of American Design* (*IAD*). The divisions were categorized together under the Federal Art Project. Additional cultural and economic programs funded at the same time and under the organization of the WPA/FAP, were the Federal Music Project (FMP), Federal Theater Project (FTP), Federal Writers' Project (FWP), Historical Records Survey (HRS), and the Women's and Professional Division.

Unlike the PWAP, the FAP was a relief program. Artists and "craftsmen" had to qualify through a series of interviews, applications, and follow-up reports. Once they qualified, they were classified according to skill level. The four classifications were: professional or technical (for administrators and specialists); skilled; intermediate or semiskilled; and unskilled. The amount of payment to FAP artists depended on their assigned skill level.

The basic premise behind the FAP was that there should be "art for every man," since the New Dealers believed that art should be accessible to everyone. The physical results of these beliefs were hundreds of thousands of murals, frescoes, mosaics, sculptures, oil and watercolor easel paintings, lithographs, prints (innovations on both the silk-screen process and color woodcut printing were developed by FAP artists), museum dioramas, furniture, and photographs. These were produced by the artists and then allocated to airports, community centers, hospitals, housing projects, libraries, museums, schools, universities, and other such public buildings. The FAP relied heavily on local sponsors who matched federal funds with a portion of the total project cost and who provided local support for the arts activities.

National FAP director Holger Cahill believed that art reflected culture and that media contributed to American art in order to form a total cultural expression:

In a program employing the services of more than four thousand artists of every racial heritage and a multitude of aesthetic persuasions, the Federal Art Project is engaged in the task of preserving, fostering, disseminating and, in a way, molding American art. Although its immediate purpose is to aid artists in economic distress, the Federal Art Project, nevertheless does not ignore the great cultural and social benefits that can accrue from its work. Outstanding of these is the preservation of the plastic arts which stood in serious danger of losing ground gained in this country during the early part of this century.[11]

The FAP strongly encouraged regionality in the art decorations for public buildings. For example, in Minnesota, the FAP promoted and incorporated Scandinavian art and design into WPA buildings and a community art center in Duluth. In Oregon, Timberline Lodge at the base of Mount Hood was a WPA project showcasing the essence of the Pacific Northwest. Decorative elements could include such things as hand-carved banisters, architectural elements, and furniture. Appalachian arts and folkways also received intense WPA/FAP interest.

The Federal Art Project in New Mexico

The FAP in New Mexico, under the direction of artist and administrator Russell Vernon Hunter, strongly supported the cultural characteristics of the region in its art and decoration of public buildings. In Albuquerque, the Community Playhouse (now the Albuquerque Little Theater), was one such featured recipient of the program. Its tin sconces, candlesticks, mirrors, nichos, exit signs, and furniture, textiles, and hand-carved architectural details such as corbels, lintels, and doors were all federally funded. "Spanish Colonial" style

furniture, fabric arts, and religious art were other integral artistic components aimed at celebrating the regional environment of New Mexico and the Southwest in dozens of municipal and state buildings as well as hotels, offices, and other structures.

As the NM FAP became more established, Hunter's application of Hispano art within the project was supported by key WPA/FAP administrators at the national level. Donald Bear, the regional advisor for WPA/FAP Region Five, which included Arizona, New Mexico, Colorado, Utah, and Wyoming, and Holger Cahill shared an interest in New Mexico and played important roles in recognizing and promoting Hispana and Hispano artists. In the beginning, however, the recognition of Hispano arts as worthy of inclusion in the art projects was debated among WPA administrators who felt Hispano arts were not of high artistic merit. Early on in the FAP, Donald Bear responded to Cahill regarding the incorporation of furniture in the New Mexico project:

> In your letter of February 4th, there is a question of wood carving and furniture making projects. I don't quite know what to say except that in the case of New Mexico these native craft projects seem rather important.
>
> In all, Mr. Hunter would probably employ about twenty craftsmen who would execute a large furniture project which would be very welcome to the state and not altogether lacking in original quality. New Mexico is poor and I don't believe many people spend any too much money on public works of any sort.
>
> On the other hand if you are interested in a type of peasant sculpture, I doubt that there are more than three people in New Mexico who qualify. Hunter's office informed me that they can employ altogether about 75 persons in various arts projects.

> If their furniture and carving project has to be canceled, I fear it will be a blow to them. Please advise me immediately so that we may make some other arrangements. Inasmuch as the art project is not very expensive in this region in comparison to some other projects, perhaps New Mexico might be allowed to go in fairly heavily because their need is rather great.[12]

Throughout the WPA archival documentation and scholarly treatises, Hunter is mentioned as having "discovered" artists such as Patrocinio Barela and Pedro Cervántez and for fostering their careers. While Hunter seemingly recognized and "encouraged" Hispanas and Hispanos, he also helped create their "naïve" and untrained or "primitive" artistic personas. Those that he really believed had "true" artistic talent received widespread recognition and national mention in correspondence with the national FAP office in Washington and in speeches by notable FAP administrators. Upon Hunter's death, Cahill commented:

> The accomplishment of the New Mexico Project under Vernon's direction was outstanding. Among the exhibits chosen by the Museum of Modern Art in New York, is sculpture by Patrocino [sic] Barela of Taos, who like many another project artists, would never have developed to the point where his work merited national and international attention if not for criticism, help and guidance. And Vernon's guidance was always given with the gentleness and courtesy which came out of a sensitive understanding of the creative process and deep respect for even the humblest struggler in the arts.[13]

When World War II broke out, the FAP adapted to the nation's needs and became the Graphic Section of the War Services Division. During this period, from March 1942 to October 1942, the artists' skills were

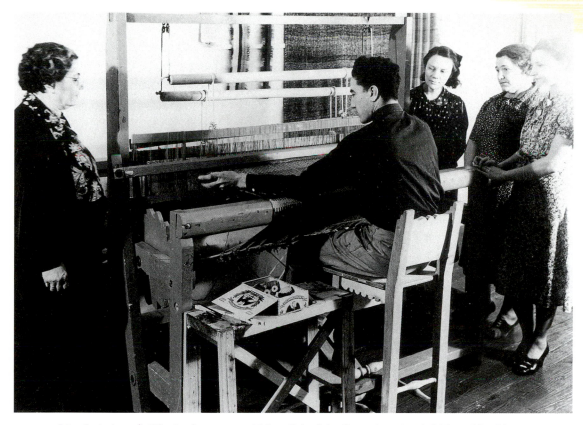

Max Ortiz (seated), Weaving Instructor at Melrose Federal Art Center (ca. 1930s), Melrose, New Mexico.
Photo courtesy of the Holger Cahill Papers, Archives of American Art, Smithsonian Institution.

used only to support the war effort by creating war-related art or by decorating officers' clubs and other military facilities. Finally, from October 1942 to April 1943, arts activities supported by government funds were grouped under the heading of the Graphic Section of Division of Program Operation. The many manifestations of the FAP ended in April 1943.

Federal Art Centers

The concept of community-based art centers became one of the lasting legacies of the WPA art programs. By 1940, there were over one hundred federal art centers and federal art galleries throughout the United States run under the auspices of the WPA/FAP. In these centers, where all the arts-related programs of the New Deal converged and mingled, adults and children could see art exhibitions, take art classes, and hear lectures on art, thus fulfilling the New Dealers' mission of making art more accessible to average people, allowing every American to experience the arts. Across the country, federal art centers were, more often than not, small spaces often housed in donated space such as storefronts and other small buildings, thus indicating community support. Although some were short-lived, many of the New Deal–era centers and galleries formed the basis for art museums and institutions that still exist—one example is the Walker Art Center in Minneapolis. In many cases, when a community did not have an art teacher or art education program in place, "trained" artists from New York were

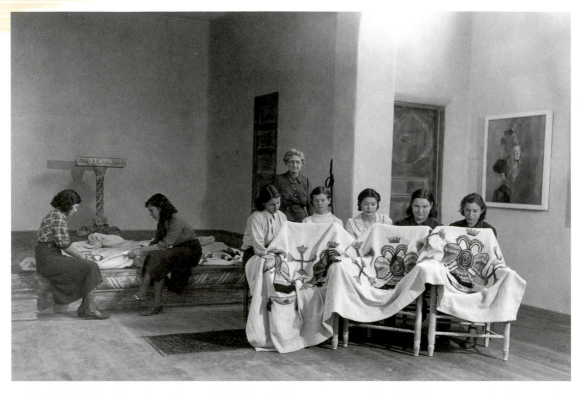

NYA Girls Embroidering Stage Curtain for the Roswell Museum, instructor Amelia B. Martínez, standing (ca. 1937), Roswell, New Mexico. Photo courtesy of the Museum of New Mexico Photo Archives, MNM no. 90206.

loaned out to what have been termed "culturally underdeveloped regions."[14] New Mexico was included in this category despite its successful reputation as a mecca for artists.

The art centers in New Mexico, located in Gallup, Roswell, Melrose, and Las Vegas, actively facilitated the FAP, CCC, NYA, and Women's and Professional Projects. The centers were intended to "embrace all racial groups" and to put children face-to-face with art and the creative process.[15] All of the art centers and galleries in New Mexico held exhibitions and traveled shows through the national WPA traveling exhibition department.

The WPA/FAP Exhibition Section was extremely active in traveling these shows from art center to art center. By putting together hundreds of exhibits and rotating them every two to three weeks, the Ex-hibition Division and the federal art centers were exposing millions of people to different types of art and media. New Mexicans saw a variety of exhibits, including *Paintings by Mexican Children*, works by Mexican painter Rufino Tamayo, *Index of American Design* plates, and an exhibit of Currier and Ives prints.

Gallup Federal Art Center

The Gallup Federal Art Center opened in 1938. From available documentation, it does not appear to have been a great producer of art but rather concentrated on exhibitions and making art available to the large Native American population of the area. Children's classes were also held here. The center was located in the pre-1939 county courthouse and furnished with Span-ish Colonial–style furniture made by Hispano artists.

Roswell Federal Art Center

One of the most successful WPA art centers developed in southeastern New Mexico, outside what is often thought to be the artistic center of the state. The Roswell Federal Art Center, which opened its doors on December 11, 1937, was often referenced in WPA official documentation and publicly lauded in speeches and lectures by top WPA officials. One official, Thomas C. Parker, mentioned it as an example of this vision:

> Another art center which strikingly illustrates special adaptation of this work to community life is to be found in Roswell, New Mexico. Community interests here are centered around the rich historical heritage of the Southwest. The Chaves County Historical and Archaeological Society, with the aid of group sponsorship, has designed, furnished and decorated a unique gallery built by the Works Progress Administration. The furnishings throughout are of traditional Spanish Colonial type. Much of the research and work in designing and executing the furnishings was done by the Federal Art Project under the direction of the State Art Project Director. Regardless of what happens in future design developments, Roswell may be very proud of the retention of the early Spanish-Colonial culture and architecture in its community life.[16]

In a 1964 oral interview recorded for the Archives of American Art, the former director, Roland Dickey, who later authored *New Mexico Village Arts,* discussed the segregation of "Negros" and "Spanish-Americans" in Roswell and its ramifications for the art center:

> You had in the City of Roswell in those days the interesting segregation system where no negro and no Spanish-American ever entered the public swimming pool. But we sort of brought down the rafters—we had a presentation of Los Pastores with a Spanish cast from the other side of the tracks which was an immense success. People were delighted with this.

Roswell Federal Art Center (ca. 1937), Roswell, New Mexico. Photo courtesy of the National Archives, neg. no. RG-69-N 10489-D.

Student in a Sculpture Class sponsored by the Roswell Federal Art Center at the San Juan Parroquia School, Chihuahuita Neighborhood (ca. 1937), Roswell, New Mexico. Photo courtesy of the Holger Cahill Papers, Archives of American Art, Smithsonian Institution.

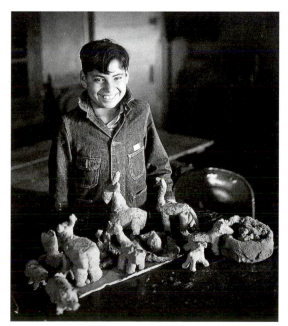

One member of the board of directors protested violently and another member of the board of directors stood up against her on this, and this was it.[17]

Despite all its highly touted success, never was the segregation of Hispano and Anglo populations more evident than in Roswell. The Roswell Federal Art Center held special classes for "Mexican" children, the younger inhabitants of the town's "Mexican barrio" southeast of downtown known as "Chihuahuita" or "Chihuahua." Previous documentation and publications have stated that these classes were held in the Roswell Federal Art Center. This was not the case. Hispana and Hispano children were taught outside of the Roswell Federal Art Center in Chihuahuita because of prejudice on the part of the Roswell Museum personnel. The classes took place on Monday afternoons from 3:30 to 5:30 P.M. in the San Juan Parroquia School. The building, erected in 1922, still exists today next to Roswell's Saint John's Catholic Church. Regarding this matter, Roland Dickey tried to place the separation in a positive light:

> Although the workshop is being held at the parochial school, it is not in any sense restricted to Catholic children, and is for the benefit of all Spanish-American children in Roswell. There is no age restriction; at present we have enrolled children between the ages of 6 and 15.[18]

Numerous images exist of instructors Juanita Lantz and Jan Marfyak teaching the "Mexican" children drawing, painting, sculpture, and weaving. The December 3, 1938 drawing and design class taught by Marfyak had the following students enrolled: Felipo Pérez, Esther Pérez, Manny García, Alice Rodríguez, Epifanía García, Lucy Cobos, Carmelita Alvarado, Antonia Chávez, Rose López, Rudolfo Pérez, and Robert Romero.[19]

Adult classes were also taught, but at the center itself. No Hispanas and Hispanos seem to have enrolled in art classes. A cursory study of the extant gallery logs indicates very few Hispanas and Hispanos visited the center's exhibits. However, the center was decorated with Hispano art, including bultos (three-dimensional religious sculptures) by Juan Sánchez, tinwork by Ildeberto Delgado, and furniture made on site by Domingo Tejada.

Melrose Federal Art Center

Melrose, New Mexico maintained an extremely active federal art center despite the town's small size and population in the 1930s and 1940s. Located between Ft. Sumner and Clovis, Melrose boasted a population of approximately five hundred and was considered the smallest town in the United States to have a federal art center. Residents at the time rallied support and the American Legion of Melrose paid the center's rent out of their treasury.[20] On June 22, 1938, the center, under the direction of Roswell artist Martha Kennedy, opened in an old storefront on Main Street. It later moved into the courthouse building.

The Melrose Federal Art Center, furnished with Spanish Colonial style furniture, also held art classes for adults and children in painting, muralism, weaving, colcha (embroidery), woodworking, and other "crafts." Estella García taught the colcha classes and Max Ortiz taught weaving on Spanish looms. Furniture artist Domingo Tejada traveled from Roswell to teach the woodworking classes. A number of Anglo artists were brought in from out of state to teach classes in painting, drawing, and lithography.

San Miguel Federal Art Center

The San Miguel Federal Art Center and Gallery on the Las Vegas Plaza was the only center situated in a predominantly Hispano area. Las Vegas was a college town and home to New Mexico Normal University

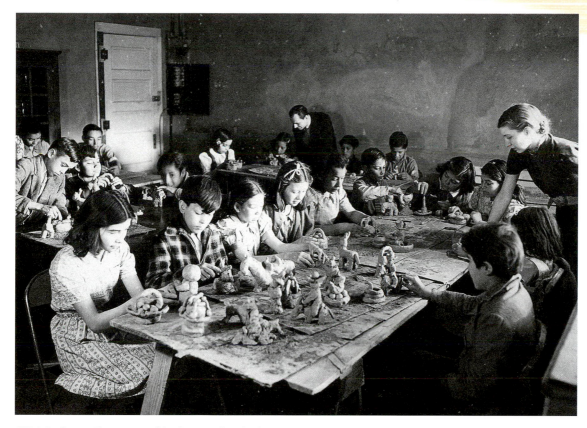

WPA Sculpture Class sponsored by the Roswell Federal Art Center under Supervisor Jan Marfyak at the San Juan Parroquia School, Chihuahuita Neighborhood (ca. 1937), Roswell, New Mexico. Photo courtesy of the Holger Cahill Papers, Archives of American Art, Smithsonian Institution.

Local Antique Show and Index of American Design Exhibit at the San Miguel Federal Art Center (ca. 1938), Las Vegas, New Mexico. Photo courtesy of the Museum of New Mexico Photo Archives, MNM no. 1630.

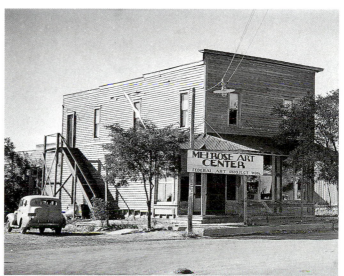

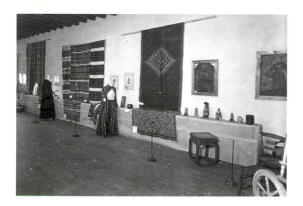

Melrose Federal Art Center (ca. 1938), Melrose, New Mexico. Photo courtesy of the Holger Cahill Papers, Archives of American Art, Smithsonian Institution.

where a large Spanish American population studied to be teachers. The director of the gallery was Mary Eleanor Thoburn and the instructors included Abraham Slifkin, who taught sculpture and designed the gallery's exhibitions; James Lechay, who helped design exhibitions and taught painting; and Helene Herald, who taught "craft" classes for children in both Las Vegas and Roswell.[21] The San Miguel Art Center also held workshops for the Spanish-speaking inhabitants of the town: "Las Vegas has a workshop for the native children who at present are interested in clay modeling and making decorated dolls."[22] Hispano attendance was high in the art center gallery and classes and Thoburn observed: "The Spanish-American population especially has more than average artistic feeling and appreciation."[23] Despite such attempts and observations, Las Vegas at the time was not without its own prejudices. Director Thoburn tried to explain these complexities in a letter to Mildred Holzhauer, the FAP assistant director:

> The greatest difficulty lies in the two towns, so close in geography as to be a unit but further apart in spirit than Beverly Hills and Boston. On the little map attached you will notice that the river divides the two: on the west lies the original town, on the east New town. Two school boards, two fire departments, two incorporations. First the railroad, later the highways were diverted to Newtown, causing much bitterness in Oldtown, nor does new town's sneering references to Oldtown as "Chihuahua" help any! Oldtown would like to merge city corporations, but Newtown violently resists since such a move would make a Spanish-American majority at the polls. Whatever one side wants the other automatically opposes. One gallery visitor actually said she really couldn't be expected to have such interest in anything located "across the bridge."[24]

WPA Exhibitions

Art made for the WPA/FAP was exhibited at the national, regional, and local levels, and state administrators sent works to the national office for distribution and exhibition. Some of the more pivotal shows include *New Horizons in American Art*, which ran from September 14 through October 12, 1936 at the Museum of Modern Art in New York City and the *Frontiers of American Art* exhibition held at the M. H. de Young Museum in San Francisco, which ran from April 4 through October 15, 1939. Both exhibitions featured works by Hispano artists from New Mexico. The latter show ran during a portion of the Golden Gate Exposition, or the "Fiesta in the West"—the west coast's answer to the 1939–1940 World's Fair in New York, where another large exhibition, *Art in Action*, also featured work by WPA/FAP artists. Diego Rivera painted a mural during this San Francisco area exposition with the help of WPA/FAP artists.

On the east coast, a major exhibition of the WPA/FAP art from all over the United States was held at the New York World's Fair beginning September 1939. The exhibit, titled *American Art Today*, was the largest display of WPA/FAP art assembled during the New Deal era and was seen by over one million visitors. A number of New Mexico Hispano works were also featured in the World's Fair exhibition. At one point, the New York organizers had wanted one room of the Roswell Federal Art Center to be reconstructed in every detail at the fair.

Other New Deal Arts Related Programs: Women's and Professional Division

One of the reasons it has been so difficult to uncover the names of women and especially of Hispana artists during the New Deal is that they were working with "traditional" materials and engaging in "women's work" such as canning, gardening, and sewing. These

and other domestic skills were not considered worth documenting in any detail. Examples of the works projects (either in place early on, or developed later) for the unemployed women in the Women's and Professional Division of the WPA included "programs in recreation, dramatics and handcrafts [sic], municipal horticultural, nurseries, child feeding, sewing rooms, gardens, canning and emergency nursery schools and housing for transients."[25] Documents indicate that at the division's inception in 1933:

> Among the projects under preparation are community centers where unemployed women trained in dressmaking, millinery, beauty culture, arts, crafts and other vocational fields may teach the less skilled. Special projects are being planned for unemployed librarians, artists, musicians, actors, home economists, home demonstration agents, vocational specialists, older women and others.[26]

Eleanor Roosevelt took a special and active interest in the Women's and Professional Division, which was directed nationally by Ellen Sullivan Woodward. In New Mexico, one of the first eight states to begin operation of projects for women, the division was first directed by Mary B. Perry and then Nancy Lane. Despite the contemporary simplistic descriptions of "women's work," New Mexico's Division of Women's and Professional Projects developed a strong focus on the cultural preservation of art, music, cultural history, and research. Hundreds of Hispanas were employed by the New Mexico projects and their work ranged from sewing bedding and clothing to copying and translating historical records. Hispanas were also employed as *enjarradoras* (adobe plasterers).

Federal Music Project (FMP)

The Federal Music Project was formed as both an education and performance entity. At its inception,

the project was divided to run on a regional basis with New Mexico in Region Eleven under the direction of Bruno David Ussher. It was later administered at the state level under the name of WPA Music Project. Like its FAP national counterpart, the FMP offered music classes for adults and children. In El Paso, the FMP also had a "típico orchestra [sic]" and a native Mexican dance troupe. New Mexico's Federal Music Project sponsored orchestras, bands, and choral groups. The WPA Music Program projects in New Mexico, in collaboration with the WPA Writers' Project, also collected and researched the folk songs and dances of Spanish New Mexico. Much of the research was conducted by University of New Mexico professor Arturo L. Campa.[27]

Federal Writers' Project (FWP)

Like the Federal Music Project, the Federal Writers' Project echoed the ideals of the Federal Art Project in its effort to document cultural history before its disappearance. The FWP hired unemployed writers to record the lore, stories, and customs of America's past. A series of guidebooks called the "American Guide Series" were researched, collected, and written, providing Americans with an expanding knowledge of their country. Among the more well-known contributions of the FWP were slave narratives collected from ex-slaves in the southern United States.

The FWP was extremely active in New Mexico; it is perhaps the WPA program that elicits the most recognition in this state. In New Mexico, the FWP focused on the richness of Hispano culture and intentionally hired Spanish-speaking interviewers to gather and collect *corridos* (songs), *dichos* (sayings), mysteries, *remedios* (cures), *cuentos* (stories), traditions, poetry, folklore, and local customs in an effort to preserve Hispano culture. A number of Hispana and Hispano writers, including Lorin Brown, Elba C De

Baca, Reyes Nicanor Martínez, and Aurora Lucero White worked for the Writers' Project. Hispano informants whose names have been recorded participated by telling their stories.[28]

The NM FWP also produced a calendar of New Mexico events, Pueblo dances, and feast days that is still in use today. Their contribution to the National WPA American Guide Series was *New Mexico: A Guide to the Colorful State.* The programs of the WPA ended in July 1943 when the country's attention and resources turned toward war.

It seems that American art was such an integral component of the seemingly endless parade of New Deal programs and alphabet combinations that even the relief programs, not originally meant to contain art, incorporated arts-related components. These included the Civilian Conservation Corps, the National Youth Administration, the Farm Security Administration, and the Soil Conservation Service (SCS).

Farm Security Adminstration

Previously known as the Resettlement Administration (RA), the FSA was implemented in 1937. Photographers hired by the project were sent out to document relief efforts and rural America. The images they left behind—more than 250,000 examples—provide us with a visual record of the depression era in the United States. The photographers most active in New Mexico were John Collier, who later became the Commissioner of Indian Affairs, and Russell Lee, who photographed Chamisal, Peñasco, the Taos area, and Pie Town. Other notable photographers, including Jack Delano, Dorothea Lange, and Arthur Rothstein also shot images in New Mexico for the FSA and also for the Bureau of Agricultural economics and the Office of War Information.

Civilian Conservation Corps

Under the direction of the War Department, the CCC was implemented in March 1933. During its existence, the CCC employed more than three hundred thousand young men nationwide.[29] A number of the camps were sponsored by or ran in conjunction with other federal agencies such as the Department of the Interior, the National Park Service, and the Soil Conservation Service because the majority of projects pertained to beautifying and strengthening national parks. Planting trees and building trails, roads, bridges, dams, picnic and recreational sites, and visitors' centers were among the many projects completed by the CCC. The program also encouraged artistic expression. Many artists were hired to go to the camps and paint scenery and daily life of the CCC-ers. Although the CCC did not allow women, FERA later developed a small number of camps for women, which in time were added to the National Youth Administration programs. These camps were sometimes referred to as the "she-she" camps, a play of words on the CCC camps.[30]

Among the forty-plus army-run camps in New Mexico were those in Albuquerque, Abiquiú, Bandelier, Bloomfield, Carlsbad, Carrizozo, Chama, Clayton, Corona, Lake Arthur, Las Cruces, Cuchillo, La Cueva, Elephant Butte, Española, Farmington, Fort Stanton, Grants, Jémez, Little Tesuque, La Madera, Magdalena, Mayhill, Otowi, Radium Springs, Raton, Río Gallinas, Río Puerco, El Rito, San Ysidro, Sandia Park, Santa Fe, Sulfer Canyon, Tularosa, Tres Ritos, and Vallecitos. Approximately eighty additional side camps and a cooks' school at Conservancy Beach were also active in the state. Other CCC projects in New Mexico included erosion and flood control, tree-planting, transplanting chamisa seed, and installing telephone lines. It has been estimated that 90 to 95 percent of enrollees in the Northern New Mexico camps were Hispano.[31]

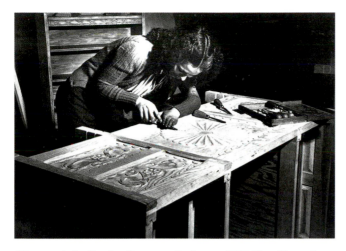

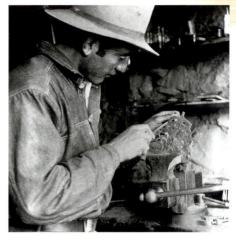

Hispana Artist Carving Rosette on Desk at an NYA Shop (December 1941), Taos, New Mexico. Photo by Irving Rusinow for the United States Department of Agriculture, Bureau of Agricultural Economics, courtesy of the National Archives, neg. no. 83-G-41746.

Iron Hardware Student at the La Ciénega Vocational School (ca. 1930s), La Ciénega, New Mexico. Photo courtesy of the National Archives, neg. no. RG-69-N 11656-C.

Equally important to the state but lesser known are the artistic achievements of New Mexico's CCC camps. The majority of the camps had orchestras or bands usually supervised by WPA music instructors. Many of the camps also conducted visual arts-related activities and classes ranging from painting and murals to furniture and weaving. For example, the predominantly Hispano Company 2843 SCS-3-N in Española had a workshop "provided for the enrollees where they were taught woodworking and Indian rug weaving."[32] Company 833 SP-1-N in Santa Fe had a "trade school" to "train enrollees for various means of livelihood after leaving the CCC."[33] The enrolled artists created carved and painted chairs and trunks in the Spanish Colonial style as well as hand-wrought iron and metal arts. As was the case with New Mexico's vocational school system, the CCC artists were allowed to keep or sell a portion of their creations.[34] The arts and architectural details created by the CCC artists were used in many of the buildings and other projects carried out by the camps such as the National Park Service Southwest Regional headquarters in Santa Fe, and the structures at Bandelier National Monument. The CCC camp located in Carlsbad also performed an extensive amount of work to enhance the famous caverns for tourism.

In 1940, the Soil Conservation Service made a film titled *Roots in the Earth* in New Mexico that was shot on location at many of the CCC project sites.[35] The narrated and musically scored production was one of a number of SCS films designed to impart the poverty and land situation of the depression era to a larger audience. Although there are segments that feature the Río Grande, Elephant Butte Lake, Chimayó, and Truchas, most of the film was shot in Córdova and focuses on the life and activities of area resident Juan Vigil and his family. Segments also include a woodcarver (probably George López, the son of José Dolores López), weavers, and adobe plasterers. *Roots in the Earth* was released in both Spanish and English in an effort to reach the Hispano population in New Mexico and other Spanish-speakers in the Southwest. It was also intended for use in Latin America because "Latin American groups are interested in the fact that

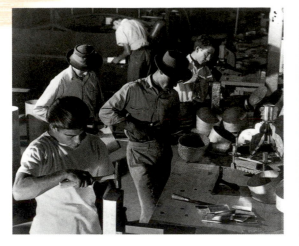

NYA Tinwork Class (1930s), Albuquerque,
New Mexico. Photo courtesy of the National Archives,
neg. no. 1195-19Q-1.

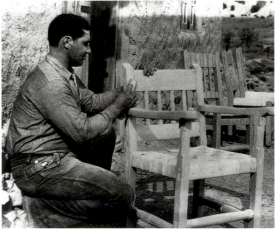

Furniture Instructor (identified as Eloy Chávez) in front of
David C' de Baca's Studio (ca. 1938), La Ciénega, New
Mexico. Photo courtesy of the National Archives, neg. no.
RG-69-N 12118-C.

we in the United States are interested in the Spanish-speaking population in this country."[36] This may very well have been a Good Neighbor Policy project related to the Office of the Coordinator of Inter-American Affairs; apparently, the Brazilian Embassy asked for a voice-over in Portuguese.[37] *Roots in the Earth* continued to be shown in Córdova-area schools until the 1960s.[38]

National Youth Adminstration

Created in 1935, the NYA was "consciously designed to allow youths to obtain the training necessary for substantial employment in later life."[39] The central objective of this program was to lay a nationwide foundation for vocational and applicable life skills training for high school and college-aged American boys and girls. In addition to arts and construction projects, administrative, business, and secretarial skills were also taught in this vocational education-focused program.

In New Mexico, NYA instructors passed on their talents in furniture-making, weaving, colcha embroi-

dery, tinwork, and music. Among the more active NYA programs in New Mexico were those in Taos, Santa Fe, Albuquerque, Los Lunas, and Roswell. Additionally, the NYA sent instructors to the state mental hospital in Las Vegas to teach woodwork, weaving, tinwork, and "other activities which would be of some benefit to patients who are almost normal."[40]

The state NYA office, furnished with art made through the projects, was located in Albuquerque and was directed by Thomas L. Popejoy, later a popular president of the University of New Mexico. The extremely active office supported creative work throughout the state. An April 1939 report states that within the NYA programs, "Crafts and Visual arts" comprised 12.1 percent of total activities. During the New Deal, the NYA participants in New Mexico programs were 66.6 percent male and 33.4 percent female.[41] A number of NYA works, including carved wooden boxes and hand-woven articles, were sent to Washington, D.C. to be exhibited during the second inauguration of FDR.[42]

One of the NYA girls' camps, located at Capitán,

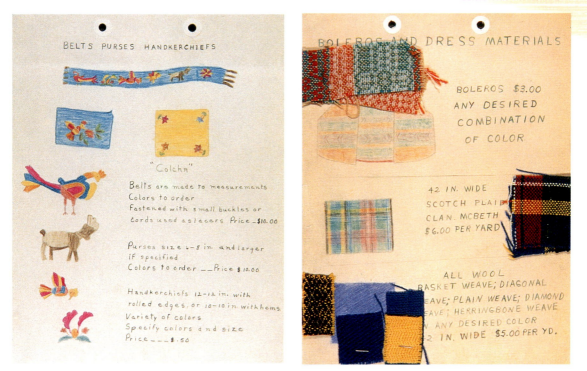

Camp Capitán Catalogue Page (1937–1939). Colored pencil on paper, Capitán, New Mexico. Photo courtesy of the National Archives, Record Group 69.

Camp Capitán Catalogue Page (1937–1939). Mixed media, Capitán, New Mexico. Photo courtesy of the National Archives, Record Group 69.

New Mexico functioned as an intensive educational experience for unemployed girls aged sixteen to twenty-five. The enrollees, many of whom were Hispanas, were either on relief themselves or came from families either on relief rolls or who were recipients of the Rural Resettlement Programs. The camp drew its enrollees from the Albuquerque, Santa Fe, and Roswell areas as well as from Lincoln and San Miguel Counties. The young women enrolled in a three-month program featuring classes in bookkeeping, stenography, typing, social sciences, penmanship, English, history, sewing, health, gymnastics, cooking, weaving, and native arts.

By March 1938 the camp had a full-time "recreational instructor" who directed the "leisure time " activities. The instructor was charged with "preparing the young women in attendance (who are mostly from rural regions) to act as recreational leaders when they return home."[43] The NYA program at Camp Capitán produced an unusually beautiful handmade catalog of their "leisure time" activities for sale including colcha, weaving, tinwork, and carving. The catalog, found in the National Archives, completely hand-drawn and illustrated with actual fabric swatches stapled to its pages, is an exquisite example of the artistry of these programs and should itself be considered a work of art.[44]

New Mexico's Vocational School System

One of the most successful educational programs that coexisted with the WPA arts-related programs in New Mexico was the system of vocational schools run

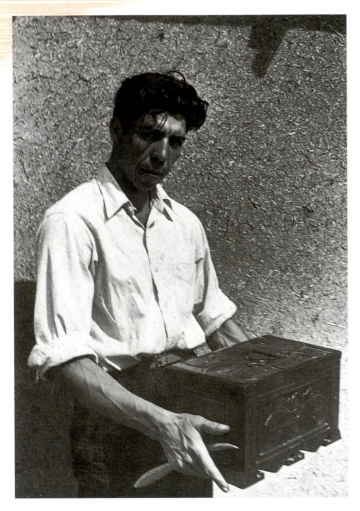

*"Spanish American Boy with a Chest which He Carved,
These People are Adept in Many of the Handicrafts"
(artist identified as Benjamín Domínguez) 1940,
Chamisal, New Mexico. Photo by Russell Lee for
the Farm Security Administration, courtesy of the
National Archives, neg. no. LC-USF-34-36986.*

under the New Mexico State Department of Vocational
Education. The roots for this were planted earlier, in
1929, when Concha Ortiz y Pino (later de Kleven),
founded the first "vocational" school in Galisteo. As di-
rector, she named the school the Colonial Hispanic
Crafts School and taught embroidery, tanning, saddle-
making, wood arts, and weaving. The idea and organi-
zation proved to be a success. In 1932, Brice Sewell
was appointed State Director for Vocational Educa-
tion and Training for New Mexico and eventually
supervised over forty vocational schools geared toward
rural and poorer communities. Schools were located
in Abiquiú, Agua Fría, Albuquerque, Antón Chico,
Atarque, Cerrillos, Cerro, Chupadero, La Ciénega,
Clayton, Costilla, Coyote, Las Cruces, Cundiyó, Delia,
Española, Galisteo, Gallup, Glorieta, Grants, Hot
Springs, Lemitar, Los Lunas, Mesilla, Monticello,
Mora, Peñasco, Pojoaque, Puerto de Luna, Questa, El
Rito, San José, San Gerónimo, Santa Cruz, Santa Rosa,
Seboyeta, Socorro, Stanley, Taos, Las Trampas, and
Las Vegas. The central objective of the vocational
school classes, similar to that of the NYA, was to teach
students skills that could result in the achievement of
financial self-supporting independent status.

Again, these schools were both independent of and
interdependent with the WPA. The details of the in-
terrelationship are intricate and complex. A number
of the vocational school instructors were paid through
funds from the Smith-Hughes Act (passed into law
in 1917), which provided government funding to
vocational secondary schools, and from the WPA
Emergency Educational Project. Additionally, the
NYA paid for participants to attend classes and learn
traditional art forms.

Once an instructor was in place, the community
would then construct or supply a building where
classes would be held. Additionally, the community
was responsible for supplying local materials from

which the artwork would be made. No WPA funds went to materials. A large portion of the art made in the vocational school system was meant for utilitarian and decorative home use within the community. Additional creations, whether furniture, tin, pottery, weaving, or colcha could be marketed either via the instructor, a wholesaler, the artists, or by other means such as the Spanish Arts and Native Market stores in Santa Fe. The "workers" received no hourly wage. Their only compensation came from the art they sold.

The art made in these schools was considered "vocational craft" and was treated with indifference and dismissed in written records. Today, the majority of artists in the vocational schools also remain "undocumented," with few names or accounts of their artistic talent recorded. The difficulties in achieving recognition for the traditional Hispano arts of the time is evidenced by an account in the 1935 *Tewa Basin Study,* which stated that out of the sixty-one students taking woodworking or weaving classes at Santa Cruz High School Vocational Training, only 10 percent would make a living at one of those two art forms. According to one of the teachers, "the reason for this is that the wages per hour on handicraft work remain extremely low, 15 cents at best. Only the few showing exceptional talent can hope to make any sort of living at it. For example, an excellent chest with 30 hours of labor in it will bring $10.00, and the cost of the wood is $2.50."[45]

As more vocational schools were built during the New Deal era, the general mission of the vocational schools was shifted. They became what Director Sewell called self-sufficient and locally supported cultural centers. One WPA administrator noted that the "program for the development of the handicrafts is based entirely on the economic returns to the workers. The cultural values have been a by-product to the program; however, there are many people in the state who feel

"Spanish-American Men with Examples of their Wood Carving which they Hope to Sell to Tourists." Artists identified as Eugenio Arrellano (left), possibly Rumaldo Córdova (center), Ernesto Arrellano (right) 1940, Chamisal, New Mexico. Photo by Russell Lee for the Farm Security Administration, courtesy of the National Archives, neg. no. LC-USF-34-37603.

that the cultural phase of the program has even a greater worth than the economic, although less tangible."[46]

One of the lasting legacies provided by instructors and the director of the Vocational School Program in New Mexico were the series of published "Blue Books" to help in art object design. Each mimeographed edition included a brief history of the art and medium as well as a description of traditional materials and motifs. Among the Blue Book titles were "Spanish Colonial Furniture Bulletin" (1933 and 1935); "Tanning Bulletin" (February 1934); "Vegetable Dyes Bulletin" (January 1934 and October 1935 by Mabel Morrow and Dolores Perrault); "New Mexico Colonial Embroidery" (1935); "Tin Craft in New Mexico" (June 1937 by Carmen G. Espinosa); "Spanish Colonial Painted Chests" (1937); and "Graphic Standards for Furniture" (February 1939 by William Lumpkins). The designs and measurements provided were drawn after objects in both private and museum collections. They continue to inspire contemporary artists.

Notes

1. Speech delivered by Holger Cahill, national FAP director, to the People's Art Center Association, St Louis, Missouri, 5 May 1941. Holger Cahill Papers, Speeches and Letters, box 1 of 8, Archives of American Art, Smithsonian Institution, Washington, D.C. (hereafter AAASI).

2. Quoted in Francis V. O'Connor, *Federal Support for the Visual Arts: The New Deal and Now* (New York: New York Graphic Society Ltd., 1969), 18.

3. Ibid.

4. Telegram from Russell Vernon Hunter, cited in letter dated 18 July 1936, from Mildred Holzhauer to Holger Cahill, Holger Cahill Papers, box 10, AAASI.

5. *National Exhibition of Art by the Public Works of Art Project—April 24, 1934 to May 20, 1934* (Washington, D.C.: Corcoran Gallery of Art), 2. In WPA vertical files, National Museum of American Art/National Portrait Gallery Library, Smithsonian Institution, Washington, D.C.

6. William F. McDonald, *Federal Relief Administration and the Arts: The Origins and Administrative History of the Arts Projects* (Columbus: Ohio State University Press, 1969), 365.

7. "Public Works of Art Project Bulletin," no. 2 (March 1934) 2, miscellaneous PWAP/WPA materials, AAASI.

8. Ibid.

9. Milton Meltzer, *Violins and Shovels: The WPA Arts Projects* (New York: Delacorte Press, 1976), 20.

10. "Public Works of Art Project Bulletin," no. 2 (March 1934), 3–4, AAASI.

11. Holger Cahill memo to Captain Brock, n.d., Holger Cahill Papers, AAASI.

12. Donald Bear to Holger Cahill, 8 February 1936, Record Group (hereafter RG) 69, Central Correspondence Files 1935–1944, New Mexico Art Program, National Archives, Washington, D.C. (hereafter NA).

13. Ibid.

14. Francis V. O'Connor, *The New Deal Art Projects: An Anthology of Memoirs* (Washington, D.C.: Smithsonian Institution Press, 1972), 3.

15. Ibid., 13.

16. "Concerning the Development of Community Art Centers," Thomas C. Parker speech delivered 14 June 1938, Francis V. O'Conner Papers, AAASI, 11.

17. Roland Dickey interview with Sylvia Loomis, 16 January 1964, AAASI, p. 12 of transcript.

18. Roland Dickey to Elizabeth Hayslip (principal of South Hill School, Roswell), 15 December 1938, Roswell Museum and Art Center Institutional Archives, Roswell, N.Mex. (hereafter Roswell MACIA).

19. There are two additional names that are difficult to read: an "E" Luján and an Antonio "C." "Instructor's Class Record," 3–19 December, 1938, drawing and design children's class, San Juan School, Roswell MACIA.

20. "Concerning the Development of Community Art Centers," Thomas C. Parker speech, 8.

21. "Loan Artists," box 4 of 10, Holger Cahill Papers, AAASI. Remarks on these loan forms indicate that Slifkin was "intensely interested in the Art Center and its problems," that Herald [*sic*] "did an excellent job," and that Lechay was "uncooperative."

22. Ina Sizer Cassidy, "Art and Artists in New Mexico: Home Arts and Crafts," *New Mexico Magazine* 17:5 (May 1939), 26–27, 46–47.

23. Mary Ellen Thoburn to Mildred Holzhauer, 1 March 1938, RG 69, NA, 3.

24. Ibid.

25. Federal Emergency Relief Act list dated 16 October 1933, cited in William F. McDonald, *Federal Relief Administration and the Arts,* 43.

26. Ibid., 43–44.

27. A recent recording taken from unpublished NM FMP files shows examples of his music. *Spanish American Dance Tunes of New Mexico: WPA, 1936–1937,* performed by the Jenny Vincent Trio. San Cristobal, N.Mex.: Cantemos Records, 2000.

28. For more information on the NM FWP see Tey Diana Rebolledo and Maria T. Márquez, eds., *Women's Tales from the New Mexico WPA: La Diabla a Pie* (Houston: Arte Público Press, 2000).

29. Meltzer, *Violins and Shovels,* 12.

30. Roger Biles, *A New Deal for the American People* (DeKalb: Northern Illinois University Press, 1991), 199.

31. Suzanne Forrest, *The Preservation of the Village: New Mexico's Hispanics and the New Deal* (Albuquerque: University of New Mexico Press, 1989), 118.

32. "Civilian Conservation Corps Official Annual 1936, Albuquerque District 8th Corps Area" (Baton Rouge: Direct Advertising Company, 1936), 27.

33. Ibid., 59.

34. Forrest, *The Preservation of the Village,* 117.

35. For more information and the script for the film, see Richard L. Boke, "Roots in the Earth," *New Mexico Quarterly Review,* vol. XI, no. 1 (February 1941), 25.

36. Ibid., 25–30.

37. Ibid.

38. Herminio Córdova, husband of artist and santera Gloria López Córdova (granddaughter of José Dolores López), remembers watching the movie in school on a number of occasions in the 1940s and 1950s. Interviews with Herminio Córdova and Gloria López Córdova, Santa Fe, N.Mex.,September 1994 and December 1997.

39. William Hickman Pickens, "The New Deal in New Mexico: Changes in State Government and Politics 1926–1938" (Master's thesis, University of New Mexico, 1971), 124.

40. "New Mexico Report of Recreation Project," 21 January 1939, NYA State Reports, RG 69, NA.

41. "NYA Statistical Report, month ending April 30, 1939," NYA State Reports, RG 69, NA.

42. Thomas L. Popejoy to Eduard C. Lindeman, 9 January 1937, box 1291, RG 69, NA.

43. "Summary of Recreational Activities sponsored by the National Youth Administration in New Mexico," in Thomas L. Popejoy to Dorothy Cline (Field Supervisor, WPA, and leader Community Organizations for Leisure Time Activities), 30 June 1936, box 1291, RG 69, NA.

44. "Catalogue Girl's Camp NYA Capitan, New Mexico," box 1935, RG 69, NA.

45. Marta Weigle, ed., *Hispanic Villages of Northern New Mexico: A Reprint of Volume II of the 1935 Tewa Basin Study with Supplementary Materials* (Santa Fe: The Lightning Tree Press, 1975), 71.

46. Ibid.

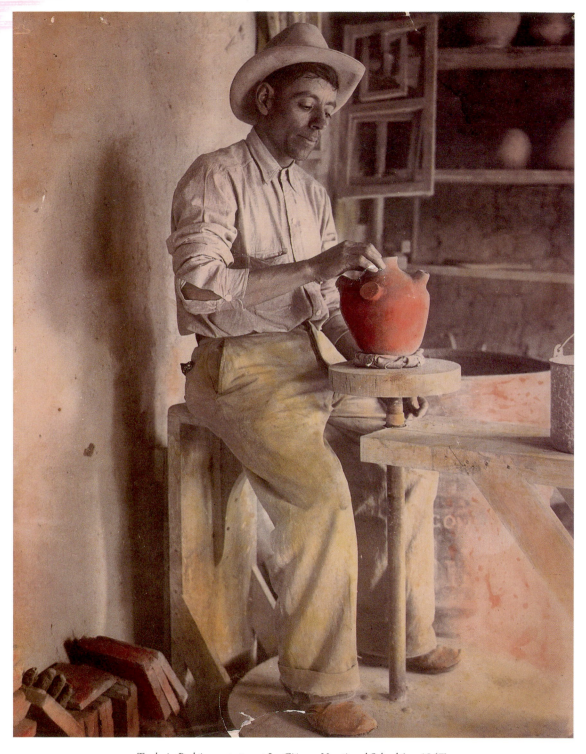

Teodocio Rodríguez, potter at La Ciénega Vocational School (ca. 1947),
La Ciénega, New Mexico. Photo courtesy of Victoria Rodríguez.

I believe these craft projects are probably more desirable

in New Mexico than in any other place, but I think

we must bear in mind the fact that we must not let

craft projects over-balance our fine arts programs.[1]

—Holger Cahill, WPA/FAP Director

CHAPTER ONE

"Craftspeople, Laborers, and Handicraft"

(Mis) Perceptions of Hispano Art of the Early Twentieth Century

WHY HAVE HISPANA AND HISPANO ARTISTS of the WPA been forgotten? The cultural climate in New Mexico and the United States during the 1930s and 1940s provides some clues. The absence of these artists from the art historical record is a result of numerous social factors. Additionally, existing scholarship on this time period focuses on the "revival" of "lost" arts and crafts and tends to glorify and illuminate Anglo WPA administration and Anglo artists of this period, most of whom were already well-established and professionally successful members of the Taos and Santa Fe art colonies. Rarely, if ever, are the hundreds of Spanish-speaking artists mentioned by name or given credit for their works. They are more often referred to in terms such as naïve, native, peasant, quaint, uneducated, untrained people who engage only in the "leisure" activities involved in making "handicrafts."[2]

Cultural Relations/Tourism

Before the turn of the century, Fred Harvey was building a railroad hotel empire that facilitated the notion of a romantic Southwest. In New Mexico, Harvey Cars took tourists on jaunts to the regional Pueblos to view Indian life up close and personal. The number of Pueblo outings far exceeded those to Hispano villages—a reflection of the intense interest in the concept of the "noble savage" held by eastern Americans and others. Southwest Indian culture was thought to be the model for a simpler idyllic lifestyle.

Among the many visitors to the Harvey Hotels in the Southwest were members of the Anglo intelligentsia who flocked to New Mexico before and after its statehood in 1912. Artists, writers, and photographers came to capture and preserve the light, landscape, and the "true" indigenous elements of the American Southwest through their images and words. Such idealism was actively pursued as a post-industrialization solution to

rapidly advancing technology and a need for preservation of indigenous and folk cultures and lifeways. Finding inspiration in the "primitive" was a direct response to rapidly increasing complexities of civilization.

Although the pervasive attitude and main focus for tourism and curios during the early twentieth century was Native American culture and arts, it was the combined elements of Spanish and Pueblo design and culture that contributed to the romance of the Southwest and especially New Mexico. Components of Pueblo and Spanish architecture combined to form "Pueblo Revival" style, a now iconic representation of the Southwest. "Eastern intellectuals" (particularly Anglos) were so taken with Indian culture that they decorated their homes with Pueblo weavings and pottery to a far greater extent than with "Spanish-American" art. It wasn't until the 1920s, with the spreading interest of the Spanish Southwest and Californio-inspired Mission style, that Anglos began to incorporate santos and other religious and decorative objects from Hispano culture into their decor. All of these elements combined to portray exotic foreign surroundings replete with different cultures and languages.

Fred Harvey and others also recognized potential financial profits in Mexican colonial antiques and Hispano arts. Most of the Harvey Hotels in New Mexico, including the Alvarado in Albuquerque, had "Mexican" rooms that displayed and sold both Mexican and New Mexican works. The La Fonda Hotel in Santa Fe had a store specializing in Spanish Colonial antiques. A number of well-known traders such as Jesusito Candelario and Jake Gold set up shop in Santa Fe and sold New Mexican colonial art.

"Preservation," "Revival," and "Rehabilitation"
New Mexico proved no exception to the wave of interest in "reviving," "preserving," and marketing

traditional arts of "native" cultures that swept the United States, Sweden, Mexico, and other parts of the world during the early part of the twentieth century. The Arts and Crafts Movement, which had started earlier in England and made its way across the Atlantic to the United States, was one of the cornerstones of this ideology. Later, the atrocities of World War I helped facilitate a burgeoning interest in what was perceived as real, simple, and rooted in the earth and landscape.

The post-industrialization ideals of a simpler lifestyle and handmade objects ran rampant in the newly proclaimed forty-seventh state, mirroring the deeply rooted worldwide reaction to rapidly developing technology and mechanical innovations. As a result, "folk" art and "handicraft" revivalists sprang into action in a massive effort to document, revive, and preserve folk arts and folk culture deemed to be in danger of disappearing.

Even before official New Deal programs began to impact the arts in New Mexico, the sense of urgency and the need to encourage and promote traditional Hispano arts, especially in northern New Mexico, was already ingrained in the minds of revivalists. In the 1920s, the intense fascination with "primitive" art and Indian culture began to expand to include the other "natives" of New Mexico. In Taos and Santa Fe, many of the individuals concerned with preserving Native American arts recognized a similar need for the artistic creations of the Spanish-speaking population of New Mexico. A conscious effort arose by some individuals to market the arts and promote economic growth for the Hispano population and the state of New Mexico. To support this mission, a number of organizations, vocational schools, and retail outlets were established. The teaching of "traditional" artistic skills was seen as a confidence building method designed to financially help the poorer classes. Often, these programs were

not viewed in the context of art, but as a means of "rehabilitation," prompting one individual to comment, "thus a measure of rehabilitation for the natives is being performed, and a tradition which ownes [*sic*] great beauty is being fostered."[3]

Spanish Colonial Arts Society

One of the many results of the local "preservation" and "revival" movement was the 1925 formation of the Spanish Colonial Arts Society (SCAS) in Santa Fe. Among the original charter members were Mary Austin, Frank Applegate, and John Gaw Meem, who were involved in both the revival movement and the later government-sponsored programs of the New Deal. From 1930 to 1933, SCAS operated The Spanish Arts, one of the first retail outlets completely devoted to Hispano art. The 1931 *Santa Fe Visitor's Guide* provided readers with both a description of the types of art for sale and the contemporary context in which they and their creators existed:

> The folk of this secluded bit of New-Old Spain are today turning, more and more, to their own indigenous crafts under leadership of such Santa Fe organizations as the Spanish Colonial Arts. Carving of wood and stone, furniture making by hand and with only a knife for a tool, hammered tin work, and hand sewing and weaving are being encouraged. Visit the display rooms of these native arts and crafts in rooms 38 and 39, Sena Plaza.[4]

The Spanish Colonial Arts Society also started Spanish Market, now one of the largest venues for the sale of "traditional" Hispanic art in the country. Held each summer and winter in Santa Fe, Spanish Market carries on the original organizational mission to encourage, promote, and maintain Hispano regional arts and culture.

Native Market

The Native Market began as a Santa Fe retail outlet for Hispano art, including tin and metal arts, fiber arts, religious and secular sculpture, furniture, and other items such as hand-forged hardware. All objects were created using traditional techniques and materials. From 1934 to 1937 the shop was located on Palace Avenue. It expanded into a larger space on College Street between 1937 and 1940. Concurrently, a satellite store opened in Tucson, Arizona. The primary intent of the Native Market was to provide an outlet for Hispana and Hispano artists who either worked independently or through the vocational school system to sell their art to both locals and tourists. Among the more successful marketing strategies for everyone involved were the artist demonstrations held inside the store. Customers could watch wool being spun or a tin frame being made. In 1937, Native Market partnered with Fred Harvey's Indian Detours and the Santa Fe Chamber of Commerce to create what was intended to be a major tourist attraction, El Parián Analco. Situated across from the old San Miguel Church, it also featured artist demonstrations, restaurants, performances, and even an ice-skating rink. Unfortunately, the venture did not last long. It closed in the early fall of 1938.

The Native Market ventures survived through the financial backing and strong interest of Leonora Curtin who in the 1960s reapplied her support toward creating El Rancho de Las Golondrinas, a living history museum devoted to early Hispano culture located just south of Santa Fe in La Ciénega. Curtin strongly believed that Hispano arts needed to be preserved and that artists in the government-sponsored vocational training programs needed to have an opportunity to sell their work. At the same time, the general attitude of Curtin and the Spanish Colonial Arts Society supporters was that "the crafts can and should remain household arts."[5]

In one instance, she was asked to travel to Washington, D.C. to champion and discuss the importance and necessity of Hispano arts with Holger Cahill.

Native Market and the New Mexico Federal Art Project were separate entities but coexisted about the same time as the WPA. The latter's art programs in New Mexico and the Native Market stores were indirectly related; a number of the artists, including Ildeberto Delgado, Abad Eloy Lucero, Max Ortiz, and Eliseo Rodríguez, created art for both institutions.

Politics

In many cases, the political and social atmosphere and attitudes toward Hispanos, Mexican Americans, and other Spanish-speaking peoples in the United States during the 1930s and 1940s was not dissimilar to what has occurred in recent years with attention on immigration and political relations with Mexico and Latin America. During both periods in history, the U.S. government encouraged political and economic policies and agreements with its southern neighbors while at the same time expressing prejudice and discrimination toward those immigrants residing within American borders.

In the 1930s and 1940s, the U.S. government initiated the Good Neighbor Policy and the Bracero Program. The Good Neighbor Policy fostered artistic, cultural, economic, and political relations with Latin American countries in order to ensure hemispheric unity during World War II. Fears existed that the Axis Powers could invade the United States via Latin America—specifically Mexico. One result of such cultural and artistic relations, in addition to the newly accessible Pan American Highway, was that many Anglo writers and artists, including many from Taos and Santa Fe, traveled to, and became enamored with, the exotic "tropicalness" of the foreign land "South of the Border" (land that not too long before had

included New Mexico). Nationally and regionally, the Good Neighbor Policy also provided an impetus to study our Spanish-speaking neighbors within the United States. For the Eurocentric mind intent on "reviving" and helping Hispano culture, an attitude that perceived Nuevomexicanos as "foreign" prevailed. Spanish-speaking citizens were "exotic" and yet they resided safely within our borders—not "South of the Border." It was much easier and less threatening to demonstrate "neighborly" relations toward those who were already citizens.

At this same time, anti-immigration and repatriation policies were intended to discourage agricultural workers from coming to the United States during the depression. The outcome was a strong anti-Mexican sentiment among many Americans and the forced deportation of a million Spanish-speaking people back to Mexico. (As a result many of the deportees were actually U.S. citizens.)

Currently, the economic policy toward Mexico is NAFTA. A new anti-immigration movement has evolved. Both periods emphasized a fear that "aliens" could take jobs away from "real" Americans. In addition, these "aliens" would benefit from government-funded social programs. Both sets of international policies have affected New Mexico and the Spanish-speaking Nuevomexicano population. Due to the relative newcomer status of the state during the depression, Spanish-speaking residents occupied an ambiguous position and were often perceived as not completely "American."

As was the case across the country, the depression hit the mostly agricultural-based economy of New Mexico very hard. Documents indicate that because of language barriers, complexities of the application process, and racial prejudice, Hispanos, more than their Anglo or Native American contemporaries, found it difficult to obtain employment or get on relief rolls

of the numerous federally funded programs. They often had to travel out of state to take jobs as sheepherders or railroad and agricultural workers. At one point, in an attempt to find temporary agricultural employment, it was suggested that Hispano laborers be sent out of state to pick sugar beets rather than "import the Mexicans from Old Mexico."[6] This was not entirely a positive solution because it replaced Mexican labor with New Mexican workers and resulted in a loss of identity and a negative perception of Hispano citizens. If Nuevomexicanos went to another state as migrant labor, it was observed: "It is also necessary for these people to move all their belongings to a strange place where they are regarded as cheap Mexicans rather than as citizens and voters as they are in their home state."[7] Once an Hispano worker left the state, the identity of the individual was perceived as foreign. At the same time, the agricultural skills of these "New" Mexicans were sought after, and offered a replacement for labor and skills provided by the Spanish-speaking workers from "Old" Mexico.

Ironically, archival evidence that indicates the difficulties experienced by Hispanas and Hispanos in finding employment and fair treatment within the various WPA programs also provides the largest record of Spanish surnames found within the official government documentation of the WPA and New Mexico. Hundreds of letters and petitions detailing complaints and concerns over unfair treatment toward Hispanos were routed through the offices of U.S. Senator from New Mexico Dennis Chávez. Spanish surname after Spanish surname is listed as not being able to get work on the programs or being let go soon after they started. In Nambé, drama teacher Lorenzo Rivera and another individual who taught woodcarving to adults and youths at the community school were laid off just as the programs were getting successful and "reaching into the homes."[8] In Clayton, Alejandro

Trujillo, Matías Padilla, Joe E. Trujillo, Fulgencio Vigil, Beto Perea, and Edward Perea, workers on the WPA library project, co-authored a letter voicing their complaints:

> We further wish to protest the attitude taken by our local agents in reducing the poorest class of people from the Federal Project. It seems that too much favoritism is being practiced by the local agents of this County, and it is our desire that if there is anything such as justice in the distribution of Federal work in Projects, that such practice be put in motion in order that we may all enjoy the privileges extended to the people of the country by our constitution.[9]

Like their male counterparts, Hispanas in New Mexico also had trouble finding full-time employment in the WPA programs due to ethnic and cultural differences. A large number of letters written by Hispanas were addressed to both Eleanor Roosevelt and Senator Chávez. The discrimination was so obvious that it prompted Ellen Woodward, Assistant WPA Administrator in Washington, D.C. to comment:

> It seems to me that when we do not lower the standard in the southern states where the problem of negro [*sic*] women is so acute it was a great pity to discriminate against the Mexican women in New Mexico.[10]

Out of all the letters received in his office, most appeared to Chávez to be "worthy cases." They became so frequent that the senator finally wrote, "I am tired of writing to WPA officials in New Mexico about persons who write to me regarding treatment they receive from the local offices."[11] The fact that discrimination toward Spanish-speaking New Mexicans reached Capitol Hill and the national offices of the WPA indicates far-reaching implications for U.S. government/Hispano relations during the New Deal era and beyond.

Identity

During the 1930s and 1940s Anglo terminology for native Nuevomexicanos wavered between "Mexican" and "Spanish-American." A thorough perusal of Albuquerque and Santa Fe advertisements from New Deal–era newspapers, menus, and other publications illustrates this identity crisis. An equal number of "Sleeping Mexican" and "Spanish Don and Señorita" images appear. This dual identity fostered by marketing, tourism, and the romance with the Southwest at the time contributed greatly to both racial and artistic discrimination and misperception toward Nuevomexicanos. On the one hand Hispanos were "American," but on the other, they were foreign, different—the "other." They had been inhabitants of this country some four hundred years but had only recently become U.S. citizens. The state's New Mexican and Spanish influence and history was still very apparent and fresh in the collective mind. Before, and soon after, the turn of the century, seemingly shared cultural roots with Cuba and Mexico during the Spanish-American War and the Mexican Revolution, respectively, reinforced Anglo suspicions about disloyalty, prompting the press at the time to make derogatory statements about Hispanos. One such article stated that Spanish-speaking New Mexicans, even after fifty years under American rule as a territory, were "as foreign as they were before the conquest of Mexico."[12]

Underlying this blatant racist and artistic discrimination was the far-reaching influence of the so-called "Black Legend." Although extending further back in history, the Black Legend, or *la Leyenda Negra,* took hold in the sixteenth century, a source of anti-Catholic and anti-Hispano biases. Its roots are buried in Protestant anti-Spanish bigotry propagandized by England, Holland, and other European countries. In their search for a uniquely "American" art created only from an American experience, Federal Art Program administrators and the handicraft "revivalists" had a difficult time when it came to applying their own set of aesthetic conventions and "American-ness" to Nuevomexicano art. Hispanos and Hispanas of New Mexico were seemingly not "American" because they spoke a "foreign" language and practiced a "foreign" religion. The Spanish idiom and Catholic religiosity increased the lack of respect and prejudice from eastern transplants and migrating Anglos who brought their English language and Protestant upbringing along the rails and roads to the Southwest. Although they had resided in the region for some four hundred years, Hispanos were not perceived as indigenous. Rather, they had come from Europe trailing Spanish roots and the Black Legend that somehow impeded their "progress" toward civilization.[13]

After New Mexico statehood, Hispanos were referred to as "Spanish American" and many self-identified with that term. Most claimed direct descent from the original Spanish colonists who came to New Mexico in the sixteenth century and, at the time of statehood, wanted to align themselves with the United States and their fellow American citizens. In doing so, they felt they could stay out of the anti-Mexican sentiment that emerged after the Mexican Revolution and increased during the depression. In a 1929 article titled, "Where Americans are Anglos," author Ruth Barker commented on the apparent rejection of Mexican heritage by the New Mexico Hispanos:

> They had deep cultural traditions which they wished to maintain—Spanish—but at the same time rejected their immediate heritage from Mexico. Their language was often considered inferior and somehow dirty perhaps because it did not well express such American values as competition and commercialism. Their religion was stringent and

sensuously pagan to many of their non-Catholic neighbors.[14]

New Deal–era documentation supports the ambiguity with which Anglos, and others outside New Mexico, viewed Nuevomexicanos. Throughout WPA documentation, Hispanos are referred to by various terms, including Spanish-American, Mexican, and Native. WPA-era folklorist Arturo L. Campa provided a brief explanation of the complexities involved in identity and the term Mexicano:

> This term can only approximately be translated as "Mexican" since the English word has pejorative overtones which the Spanish one typically lacks. In New Mexico, however, as a result of inter-group tensions, even this word becomes ambivalent, and although it is used within the group with considerable freedom, it may mean "New Mexican" and "us" one minute and "Old Mexican" and the "them" the next.[15]

The concern and struggle to understand the different identifying terms (and the repercussions if the wrong one was applied) was addressed by the state supervisor of the WPA Federal Writers' Project in New Mexico. When he received the proofs for the Writers' Project *Guide to New Mexico,* Charles Ethridge Minton hurried off a response to the National Office in Washington, D.C.:

> The most serious mistake was in the caption under the "Typical New Mexican Farm House," where it was stated that "it is a Mexican custom to build on," etc. Because of the opprobrium attached to the term "Mexican" by the gringos who hold the native population in contempt, if "Mexican" instead of "New Mexican" should appear anywhere in the copy, there would be such a storm raised and such bitter, unrelenting opposition to the project

that it would be abandoned—and I should be exiled. I assure you we cannot be too careful about this.[16]

This self-identification of Hispano, Spanish—even Español—continues today. The use of Mexican as an identifier is more often than not used to refer to recent arrivals from Mexico. With older generations there still appears to be a level of negativity and resentment attached to the uses of Mexican as a signifier. For example, when many older Nuevomexicanos refer to something that is not well-constructed, they use *"a lo mexicano"* meaning, the "Mexican way." In another example, the ambiguous status of New Mexico and New Mexicans is still acknowledged monthly in *New Mexico Magazine.* A national glossy publication, it contains a regular column entitled "One of Our Fifty is Missing," which features anecdotes about banks asking travelers if they need pesos for the trip to New Mexico or postal employees insisting that foreign postage and customs regulations must be applied to parcels sent to "New" Mexico. The Land of Enchantment, it seems, continues to be perceived as not quite "American."

Eurocentric Aesthetics and Artistic Discrimination

The New Mexican identity crisis had a direct effect on Hispano artists of the era. As previously mentioned, the interest in Native American culture and art far outweighed that in Hispano art and culture during the early twentieth century. As a result, Native American arts began to transition from utilitarian cultural articles for everyday use to items and "curios" sold to tourists. The objects then became the subjects of anthropological and scientific study. As they were collected by museums, they transformed again from anthropological specimens to "fine" art worthy of exhibition in non-ethnographic-oriented museums. To

a great extent, the Native American artistic mediums of pottery, painting, weaving, and figurative sculpture were embraced. The modern art movement helped the aesthetic transformation of these art forms, and as a result, the "noble savage" evolved from indigenous craftsman to artist. Native and "naïve," their creativity was embraced by art intelligentsia and the museum world as the "true" art and output of our indigenous past.

The same was not true about perceptions of Hispano art and identity at this time. A few artists were embraced, but many more remained classified as "crafts workers," despite the fact that they, too, were using traditional utilitarian art forms to create non-utilitarian objects. The result was that Native American arts increased in status but Hispano arts remained difficult to categorize and were still treated as "folk" art, perhaps because they continued to be seen as "foreign" and thus not elements of American patrimony. Scholar Enrique Lamadrid has referred to this cultural dichotomy in New Mexico as that of the noble/ignoble savage. Native Americans were noble whereas "Mexicans" were the ignoble (lower, common, plebeian) savages.[17] The latter weren't uncivilized, but through Anglo eyes they weren't civilized enough. They spoke Spanish but they weren't Mexican. As a result of their "ignobility," Hispanas and Hispanos who created art during the early twentieth century were seen as artisans and not artists.

The dismissal of Hispano art and artists pervaded popular opinion throughout this era. Anchored in Protestant ideology, northern European aesthetic values were applied to a population and an artistic movement to which they could not pertain. Anglos saw the traditional arts in churches and homes—the creative result of the Nuevomexicano artistic legacy adapting and evolving over centuries—as "crude," "primitive," and "grotesque." The Cristo Crucificados were too bloody. The Penitente sect was simultaneously

horrifying and fascinating. Once again, Hispano culture was perceived as exotic, pagan, and foreign. It did not matter if the artist was conventionally trained, evidenced by Gustave Baumann's critique of the painted works of Esquípula Romero de Romero:

> The Spanish-American appears to have little interest in painting—as we know it—his artistic expression is really a by-product of the drafts [*sic*]. Give him a loom, tin or wood plus dye and color and he will with the simplest means evolve a purely utilitarian object having a certain amount of artistic content.
>
> As the one Spanish-American artist it was necessary to accept him "in toto." As a sign painter he learned to love Russian [*sic*] blue— I presume decorations largely in that color and badly drawn will enhance the solemnity of the Sandoval County court room—however when a Spanish-American artist places his work in Spanish-American surroundings, no Anglo need object.[18]

Despite the fact that Romero de Romero had trained at the Academia San Carlos in Mexico City with instructors that included Diego Rivera, his work was not acceptable as art to Baumann and his Eurocentric standards.

Contemporary Hispano scholars noted and commented on the patronizing observations regarding Hispano art. On the eve of the much-celebrated Coronado Cuarto Centennial in 1939, Arturo L. Campa wrote a series of articles for *El Nuevo Mexicano,* the foremost Spanish-language newspaper in New Mexico. One article that ran June 29, 1939 was titled "New Mexican Popular Arts." Originally written in Spanish, these articles were collected and published in 1980 by Anselmo F. Arellano and Julián Josué Vigil. The following is a translation by Vigil that I have included in its entirety because it, too, has been long

overlooked. It was written at the same time as the Anglo intelligentsia were writing profusely on, and becoming experts in, the arts of Spanish New Mexico. Campa addresses the problematic application of northern European artistic standards to the art of Spanish New Mexico:

> When speaking of colonial and Spanish art, many persons who are familiar with woodcarving, weaving and leather craft affirm that the charm of all popular art lies in its spontaneity and its individuality. The critics say—those who have done lengthy studies on these matters—that New Mexico had lost almost all of its artistic heritage, that is to say, that the patrimony of centuries was about to disappear.
>
> Several organizations were founded to preserve the Hispanic popular arts in New Mexico, and new schools were opened with the intent of propagating the works of tinsmithing, carving, etc., etc. With the constant tenacity of those persons who saw great value in the regional, provincial art of our fellow countrymen, they were able to awaken an interest everywhere, and the artistic renaissance of New Mexico became a reality.
>
> Death has befallen many of those persons, who in spite of their many mistakes, had a sincere desire to see something other than disdain and cultural decay among the Mexican people. Mary Austin died after becoming interested in Hispanic *folklore* and popular art, but the seed was planted and now begins to bear fruit. Likewise Cutting, another person who took an interest in the Hispanic heritage. That he was a politician does not concern us here; what matters is seeing the enterprises which he supported with his own effort and personal interest—enterprises which will last longer than the votes he won.
>
> We have reached a new height in this renaissance of the popular arts that the state takes pride in displaying its true strength in carpentry, saddlemaking, tinsmithing, and even some pottery. But as happens in all cases where a financial aspect and some commercial gain can be seen, there are plenty of merchants who reap all profits, with the true artists becoming mere errand boys or "employees" of businessmen who could care less about popular art.
>
> There is another danger which even those who dedicate themselves to the popular arts rarely recognize. We have many "experts" who boast of knowing "all popular art," and who tell us what the "true" art of our ancestors is. This is a form of materialized knowledge which, in the guise of sincere interest for our culture, becomes a dictatorship which does not permit growth within popular art. For example, a craftsman who creates a new design of his own is told by one of these experts or connoisseurs that his table or chair or whatever creation it might be is of inferior quality. Why? Because it is not truly Spanish. And, what did we say was the true Spanish style. That which expresses its own spontaneity. If such is the case, as it is, how can this subjectivity be dictated by an outsider? And if popular art is something individual, why is it necessary to follow the norms dictated by an outsider.
>
> If the case were but to reproduce what has already been manufactured for years, then we could have every design and model cataloged, and the craftsmen, like mules in the pit, could follow the norms without creating anything new. For an art to be truly Spanish, it need

not be inert and lifeless; but rather, something which grows day to day and with all individuals. We have not revived a sepulchre which can remind us of the past—no! There has been a revival of a current popular culture which since the people themselves have been almost lifeless, was about to perish. There are no norms for artistic creation. If such were the case, we would have never changed our way of life.

Unfortunately, many of our artisans find themselves enslaved by the dictates of newcomers who believe that they have "discovered" the secret of our culture. If New Mexico is to further an art of its own, and art of flesh and bone, it will have to declare its independence and on its own establish the modes which express its proper being and feeling. So there is a need to create a New Mexican popular art which is based on our Spanish and Mexican heritage. There is a need to free this art from the criticism of strangers, in order for it to be subjective and spontaneous. It behooves us to continue the development and creative artistic means to avoid becoming only simple and blind imitators of colonial times.[19]

The issue of artistic dismissal and mistaken identity continued at a national level. At the end of the PWAP program, the Corcoran Gallery in Washington, D.C. hosted the *National Exhibition of Art by the Public Works of Art Project* from April 24 through May 20, 1934. The exhibit received great acclaim via press coverage and in art circles. However, the exhibition organizers apparently found the lone Nuevomexicano contribution difficult to categorize. In the exhibit catalog and gallery handout, the sculpture, *Our Lady of Light,* by José Dolores López was listed, alongside works by María Martínez and Pablita Velarde, under "Indian Arts" in Gallery G. The confusion about

Hispano identity and the intent of the piece didn't end with the Corcoran Exhibition. Later, López's same sculpture (now in the Taylor Museum of Fine Arts in Colorado Springs, Colorado) was labeled *Wooden Religious Figure Made by Indian* in a 1937 *Rural Arts Exhibition* held at the Bureau of Agriculture Building in Washington, D.C. This mis-identification of López's sculpture set a precedent for misclassification, misattribution, and confusion early in the New Deal art programs about the art forms created by Hispana and Hispano artists of the WPA in New Mexico.

Racial inequality appears to have corresponded with inequality in terms of artistic values as far as Hispano art was concerned. With few exceptions, Spanish-speaking artists and their art were accorded second-class status. Since Anglos administered almost all the WPA art programs in New Mexico, the inclusion of and assignment to arts programs of what was considered "handicraft" and what was considered "art" correlated directly with Eurocentric perceptions and preconceptions.[20] Furthermore, administrators knew each other, exchanged ideas, and referred artists from one project to another in a closed network. Despite the increased interest in developing and preserving native "crafts" thought to be on the verge of disappearing, Hispano art was rarely regarded during the 1930s and 1940s as more than "curios." These discriminatory concepts were deeply ingrained, but for the most part, unintentionally perpetuated by revivalists and individuals directly involved with WPA art programs. Manuscripts from the New Mexico WPA Writers' Project provide numerous contemporary accounts of such views applied to the art of Spain and the Spanish-speaking Hispano population of the state. One project author wrote:

> Strictly speaking, Spain had no national art, no primitive painting of significance except the early cave pictures. The glory of her paintings

hinges upon the works of Goya and Velasquez [*sic*], and El Greco, who was not a native of the country.[21]

Commenting on religious sculpture and santos he added:

There are those who bespeak the saccharine Murillo, and those who hark back to the ghastly penitent feeling of other painters of Spain. We find Murillo quality in many of the pictures of the Virgin of Guadalupe—but again she is often depicted as a repentant wretch, bereft of all her transcendent glory, with a crude "esplendor."[22]

The author's clear bias against the art of Spain and Spanish New Mexico is readily apparent. His words are especially alarming because the article was written for the WPA Writers' Project for the purpose of publicizing New Mexico. His artistic categorization and lack of appreciation for Hispano arts and Hispano artists continues in the following excerpt from the same manuscript:

There were, in New Mexico, no great professional artists. This was a folk art, adapted to its environment with simplicity of design. It was often a leisure time occupation. It is not to disparage the race to say that this primitive quality was a decadence. On the other hand, it was rather a healthy sign of adjustment to the surroundings. But it seems singular that, at the very height of what artistic glory she achieved, Spain should be mother to a primitive art profound.[23]

Russell Vernon Hunter, New Mexico's Federal Art Project Director, was deeply involved in the idealism of the times and the goals that the FAP set out to achieve. However, it is evident that he wanted to control not only the quality, but also the creative process of Hispano arts. He designed furniture, colcha, and even tinwork pieces, rather than encouraging individual

creative skills of Hispana and Hispano artists. The designs were then sketched and given to artists who were working on the projects. Additionally, painters like Pedro Cervántez had to submit sketches of their works for approval before they painted them. In contrast, Hunter did not require mock-ups or sketches from Anglo artists. Although probably not malicious in intent, a double standard did exist—a result of racial and artistic perceptions among administrators.

These prejudices in relation to Hispano, Chicano, and Latino art continue even at the end of the twentieth century and beginning of the next. The struggles and debates over what is "folk" or "fine" or what is "high" or "low" Hispano art that existed in the 1930s and 1940s have continued to the present. Opinions that assume that people of color cannot create fine art "of quality" are numerous. As a final example here, a 1971 master's thesis on arts in Santa Fe stated that: "In addition, there is a strong relationship between ethnicity and type of works produced. Very few Indians or Spanish-Americans engage in fine art."[24]

Index of American Design and the *Portfolio of Spanish Colonial Design*: An Illustrative Example of Artistic and Cultural Dynamics in New Mexico

The WPA/FAP's focus on preservation of American artistic identity through folk arts had its greatest manifestation in one of its largest programs, the *Index of American Design (IAD)*. The *IAD* was a national attempt to record American art of previous centuries before it disappeared. It was meant to be a design and research resource for artists and scholars. Thousands of artists made visual records of America's pre-1890 material "native" past by sketching and drawing art objects in museum and private collections.

New Mexico's contribution to this massive undertaking, the *Portfolio of Spanish Colonial Design*, was

problematic at best and exemplifies some of the issues surrounding Hispano arts during this period. It is often used as an example of Hispano art, even though the original plates were rendered by E. Boyd, the "god-mother" of Spanish Colonial artistic studies in New Mexico who directed the *Portfolio* project from 1936 to 1937.

According to her own notes, in order to conduct research and make renderings, Boyd traveled to places like Santo Niño, Rociada, Cubero, Las Colonias, Tecolote, and Ojo Caliente.[25] She carried with her a letter of introduction written in Spanish by Archbishop Rudolph A. Gerken which she referred to as an "Open Sesame" that allowed her access to village churches "where the villagers were still suspicious of any foreigners. Foreigners, by the way, meant anybody who came from outside of their village, including Santa Fe."[26] The idea that even Boyd felt like a "foreigner" provides a clue to how the interaction between Anglos and Hispanos was perceived, at least by Anglos, during the New Deal era.

For the *Portfolio* project, Boyd did watercolor renditions of santos, altar screens, hide paintings, missal stands, chests, and other art in churches and chapels. She also used many of the bultos and retablos in the Museum of New Mexico's collections as well as other objects, which at the time were for sale in curio stores, as subject matter. According to Boyd, she did all "but 5 or 6 plates for the portfolio as well as twenty five water color renderings for the Index of American Design." Linoleum or wood block prints were made from Boyd's more than fifty original renderings. She then hand colored the "guide" or key plates and the prints were sent to artists across the state.

The *Portfolio of Spanish Colonial Design* is often used as an illustrative statement that Hispanos and Hispanic art were integral participants in the New Mexican WPA art programs. However, not one of the final *Portfolio* renderings was done by Hispana or Hispano artists despite the fact that there were a number of them involved with the project. The perception at the time was that Hispana and Hispano artists did not have the artistic ability to properly contribute, even though many of them had been schooled in the so-called "fine" arts. They were considered "colorists" and not "artists." In documentation, Boyd specifically mentions one Hispano artist from Albuquerque as "a native named Mirabal, who made some sadly sickly sweet renderings of chromos & such things as he found in old town San Felipe Church and among his family and friends."[27]

Additional *Portfolio* artists, many of whom had received conventional "fine" arts training during their careers, included painters Carlos Cervantes, Samuel Moreno and Eliseo Rodríguez, as well as mixed-media master Ernesto Roybal, and sculptor Juan Sánchez. A number of other Spanish surnames appear among the credits to the *Portfolio.* They include Mary Baca, J. V. Delgado, Florencio Flores, Juan García, Felix Gutiérrez, Lucino Huerta, Isauro Padilla and Lumina Rodríguez. All wait to be researched. As a "copyist," Eliseo Rodríguez remembers being sent large quantities of the same black-and-white printed plate to hand color and fill in along with a set of watercolors. Once an artist had completed a set, he/she would then return it to the project offices.

Accusations of sloppiness and lack of artistic talent were directed toward Hispana and Hispano artists, now "colorists." Their work was also criticized by FAP administrators for not adhering to the original color scheme in Boyd's renditions, and no acknowledgment was given to the fact that the colorists, most of whom had never seen the original subject matter or Boyd's original watercolor renderings, were sent different sets of watercolor paints than those used in the original renderings and master copies.[28] The

criticism reached a national level with Holger Cahill, who noted that the *Portfolio* included "a great deal of material not very well-drawn but valuable as record."[29] The cultural dynamics of the *Portfolio of Spanish Colonial Design* proved to be extremely problematic for all involved. Perhaps one of the main reasons was the lack of creative freedom the artists had. Boyd mentioned what she thought was one of the most pervasive problems: "the greatest difficulty was to find, among all the self-expressive creative artists, anyone else who was willing to do literal renderings of work which they had not invented themselves."[30] Much later in her life, Boyd's thoughts toward a number of Hispana and Hispano FAP artists and their skills were recorded in a 1964 interview. Sylvia Loomis asked her to comment on the lack of skill of the project artists and the lack of "standards" within the FAP:

> In some cases they happened to have employed on the art project, competent artists. Most of these competent artists wanted to express themselves, do creative work and most of them were allowed to, but at the same time they not only employed all artists in need but also any that claimed to be artists, or even those who had always wanted to take up art and never had time.[31]

The *Portfolio* was not included in the final publication of the *Index of American Design.* Instead, copies were distributed to administrators, schools, and libraries. Among the individuals receiving the editions of the *Portfolio of Spanish Colonial Design* were FDR and René d'Harnoncourt, head of the Indian Arts and Crafts Board.

In New Mexico, though exhibition and gallery space has increased since the New Deal, there are still few venues for the sale of Hispano art. Whether intentionally motivated or not, both artistic and racial discrimination has played a role in excluding these artists. A direct result of these misguided and commonplace attitudes is the "undocumented" status of Hispana and Hispano artists who created works in a variety of media for the WPA programs, vocational schools, and retail outlets. The majority of Hispana and Hispano WPA artists worked with traditional materials such as tin, fabric, and wood; mediums that were not considered elements of fine art according to dominant artistic values and aesthetic sensibilities at the time. Nonetheless, Hispana and Hispano artists who mastered "high art" mediums during the New Deal–era were also criticized for their perceived lack of artistic skill. Rather than considered an aesthetically pleasing and strong component of American art, the Hispano art of the WPA was never viewed as equal to art produced by Anglo artists in Santa Fe and Taos. Nor was Hispano art romanticized or partially accepted as Native American art in New Mexico was during this era.

For many Hispanas and Hispanos, being employed as an artist or "craftsperson" was an opportunity to use their artistic skills as an alternative to working on road crews or building dams. It was a means of survival and the artists were thankful for being utilized creatively. Some were chastised by other members of the Nuevomexicano community for accepting government monies, but for those who were hired by the various WPA programs, art became a means of survival during tough economic times. The importance instilled in Hispana and Hispano artists by the New Deal opportunities are still evident today. Many artists who are still alive have an image of FDR, "our president," proudly displayed in their homes as they would display a religious print or other devotional image.

Notes

1. Holger Cahill to Donald Bear, 13 February 1938, Central Correspondence Files, Record Group (hereafter RG) 69, National Archives, Washington, D.C. (hereafter NA).

2. "Handicrafts" and "handcraft" are the terms most often used for art made by the Hispana and Hispano artists during the New Deal. Although such attitudes toward Hispano art forms were embedded in the thinking of that historical era, I am placing them in quotation marks because I question the designation. Additionally, at times throughout this work, the term "traditional" will appear within quotation marks. Again, this is my commentary regarding the use of this term within the hierarchy of art historical categories.

3. Untitled manuscript about Spanish Colonial art. It was probably a draft of "Spanish-Colonial Arts and Crafts in New Mexico" by William Pillin, Federal Writers' Project, WPA File 329, New Mexico State Records Center and Archives, Santa Fe, N.Mex., (hereafter NMSRCA), 13–14.

4. "Spanish Towns," *Santa Fe Visitor's Guide* (Santa Fe: Santa Fe Chamber of Commerce and the Santa Fe *New Mexican* Publishing Corp., 1931), 35.

5. Minutes of meeting, papers of the Spanish Colonial Arts Society, cited in Marta Weigle, Claudia Larcombe, and Samuel Larcombe, eds., *Hispanic Arts and Ethnohistory in the Southwest* (Santa Fe: Ancient City Press, 1983), 193.

6. "File Notes" dated 18 May 1942, box 1919, WPA Central Files, RG 69, NA.

7. Ibid.

8. Mary Watson to Dennis Chávez, 10 April 1940, box 1924, RG 69, NA.

9. Alejandro Trujillo, et al., to F. C. Harrington (WPA administrator), 12 January 1939, box 1923, RG 69, NA.

10. Ellen H. Woodward (WPA assistant administrator), to Mary H. Isham (WPA regional director, Salt Lake City), 20 November 1936, WPA Central Files, box 1934, RG 69, NA.

11. Dennis Chávez to Howard O. Hunter, 24 March 1941, box 1924, RG 69, NA.

12. Cited in Anselmo F. Arellano, "Las Vegans and New Mexicans during the Spanish-American War, 1898," in *Las Vegas Grandes on the Gallinas, 1835–1985* (Las Vegas, N.Mex.: Editorial Telereña, 1985), 57.

13. The Black Legend, or *La Leyenda Negra,* is rooted in the sixteenth century. It is based on a Protestant anti-Spanish campaign perpetuated by England, Holland, and other European countries. For a more complete explanation of the roots of this anti-Spanish propaganda movement, see Philip Wayne Powell, *Tree of Hate: Propaganda and Prejudices Affecting United States Relations with the Hispanic World* (Vallecito, Calif.: Ross House Books, 1985).

14. Ruth Barker, "Where Americans are Anglos," *North American Review* 228 (1929), 568. Cited in William Hickman Pickens, "The New Deal in New Mexico: Changes in State Government and Politics, 1926–1938" (Master's thesis, University of New Mexico, 1971), 16.

15. Arturo L. Campa, *Spanish Folkpoetry in New Mexico* (Albuquerque, University of New Mexico Press, 1946), 3.

16. Charles Ethridge Minton to J. D. Newsom (WPA Writers' Project National Director), 10 April 1940, box 1932, RG 69, NA.

17. Enrique R. Lamadrid, "Ig/Noble Savages of New Mexico's Silent Cinema, 1912–1914," *Spectator* 13:1 (fall 1992), 12–23.

18. Gustave Baumann, "A Retrospect of Work and the Artists Employed in the Thirteenth Region under PWAP," dated 19 September 1934, WPA File no. 155, NMSRCA.

19. Anselmo F. Arellano and Julián Josué Vigil, *Arthur L. Campa and the Coronado Cuarto Centennial* (Las Vegas, N.Mex.: Editorial Telaraña, 1980), 28–29. See also Arellano and Vigil's collection of Campa's articles for an understanding of Hispano perspectives in the 1930s and early 1940s.

20. During the New Deal era, "art" and "craft" were differentiated by the perceived level of formal training and the type of medium used. European "high" art mediums of painting, sculpture, and murals were considered "art." They were generally thought to be the results of "formal" schooling, whereas "craft" like woodcarving, weaving, embroidery, and metal work, were perceived to be the product of a trade or an artisan class and informal training.

21. Pillin (probably), untitled manuscript on Spanish colonial art, 2.

22. Ibid., 4.

23. Ibid., 5.

24. Suzanne Marie de Clercq, "Santa Fe, New Mexico: A Geography of Arts and Crafts" (Master's thesis, University of Minnesota, 1971), 37.

25. E. Boyd Memoirs, dated 6 November 1963, Archives of American Art, Smithsonian Institution, Washington, D.C. (hereafter AAASI), 1.

26. Sylvia Loomis interview with E. Boyd, 8 October 1964, AAASI, p. 5 of transcript.

27. Boyd is referring here to Alfonso A. Mirabal, an artist and researcher who worked as an "Artist, Research Worker and water color illustrator" on the project from July 1936 through August 1937. He also worked for Arturo L. Campa, a professor at the University of New Mexico, and he painted furniture for UNM. To date, little else has emerged regarding Mirabal's work. It may be that he actually did some work on the *Portfolio* project. E. Boyd Papers, AAASI, 1.

28. Eliseo and Paula Rodríguez interview, 19 March 1997, Santa Fe, N.Mex.; Loomis interview with E. Boyd, 8 October 1964, p. 9 of transcript.

29. "Notes on IAD," Holger Cahill Papers, AAASI.

30. Loomis interview with E. Boyd, 8 October 1964, p. 4 of transcript.

31. Ibid., 11.

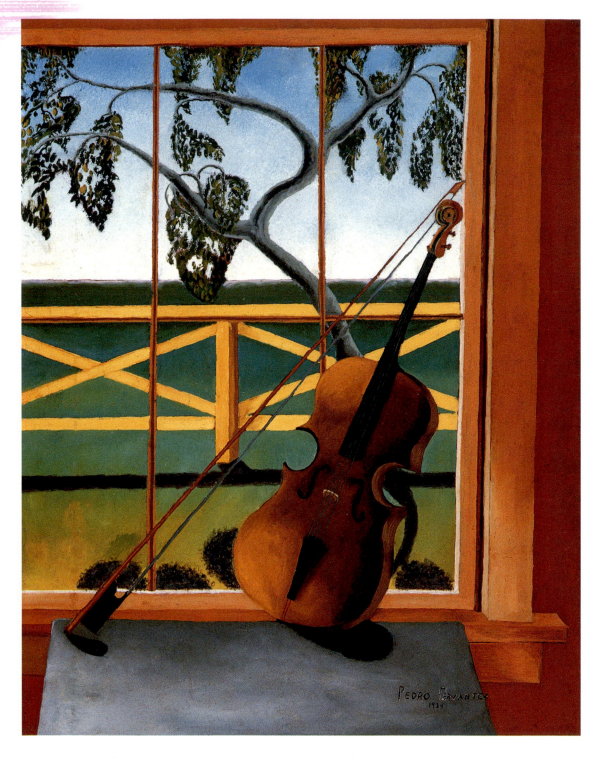

Pedro López Cervántez (1915–1987), Violin *(1934), oil on masonite, Texico, New Mexico.*
Panhandle-Plains Historical Museum, Canyon, Texas. Photo by Blair Clark.

CHAPTER TWO

"All this Beauty and Color Should Have a Place in Every Home"

The "New Mexican" Muralists and Painters of El Diablo a Pie[1]

THE HISPANA AND HISPANO *pintores* and *muralistas* of El Diablo a Pie received far less attention than their Anglo and Native American counterparts in New Mexico and across the country. They also received less attention than other Hispano WPA artists who utilized traditional techniques, materials, and designs. Such juxtaposition is ironic when one considers that these artists were working during the period when mural fever and fervor swept the country. It seems reasonable to assume that with the nationwide focus on post office and other public murals, as well as on the publicity and influence of the Mexican muralists, that muralism and painting by Hispano artists in New Mexico would have received extensive attention and encouragement.

As I conducted my research for this project, I would often mention my topic. The most common response was, "Oh, you mean Diego Rivera and people like that?" Diego Rivera never painted in New Mexico. The closest most New Mexicans came to WPA-era Mexican art were the works of painter Rufino Tamayo that traveled the state in an FAP exhibition.[2] As it turns out, there were enough "New Mexican muralists" who covered canvases and walls with their brushstrokes and colors, leaving a comparable artistic legacy.

The "New Mexican" muralists and Hispano painters of the WPA learned their art through a variety of different experiences. Many were formally trained in well-known art schools by well-known artists. Others took classes offered by the four federal art centers and galleries around the state. Art classes that focused on painting, drawing, and muralism were also taught through the NYA, the CCC, and the Division of Women's and Professional Projects.

In early 1940, the Commander of CCC Camp Company 3834 (Camp GI49N) in the Roswell area signed an official agreement with the Roswell Federal Art Center to "provide educational training in art for its enrollees." The FAP provided boards, panels, and canvas for CCC camp murals. Classes in sketching and applied art were

taught in the CCC camp buildings. A written agree-ment outlined the purpose of such a partnership:

> The Art Instructor will supervise decorations and murals for Company 3834. However, it is understood that this project has the primary purpose of giving enrollees of the Company instruction and practice in mural and deco-ration work, and therefore the greater part of the actual labor involved shall be done by CCC enrollees and under the direction of the instructor.[3]

One of the painting classes was taught by Dale Casey. Documents in the Roswell Museum and Art Center Institutional Archives mention a handful of Hispano artists, including Pablo Padilla, Rafael Villalobos, and Frank Emilio. The documents detail their development in the classes. Class records also list other Hispanos en-rolled in the CCC company art classes as Baca, Tony Luna, Lucero, Antonio Pino, and Gallegos. These art-ists painted panels and murals for CCC buildings, classrooms, reading rooms, and the Grazing Depart-ment.[4] Casey's daily individual activity records describe the artistic training and activities that occurred in class. The artists developed mural themes, prepared and painted panels, and sketched from life. Casey seems to have challenged his students to concen-trate on sketching from life and working on form and shad-owing. The instructor even took his classes out to fields to research and sketch native New Mexican grasses and plants. One mural panel depicted a county fair scene; another was titled *Spanish Conquest*.

Paintings and murals from the Roswell CCC camp were also created for the Coronado Cuarto Centennial festivities celebrated throughout the Southwest dur-ing 1940. The Coronado art exhibit featured the fol-lowing paintings (which today remain unrecovered) by the Hispano artists in that CCC class: *Cattle in Winter* and *Burros* by Pablo Padilla and James Beasley;

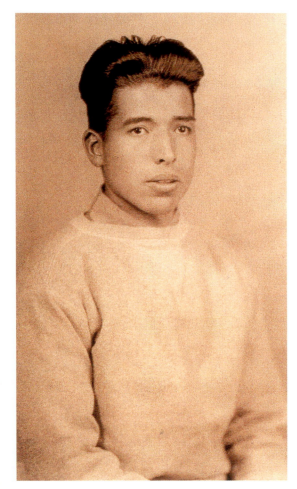

Carlos Cervantes (1934). Photo courtesy of Mary L. Cervantes.

Coronado at Zuni and *Cow-Ponies* by Rafael Villalobos; and *Prairie Dogs* by Pablo Padilla. Other works in the exhibit included *Lenten Night* by Regina Cooke; *Adobe Church* by Ernest L. Blumenschein; and *Rabbit Hunters of Taos* by Bert Phillips.

CCC enrollee and muralist Rafael Villalobos was recognized for his talent and workmanship. After taking the classes, Villalobos appeared on the FAP/WPA rolls for the Roswell Museum Art Center in a shared assignment as "handicraft" worker. Such categorical titles reiterate artistic perceptions of

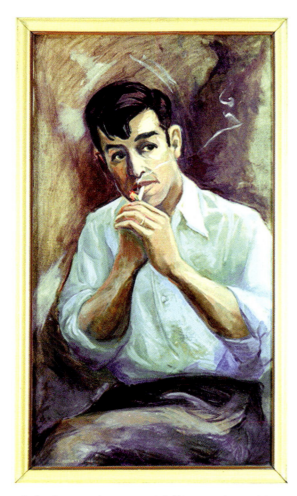

Carlos Cervantes (1913–1993), Self Portrait *(ca. 1948), oil on canvas. Collection of Mary L. Cervantes.*

Hispanos and Hispano art of the time. Villalobos was a skilled artist whose work was good enough for public exhibition at the Cuarto Centennial but he didn't have the title of "artist."

Carlos Cervantes (1913–1993)[5]

Born in Lucero, Coahuila, Mexico, Carlos Cervantes came to the United States with his widowed mother to escape the Mexican Revolution. The two settled in El Paso, Texas, where his mother, Maria Candelaria Quintero, worked as a priest's housekeeper. The family later moved to Dawson, New Mexico, a small coal-mining town near Raton in the northern part of the state near the Colorado boarder. There, Cervantes went to grade school and got his first exposure to art. As a young adult, he met some of the Taos artists. Joseph Henry Sharp, a native of Ohio and former instructor at the Art Academy of Cincinnati, noticed his talent and wrote him a letter of recommendation to that institution. Armed with a six-hundred-dollar Montgomery Ward scholarship that his mother earned by selling merchandise from the company catalog, Cervantes went to Cincinnati in 1935.

For the next three years, he studied at the Art Academy during the school year and returned to New Mexico every summer, often hitchhiking. Once, he bicycled the thirteen hundred miles. During those summers, he painted for the Federal Art Project at the invitation of Russell Vernon Hunter. He also spent the summer of 1939 studying with members of the Taos Art Colony. During the New Deal era his body of work—mostly watercolors and oils—featured many landscapes and portraits of New Mexico. At least two of his works, *Jane* and *Carson Smith,* were shown in the 1940 WPA-sponsored *Coronado Cuarto Centennial* exhibition in Albuquerque. In addition to his oil and watercolor easel works, Cervantes was also one of the artists who contributed to the *Portfolio of Spanish Colonial Design* project as a so-called "copyist." As a watercolorist, he may have contributed extensively to coloring both the *Portfolio* plates and the renderings.

Cervantes received a number of prizes and scholarships throughout his career. In 1936, he was awarded his first full scholarship to the Cincinnati Art Academy based on his oil-on-canvas work titled *Good Day Amigo.* He also got third place in the Latham Foundation for the Promotion of Humane Education international poster contest. In 1938, Cervantes received one of ten national one-year scholarships to the Art Students

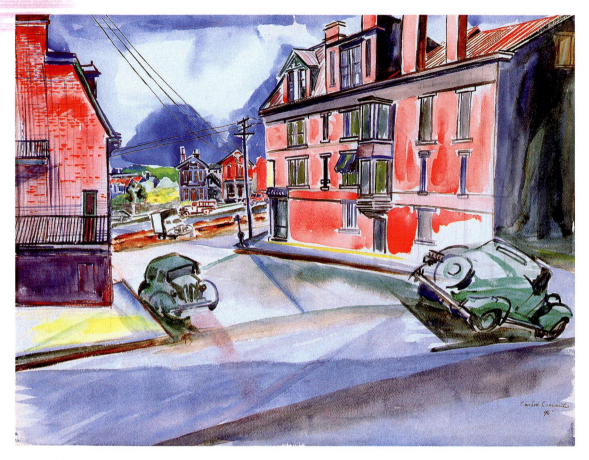

Carlos Cervantes (1913–1993), Street Scene in Cincinnati *(ca. 1946), watercolor. Collection of Mary L. Cervantes.*

League in New York City. While there, he studied with George Bridgman, Maurice Cantor, and William Zorach. Newspaper articles of the time also mention that Cervantes met Taos artist Helen Blumenschein, daughter of Taos Society of Artists co-founder Ernest Blumenschein. At her urging, an exhibition of Cervantes's works was held in Raton, New Mexico. Little else is known about his experiences in New York during that year but he did go to the 1939 World's Fair where he may have viewed art by his WPA colleagues, including Pedro Cervántez, Edward Chávez, and Patrocinio Barela. Cervantes continued to receive scholarships. He studied at the Art Academy until 1940, when he graduated and returned to Dawson.

On October 5, 1940, Cervantes became a naturalized citizen of the United States and, in what his wife always described as a "burst of patriotic fever," he immediately enlisted for military service in the army. He served as a machine gunner for the 2nd Division, 9th Infantry Regiment. He never knew that he could have served as a combat artist. On D-Day plus 1 (June 7), he landed at Normandy and thus began his European war experience. In France, he was severely wounded. After recuperating in Europe, he went to Ohio and then to Colorado Springs, where he was later discharged. During the time he spent recuperating, he took up painting again and was once quoted as saying, "there is no place of my own where I can paint in the army."[6]

After the war, Cervantes married fellow Art Academy artist Dorothy Christy and returned to Cincinnati to continue classes and later to teach. According to his family, Cervantes returned from World War II more "remote and intense" than he had been prior to his service.[7] He suffered from post-traumatic stress disorder and often experienced nightmares about combat. Returning to art proved therapeutic. Cervantes was quite prolific during this period, painting numerous cityscapes of Cincinnati neighborhoods and buildings in addition to his New Mexican and Mexican scenes and cactus landscapes.

His portraits result from bold brushstrokes and highlight the innate strength and personalities of his often seated models. Black-and-white photographs of his 1930s work, taken in Dawson, New Mexico, indicate that he studied social realism and mural composition. A crucifixion scene, dated 1947, conveys a heavenly yet mysterious environment in which Chagall-esque figures view the religious scene. Cervantes's watercolors span his career and showcase a defining linear style with flowing color that transitions beautifully from architectural forms to natural surroundings and textures, and asphalt streets to wired telephone poles.

Shortly after his death in 1993, a major retrospective of his work and that of his wife was held at the Cincinnati Art Club. The impetus for this successful exhibition was not only to honor these talented artists but to share part of the treasure trove of works and documentation that Cervantes's children had discovered. Their findings included more than three hundred paintings, many of which were streetscapes of Cincinnati. They also found numerous sketchbooks and scrapbooks that the artist had kept throughout his work and life.

Pedro López Cervántez (1915–1987)

With the exception of Taos sculptor Patrocinio Barela, painter Pedro López Cervántez is the only other Hispano artist to achieve significant national recognition during the years of the New Deal art programs. One of five children, Cervántez was born in Wilcox, Arizona in 1914 or 1915 to parents of both Mexican-Indian and Spanish heritage. His grandparents on his mother's side were potters from Gómez Palacio, Durango, Mexico.[8] During the Mexican Revolution, their pottery shop and kiln were destroyed and they fled to Arizona to join other members of their family. In official documentation, Cervántez listed his residency as New Mexico since 1916 when his father, who was employed as a section hand for the Santa Fe Railroad, was transferred to Texico, an active hub for railroad activity.

Pedro López Cervántez in his Studio (ca. 1936), probably Texico, New Mexico. Photo courtesy of Museum of New Mexico Photo Archives, MNM no. 20401.

Pedro López Cervántez (1915–1987), Doves *(1930s), Federal Art Project, Texico, New Mexico. Photo courtesy of the Holger Cahill Papers, Archives of American Art, Smithsonian Institution.*

Pedro López Cervántez (1915–1987), Croquet Ground *(1930s), Federal Art Project, Texico, New Mexico. Photo courtesy of the Museum of New Mexico Photo Archives, MNM no. 20405.*

Cervántez began to paint while in school in Texico. As a young man he also worked for the railroad and picked cotton.[9] According to one newspaper article, Cervántez commented that he had "been drawing ever since he was little, but had just started in oils in about 1930."[10] Cervántez also had some "vocational" training in "craft" work and learned how to decorate pottery with his grandfather.[11] Cervántez's father was also a skilled ceramicist. He helped open and instruct pottery classes at La Ciénega Vocational School near Santa Fe in the early 1930s. A questionnaire that Cervántez filled out in his own hand states that he studied in private lessons with Russell Vernon Hunter from 1930 to 1937 and then with Jim Rowan and Edward Slockbower at Eastern New Mexico University in Portales from 1938 to 1939. Additionally, a number of references also mention that he took art correspondence courses.

Like Patrocinio Barela, who will be discussed in another chapter, Cervántez was "discovered" by Russell Vernon Hunter, an artist who worked in the Texico/Clovis area and who later became the state director of the FAP in New Mexico. Hunter wrote:

> The first time I saw Cervántez he was in the corner drug store . . . From memory I did a small color sketch of him. Someone told him about it, and he came to the studio to see it. He kept coming back daily for several weeks, silently watching me paint. One day he appeared with a group of sketches over which I was most enthusiastic. He said he had often thought it would be nice to make pictures, but he had not known how to go about it. Two months later one of Cervántez' paintings was sent to the Fiesta Show in Santa Fe and was bought by Jozef Bakos.[12]

Hunter's painting of Cervántez was later described as a "wonderful picture of Pedro Cervantes [*sic*], who had a very dark complexion and very red lips, and he

Pedro López Cervántez (1915–1987), Saw Tooth Range *(1938), oil on masonite, Federal Art Project, New Mexico. Photo courtesy of Museum of New Mexico, Photo Archives, MNM no. 20400.*

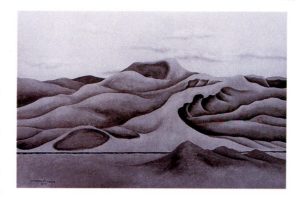

painted him eating an ice cream cone of raspberry color. It was a wonderful picture."[13]

After their initial introduction, Cervántez became Hunter's student and assisted him on fresco murals at the De Baca County Courthouse in Ft. Sumner. The murals, painted for the PWAP in 1934 and titled *The Last Frontier,* depict historical scenes that included industrialization and personages of eastern New Mexico, including Billy the Kid. Hunter has always been given total artistic credit for these frescos and Cervántez received little recognition for his work on the project. Evidence exists in a number of the mural segments that Cervántez had a larger amount of artistic input than the public has been led to believe. One segment of the Hunter-Cervántez mural illustrates the industrialization of the Ft. Sumner-Clovis-Texico area. In the central right portion of the mural is an adobe-like structure with an outhouse nearby set against a vibrant and expansive blue sky. Inserted onto a background brown landscape, the entire image stands apart from the rest of the representative renderings in the mural both stylistically and visually. When compared to Cervántez's works *Bovina Elevators* (1935) and *Los Quates Privados* (1937), the mural detail bears striking similarity to the structures positioned prominently in these other paintings. In all three images, the use of soft undulating lines, subtle shading and color, and landscaped backgrounds and foregrounds, strongly suggest that the same artist did all three. Upon completion of the De Baca County Courthouse Murals, Hunter and Cervántez teamed up again to paint a mural in the basement of a three-story building known as the "old Cruce" building that Hunter owned in

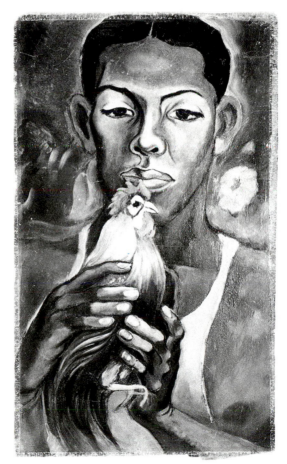

Russell Vernon Hunter (1900–1955), Portrait of Pedro López Cervántez *(ca. 1930s), probably painted in Texico, New Mexico. Photo courtesy of Museum of New Mexico Photo Archives, MNM no. 31545.*

Texico. The store is now "Rip's Western Wear."[14] When Hunter became director of the state FAP projects, Cervántez was hired onto the project as a painter and not as a "craftsman."[15]

Cervántez was a prolific artist during the FAP years. His work received enough attention in national exhibits and art reviews to warrant mention in the 1940 WPA Federal Writers' Project Guide, *New Mexico: A Guide to the Colorful State,* part of the WPA's American Guide Series: "in Texico is Pedro Cervántez, a strong primitive, former student of Vernon Hunter, who spent his formative years in Texico and has painted some of the most significant pictures of the Southwest."[16] In 1941, artist Alfred Morang in the *Santa Fe Tourist Guide* described Cervántez's work in the following manner:

> Pedro Cervantez [*sic*] is one of the most interesting formists in the Southwest. His canvases are units of creative design, and he uses color with exact regard for its function within the creative, overall design. He could be placed with some of the best formists in Europe and stand up under that most exacting comparison.[17]

Many of his FAP works traveled under the auspices of the WPA exhibition division and were displayed across the United States. Exhibition *#409* included eleven of his paintings: *Hollyhocks, Rubber Plant, Malpais, Callas, House in Roosevelt County, Saw Tooth Range, Stove, Pigeons, Pump House, Red Chimneys,* and *Fruits.* FAP exhibition *#348* included his *Geraniums.* National FAP director Holger Cahill often used slides of these and Cervántez's other work including *Panhandle Lumber Company* in his official FAP speeches.[18]

Cervántez preferred to paint still lifes and landscapes. The latter genre always featured the expanses of the Llano Estacado in eastern New Mexico. The artist drew his inspiration from local scenes in Clovis and Texico and the lifeblood of these communities, the

railroad. He captured the colors of the land and sky. He took uncomplicated functional buildings such as railroad pump houses, grain elevators, windmills, and other local town landmarks and rendered them outstanding as forms and shapes. With softened lines and expansive vistas he used the New Mexican llano, much as Thomas Hart Benton used Missouri and Grant Wood used Iowa, to depict and convey the depression-era life and landscape. With the known exceptions of his *Croquet Ground* and *Pigeons,* Cervántez rarely portrayed humans or animals but his work still powerfully evokes the rural experience so important as WPA-era subject matter in paintings and murals across the nation.

Cervántez preferred to oil paint on masonite or canvas board but he did also apply gouache on masonite. He worked from original sketches, and during his FAP years would submit them to the state

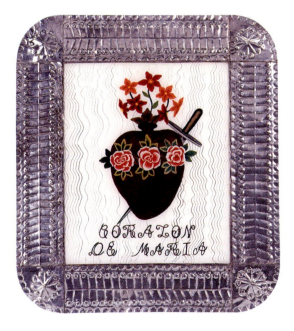

Pedro López Cervántez (1915–1987), Corazón de María *(ca. 1930s), oil, glass, and tin, Federal Art Project, Texico, New Mexico. Museum of International Folk Art, a unit of the Museum of New Mexico, Santa Fe. Photo by Blair Clark.*

office in Santa Fe for approval before he began each work. One reporter described his creative space:

> His studio consists of a small room in the local concrete section house, surrounded in native fashion by a riot of color in flowers and long pepper-strings with an old fashioned kerosene lamp as his only light for night work. Paint brushes have been carefully cleaned and thrust into pottery jars, while his desk has been fashioned from an extinct sewing machine. No fancy painters pallete [*sic*] adorns his typical workroom, only a large flat strip of beaverboard is on hand, with the customary daubs of mixed and plain colors.
>
> A tall handmade easel stands by the double windows in the simple room and large pieces of common beaverboard are the usual materials for his picture making. One chair, a small desk, a large assortment of brushes, tubes, jars of paints, turpentine and linseed oil completes his workshop. On the bookstand are a number of "scrap books" which he proudly displays, with clippings telling of his progress in the artist world.[19]

Cervántez also painted on glass in a traditional reverse technique. His *Corazón de María,* now in the collections of the Santa Fe Museum of International Folk Art, was painted for a family in Texico named Mendoza. The family, originally from Mexico, also commissioned a companion piece, *Corazón de Jesús.* He probably did the tin frames for both pieces.[20] He made a number of other reverse paintings on glass for the FAP, some of which are in private collections. One such image is a beautiful rendering of calla lilies, also in a tin frame. The glass was broken in an exhibition shipping; Russell Vernon Hunter gave it to one of the other project artists.

However, the works that really brought Pedro

Pedro López Cervántez (1915–1987), Bovina Elevator *(ca. 1935), oil on masonite, Federal Art Project, Texico, New Mexico. Sheldon Memorial Art Gallery and Sculpture Garden, University of Nebraska-Lincoln, UNL-Allocation of the U.S. Government, Federal Art Project of the Works Progress Administration. Photo by Blair Clark.*

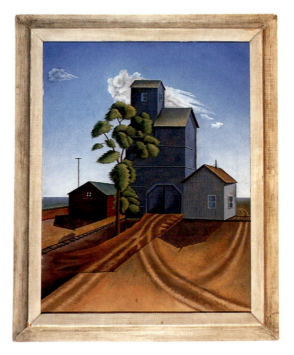

Cervántez to the forefront of WPA art publicity were his oil-on-canvas paintings, many of which director Dorothy Miller (wife of Holger Cahill) considered for inclusion in the 1938 *Modern Primitives* exhibit at the Museum of Modern Art (MoMA) in New York City. In the final cut, Holger Cahill chose ten out of seventeen of Cervántez's paintings, including *Pink Oxillis on Stove,* for this feature exhibition, *Masters of Popular Painting: Modern Primitives of Europe and America.* Another work, *Bovina Elevator,* was shown in the WPA exhibit at the 1939 World's Fair in New York. Cervántez received a great deal of attention in the regional and national press; headlines such as "Painting of Young Texico Artist is Shown in New York Museum" and "Work of Spanish-American Youth

is Shown in New York Art Museum" broadcasted Cervántez's success.

Allocated to museum and educational institutions at the close of the FAP in 1943, Cervántez's works are now scattered across the United States. While the locations of many have been recorded and registered with the General Services Administration as "Property of the United States Government on Permanent Loan" to some institutions, an equal number remain absent from written and visual documentation. Their existence is known only from glass slides archived in the Holger Cahill Papers at the Archives of American Art or in black-and-white WPA-era photos in the collections of the National Archives. A number of archived images, including one of a windswept tree and a still life of assorted flowers, are untitled. Among other works still unaccounted for are *Fruits, Stove, Pigeons, Croquet Ground,* and *Pump House.* From available photographs, *Croquet Ground* seems a departure from the artist's penchant for landscapes and still lifes. It is a linear composition and yet somehow surreal in overall appearance. Cervántez painted the scene from an unusual high vantage point, which is partially obscured by a windmill. *Pump House* was more representative of Cervántez's paintings. This work of the then twenty-one-year-old was described in a 1936 newspaper article:

> One of his latest works, yet to be sent for display in Santa Fe is an excellent reproduction of the southeast view of the pump house by the railroad in Texico. Clearly etched against the blue of the sky are the telegraph wires, with the pump tower rearing its height above all else, while tucked into a tiny corner is the railroad itself, not enough to detract from the major part of the picture, and yet not to be overlooked.[21]

The Sheldon Memorial Art Gallery at the University of Nebraska-Lincoln was allocated *Bovina Elevator,* an oil-on-masonite work, dated circa 1935. The painting depicts the grain elevators in Bovina, Texas, only a few miles from Texico. The structures, situated along the railroad tracks and across from a small Santa Fe Railroad building, rise up so high they almost scrape the blue sky. A large leafy tree grows in front of the elevators, obscuring part of them from view. A few white puffy clouds dot the sky while the llano in the background stretches as far as the eye can see.

Street Corner in Taxco, a 1937 gouache-on-masonite, was allocated to the Oklahoma City Art Museum, where it still resides. The Oklahoma City Art Museum began its existence as the Oklahoma Federal Art Center and was given the gift at the close of the FAP. The title of the piece was provided either by FAP administrators or interested parties who documented and then shipped it out for exhibition, and speaks to many of the issues explored in this body of work, including the perception of Hispano artists of the WPA. The piece is definitely not a street corner in Taxco, Mexico. There is no indication of a high and hilly silver-producing town with cobbled stone streets. Rather, it represents a corner in Texico, with its llano plains, adobe stucco, and wide blue sky. A sign in English reads "CKs RECREATION." In fact, the original title was *Corner Street in Texico, New Mexico.* Yet, until recently, the work remained titled *Street Corner in Taxco,* further confirming the historical (and continual) conflation of New Mexico and Mexico and the inability of many to distinguish between the two.

Two more of Cervántez's FAP works were transferred by the General Services Administration. *Los Privados* and *View of the Artist's Home* are now allocated to the collections of the National Museum of American Art in Washington, D.C. In 1982, *View of the Artist's Home* was found in Room 4131 of the Main General Services Building (GSA) in Washington, D.C.

Pedro López Cervántez (1915–1987), Street Corner in "Taxco" *(Texico), 1937, gouache on masonite, Federal Art Project, Texico, New Mexico. WPA Project Collection, Oklahoma City Art Museum, Oklahoma City, Oklahoma. Photo by Blair Clark.*

The painting has the date 10–19–38 and a price of $9.40 written on the back. *Los Privados* may have been originally named *Los Quates Privados* [*sic*], or "Twin Privies." Documentation in Cervántez's own hand uses this title to refer to the image reproduced in the May 9, 1939 issue of *Look Magazine* and featured in MoMA's *Modern Primitives* exhibition catalog.[22]

Among Cervántez's other known works in U.S. collections are *Calla Lilies,* allocated to the San Francisco Museum of Modern Art, and *The Wind Mill* and *Zinnias,* purchased by the Melrose, New Mexico school district.

Documentation also exists that indicates that Cervántez had art patrons very early in his career.

Texico judge James D. Hamlin was apparently one of the first collectors outside the government programs to recognize Cervántez's talents:

> The boy became interested in painting and I was his first patron, purchasing a couple of his earliest canvases, one if I remember right, a still life of a fiddle; and the other a portrayal of the Station here at Texico. The boy later came into considerable prominence and had an exhibit in New York several years ago, which received a great deal of attention, and quite an article in Time [*sic*] and several other magazines.[23]

Despite the recognition Cervántez got in art circles, his ethnicity seemed to affect how his art was received,

Pedro López Cervántez (1915–1987), Red Flowers *(1937), oil on masonite, Texico, New Mexico.*
International Folk Art Foundation Collection, Museum of International Folk Art, a unit
of the Museum of New Mexico, Santa Fe (FA.1999.33.1). Photo by Blair Clark.

evidenced by the following comment in the MoMA exhibit: "With his racial love of color, Pedro does marvelous work in clear sharp colors, which blur off into soft tones, before the eye can follow."[24] His ambiguous Hispano identity made it difficult for the upper echelons of the art world to completely embrace this talented artist. At one point, an attempt to separate him from the concept of "Mexican" and identify him instead as a naïve but noble Spaniard was made in a MoMA publication:

> Pedro had apparently never thought of using
> a family name until someone suggested that
> he sign the first painting he exhibited. Then,

instead of taking his mother's name in accordance with the usual custom of his people, he took his father's name, because he had been told of an earlier Cervántez who was a great man.[25]

In contrast to this account, when Holger Cahill mentioned the work of Cervántez in his FAP lectures, the artist was referred to as a "laborer."[26]

Cervántez himself described his art and work with the FAP in an article that was to be included in the final published report of the Federal Art Project. It never was. In the one-page statement titled "My Attitude Toward Painting," the artist wrote about his passion:

> Since childhood I have had a very great interest

in art and may I say that the greatest ambition of my life has been that I might reach that place among artists where I might be as one having a marked ability in this line of work.

My favorite subject is landscapes, direct from nature, because I feel that all this beauty and color should have a place in every home. Next to this I am interested in still life, portrayed in its many forms.

My first real opportunity was when I was assigned to certain work under the Federal Art Project and I am unable to express in words just what this has meant to me. Since my employment with the F.A.P. ceased I have continued my work taking advantage of every opportunity and it is my wish that I may again be assigned as a painter on the Art Project.

—Pedro Cervántez[27]

In the 1960s art historian Francis V. O'Connor, an expert in WPA art, discovered the statement, along with many others, in the private collection of Dorothy Miller. O'Conner edited the manuscripts and published many under the title *Art for the Millions: Essays from the 1930s by Artists and Administrators of the WPA Federal Art Projects* (1973). He chose not to include Cervántez because he felt a number of the essays were dull and repetitive.[28] It would have been the only essay in an Hispano artist's own words.

Cervántez's work with the FAP ended in 1941 when he went to Europe in World War II. He was stationed overseas from 1941 until 1945. According to author Jacinto Quirarte in his book *Mexican American Artists* (1973), Cervántez was able to view many works in the major European museums.[29] Upon his return to Clovis, he received training under the G.I. Bill. In 1947, his name, accompanied by the title and description "painter: oils in primitive realism," was listed in the *Art Directory of New Mexico* published

Pedro López Cervántez (1915–1987), Still Life with Pineapple *(date unknown), Texico, New Mexico. Jonathan Parks Collection. Photo by Blair Clark.*

by the Museum of New Mexico and the School of American Research in Santa Fe. He also received an award at the Tri-State Fair in Amarillo.

Cervántez's work was selected for the art exhibition at the New Mexico State Fair in Albuquerque in 1949 and 1950. From 1949 to 1952, he took classes at the Hill and Canyon Art School in Santa Fe. These classes may have focused on "commercial" art, as listed in his biographical sheet at the Museum of Fine Arts. In 1952, Cervántez won third prize in the international poster contest sponsored by the Latham Foundation in Stanford, California. During the 1960s, he painted signs for the Coca-Cola Bottling Plant in Clovis. Jacinto Quirarte documents Pedro Cervántez's work during the 1970s in *Mexican-American Artists*.[30]

During Cervántez's lifetime, exhibitions of his work

were held at the Colorado Springs Fine Arts Center, the Dallas Museum of Fine Arts, the Denver Art Museum, the Whitney Museum of American Art in New York, MoMA, the World's Fair in New York, and other venues in San Antonio, Washington, D.C., and at the Terry National Art Exhibit in Miami. His paintings were also featured in an international exhibit in France and a touring exhibit along the East Coast. In New Mexico, his work has been exhibited in the Museum of Fine Arts in Santa Fe, the Roswell Art Museum, and Eastern New Mexico State University in Portales during the 1930s and 1940s.

Cervántez's painting, *Father's Equipment,* from the collection of Cady Wells, was exhibited in the "Paintings and Sculpture from the New Mexico Section" of the 1940 *Coronado Cuarto Centennial* exhibition in commemoration of the multi-state event.[31] Cervántez's work also found homes in the private collections of many Anglo WPA, PWAP, and FAP colleagues and

Edward Arcenio Chávez (ca. 1960), Old Forge Gallery Pamphlet, Woodstock, New York. Photo courtesy of the Edward A. Chávez Papers, Archives of American Art, Smithsonian Institution, Washington, D.C.

contemporaries, including Jozef Bakos, Spud Johnson, and Olive Rush.[32] Despite all of the artistic national and regional recognition he received during and beyond his WPA career, until recently (1999), there was not one of his oil-on-canvas or -board paintings in a public museum in the state of New Mexico.

Edward Arcenio Chávez (1917–1995)

Although he became well known as a Colorado WPA artist, Edward Chávez should be included here. He was born in Ocaté, near Wagon Mound, in the northern part of New Mexico. His mother, a native of Taos, was a member of the Romero and Martínez families, and his father was a sheep rancher originally from Tascosa, Texas.[33] At the age of five, when his father lost all his sheep during an extremely cold winter, Chávez moved with his parents and nine brothers and sisters to eastern Colorado. There, the family worked as sugar beet pickers.

Chávez became interested in drawing and painting when he went to grade school in Sterling and Denver. In the mid-1930s, he studied with painters Frank Mechau and Boardman Robinson at the Colorado Springs Fine Arts Center. He also studied with Peppino

Pedro López Cervántez (1915–1987), Untitled (View of Canyon Road), *1952, oil on canvas, Santa Fe, New Mexico. Private collection, Española, New Mexico. Photo by Blair Clark.*

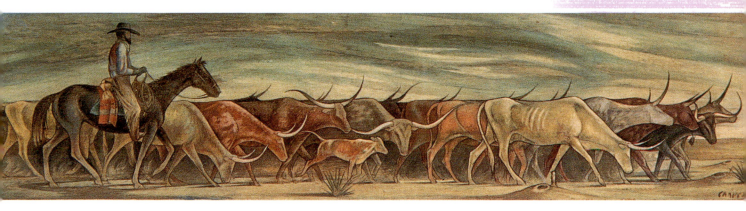

Edward Arcenio Chávez (1917–1995), Longhorn Trail *(1938), egg tempera on panel, most likely Treasury Relief Art Project, Colorado. Purchased by the Amarillo Museum of Art with funds provided by Ms. Ninia Bivins in Honor of Mr. M. T. Richie, Mr. and Mrs. Paul Buckthal, and Mr. and Mrs. James Holcomb.*

Mangravite, Director of the Art School at Columbia University in New York. While studying art in Colorado Springs, Chávez became involved with various WPA arts projects. He painted post office murals in Geneva, Nebraska, Center, Texas, and Atlantic City, New Jersey for the Treasury Relief Art Project (TRAP). In Colorado, he executed a number of murals, including one in the Glenwood Springs Post Office titled *View of Glenwood Springs and Surrounding Area, 1937.* Chávez also assisted his mentor, Frank Mechua, on post office murals in Colorado Springs and Washington, D.C., and with frescoes for the Colorado Springs Fine Arts Center. During his FAP years, Chávez's art was visibly inspired by the social realist mural trends. Like Pedro Cervántez, his work portrayed American scenes with bold but softened depictions of landscapes, people, and horses. One of his mural studies, titled *The Longhorn Trail,* was probably produced for the Treasury Relief Art Project post office mural competition but never made the final cut. This study is in the permanent collection of the Amarillo (Texas) Museum of Art.

Among the canvas works that Chávez painted for the FAP were *Watering Tank* (1937–1938), allocated to the Sheldon Memorial Art Gallery at the University of Nebraska in Lincoln, *Evening Chores* (1937), and *Redstone, Colorado* (1938), both allocated to the Newark Museum in New Jersey. He also produced a number of lithographs, including *Fighting Cocks* (1930s) in the Special Collections Division of the Georgetown University Library and *El Ezquindo Lo* [*sic*] (1930s), allocated to the San Francisco Museum of Modern Art. Among his "whereabouts unknown" works are *Colt* (1938), *The Pony* (n.d.), and *Irrigation* (n.d.).[34] During the New Deal era his work was exhibited at the New York World's Fair (1939–1940), the National Academy of Design (1943), the Cleveland Institute (1942), the San Francisco Museum of Modern Art (1940–1941 and 1944–1945), and the Los Angeles County Museum of Art (1944–1945).

In 1941, Chávez became War Art Correspondent for the U.S. Engineer Office of the War Department. He painted murals in service centers in Wyoming, including one titled *Indians of the Plains* at Fort Francis E. Warren. During World War II, he painted scenes of war-related activities in the States, and also served for a time in Brazil where he painted a mural in the 200th station hospital located in Recife. His 1942

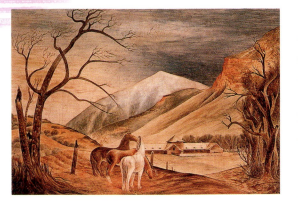

Edward Arcenio Chávez (1917–1995), Redstone, Colorado *(1938), oil on board, probably Federal Art Project, Colorado. On loan to the Newark Museum from the Fine Arts Program, General Services Administration. Photo by Blair Clark.*

Edward Arcenio Chávez (1917–1995), The Watering Tank *(1937–1938), tempera on gessoed masonite, Federal Art Project, Colorado. Sheldon Memorial Art Gallery and Sculpture Garden, University of Nebraska-Lincoln, UNL-Allocation of the U.S. Government, Federal Art Project of the Works Progress Administration.*

Edward Arcenio Chávez (1917–1995), Evening Chores *(1937), oil on masonite, Federal Art Project, Colorado. Allocated to the Newark Museum from the Fine Arts Program, General Services Administration. Photo by Blair Clark.*

watercolor *Convoy Practice* depicted a group of convoy trucks practicing evasive maneuvers. It won third prize in *Life* magazine's art contest that year. When the war ended, Chávez moved to Woodstock, New York where he opened a gallery called "The Old Forge," named for the building in which it was housed. Here he exhibited his drawings, paintings, sculpture, and jewelry. During his career, he taught at the Art Students League, Colorado College, and Syracuse University. He was the recipient of many honors, including the Louis Comfort Tiffany Award to study painting in Mexico (1947), a Fulbright grant to study in Italy (1952), and a Hallmark Christmas card design

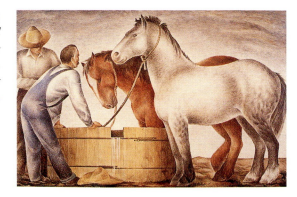

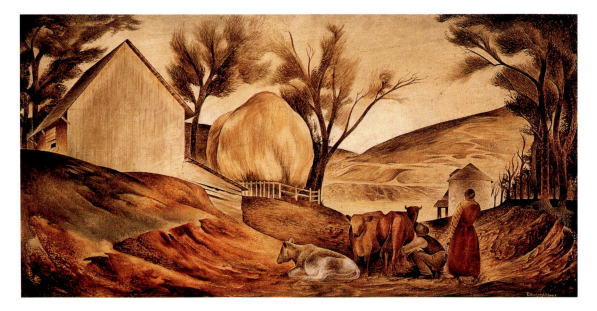

prize (1952). He married Jenne Magafan, a fellow WPA painter and muralist who died in 1952. In the early 1970s Chávez returned to Taos and opened up a gallery with his second wife, Eva Van Rijn Chávez.

In addition to the museums listed above, Chávez's works are in the permanent collections of the Detroit Institute of Arts, the Grand Rapids Museum of Art, the Whitney Museum of American Art, the Hirshhorn Museum and Sculpture Garden, the Library of Congress Print Collection, MoMA, the Metropolitan Museum of Art, the University of Texas at Austin, the Santa Barbara Museum of Art, and the Watkins Gallery at American University. In New Mexico, his works are in the collections of the Museum of Fine Arts in Santa Fe and at the Roswell Museum and Art Center.

The continual national and international success that this native New Mexican achieved through his art was, at the time, unparalleled in the Hispano art world. More pointedly, it must be noted that Chávez achieved national prominence outside New Mexico, first in Colorado and later in New York. However, he always referenced his love for New Mexico in his work and once commented that "in spite of the fact that I have not lived in New Mexico since my childhood, my work has always been influenced by the Southwest in General and New Mexico in particular."[35] His example provides an eye-opening contrast to the treatment of other Hispana and Hispano artists working in New Mexico at the same time. According to Jacinto Quirarte, Chávez considered himself to be "largely self-taught." However, he was embraced throughout national and international art circles.[36] In a 1964 interview, Chávez commented on the difference in the administration of the Colorado art project in comparison with other states:

And in Colorado the administration was somewhat different, in that we were able to work individually, independently in our own

Edward Arcenio Chávez (1917–1995), Fighting Cocks *(1930s–1940s), lithograph, Colorado. Special Collections Division, Georgetown University Library, Washington, D.C. Photo by Blair Clark.*

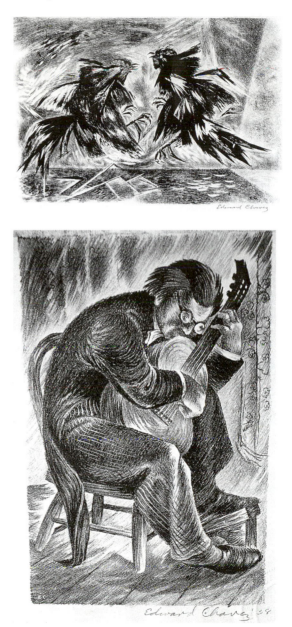

Edward Arcenio Chávez (1917–1995), Guitarist *(1938), lithograph. Collection of the Colorado Springs Fine Arts Center.*

studios. In other words, we had no ties to anyone except to, I think it was every month, submit the work that we did; it was reviewed and then a certain amount of work was selected . . . My experience was that I had more freedom, possibly more freedom than one does now with coping with galleries and dealers, and so forth. Complete freedom in what we could do. Complete freedom in what I was able to do and also the fellow painters that I knew at the time.[37]

It seems that artists had more creative freedom in the Colorado FAP. Furthermore, outside of New Mexico and within a different artistic environment, this artist, a descendent of Padre Antonio José Martínez of Taos, was recognized and embraced not as a "Spanish-American artist," but simply as an artist.[38]

Margaret Herrera (Chávez) (1912–1992)

Born in Las Vegas, New Mexico, Margaret Herrera grew up on her parent's ranch in Mora County. Upon graduation from high school, she taught in rural elementary schools near Las Vegas. Although it has yet to be determined if she ever worked officially for the Federal Art Project or a related WPA art program, Herrera did work for the WPA's county extension service and from 1939 to 1943 she worked as a farm supervisor for the Department of Agriculture in Taos. From 1943 to 1944 Herrera worked for this same department as a home agent in Las Cruces.

She began painting during the New Deal era and it seems likely that she was influenced by the very active presence of the WPA Federal Art Center in Las Vegas. Among her favorite subject matter were landscapes. She often included the area around Las Vegas and Mora in her drawings, watercolors, and paintings. Local flora, including yucca flowers, and buildings such as the Montezuma Seminary became central themes in

Margaret Herrera Chávez (ca. 1930s). Photo courtesy of Marcella Falvey, Santa Fe, New Mexico.

her art. Among the known titles of her other landscapes are *Highland Village, Trampas Village, Sandia Mountains in Springtime* and *Isleta Church.* She also developed an enormous body of work that dealt with people and traditional Hispano customs, often depicting such images as her 1960 portrait of *Irene López,* the Santa Fe Fiesta Queen that year. An earlier oil-on-canvas piece depicted an older man in a church titled *The Worshipper.* Herrera worked in a variety of mediums, including sculpture, graphic prints, wood-block prints, copper etchings, and ceramics. In a 1964 review of one of her gallery shows in Laredo, Texas, her works on paper and canvas were described as those that "seem to bridge the gap between the entirely representational

art of the past and the extreme abstract art of the avant garde."[39] Like her paintings, Herrera drew inspiration for her etchings and lithographs from the mountains, landscapes, and people of northern New Mexico as well as from her travels to Spain, Mexico, and Latin America. Her colored woodcut *Holiday* won the 1957 purchase award at the Museum of Fine Arts in Santa Fe. In 1964, her etching *Franciscan Friars* won first prize in the annual Fiesta Art show in Santa Fe. Whether in color or black-and-white, Herrera seemed to intentionally reclaim and acknowledge many local Hispano customs and scenery in New Mexico and other countries; so much so that it was stated: "the atmosphere of Mexico and the Spanish and Indian Southwest permeates many of her canvases."[40]

Once World War II ended, Herrera began a thirty-three-year teaching career in the Albuquerque school system. She did not abandon her art, however, and in 1953 she completed a Master's degree in art at Highlands University in Las Vegas. Her coursework included studying at the famous art colony Instituto San Miguel de Allende in Guanajuato, Mexico where she was featured in a movie with well-known Mexican artist Rufino Tamayo. She was actively involved in arts and educational organizations throughout New Mexico and the nation as a member of the National League of Pen Women, where she served as National Graphic Arts Chairman. In 1963, she was appointed state chairman of National Art Week. She was also a member of the New Mexico Education Association and the National Education Association, as well as the Hispanic Cultural Society. Her works have been exhibited at the University of New Mexico, the Smithsonian Institution, the Nelson Atkins Museum of Art in Kansas City, Missouri, and in the Museum of Fine Arts and the Museum of International Folk Art in Santa Fe. Her works are in both the permanent collections of the latter, and in those of Highlands University.

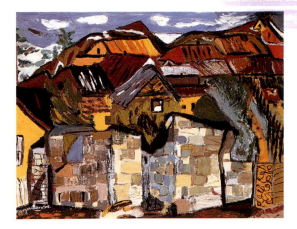

Margaret Herrera Chávez (1912–1992), Rusty Roofs *(1941), oil on canvas, Albuquerque, New Mexico. Private collection, Los Griegos, New Mexico. Photo by Blair Clark.*

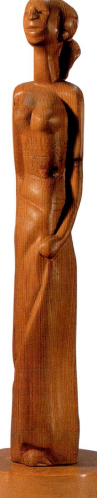

Margaret Herrera Chávez (1912–1992), Woman *(date unknown), wood, Albuquerque, New Mexico. Private collection. Photo by Blair Clark.*

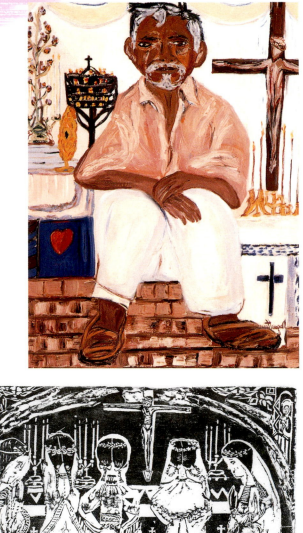

Margaret Herrera Chávez (1912–1992),
Communion *(early 1950s), wood block
print on Japanese paper, Albuquerque,
New Mexico. Museum of Fine Arts,
a unit of the Museum of New Mexico,
Santa Fe. Photo by Blair Clark.*

Margaret Herrera Chávez (1912–1992),
The Worshipper *(date unknown), oil on canvas,
Albuquerque, New Mexico. Private collection.
Photo by Blair Clark.*

Herrera was one of only two female artists featured in Jacinto Quirarte's book *Mexican American Artists.*

Herrera married Paul M. Chávez of Albuquerque and though she was always referred to as Mrs. Chávez, she continued to paint under her maiden name. Throughout her life she collected works by her contemporaries, including Patrocinio Barela. Her artistic family included her sister, Crisóstoma Luna, a WPA fiber artist and her brother-in-law, Máximo Luna, who taught furniture-making at the Taos Vocational School.

Samuel Moreno (dates unknown)

Little is known about Samuel Moreno, who is also listed as one of the artists who worked on the *Portfolio of Spanish Colonial Design.* He was formally trained and apparently active in the Santa Fe art scene just before the WPA years. A 1932 article describes him and Esquípula Romero de Romero as "Spanish-American" and deserving of special recognition: "Moreno's *Flower Vendor,* with its massive design in white lilies, is one of the most unusual canvases in the exhibit. His work shows the influence of Rivera, under whom he studied."[41] An article by New Mexico Federal Writers' Project writer Janet Smith also mentions Moreno's "expression of form" and its "massive" qualities:

> Samuel Moreno's massive simplified primitive figures have a rhythmic significance of their own. A native of Old Mexico, Mr. Moreno has studied under Diego Rivera. He has exhibited in Chicago, Los Angeles, Colorado Springs, Philadelphia, and in a number of Southwestern and Mexican cities.[42]

To date, no official WPA/FAP works by Moreno have been identified in New Mexico public or private

collections. Moreno's connection to Mexico (and Diego Rivera) during this period is intriguing and warrants further exploration. Why did he not receive more critical attention? The juxtaposition of the recognition of his talents as a contributor to the *Portfolio of Spanish Colonial Design* and his apparent non-participation in the FAP could provide additional insight into issues about "fine" versus "folk" art and Mexicano versus Hispano identity.

Eliseo José Rodríguez (b. 1915)

Eliseo Rodríguez, credited for his revival of straw appliqué art during the WPA, started his FAP career painting on canvas and reverse painting on glass. He was officially hired by the Federal Art Project in 1936. He was paid seventy-eight dollars a week. Also in 1936, probably as result of the FAP projects, Rodríguez was one of a number of New Mexican artists selected to paint murals for the Texas Centennial. *Western Artist* announced this honor:

> Eliseo Rodriguez [*sic*], young Santa Fe artist has succeeded in winning a place on the staff of New Mexican artists preparing murals for the state exhibit at the Texas Centennial.
>
> He is a native of Santa Fe. He has been active on the federal art projects. His originality and quality resulted in his promotion to the present art project.[43]

Prior to his work with the FAP, Rodríguez received formal training as the "only Spanish" in the private Santa Fe Art School.[44] He attended this prestigious school on a two-year scholarship funded by writer T. (Ted) Flynn. Rodríguez studied painting with Cyril K. Scott, the school's founder, and with painter Hubert Rogers and muralist Howard Coluzzi. He also studied with Jozef Bakos and a number of other easily recognizable names among the Santa Fe artistic elite. According to Rodríguez, the Cinco

Pintores "gave me a few pointers."[45]

Rodríguez was already acquainted with many of these artists because when he was fourteen years old, he earned money delivering wood and lighting fires in the fireplaces of the artists' homes along Canyon Road in Santa Fe. After attending the Santa Fe Art School, the Sexto Pintor worked as an artist painting on both canvas and "leaded glass." He also did "little carvings" for both the Native Market store and its spin-off, El Parián Analco.

The majority of the paintings Rodríguez did for the FAP remain unidentified. Few are included in available WPA/FAP documentation. Rodríguez himself remembers painting subject matter such as the "Santuario de Chimayó" and "Aspens in the Fall" for the FAP.[46] In spring 1936, one of his works, "a wood panel showing Juan Diego, done in the natural darker wood tones of the panel," was exhibited with paintings of Anglo FAP artists in the Santa Fe Art Museum."[47] He was also a "colorist" for the *Portfolio of Spanish Colonial Design*.

In June 1938 the works of sixty artists were exhibited at the Santa Fe Gallery in Sena Plaza. Among the works by Jozef Bakos, Gustave Baumann, and Sheldon Parsons was one of Rodríguez's paintings, described in the following manner: "Eliseo Rodríguez, a young Spanish-American artist of Santa Fe has a small oil which shows definite promise. He has recently started to paint and his progress will be interesting to watch."[48]

True to this foresight, Rodríguez did prove interesting to watch. He painted a number of masterpieces. Perhaps his most evocative work has recently been identified and recovered during my research for this project. The work, a large reverse painting on glass of a Cristo crucificado (crucifixion), was in the collections of the Palace of the Governors in the Museum of New Mexico in Santa Fe. It had been donated by the Historical Society of New Mexico to the Museum in January

1943 following the end of the Federal Art Project. A black-and-white photo of the image appears in all of the major national WPA archival collections, but no one knew its location or the name of the artist. On the backs of some of the images, Rodríguez is credited with making the tin frames. He is not credited for the paintings, however. The frames were actually the work of tin artist Ildeberto Delgado, whom I will discuss in a later chapter.

Crucifixion was painted by Rodríguez in 1938, and the artist still has the original sketch. The fine lines of the Christ figure, angels, and flower urns are meticulously detailed. Although relatively small, the overall rendering conveys a poetic strength and inspiration. Rodríguez's artistic skill was recognized at the time in the words of another artist:

> A glass painting by Eliseo Rodríguez has a deeply religious quality. And it also contains many of the virtues often connected with much of the contemporary European art. The line is not forced; it swings with inner life, and the conscious distortion lends a note of intensity often seen in the works of Nolde.[49]

Not long after he began painting for the WPA/FAP, Russell Vernon Hunter showed Rodríguez a colonial straw appliquéd cross with intricate design. He asked if Rodríguez would be interested in figuring out how the work had been done. Rodríguez agreed to try and emerged as the person responsible for the "revival" of straw artistic traditions in New Mexico. He had few visual references excepting a few pre-1900 pieces from museum collections. Rodríguez quickly applied his painterly perspective and mastered this art form as well. The formal training he received at the Santa Fe Art School is evident in the composition of his crosses and in his application of proportion and shading while using only straw to create the images.

In conversations with the author, Rodríguez ex-

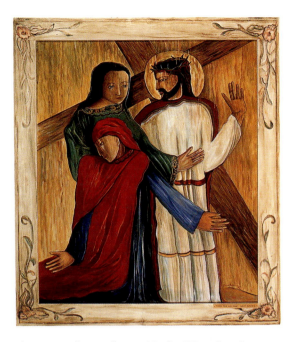

Eliseo José Rodríguez (b. 1915) Ladies Weep Over Jesus *(ca. 1939), oil on canvas, Santa Fe, New Mexico. Collection of the artist. Photo by Blair Clark.*

plained how pleased he was to be making a living as an artist. It is clear that Hunter did not actively discourage Rodríguez's painting talents, but rather strongly "encouraged" him to attempt the traditional craft of straw appliqué. Most of the written research on Rodríguez mentions straw appliqué as his only art technique. With few exceptions, the accounts fail to acknowledge and elaborate on his work as a painter. They overlooked the fact that the mastery of the execution of his straw art is rooted in his artistic skill and formal training in another medium.

The Rodríguez home is filled with the artist's paintings, the majority of which are religious in subject matter. The oil-on-canvas works in the artist's collection include *Ladies Weep over Jesus, New Mexico Crucifix, La Presentación, San Francisco, Isías, Jeremías, Geranium II, Tewa, Viernes Santo, Crucifixion, Callejon del Beso Guanajuato,* and *Camino a Nambé.*

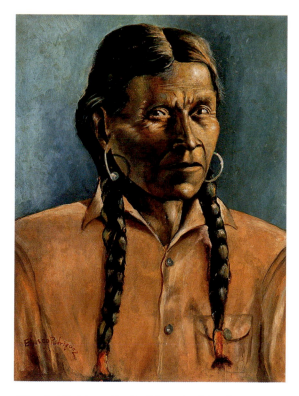

Eliseo José Rodríguez (b. 1915) Portrait of Aquilino Nieto (1939), oil on canvas, Santa Fe, New Mexico. Collection of the artist. Photo by Blair Clark.

All exemplify Rodríguez's individual painting style. The larger paintings demonstrate his use of bold strokes to form strong, powerful imagery. The smaller paintings on glass and canvas, done with reduced strokes, manage to elicit the same sense of bold eloquence and strength. Rodríguez's color palette was comprised of both bright and muted shades, and both worked to contribute to his passionate figurative and scenic representations. His works emote an artistic and spiritual religiosity that transcends time and place.

With the exception of the Cristo crucificado on glass in the collection of the Palace of the Governors, and a small painting at the National Hispanic Cultural Center in Albuquerque, there are no attributed Rodríguez paintings in public collections within the state of New Mexico. Despite the fact that a metal sculptured plaque (it reads "Eliseo Rodríguez, Painter") is set into the sidewalk in front of the Fine Arts Museum in Santa Fe, the museum has none of his paintings in their collection. On the other hand, numerous examples of his intricate use of straw appliqué are in the collections of the Museum of International Folk Art, The Albuquerque Museum, the Taylor Museum of the Colorado Fine Arts Museum, the National Museum of American History at the Smithsonian Institution, and the Museum Für Deutsche Volkskunde in Berlin (Museum of German Folk Culture). The absence of his paintings from fine arts collections and the inclusion of his applied "craft" are clear testimonial to the perceptions of what type of recognition is permissible for Hispana and Hispano artists.

Later in his WPA career, Rodríguez worked with his friend Louie Ewing. He applied the new FAP-enhanced process of serigraphy.[50] Ewing and Rodríguez were such a superior silk-screening team that they soon became well known for this art form all over Santa Fe. Their talents in this medium were noted during one Santa Fe Fiesta celebration: "Lest the gente forget and start home after the coronation at La Fonda Saturday night, posters in both Spanish and English amusingly executed by Eliseo Rodríguez and Louie Ewing will soon sprout over town reminding of the time to come."[51]

Together, with the help of Rodríguez's wife Paula, they did two silk-screen portfolios for the Laboratory of Anthropology; one of Native American rugs and the other of santo images. Despite the manner in which the three artists collaborated, Louie Ewing is always given singular credit. Rodríguez and Ewing also painted and layered the mosaic terracotta tile on the fountain designed by Eugenie Shonnard for the Carrie Tingley Hospital, a WPA project in Hot Springs (now Truth or Consequences), New Mexico.

When Rodríguez left the FAP in 1939, he went to work for Southwestern Master Craftsmen, a furniture-making company in Santa Fe. He painted furniture for the company and later became the shop's chief carver and manager. Rodríguez remembers that a number of pieces of his furniture were sold to the Marshall Fields department store chain.[52] In addition, he also created his reverse paintings on glass for Southwestern Master Craftsmen. In 1941, Rodríguez won first prize at the New Mexico State Fair for one of his paintings on glass.

During World War II, he did a three-year tour of duty in the South Pacific and took part in the invasion of Okinawa. There, he continued to paint under the most difficult of circumstances. According to Rodríguez, "the morale was pretty bad, so they let me paint to help the men feel a little closer to home."[53] Between starting fires and boiling water for his fellow G.I.s, Rodríguez painted portraits of them and their loved ones back home.[54] After his tour, he returned to Santa Fe and Southwestern Master Craftsmen. During the 1950s, he taught furniture design and supervised carving and cabinetry classes at the Agua Fría Vocational School at St. Michael's College in Santa Fe.

Throughout his career, Rodríguez has never stopped painting. In 1955, he was nominated by Governor John F. Simms as the "foremost religious portrait painter in the state" for the Madonna Festivals in Los Angeles, California.[55] Soon after, the artist was invited to be an exhibitor for the Grand Prix International for Painting and Sculpture in Monte Carlo.[56] From 1964 to 1972, Rodríguez worked on a large project for Our Lady of Grace Church in Castro Valley, California. The Catholic Church project commissioned Rodríguez to portray "The History of Salvation and Fulfillment of the Promise" in fifteen four-foot by twelve-foot panels of Church history. Each panel features the Old Testament version on the left and the New Testament version on the right.[57] A smaller set of these panels was later donated to the Penitente Morada in Córdova, New Mexico. In 1972, Rodríguez illustrated the book *Echoes of the Flute* by Lorenzo de Córdova. The small booklet features some of the folklore that Córdova (also known as Lorin Brown) collected for the Federal Writers' Project. In 1979, Rodríguez's painting *Ladies Weep over Jesus* was chosen for the pivotal and important *La Cofradía Exhibition* in Santa Fe's Guadalupe Church.[58] Albuquerque's Feria Artesana voted Rodríguez its Honored Artist in 1983. His painting, *Santuario de Chimayo,* graced both the poster and program for the event.

The multiplicity of Rodríguez's artistic talents encompasses a wide variety of mediums and is far-reaching. He created with oil on canvas, oil on glass, watercolors, lithographs, serigraphs, ceramics, and wood. His work, especially his painting, is a testimonial to his creative vision and to that of other Hispana and Hispano artists working in New Deal art projects. With regard to the struggle for acceptance in which these artists engaged, Rodríguez notes that "it was very hard to break the lines."[59] In acknowledging his position as the only "Spanish" painter among the Anglo painters in Santa Fe during the 1930s and 1940s, Rodríguez once stated that "I competed with the giants in the history of painting. And I always felt very humble, but I did my work more for my own satisfaction than for anything else."[60] The entire body of Rodríguez's work, not just his masterful straw appliqué, deserves to be recognized and studied.

Esquípula Romero de Romero (1889–1975)

Esquípula Romero de Romero was born in Cuba, New Mexico on December 3, 1889 and moved to Albuquerque in 1904. Romero de Romero was "for-

Esquípula Romero de Romero (1889–1975), Black Shawl *(ca. 1933), oil on canvas, Albuquerque, New Mexico. Museum of Fine Arts, a unit of the Museum of New Mexico, Santa Fe. Photo by Blair Clark.*

mally trained" and he considered his style of work to be "objective, expressionistic and impressionistic."[61] The medium of choice for the artist was oil on canvas, with which the he recreated landscapes, portraits, and figurative scenes. He often painted New Mexico-related scenes that included some that dealt with the Penitente religion and its participants. Later in his career, Romero de Romero described his work thus: "I don't distort nature for the sake of getting the on-looker to feel the same emotion. However I do take liberties with bold color, design and composition to gain forcefulness without sacrificing perspective."[62]

Records indicate that Romero de Romero studied with Ritter Asch in Los Angeles from 1908 to 1909. A few years later he went to New York City and studied with Frank Leyendecker, Coles Phillips, and Windsor McKay from 1912 to 1913. He returned briefly to New Mexico and spent the next few years touring on one of the state's first motorcycles. A 1913 newspaper account described how Romero de Romero visited the village of Abiquiú on his motorcycle, causing all the inhabitants to flee with shouts of "¡Brujo! ¡Brujo!" (witch).[63] From 1917 to 1928, the artist spent a great deal of time in Mexico and Latin America, studying sporadically at the Academia de San Carlos in Mexico City. Romero de Romero worked with recognized painters Rafael Caloca, Carlos Orozco, Santos Sierra, and Diego Rivera. He also spent time with many other Latin American artists during this early period in his career, and his work was exhibited in a number of Latin American cities including Buenos Aires, Quito, Guatemala City, Mexico City, and Vera Cruz. About this same time, he was also owner of

New Mexico Magazine (August 1933), Santa Fe, New Mexico. Museum of Fine Arts, a unit of the Museum of New Mexico, Santa Fe. Photo by Blair Clark.

Romero Outdoor Advertising Company in Albuquerque, a venture he sold in 1926 in order to focus seriously on his work at the Pennsylvania Academy of the Fine Arts.

In the United States, Romero de Romero's work was featured at the Art Institute of Chicago at the Century of Progress Exhibition (1933), the Chicago World's Fair (1934), Chicago's La Salle Hotel (1934), McBeth Galleries in New York City (1936), Frank Arpin Galleries in Miami (1937), Oklahoma City (1937), and the Pennsylvania Academy of the Fine Arts in Philadelphia. His works were also displayed in Cleveland, Corpus Christi, Denver, El Paso, Kansas City, Laredo, Los Angeles, New Orleans, Oakland, Salt Lake City, San Diego, and San Francisco.

Before the WPA art programs, Romero de Romero exhibited quite a bit in New Mexico, where his work was featured at the State Museum in Santa Fe and in Albuquerque, Alamogordo, Cloudcroft, and Las Cruces. The 1932 Fiesta exhibition at the Museum of Fine Arts in Santa Fe featured two Romero de Romero works, *Mis Amigos*, "an able canvas of three figures," and *Black Shawl*, which, "though more usual has a particular charm."[64] *Black Shawl*, a striking and powerful portrait of the artist's daughter dressed in a *tapada* standing in the foreground with a tall mesa and other structures in the background, later appeared on the covers of the August 1933 and May 1934 issues of *New Mexico Magazine*. The multiple appearances were a depression-era effort for the publication to save money.

In February 1936, Romero de Romero's works were featured in an exhibit at the Museum of Fine Art in Santa Fe with works by Charles Berninghaus, Fremont Ellis, Oden Hulenkremer, Raymond Jonson, Sheldon Parsons, and Olive Rush. Another exhibition held at the state museum in Santa Fe in December 1952 featured seventeen examples of his work that included sketches, portraits, and landscape paintings he did during his travels to Hawaii and national parks in the Southwest.

Romero de Romero's only documented artistic contribution to the WPA art projects is a mural he did for the Public Works of Art Project. He was one of three artists given the PWAP commission to create a large work in the old Sandoval County Courthouse in Bernalillo. The other artists on the project were Brooks Willis and Stuart Walker. The mural, comprised of scenes in Albuquerque history, was apparently removed when the courthouse building was torn down; it is now in a private collection.[65]

Although only this one work by Romero de Romero is known to have been created for the WPA, it left a legacy of sorts and appeared as the subject of Gustave Baumann's quote cited in chapter 1. Baumann was Romero de Romero's field supervisor during the PWAP and he may have known him—"one Spanish-American artist"—through art circles. Baumann criticized Romero de Romero's technique as "badly drawn" with an overt use of "Russian Blue." To date, no mural study or photograph of Romero de Romero's courthouse mural has been found, making a critical analysis of it difficult, if not impossible. Based on examinations of available images of Romero de Romero's other works from the New Deal era, Baumann's comments seem unwarranted and possibly racist. His implication that the poor execution of the mural wouldn't matter as long as it was in a "Spanish-American" environment supports the idea that artistic and racial prejudice prevented Hispana and Hispano artists from achieving recognition for their New Deal artistic contributions. If such discriminatory attitudes (could not the color have just as easily been "New Mexican" blue?) toward Hispano art were disseminated, whether intentional or not, it is no wonder that the artists (some even formally trained) were treated as unskilled "handicraft" creators.

After the PWAP mural was completed, Romero de Romero apparently made enough money to disqualify him for further relief work with the FAP. During the 1930s and 1940s, he worked as a builder in Albuquerque and he also completed many homes in El Paso and San Francisco. Romero de Romero's own home on Central Avenue, near Albuquerque's Old Town, served as an art exhibition space. Here, the artist exhibited his own works as well as those of many of his friends and colleagues from the Taos and Santa Fe art worlds. In the mid 1930s, the artist transformed the building into a nightclub called the Villa Romero.

In the late 1930s, Romero de Romero again left Albuquerque and traveled around Latin America, Canada, and the United States, painting his experiences as he went. His mode of transportation was a travel trailer said to have belonged to actress Jean Harlow. Many newspaper accounts of the artist's activities state that the trailer may have been the first of its kind to be driven into Mexico City.

Romero de Romero's work was exhibited at the first *All Albuquerque Artists Exhibit* held in Old Town May 26 through July 5, 1950. The works of seventy-one artists and "highly talented amateurs" were shown in the La Placita and La Cocina restaurants. After the exhibition, the artist again traveled to Mexico where he befriended sculptor Rodolfo Gonzales. The two artists traded works; Romero de Romero received a bronze bust of himself and Gonzales became the owner of a portrait of himself that his friend had painted.

From his mobile abode, nicknamed "The Romero Royal Mansion," the artist exhibited and sold his work, but during the 1960s, his traveling decreased. He continued to manage the Villa de Romero Inn on Central Avenue and he painted at least one mural (no longer visible) in the restaurant and dance hall. According to one 1930s source, a number of additional works were visible in the building when it was an Al-

Esquípula Romero de Romero (1889–1975), Tree of Sorrows *(ca. 1961), oil on canvas, Albuquerque, New Mexico. Collection of The Albuquerque Museum. Photo by Blair Clark.*

buquerque hot spot. The report does not list names of the works, but states that "Esquipulo [*sic*] Romero de Romero is particularly interested in New Mexican types and landscapes," so we know that his work was probably displayed there.

Few of Esquípula Romero de Romero's works are in public collections. Among those in private collections are a number of New Mexican landscapes that include scenes of Cloudcroft, Ruidoso, and northern areas of the state. Additional portraits of his daughter, companion pieces to *Black Shawl,* and those of friends and acquaintances including Romero de Romero's gardener, are numerous. The artist was skilled at portraiture and often painted both romanticized and unromanticized images of Hispanos, conveying their experiences, struggles, and culture. However, Romero de Romero did not strictly adhere to images of Hispano New Mexico as his subject matter; he also painted pueblo life, following the trend of Santa Fe and Taos artists of the time. One such striking image, titled *Jose*

Miguel, is signed on the back of the canvas in the artist's distinctive hand. He also wrote that it was painted from life on November 28, 1930. It depicts "Jose Miguel," a Santo Domingo Pueblo Indian, draped in a distinctive red and light blue or white trade blanket. The subject is standing in a picturesque doorway holding a large Native American pot. The door is slightly ajar and the viewer can see the New Mexico landscape in the background.

Despite the formal training Romero de Romero received, and despite the frequent and international exhibition of his works, public collections in New Mexico have few examples of his art. Early in 1999, *Black Shawl* was purchased by the Museum of Fine Art in Santa Fe after I spotted it at a Santa Fe antiquities show. It had returned to New Mexico via a detour at the Pasadena Rose Bowl flea market. The Albuquerque Museum has another of his works—an oil on canvas—in its permanent collection. This circa 1961 work, titled *Tree of Sorrows,* appears to depict a small Mexican town. The central image in the piece is a large tree with draping limbs that fills the canvas. In the bottom left corner, two men drive their burros toward a colonial-style town.

Esquípula Romero de Romero expressed his interest in Mexico throughout his career. He had studied painting with Portuguese painter Carlos Vierra in Santa Fe and the two had traveled to Mexico together.[66] Romero de Romero was fascinated with Mexico's culture and architecture. However, he removed himself and his heritage somewhat from Mexicans and other Latin Americans: "The Latin People have a sense of the use of color in their houses, their clothing and their flowers. That is one of the reasons I delight in painting them."[67]

That Romero de Romero was included in prominent New Mexico exhibitions and elsewhere in the country during the WPA era demonstrates the fact that he was recognized, at least for a time, as an artist worthy of inclusion. This position may have been facilitated through his friendships with Carlos Vierra and other Santa Fe and Taos artists. After the 1940s, his artistic achievements fade somewhat from view. In the 1950s, a number of articles in Albuquerque newspapers mention Romero de Romero and his travels. The artist and muralist accused of improperly using "Russian Blue" applied his artistic knowledge to his building and outdoor sign company in Albuquerque. Although he continued to paint throughout his life, he never achieved the fame and national recognition that his Anglo contemporaries did. This is not to say that Romero de Romero did not benefit from his partial recognition in the art world, for without such social and financial support, he would not have been able to travel throughout North America in his mobile home and paint the experiences and landscapes of his journeys.

Las Pintoras

Aside from Margaret Herrera Chávez, research has turned up only a few names of Hispanas who painted for the WPA's art programs. One artist, a student in Howard Schleeter and Dale Casey's painting class at the San Miguel Federal Art Center, did have her work exhibited in the WPA gallery space on the Las Vegas plaza. The student's age and identity remain unknown. Another Hispano artist's work, Epimenia Delgado's *Green Dog,* warranted specific mention in the local newspaper and was declared "of particular merit."[68]

Amelia B. Martínez, originally from Taos, has also been identified as a painter during the New Deal era. So far, documentation only yields the fact that she was hired to teach colcha embroidery to NYA girls in Roswell. We have yet to learn of her painting talents. Hopefully, additional Hispana artists will emerge from

obscurity to be included in this rich but as yet incomplete history.

With the exception of Eliseo Rodríguez, Hispano artists who engaged in the traditional mediums of "high" art seem to have been somewhat artistically disassociated from traditional Hispano culture of New Mexico. In most cases, this disassociation was achieved through WPA-era media and written accounts about their art, in addition to exhibitions of their work in art museums and gallery spaces. As a result, they were able to make it "big," at least temporarily, as artists and not craftsmen. As evidenced by Edward Arcenio Chávez's success, those who studied outside the state within a European tradition of artistic learning and apprenticeship, and thus were accompanied by a different set of sociocultural circumstances and artistic environment, had a more worldly appeal to more Eurocentric aesthetic sensibilities than those who remained in New Mexico as living and vital participants of Nuevomexicano life and art.

Notes

1. The quote in the chapter title is from painter Pedro Cervántez, who wrote a short essay that was to have been included in the FAP volume *Art for the Millions.* It was edited out. See Francis V. O'Connor, ed., *Art for the Millions: Essays from the 1930s by Artists and Administrators of the WPA Federal Art Program* (Greenwich, Conn.: New York Graphic Society, Ltd., 1973), 15.

2. Although it is not clear how he qualified for United States Federal Government/WPA Support, Rufino Tamayo created a number of works, mostly watercolors, for the FAP in New York City. Among them was *Waiting Woman,* now on permanent loan to the Museum of Modern Art in New York City. Tamayo's works were circulated to art centers and other venues by the FAP's exhibition division.

3. "Agreement between the New Mexico Art Program of the Works Progress Administration, and CCC Company Commander of Company 3934, Camp GI49N of Roswell, New Mexico, providing educational training in art for enrollees of Company 3834," Roswell Museum and Art Center Institutional Archives, Roswell, N.Mex. (hereafter Roswell MACIA).

4. CCC Company 3834, a "Grazing Service Camp," was a component of the Grazing Service or Grazing Department that oversaw grazing rights for the livestock industry. CCC Company 3834 in Magdalena, New Mexico to Russell Vernon Hunter, 13 October 1939, Roswell MACIA.

5. My deepest thanks go to Mary Cervantes, the artist's daughter, and to the rest of the Cervantes family in Cincinnati, for providing this remarkable amount of information about Carlos Cervantes.

6. "Raton Private Gets Back To Painting," no author, newspaper article dated 15 January 1945, Cambridge, Ohio, Personal Scrapbooks of Carlos Cervantes, in possession of the Cervantes family.

7. Personal correspondence with Mary L. Cervantes, 9 January 2000.

8. Dorothy Miller (D. C. M.), "Masters of Popular Painting: The Museum of Modern Art," Francis V. O'Conner Papers, microfilm roll 1091, Archives of American Art, Smithsonian Institution, Washington, D.C. (hereafter AAASI).

9. WPA-FAP Artists' Biographical Data Cards, microfilm roll 3244, AAASI.

10. Abbie Graham, "Work of Spanish-American Youth Shown in New York Art Museum," *Amarillo News,* 2 October 1936.

11. WPA-FAP Artists' Biographical Data Cards, microfilm roll 3244, AAASI.

12. Miller, "Masters of Popular Painting."

13. Sylvia Loomis interview with Joy Yeck Fincke, 9 January 1964, Albuquerque, N.Mex., transcript in the oral history collection, AAASI.

14. Don McAlavy (Clovis, New Mexico) to Kathy Flynn (Assistant Secretary of State of New Mexico), 8 December 1995, courtesy of Kathy Flynn.

15. His classification as a painter was probably the result of his relationship with Russell Vernon Hunter.

16. The categorization of this Hispano artist as an artist may have been based on Hunter's acknowledgment of Cervántez's talent. Compiled by the Workers of the Writers' Program of the Works Projects Administration in the State of New Mexico, *The WPA Guide to 1930s New Mexico* (Tucson: University of Arizona Press, 1989), 169.

17. Alfred Morang, "Some Artists of New Mexico," Fiesta Issue of *The Santa Féan* (Santa Fe: The Santa Fe Press, Inc., 1941), 73. It is not entirely clear what Morang meant by the term "formist." He may have been referring to Cervántez's attention to individual shapes.

18. Holger Cahill, speech in "Miscellaneous Manuscripts," Holger Cahill Papers, AAASI.

19. Graham, "Work of Spanish-American Youth is shown in New York Art Museum."

20. Don McAlavy to Kathy Flynn, 8 December 1995.

21. Graham, "Work of Spanish-American Youth is shown in New York Art Museum."

22. Artist biographical files, Museum of New Mexico, Museum of Fine Arts vertical files, Santa Fe, N.Mex.

23. James D. Hamlin (Texico, N.Mex.) to Boone McClure (Canyon, Tex.), 22 November 1946, James D. Hamlin Papers, Research Center, Panhandle-Plains Historical Museum, Canyon, Texas.

24. Graham, "Work of Spanish-American Youth is shown in New York Art Museum."

25. Miller, "Masters of Popular Painting." The term "Spanish-American" was applied and utilized for a number of reasons, one of which was that the idea of "Spanish" meant that someone was more "white" and thus more "American." "Mexican," therefore, was considered more

"foreign and threatening."

26. Holger Cahill, Holger Cahill Papers, "Miscellaneous Manuscripts" folder, box 5, Alphabetical Files, AAASI.

27. Pedro Cervántez, unpublished manuscript, Francis V. O'Conner Papers, microfilm roll 1091, AAASI.

28. Francis V. O'Connor, ed., *Art for the Millions,* 15.

29. Jacinto Quirarte, *Mexican American Artists* (Austin: University of Texas Press, 1973), 70.

30. Ibid., 69–71.

31. "Paintings and Sculpture from the New Mexico Section of Coronado Cuarto Centennial Exhibition," 1940 exhibition and price list, Roswell MACIA. The current location of this painting is unknown.

32. WPA-FAP Artist's Biographical Data Cards, microfilm roll 3244, AAASI.

33. "Biography," Edward Chávez Papers, AAASI.

34. The oil-on-canvas FAP work, *Colt,* was purchased by MoMA in the late 1930s.

35. "Mora Artist Edward Chavez Opens New Cabot Plaza Gallery," *Taos News,* 20 September 1972, B1.

36. Jacinto Quirarte, *Mexican American Artists,* 59.

37. Joseph Trovato interview with Edward Arcenio Chávez, 5 November 1964, microfilm box 3418, AAASI, pp. 3–4 of transcript.

38. Chávez included his relationship to Padre Martínez of Taos in his biography for *Who's Who in American Art.* Edward Chávez Papers, AAASI. In the mid-1800s, Padre Martínez opposed Santa Fe Archbishop Jean Baptiste Lamy's policies and management of the Catholic Church in New Mexico.

39. No author, "Margaret Chavez Exhibit Reviewed in Laredo, Tex.," newspaper article dated 27 December 1964. Margaret Herrera Chávez Papers, National Hispanic Cultural Center, Albuquerque, N.Mex.

40. Ibid.

41. "The Fiesta Exhibit," *El Palacio,* vol. 32, nos. 17–18 (26 October–2 November 1936), 165.

42. Janet Smith, "The Arts in Albuquerque: Painting and Sculpture," 26 November 1937, Holger Cahill Papers, microfilm roll 1106, AAASI.

43. "With the Artists," *The Western Artist* 2 (June 1936), 9.

44. Interview with Eliseo Rodríguez and his wife Paula, 11 December 1996, Santa Fe, N.Mex.

45. Ibid.

46. Carmella Padilla, "Eliseo and Paula Rodríguez: Golden

Couple Creates Golden Works in Straw," *Spanish Market Magazine,* vol. 10, no. 1 (1997): 30–35, 53.

47. Ina Sizer Cassidy, "WPA Artists Display at Santa Fe Art Museum," *The Reporter,* Works Progress Administration (April 1936), WPA Central Files, Record Group 69, National Archives, Washington, D.C., 22.

48. "More than 60 Artists Exhibit in Comprehensive New Show at the Santa Fe Gallery in Sena Plaza," *Santa Fe New Mexican,* 24 June 1938.

49. Alfred Morang, "WPA Art Projects Disclose Persons with Talent," miscellaneous newspaper article, 24 May 1940, in Holger Cahill Papers, 1939–1943, box 7 of 9, AAASI.

50. Nationally, the Federal Art Project developed and expanded graphic arts techniques and processes. The FAP also contributed greatly to the acceptance of the graphic arts as "fine" art. Among the graphic arts expressions that the FAP developed were serigraphs (print-making based on a stencil technique brushed through a silk screen). See *WPA/FAP Graphics Handbook* (Washington, D.C.: Smithsonian Institution, 1976) and Bruce I. Bustard, *A New Deal for the Arts* (Washington, D.C.: National Archives and Records Administration and the University of Washington Press, 1997).

51. Undated newspaper article, collection of Eliseo and Paula Rodríguez, Santa Fe, N.Mex.

52. Interview with Eliseo and Paula Rodríguez, 11 December 1996.

53. Jim Sagel, "Eliseo Rodríguez," *Feria Artesana Program* (Albuquerque: City of Albuquerque, 1983), 10.

54. Ibid.

55. Calla F. Hay, "Paso Por Aqui," *Santa Fe New Mexican,* 23 June 1970.

56. According to one account, Rodríguez did not accept the Monte Carlo invitation because he could not translate the entire invitation. It was written in French. Calla F. Hay, "Paso Por Aqui."

57. Sagel, "Eliseo Rodríguez," 11.

58. La Cofradía was a group of artists, many of whom identified themselves as Chicano. The show at the Guadalupe Church was pivotal because it was one of the first large exhibitions put on by the members of La Cofradía. It featured works in many mediums; not just pieces thought of as "traditional Hispanic art" like santos.

59. Interview with Eliseo and Paula Rodríguez, 11 December 1996.

60. Sagel, "Eliseo Rodríguez," 12.

61. Artist biographical files, Museum of New Mexico, Museum of Fine Arts vertical files, Santa Fe, N.Mex.

62. Jane Marvin, "Artist Romero Back from Mexico with Original Plans for Home," *Albuquerque Tribune,* 7 August 1951.

63. Howard Bryan, "Quite a Trip: The Romero Adventure," *Albuquerque Tribune,* 28 January 1970, Artist Files, Special Collections, Albuquerque Public Library, Albuquerque, N.Mex.

64. "The Fiesta Exhibit," 165. The current location of these paintings is unknown.

65. Kathryn A. Flynn, ed., *Treasures on New Mexico Trails: Discover New Deal Art and Architecture* (Santa Fe: Sunstone Press, 1995), 24. To date, I have been unable to locate an image of this mural.

66. "Romeros at Zion Park," *Albuquerque Tribune,* 24 September 1951. Carlos Vierra, a painter of Portuguese ancestry, was originally from California. He came to Santa Fe in 1904 for health reasons (a respiratory ailment) and has been given the distinction of being the city's "first resident artist." Vierra was well known for his southwestern landscapes. See Charles C. Eldredge et al., *Art in New Mexico, 1900–1945: Paths to Taos and Santa Fe* (New York: Abbeville Press, 1986).

67. Jane Marvin, "Artist Romero Back from Mexico With Original Plans for Home."

68. This exhibit also featured watercolors by Leroy Montoya, and a "character sketch from life that embodies definite humor as well as penetrating observation," by Polo Sena, age seven. "Art Center Will Exhibit Pictures in Water Colors: Wide Range of Subjects are Shown in Latest Art Center Exhibit," *Las Vegas Optic,* 21 April 1938.

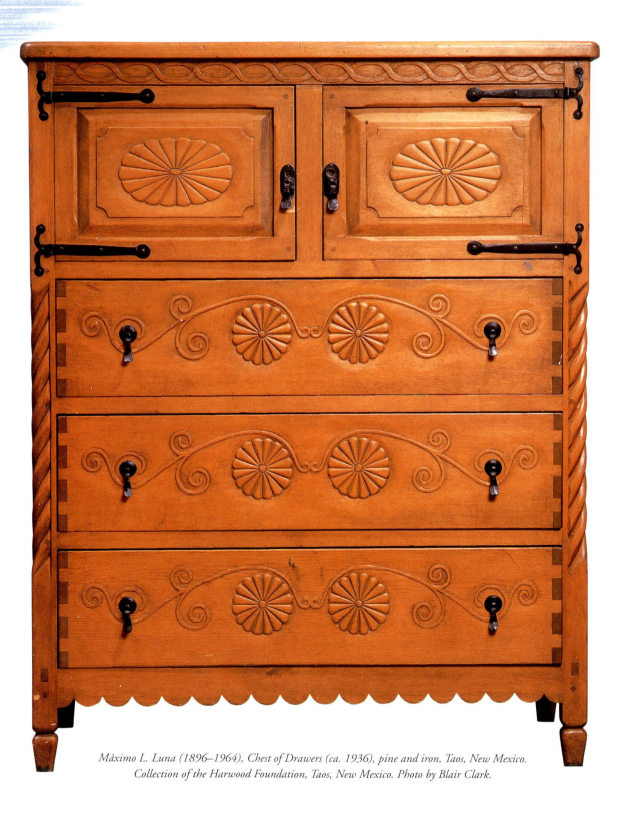

Máximo L. Luna (1896–1964), Chest of Drawers (ca. 1936), pine and iron, Taos, New Mexico.
Collection of the Harwood Foundation, Taos, New Mexico. Photo by Blair Clark.

I do not think you should go into an extensive woodcarving and native crafts program in New Mexico unless you feel that the work produced is of high quality, and I do not think that we should make furniture to be used in public buildings. I think all of our wood carving should be of the type which can be considered to have art quality.[1]

CHAPTER THREE

Art for Everyman

New Mexican Furniture as New Deal Art

IN COMPARISON TO NEW MEXICAN MURALISTS AND PAINTERS, Hispana and Hispano artists who created furniture and utilitarian art for El Diablo a Pie received little consideration, other than as craftspeople, during the "revival" period. Today, however, the opposite is true. The canvases and walls intricately colored by the "other" WPA muralists continue to be ignored, while New Mexican WPA-era furniture has become the most easily identifiable and recognizable New Deal art form created within the state. Samples of WPA furniture are highly desirable, and have rapidly become one of the most collectible of New Mexican art forms.[2]

Previously not thought of as "art" because of their utilitarian function and decorative status as "replicas" and "copies" of colonial antiques, these works are beginning to be viewed by scholars, collectors, and dealers as masterful pieces of artistic execution, and as worthy of study and value. The furniture made during this "revival" period and during the WPA era had a dramatic effect on the regional and national "Santa Fe Style" so pervasive today. The work has also served as an inspiration for a new generation of artists and a re-categorization of this art form as Carmella Padilla and Donna Pierce have commented:

Although the production of Spanish Colonial furniture has continued throughout northern New Mexico, perhaps the strongest wave of interest in the craft has occurred in the past thirty years. During that time, yet another generation of fine Hispanic woodworkers has returned to the construction styles and techniques of the state's earliest furniture makers. The quality and beauty of their work has resulted in a new respect for the craft as a fine art form and has helped create a contemporary revival of Spanish Colonial furniture.[3]

Still, while contemporary furniture artists who show in Spanish Market have achieved artistic recognition for their skills, their predecessors—those whose New Deal creations are now copied—are only just receiving name recognition.

The artistic obscurity of the Hispana and Hispano furniture artists is again a result of the conceptualization of what is "art" and what is "craft."[4] At the time it was produced, furniture made under WPA umbrella programs was categorized as "handicraft," despite the labor-intensive artistic talent it took to make it. These objects were considered to be simply office furniture and other utilitarian items that served functional and practical purposes. Donald Bear, the regional FAP director, and Russell Vernon Hunter, the state director, consistently had to justify the inclusion of furniture in New Mexico's art projects. Holger Cahill's letter at the beginning of this chapter was a response to this letter from Bear:

> It is quite possible to employ over a hundred people in New Mexico, providing you wish to go into woodcarving and native crafts extensively. The native wood carvers are capable of making some very excellent furniture to be used in public buildings; also there are one or two wood carvers in New Mexico who do very

interesting and amusing wood sculpture. On the whole, I should say that out of region five, New Mexico would produce by far the best results in the art project.[5]

In the end, Bear and Hunter prevailed and New Mexican WPA furniture, all of which was hand-fashioned, decorated federal and state buildings. Even the Department of the Interior building in Washington, D.C. had furniture (albeit categorized as "Indian Arts and Crafts") that was "Spanish Colonial Type, hand carved and put together with wooden pegs" in the main hall of the first floor.[6] By 1938, the economic success of the New Mexican furniture projects was well-known and even recorded in the Congressional Record. California representative H. Jerry Voorhis remarked:

> At one time practically a whole village in New Mexico went off relief as the result of a WPA project through which a community workshop was established for making furniture of Moorish designs.[7]

Hotels in New Mexico also sponsored projects through vocational schools, which contracted Spanish Colonial-style furniture for their facilities. However, in an effort to ensure the "art" quality of WPA furniture, Hunter often sketched designs himself. Others were done by project architects such as John Gaw Meem. This was the case with Meem's furniture designs destined for the Albuquerque Community Playhouse. A request for that project stated that among the items needed were: "Handmade furniture: Spanish-Type, in accordance with architect's sketches from which full size working drawings are to be made. Furniture for foyer, director's office and lounges."[8]

Despite the fact that furniture design was controlled in many instances, Hispana and Hispano artists of the WPA applied their talents and infused their artistry into these works. To a great extent, furniture artists

were confined within aesthetic parameters, but the array of furniture created on the projects varied in design, form, and function. Unfortunately, the majority of pieces found today are unsigned; consequently, we may never know whether they were made in vocational schools, the CCC camps, or through the NYA or the FAP. At this time, there are few identified and attributed examples, which make stylistic analysis difficult. However, New Mexican work, as a body, can be distinguished because of the almost exclusive use of pine that is glossed in medium finish, mortise and tenon joinery, carved rope motifs usually on edges and legs, chip-carved borders, and an adherence to other Spanish Colonial design elements such as vegetal motifs and Hapsburg double-headed eagles.

Vocational Schools

The highly successful statewide vocational school system, under the direction of Brice Sewell, had a tremendous impact on what is commonly referred to as New Mexican "WPA" furniture. As I have mentioned, most furniture designs of the WPA era are rooted in what was, and is, known as the "Blue Book," a mimeographed manual with a blue construction paper cover issued in October 1933, revised in April 1935, and "re-run" in March 1946 by the New Mexico Department of Education. The manual, officially titled *Spanish Colonial Furniture Bulletin,* contained a three-page forward on the general history and construction of furniture in New Mexico, followed by some eighty-plus pages of design schematics and drawings. The introduction to the bulletin also included "principals of good furniture," the first of which stated that "the shape and style of the furniture be governed by the use to which the furniture is placed."[9] The second principal addressed artistic qualities of the object:

> The furniture must be pleasing to the eye as well as serviceable and comfortable, but a great

deal of this beauty must be achieved through pleasing proportions. There must never be more carving than is absolutely necessary to relieve the monotony of some plain surface.[10]

Additional aesthetic qualities were dictated in the introduction:

> In the making of modern furniture, it is suggested that the woodworker adapt the best qualities of the old traditional designs, paying particular attention to modern needs particularly in regard to proportions and comfort, but great care should be taken to keep the feeling of simplicity and honesty of construction that is found in the original pieces.[11]

Finally, a conscious attempt was made to distinguish the aesthetic and "true" qualities of New Mexican furniture from its popular California counterpart:

> It should be noted from the above information that there is very little relationship between true Spanish Colonial furniture and the so-called Spanish Mission Style of furniture which was recently in vogue and so displeasing through its illogical massive qualities and monotonous design.[12]

In February 1939, another furniture manual, titled *Graphic Standards for Furniture Designers,* was published by the New Mexico Department of Vocational Trade and Industrial Education. This bulletin provided maximum and minimum dimensions for different types of furniture, including tea tables and typewriter stands. As inspiration, the "Blue Books" were extremely valuable and important to the furniture artists who referenced them over and over for design sources. Well-used and dog-eared editions of the *Spanish Colonial Furniture Bulletin* still exist today in the collections of Abad Lucero and the family of George Segura.[13]

Hundreds of Hispano and Hispana students took vocational woodworking classes that were funded by

"Girls do Woodwork in the NYA Shop in Taos" (December 1941), Taos, New Mexico. Photo by Irving Rusinow for the United States Department of Agriculture, Bureau of Agricultural Economics, courtesy of the National Archives, neg. no. 83-G-41744.

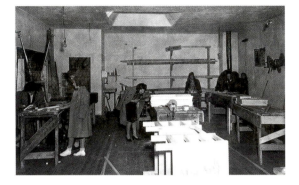

the NYA or through other relief means. Hispana furniture artists created many of the WPA-era pieces, although fewer in number than their male counterparts, due to the fact that they were often participating in traditional and stereotypical women's arts such as weaving and colcha. However, a series of photographs taken by Irving Rusinow for the United States Department of Agriculture's Bureau of Agricultural Economics documents the participation of women in woodworking classes. The images, taken in Taos County in December 1941, feature one young woman in the process of carving a traditional rosette design onto a desk, and another features a group of nine women at various creative stages of artistic furniture production. Both images carry the same caption: "Girls do woodwork in the N.Y.A. Shop in Taos."[14]

The 1935 *Tewa Basin Study* mentions that thirty-eight students at one time were taking woodworking classes as part of the vocational training at Santa Cruz High School.[15] Across the state, vocational school artists created thousands of pieces of furniture that sold through outlets such as Native Market, or through hotel sponsorship and various WPA programs. The more successful vocational schools included Taos and

El Rito, both of which had instructors who, as artists, created furniture for the Federal Art Project (FAP) and other WPA programs.

The hand-carved Spanish Colonial-style furniture encouraged in the "Blue Books" was made for the majority of WPA-funded buildings in New Mexico. The furniture not only visually supported the regionally based aesthetic and didactic mission of the Federal Art Program, but enhanced the local Pueblo Revival adobe-inspired style of architecture as well. This relationship of form and function was also conveyed in the introduction to the *Spanish Colonial Furniture Bulletin*: "This type of furniture, with proper adaptations, is particularly well-suited to the Southwestern type of architecture that has been revived and is prevalent in this region. The furniture is contemporary with this period of architecture."[16]

The buildings constructed under the auspices of the various WPA programs and furnished with this New Mexican art form included Veterans' Hospital at Kirtland Air Force Base, the old Albuquerque Airport terminal, the Laboratory of Anthropology in Santa Fe, the Harwood Foundation and Museum in Taos, Carrie Tingley Hospital in Truth or Consequences (formerly Hot Springs), and the New Mexico School of Mines in Socorro (now New Mexico Tech).

In addition, a number of WPA-era schools across the state were also furnished with this art, including the Albuquerque, Clayton, and Taos public schools. Many University of New Mexico buildings, including the old student union (now the anthropology building), Scholes Hall, and Zimmerman Library were also furnished in this manner. As testimony to the skillful construction and detailed design by the WPA artists, many of these pieces are still in use in staff offices. WPA "Local Request # One-1883" listed the items to be made for Zimmerman Library as:

22 Library Tables

7 Library carrels

227 Library chairs

14 Classroom tables and chairs

2 Seminar tables

24 Chairs for seminar rooms (no arms)

10 Armchairs for Board of Regents room

18 Office Chairs (with arms)[17]

Guest facilities and visitor-oriented buildings in regional tourist attractions like Bandelier National Monument and Carlsbad Caverns National Park also had furniture specially constructed by artists working in the various WPA art programs. "Spanish Colonial"– style furniture was made by CCC enrollees for the museum and the administration building at White Sands National Monument.

In some cases, the furniture created for WPA-era buildings differed from the designs in the "Blue Books" and reflected the local surroundings beyond the Spanish Colonial and Pueblo Revival guidelines. For example, furniture constructed in the Gallup area featured Native American design elements, while furniture found at the old officers' club at Kirtland Air Force Base in Albuquerque incorporated carved propeller motifs.

WPA furniture "showcases" in the state included most notably the Harwood Foundation in Taos, the Albuquerque Community Playhouse, and the Roswell Federal Art Center. Official WPA/FAP photographs of the furniture made for these buildings are abundant in the archival collections of New Mexico, the National Archives, and the Archives of American Art. The photos were used as a propaganda method to convey the success of the New Mexico projects. They were often accompanied by an explanatory text such as the following:

In New Mexico, there are many unusual types

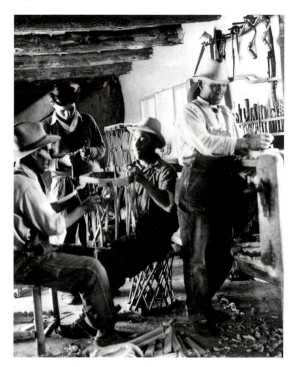

Chupadero Furniture Artists (ca. 1934), Chupadero, New Mexico. Photo courtesy of the National Archives, neg. no. RG-69-N 12374-C.

of handicraft projects. There is the furniture project, which uses native white pine, which is soft and suitable for reproducing the copies of the fine old Spanish Colonial furniture. This wood is also the most readily available and is economical.

In the replicas, it may be noted that spindles are used, wherever possible. This is reminiscent of a strong Moorish influence as nails and screws were never used in the making of early furniture. Nor did the carving appear in the old furniture, either the true medieval, or the genuine Spanish Colonial New Mexican. The furniture produced on the WPA projects, observes this, too. There is just enough decoration to break the monotony of the plain surface.[18]

Artist Unknown, Chair and Stools (1930s), willow, hide, and paint, Chupadero Vocational School, Chupadero, New Mexico. Chair and Large Stool, International Folk Art Foundation Collection, Museum of International Folk Art, a unit of the Museum of New Mexico, Santa Fe (FA.1998.64.1 / FA.1998.34.1). Small painted stool, collection of Barry and Arlette Richmond. Photo by Blair Clark.

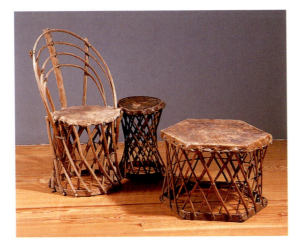

The use of such descriptions allowed WPA officials to tout the success of their vocational and economic "rehabilitation" programs. At the same time, however, they also implied that the artists were simply making replicas of furniture that could be traced back to Spain rather than creating new or original works of art.

Chupadero Furniture Project

The WPA Emergency Education Project in Chupadero was highly acclaimed during the WPA era. Chupadero, a small community near Nambé, experienced rapid success via federally funded vocational training. In 1935, the *Tewa Basin Study* stated that the residents of Chupadero had "depended upon agriculture entirely for their living, and have never learned handicraft. They do not weave or make furniture. A vocational school has been started to fill this need by Mr. Soule [*sic*]."[19] The school was funded under the WPA's Emergency Education

Project, OP No. 65–85–1340 and employed an Hispano instructor.[20] By 1936, the production of willow, reed, and rawhide furniture had become a great economic resource. The furniture, unique in the New Mexican sense, took the form of stools, chairs, and tables very similar to the Mexican *equipale* (leather and wood) style so popular in the 1930s that is currently making a comeback as part of California, southwestern, and Mexican styles. Few examples exist today because of its popular use at the time as patio furniture. A 1936 report on the project's success stated:

> All families in this village, who are descendants of the early Spanish settlers, were formerly on relief, having made their livelihood by hauling wood to Santa Fe, revenue from which was discontinued through introduction of natural gas in Santa Fe four years ago. The income derived from the making and selling of furniture has taken practically every family in the community off relief rolls.[21]

Another WPA article discussed the "re-ordering" of life in Chupadero:

> Under a WPA project, both the young and old were instructed in the fashioning of furniture from pine, willow and rawhide, which has found a ready sale. Recently the people of the village built a community vocational school and workshop combined, all labor having been contributed by the villagers, who have turned with enthusiasm to their new method of living.[22]

Chupadero was even discussed on the radio in WPA related programming across the country:

> It concerns an entire village—the hamlet of Chapadero [*sic*], New Mexico. the folks out there used to have all the work they needed—until the industrial concern from which they got their income closed up in the area some

years ago. Then, the entire town was jobless. They finally had to go on relief. In 1936, the WPA set up a handicraft project for them, on which they were taught to make authentic copies of antique furniture owned by the Spaniards who first settled Mexico. Native lumber—their only commercial project—was used. Interesting Moorish designs of a by-gone day were painstakingly carved by the natives of Chapadero [*sic*], who put their furniture together sturdily with wooden pegs. Their handiwork attracted such widespread interest that a commercial interest grew out of it which, by the end of 1936, had taken every able-bodied citizen of the town off relief.[23]

The joint vocational school- and WPA-supported project in Chupadero was so successful that a number of the works produced there were featured in National exhibitions of "Handicrafts" and WPA art. One example was a reed-and-rawhide stool featured in a January 1938 WPA exhibition held at the National Museum (Smithsonian Institution). The exhibition featured the work of "non construction WPA projects" and demonstrated "skills of the unemployed."[24] The Chupadero-style furniture was sold through the Native Market store and other retail venues.

La Ciénega

The furniture project at La Ciénega was also funded under the Emergency Education Project OP No. 65–85–1340. Here, Hispana and Hispano artists created furniture for many federal and state buildings as well as for commercial structures like the Hilton Hotel (now La Posada) in Albuquerque. Like its sister project in Chupadero, the La Ciénega furniture project was initiated in an effort to introduce economic revival into the small community. One WPA writer described the attempt in the following words:

Artist Unknown, Chaise Lounge (1930s), pine, willow, and hide, Chupadero Vocational School, Chupadero, New Mexico. Gift of Barry and Arlette Richmond, collection of the Museum of International Folk Art, a unit of the Museum of New Mexico, Santa Fe (A.1999.5.1). Photo by Blair Clark.

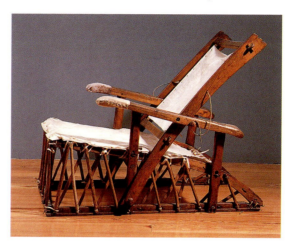

The furniture project was located in Cienega [*sic*] because it was deemed necessary to augment the economic decline of this village whose economic means had been based on agriculture. The tanning of leather and the commercial production of pottery and floor tile also provided a means of earning money in this village.[25]

Some of the pieces made in La Ciénega included armchairs with woven leather seats. At the beginning of the project, a La Ciénega carved chest and chair were circulated around the WPA art centers and other exhibition venues as an example of the successes of both the Ciénega and the New Mexico projects. Among the instructors at the Ciénega furniture school were Eloy Chávez and David C' de Baca.[26]

Civilian Conservation Corps (CCC) Artists

The art of New Mexican furniture during the WPA was not exclusive to the FAP and the vocational school system. Many of the state's CCC camps also held wood arts classes, where carving and furniture-making were

Elidio Gonzales (1912–1988) in Taos, New Mexico. Photo by Jean Rodgers Oliver from Sun and Adobe: Camera Impressions of the Enchanted Land, *Revelo Press, 1955.*

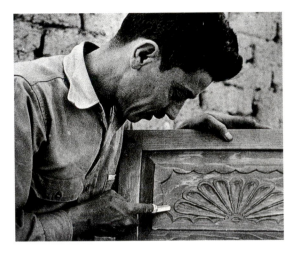

taught. CCC camp artists created pieces for the National Park Service offices and buildings around the state, including the regional headquarters in Santa Fe. Among others furnished with the Spanish Colonial style were the administration buildings and visitors' centers at White Sands National Monument and Carlsbad Caverns National Park.

The artist enrollees at CCC Camp NM-1 at Bandelier National Monument also created the Spanish Colonial–style furniture that graced the guest lodge. The Bandelier artists were especially noted for their skill and they were commissioned from outside the state to create a set of intricately carved doors with handmade iron decoration and hardware for the new museum at Tumacácori National Monument in Arizona.[27]

A workshop was also provided for CCC Company 2843 SCS-3-N in Española to teach enrollees woodworking and rug weaving.[28] In addition, Lieutenant Clarence Martin, the company commander of Company 833 SP-1-N in Santa Fe, established a trade school "to train enrollees for various means of livelihood after

leaving the CCC."[29] A photo of some of the artists standing next to their works indicates that enrollees of this camp created chairs, cajas, and shelves.[30]

Elidio Gonzales (1912–1988)

Elidio Gonzales was born in Cimarrón, New Mexico but spent most of his lifetime in the Taos area. In 1934, he began learning the art from Abad Lucero at the Taos Vocational School. According to Lucero, Gonzales "was my star pupil."[31] Under Lucero's direction, Gonzales quickly mastered the art of "Spanish Colonial style" furniture-making, so much so that "within three months he became so skillful that he was made an assistant instructor."[32] Gonzales later became the woodcarving instructor for both the vocational school and the NYA in Taos. Through Lucero's mentorship, Gonzales eventually went to work for Native Market and the FAP.

Included in the identified work Gonzales created that was funded by the WPA is a set of furniture in the McKinley County Courthouse in Gallup. The Pueblo Revival–style courthouse building, complete with bell tower, was funded by the Public Works Administration and constructed during 1938 and 1939. It is unclear whether Gonzales created the works in Taos, or whether he traveled to Gallup and made the pieces in local WPA-funded workshops, or at the Gallup Federal Art Center.[33] The Octavia Fellin Public Library in Gallup also has two *trasteros* (standing cabinets), one of which is carved, that could be Gonzales's work. Another WPA/FAP artist, Eliseo Rodríguez, remembers Gonzales working in the WPA shop in Santa Fe.[34] Gonzales also worked for the WPA/FAP in Roswell and may have assisted artist Domingo Tejada with furniture for the Roswell Federal Art Center and other area projects.[35]

During World War II, Gonzales served as an instructor for army rehabilitation programs.[36] In 1945, after the WPA ceased operation and World War II

had ended, Gonzales returned to Taos and opened a hand-carved furniture business, El Artesano de Taos, with Abad Lucero. Until recently, family members and artists who apprenticed with Gonzales still ran the store and created furniture in the "Spanish Colonial style."

In 1955, Gonzales and his work were featured in *Sun and Adobe: Camera Impressions of the Enchanted Land,* a small tourist booklet with photographs by Jean Rodgers Oliver and text by Roland Dickey, former director of the Roswell Federal Art Center. Gonzales's image helps illustrate the following text:

> New Mexico's distance from the centers of fashion and supply—six months by oxcart from Mexico City—encouraged her Spanish colonists to develop a distinct regional style of art, examples of which are now exhibited in museums in many parts of the world. In keeping with the local architectural styles, artists and craftsmen still make handsome furniture, tin pieces and textiles in traditional designs.[37]

Throughout his life, Gonzales also did customized doors and windows for many northern New Mexico homes. He even reportedly designed all the cabinetry and furniture for a house in Kansas City. In 1987, he was commissioned to carve the large double doors for the main room of the permanent Hispanic Heritage Wing at the Museum of International Folk Art in Santa Fe. The doors, based on those still extant at the Santuario de Chimayó, may be among his last works. He died shortly after beginning the commission. The doors were completed by his apprentice, Antonio Archuleta.[38] Other examples of Gonzales's work have been featured in exhibitions at the Taylor Museum of the Colorado Springs Fine Arts Center, the Denver Art Museum, and the Pasadena Art Museum. As a tribute, scholar William Wroth wrote this dedication: "This article is dedicated to the memory of Elidio

Abad Eloy Lucero in his Studio (1999), Albuquerque, New Mexico. Photo by Tey Marianna Nunn.

Gonzales, master furniture maker of Taos, one of the committed artists who kept the craft alive from the 1930s to the 1980s."[39]

Abad Eloy Lucero (b. 1909)

Abad Lucero was born in Cerrillos, New Mexico in 1909 and began his artistic career in the 1920s making cabinets for George Gormley's Tile and Pine Shop in Santa Fe. Gormley, an antique dealer, had acting aspirations and he left for Hollywood, leaving Lucero in charge of the shop. During the next few years, Lucero managed the business and created furniture for the shop. Later, he and his colleague Ben Sandoval left Santa Fe for a short while to work on furniture and decorative carving for the Harvey House in Winslow, Arizona.[40]

In 1933, Lucero began teaching woodcarving and furniture-making at the Taos Vocational School. During this time, he helped construct the original buildings of the Harwood Center, including the

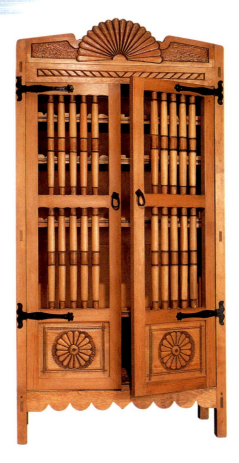

Abad Eloy Lucero (b. 1909), Trastero (1999), pine and iron, Albuquerque, New Mexico. International Folk Art Foundation Collection in memory of Oliver Seth, Museum of International Folk Art, a unit of the Museum of New Mexico, Santa Fe (FA.1999.23.1). Photo by Blair Clark.

frames and doors and also the children's furniture for the library. As I mentioned earlier, Vocational School furniture projects were often sponsored by individuals and hotels. One of the first sponsors of work from the Taos school was Pasqual Martínez of the U.S. Forest Service. Martínez contracted Lucero and his students to make signs for Forest Service use. The signs were done in carved relief, and the letters were burned to darken and distinguish the characters from the rest of the wood. Under Lucero's direction, the Taos Vocational School also made furniture for the Hilton Hotel (now La Posada) in downtown Albuquerque, some of which is still in use in the lobby and guest rooms.

During the 1930s, Lucero worked for the Native Market store in Santa Fe. Rather than creating and demonstrating work in the physical setting of the store itself, like so many of the Native Market artists did, Lucero made furniture in a back room of his Santa Fe home. He sold through Native Market outlets in both Santa Fe and Tucson, as well as through the store's mail-order catalog. Lucero also served as the shop manager for the Native Market store in Santa Fe. According to the artist, his chairs sold at Native Market for $12 each.[41]

Lucero went to Mora in 1938 to initiate the woodworking and furniture-making program at the Mora Vocational School. Lucero remembers working and tanning hides with Estevan Zamora, who taught leatherwork.[42] In 1939, he moved to Tucumcari where he left the state vocational system and began his career with the federally funded NYA. He returned

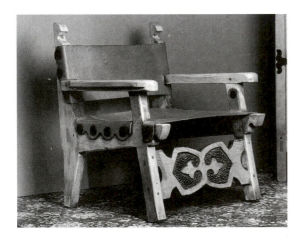

Abad Eloy Lucero (b. 1909), Armchair (1996), pine, leather, and iron, Albuquerque, New Mexico. International Folk Art Foundation Collection, Museum of International Folk Art, a unit of the Museum of New Mexico, Santa Fe (FA.1999.23.2). Photo by Blair Clark.

to Taos in late 1939, this time as an NYA instructor where he was paid $105 per month.[43] The NYA shops and classrooms eventually outgrew the Harwood facility and the program moved into the old Taos post office building.

In 1943, Lucero and his wife Emma moved to Dayton, Ohio to Wright-Patterson Field where he applied his technical expertise to a new role as pattern-maker. During World War II, he was stationed in Biac, New Guinea as an aircraft woodworker where he repaired planes. When the war ended, Lucero returned to Santa Fe, built a house, and raised three children. He and his family then moved to Albuquerque in 1950 and he went back to work for the Forest Service. He worked in the Coconino National Forest in Arizona and then he transferred to the engineering and sign shop of the Forest Service's Albuquerque office. The signs Lucero created for the Forest Service during this time were completely hand-carved. The artist remembers making a large number of "entering" and "leaving" forest signs and laments the fact that most of his work was later replaced with metal signs: "We were doing everything by hand, you know carving. They took the beauty away from it," he says.[44] During the New Deal era, Lucero rarely signed his work but sometimes would add his initials to those signs. The artist and his wife saw one such sign at the Grand Canyon. In 1966 Lucero worked another government job for the Forest Service in Lincoln at Camp Capitán. He worked with troubled young men from the Springer boys' facility.

In the decades after his successful WPA career, Lucero created furniture for private individuals, which include *bancos* (benches), chairs, coffee tables, desks, dining room tables, gun cabinets, *repisas* (wall shelves), tile-top tables, trasteros, and trunks. Lucero prides himself in only using mortise-and-tenon construction in all of his work, a practice he continues to this day. Much of his New Deal–era art was created using traditional

Abad Eloy Lucero (b. 1909), Santa Cruz Mission *(1996), oil on canvas, Albuquerque, New Mexico. Collection of Abad and Emma Lucero. Photo by Blair Clark.*

Abad Eloy Lucero (b. 1909), San Geronimo Church, Taos Pueblo *(1993), oil on canvas, Albuquerque, New Mexico. Collection of Abad and Emma Lucero. Photo by Blair Clark.*

New Mexican techniques of mortise-and-tenon joinery, chip-carving and other decorative and structural components. According to Lucero, he did a large conference table and numerous matching chairs with spindles for the University of New Mexico's Zimmerman Library with a number of other FAP artists under the direction of Russell Vernon Hunter. The table still sits in an upstairs conference room of the library.

Later in his career, Lucero began breaking away from the designs set forth in the New Mexico State Department of Education bulletins. One 1946 example of his individual style indicates a more *modernista* approach. In the design for this chair, he incorporated Spanish and Mexican elements to create a dramatic work of wood, leather, and metal. His original design is sleek yet bold and utilizes domed iron nails to secure the leather seat and back. In the 1970s, Lucero created replicas and reproductions of many of his earlier works. However, these were not exact duplicates of his depression-era pieces; the design elements and proportions changed.

Abad Lucero, like his friend Eliseo Rodríguez, does not apply his creative energy and artistic skill to just one medium. He creates furniture, but he has also carved bultos, painted retablos, and has worked with tin. He started carving bultos in 1970. At the time of this writing, Abad Lucero is still sharing his knowledge, teaching senior artists how to make furniture and retablos through Albuquerque's Senior Art, Incorporated. Currently, he is studying painting at the North Valley Senior Center close to his home. Although he took formal lessons in the 1930s with Regina Cook in Taos, he began actively painting in 1991. His subject matter, done with a narrative realism, reflects his life experiences in New Mexico, including Taos Pueblo, Madrid, his childhood home in Cerrillos, and scenes like one that features a man

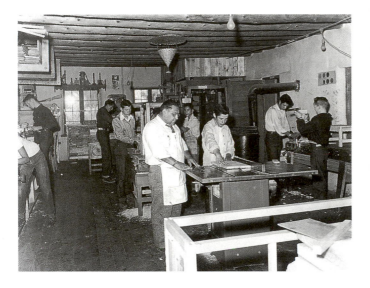

Máximo L. Luna with his Students in the Taos High School Vocational Shop (ca. 1946), Taos, New Mexico. Photo courtesy of Marcella Falvey, Santa Fe, New Mexico.

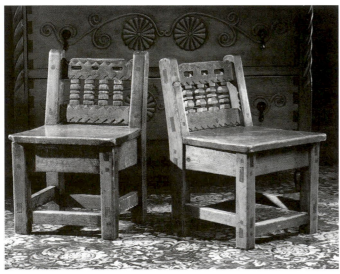

Máximo L. Luna (1896–1964), Children's Chairs (ca. 1930s), pine, Taos, New Mexico. Collection of the Harwood Foundation, Taos, New Mexico. Photo by Blair Clark.

riding one of two donkeys. Lucero's recent work has also included a number of retablos painted on board and framed with tin. Lucero himself did the frames. He has been featured in exhibitions at Los Colores in Corrales, and the Harwood Foundation and Millicent Rogers Museums in Taos. His paintings were shown in *One Space: Three Visions*, an exhibition at The Albuquerque Museum. In September 1993, the Owings Gallery on the Santa Fe Plaza exhibited his furniture. The artist was awarded the Governor's Award for Excellence and Achievement in the Arts in the State of New Mexico in 1995.

Máximo L. Luna (1896–1964)

Máximo "Max" Luna was another important artist and figure in the resurgence of interest in the Spanish Colonial furniture style during the 1930s. He was already an established furniture artist when he began teaching at the Taos Vocational School in 1936. Luna and his students created hand-carved, mortise-and-tenon furniture for the Harwood Foundation, the municipal school district, the courthouse and the chamber of commerce, all in Taos. They also created a number of pieces for the University of New Mexico and private homes. Many other pieces were shipped to places outside New Mexico.[45] Their body of work created at the Taos Vocational School included cabinets, chairs, chests, desks, divans, tables, radiator cases, and wall brackets. Additionally, Luna hand-forged all the iron fittings for his pieces and did ornamental tinwork.

Luna was a member of a renowned family of artists—four generations of Lunas in Taos had been filigree jewelers. His carved works highlight his artistic inheritance. Although he was working with traditional style elements, his art is distinguished by its delicacy, which bears a relationship to the work of his other family members.

Máximo L. Luna (1896–1964), Taos Pueblo (date unknown), oil on canvas, Taos, New Mexico. Private collection. Photo by Blair Clark.

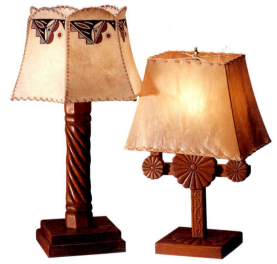

Máximo L. Luna (1896–1964), Lamps (1930s), wood, hide, and metal, Taos, New Mexico. Collection of Barry and Arlette Richmond. Photo by Blair Clark.

In addition to his fine wood artistry, Luna painted in oils. To date, only three of his oil-on-canvas works, all depicting Taos Pueblo or the surrounding landscape, have been identified. It is not known whether he studied with any of the Anglo Taos artists, but like his colleague Abad Lucero, Luna was obviously influenced by the artistic movement in Taos during the New Deal era.

After World War II, Luna continued to teach in the Taos Vocational School. During the days, his classes were filled with junior and senior high school students. In the evenings he taught a class for returning G.I.s. Luna taught in Taos for thirty-five years and was named posthumously to the New Mexico Education

George Alfred Segura (1945), University of Southern California Dental School. Photo courtesy of Rose Trujillo Segura.

Association's Hall of Fame. He married New Deal–era fiber artist Chrisóstoma "Chris" Luna. He was also the brother-in-law of painter Margaret Herrera Chávez, both of whom are included in this book.

George A. Segura (1908–1988)

George Segura was born in Santa Fe in 1908. As a child, he spent time in California but returned to New Mexico in 1926.[46] In 1931, Segura taught furniture-making at the Spanish American Normal School in El Rito, and was later a supervisor for NYA students working in the same vocational shop. Under his direction, El Rito gained recognition for its artistic production of furniture, much of which is still in use throughout the Northern New Mexico Community College campus. A 1945 article about the school mentioned the commercial success of the NYA project: "In pre-OPA [*sic*] days the school maintained a neat little business in its wood-carving and weaving departments. Nearly all of the school furniture was made by the students at a cost of about one-fifth the price of a store purchase."[47] In addition to the work he did for the campus, Segura's Spanish Colonial–style furniture and that of his students was used to decorate many local and federal buildings in New Mexico.

While at El Rito, Segura was approached by Russell

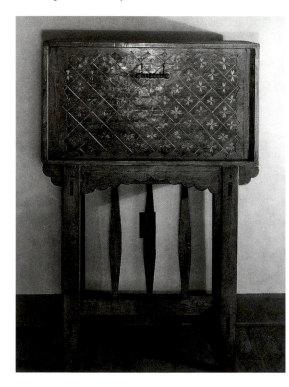

George Alfred Segura (1908–1988), Straw Appliqué Vargueño (ca. 1936), wood and straw, Works Progress Administration, El Rito, New Mexico, for the Albuquerque Community Playhouse (Albuquerque Little Theatre). E. Boyd Files 207 53802, Museum of International Folk Art, a unit of the Museum of New Mexico, Santa Fe.

Vernon Hunter about making the furniture for the Albuquerque Community Playhouse (now the Albuquerque Little Theater), a WPA-funded project. Segura and his students created all the colonial- and territorial-style furniture, including a ticket box, a sitting bench with back, a colcha-embroidered backless bench, a large dining table, a small coffee table, four armchairs and a chaise lounge that featured carving and other traditional detailing. The back of the sitting bench was intricately appliquéd with straw. The bench, table, and armchairs are still in use today in the upper and lower lobbies of the Albuquerque Little Theater. The theater's backless bench was embroidered in floral-patterned colcha designs by Estella García and her class in the Melrose Federal Art Center. Another colcha-upholstered bench in the Melrose high school auditorium was also done by George Segura.[48]

A number of other pieces were created especially for the Playhouse's ladies' lounge. These included a

Lobby Interior, Albuquerque Community Playhouse. Architect John Gaw Meem (1936), Albuquerque, New Mexico. Photo courtesy of the National Archives, neg. no. RG-69 AG-940.

George Alfred Segura (1908–1988), Armchair and Table (ca. 1936), pine, Works Progress Administration, El Rito, New Mexico. Collection of the Albuquerque Little Theater, Albuquerque, New Mexico. Photo by Blair Clark.

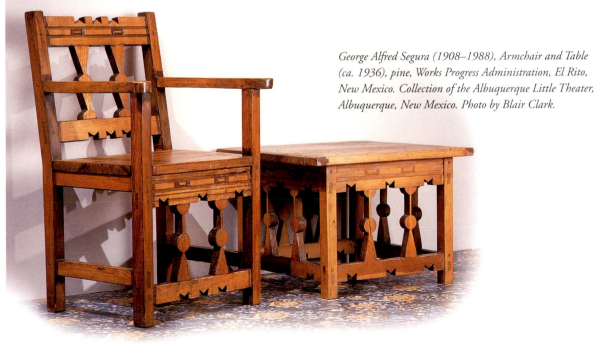

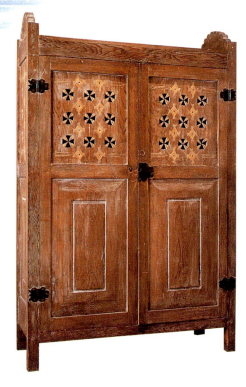

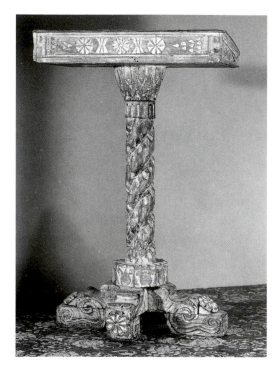

Domingo Tejada (1903–1993), Trastero (ca. 1937), pine, straw, and iron, Federal Art Project, Roswell, New Mexico. Permanent collection of the Roswell Museum and Art Center. Photo by Blair Clark.

Domingo Tejada (1903–1993), Podium (ca. 1937), pine, Federal Art Project, Roswell, New Mexico. Permanent collection of the Roswell Museum and Art Center. Photo by Blair Clark.

number of empire-style chairs, a coffee table, a long spindle-sided dressing table, and an exquisite straw appliquéd *vargueño* (writing desk). The appliquéd design on the vargueño was the same as that of the sitting bench made for the lobby. Over the years, the furniture from the ladies' lounge has disappeared, perhaps becoming props for the theater's productions.

At the time, Segura's work and active contributions to the FAP seem to have been held in high regard—so much so that he was recommended to sit on the state advisory committee for the *Portfolio of Spanish Colonial Design*. Russell Vernon Hunter submitted his name for consideration with the accompanying words:

Mr. Joseph Grant, president of the Spanish-American Normal School at El Rito, has re-

quested that Mr. George A. Segura, a faculty member replace him. He feels that Mr. Segura will have more time to devote to this field and has a marked interest in it. He has been of much assistance to the project which is sponsored there; this is the engraving and printing of the portion of the Spanish-Colonial art Portfolio.[49]

Segura married Rose Trujillo, daughter of Esquípula Deagüero (E. D.) Trujillo. In the 1930s, Segura and his brother-in-law James Grant, son of El Rito president Joseph Grant, were commissioned to create many of the architectural elements going into Santo Tomás church in Abiquiú, which was rebuilt in 1937. The commission included corbels, doors,

Domingo Gusmán Tejada (ca. 1930s).
Photo courtesy of Louise Gonzalez.

Domingo Gusmán Tejada (ca. 1930s).
Photo courtesy of Louise Gonzalez.

lintels, and railings, including the exterior façade balcony.[50] The altar railings, one of which carries the artist's signature, were made in El Rito during Segura's time there. A dedication to Charlotte Howland, Segura's mother, can be found in the choir loft.[51] In addition, much of the furniture that was made by the El Rito NYA students under Segura's supervision is still used in the church.

Segura preferred to work with pine, and he typically left his furniture in its natural color, although he occasionally applied a gray stain in order to achieve an "antique" look.[52] He made few pieces of furniture after World War II, choosing instead to become a dentist. He attended the University of Southern California Dental School, then returned to Santa Fe and built a successful dentistry practice.

Domingo Gusmán Tejada (1903–1993)[53]

Beginning in 1933, Domingo Tejada was also a student of Abad Lucero in Taos. Lucero remembers that the Tejada family came directly from Spain, and lived for some time on the old Martínez hacienda in Taos.[54] Tejada may have started out in the WPA agricultural programs eventually taking classes from Lucero before starting work with the FAP. He spent much of his artistic career as the furniture and carving instructor at the Roswell Federal Art Center. In describing the center's staff at its inception, director Roland Dickey said of Tejada:

> Then there was a kind of handyman who was a peripheral assignment, that is he was a man who did crafts. He was a Spanish chap by the name of Tahada [*sic*], a very good carpenter and he constructed a loom entirely by hand in the old manner. He could do things like that.[55]

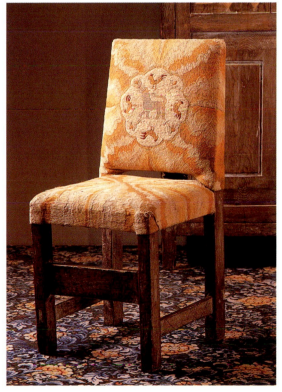

Domingo Tejada (1903–1993), Embroidered Chair (1937), pine, linen, and wool, Federal Art Project, Roswell, New Mexico. Collection of Ray and Judy Dewey, Santa Fe, New Mexico. Photo by Blair Clark.

Domingo Tejada (1903–1993), Mountain Range Landscape *(ca. 1938). Collection of Loren and Vikki Tejada. Photo by Blair Clark.*

Tejada was not just a handyman and carpenter; he was the supervisor of the NYA furniture project in Roswell. He was a dedicated artist who often worked extra hours in order to finish his projects.[56] An assistant named Bernal was assigned to the NYA workshop, but Tejada felt his presence did not alleviate the workload:

> Mr. Tejada has asked me to mention that the quality of Mr. Bernal's work is not what it should be and that within the last several weeks the latter has been guilty many times of insubordination and has done much toward breaking down the moral [*sic*] and discipline of the NYA workshop. Mr. Tejada further states that Mr. Bernal cannot maintain order during Mr. Tejada's absence and that he is in no sense a helper, a sixty-dollar a month man.[57]

This type of documentation suggests that Tejada, like his colleague George Segura, was to some extent taken seriously with regard to his work and his role

as an instructor within the WPA. At the same time, however, while various WPA archival collections contain the entire correspondence regarding Tejada's difficulties with Bernal and Tejada's overtime hours, they have no additional information on the life of this talented artist.

The artists working under Tejada's direction in the Roswell Art Center's wood shop, located in the building's basement, created all of the solid and upholstered pieces of Spanish Colonial- and territorial-style furniture for the Roswell Federal Art Center's offices, reception area, and gallery. Tejada was also provided with gold leaf to adorn the nichos that housed the busts of the museum's founders. Through his artistic efforts, and through those of his students, Tejada created what became a showcase of WPA/FAP art. With the exception of a few pieces now in private collections, many fine examples of his artwork that he made for the gallery and the offices remain in the collection of the Roswell Museum and Art Center.

Unfortunately, the same cannot be said for the works Tejada created for the center's ladies' lounge, the fate of which are still unknown. Uniquely different from the Spanish Colonial–style furniture decorating buildings across the state, Tejada and his NYA students furnished the ladies' lounge with territorial-style furniture. Historical images of the lounge indicate that there were many pieces, including a vanity table with rosette mirror, a matching stool, a harp-backed upholstered chair, and an upholstered chaise with a harp-motif arm. All of the lounge furniture was fashioned from pine and painted white. The furniture was designed to be a "heavy rendition of the French Empire Style which had been copied by New Mexico artists and

Domingo Tejada (1903–1993), Landscape with Covered Wagon *(ca. 1938).*
Collection of Loren and Vikki Tejada. Photo by Blair Clark.

furniture makers when it was brought in by Anglos and the railroad in the nineteenth century."[58]

It was the furniture in the ladies' lounge that Roland Dickey described as a showcase of what the effort of the Federal Art Project could achieve:

> And one of the charming things, the ladies powder room was done as kind of [*sic*] Spanish colonial room of the middle 19th century period where American influences were coming in, and you got the Spanish colonial version of the American mid-Victorian furniture. And Vernon designed this room. Around the walls were painted an imitation of a kind of gingham related to embroidery. The furniture was upholstered, it was all hand made; the mirror had a tin frame and so on. And the whole room was just a gorgeous piece. We always showed the ladies' powder room to

visitors, because it was a perfect kind of thing.[59] Through this and other such local and national accounts, the ladies' lounge in the Roswell Art Center became perhaps the most famous ladies' room during the WPA.

The interior furnishings for the Roswell Art Center's administrative office included a three-drawer office desk with decorative paneling, a "deal" chair with a carved steerhead motif and decorative crown, and a straw-inlaid trastero with lunette and hand-wrought iron hinges. Tejada and his students also made a library table with scalloped edges and carved medallions, two more deal chairs with flower-carved backs, two deal chairs with seats and backs upholstered in colcha embroidery, and a carved wooden "box" and stand with decorative holes for the office.[60]

The straw-inlaid trastero (circa 1937) is an outstanding example of Tejada's work. Roland Dickey

described the piece in his 1970 book *New Mexico Village Arts* as "one of the best modern examples of straw mosaic is on the *trastero* at Roswell Museum, reproduced by WPA artisans from an earlier piece."[61] The trastero remains in the permanent collection of the Roswell Museum and Art Center.

The center's gallery sported a registration table for the gallery attendant with carved apron and panels, and a matching chair with carved apron and scalloped edges and carved back rest. Visitor seating was provided by two two-seated benches with curved legs and rounded arms, and one five-seat bench in the same style. These armed benches were said to be patterned after originals in the La Fonda Hotel in Santa Fe. The La Fonda benches were later moved to the patio of the Palace of the Governors.[62] Two armchairs with beaded molding backrests and carved upright stiles were also used for gallery guests. Two three-foot-tall wooden candlesticks, patterned after antiques in Santa Fe, were also carved. The stems of the candlesticks had a metal-leaf overlay and were white-toned.[63] An elaborately hand-carved speaker's podium was also made for the gallery and stage area. Historical photographs of the gallery document a large carved desk with intricate chip-carved decorative design elements running down the corners of the legs, the two colcha-embroidered chairs, an armchair, and a colonial-style desk chair with a carved back.

Tejada completed a pair of colcha-embroidered chairs on October 30, 1937. The chair, pictured in many of the official Federal Art Project photos, is straight-backed with mortise-and-tenon joined legs and an elaborate colcha-embroidered seat and back colored in creams, oranges, yellows, and browns. A center rosette medallion on the seat back features a feline-like animal encircled by roosters and some floral designs. As exquisite as these chairs are, the colcha upholstery was not typical of Spanish Colonial style and enforces the idea that these pieces were designed not by Hispano artists but probably Anglo artists with a more European perspective. Nevertheless, both chairs traveled to New York City where they were featured in New Mexico's WPA exhibit space at the 1939–1940 World's Fair.

Ironically, Tejada's furniture, though recognized for its artistry during the New Deal, achieved a fine-art status through a series of 1937 woodcuts by fellow WPA artist Manville Chapman, who was taken by the beauty of the furniture. Tejada's pieces served as inspiration for these woodcuts. The prints of the woodcuts were used to illustrate the inaugural program and accompanying newspaper articles for the Roswell Art Center. The original woodcut blocks are in the collection of the Roswell Museum and Art Center. Their prints were re-issued in the same program format for the Roswell Museum and Art Center's fiftieth anniversary in 1987.

Tejada, his NYA students, and possibly his younger brother José Moíses Tejada, created furniture for other Roswell area projects as well.[64] The workshop made the desk, a large carved chest, and a number of chairs for the Roswell Girl Scouts' office. The pieces were later given to the Roswell Federal Art Center. Tejada also made the table for the National Youth Administration (NYA) Girls' Camp in Capitán, where Lucy Lepper Shaw was the camp director. The NYA camp paid for all materials and Shaw requested that the table be 72 inches long by 30 inches wide and that it have a "natural dull wax finish."[65] To date, the table, once documented so fastidiously in archival correspondence, has not been located. During the WPA era, Tejada was temporarily transferred to the Melrose Art Center where he also taught woodworking and

furniture classes and created furniture for the art gallery.[66]

Recently, the family of Domingo Tejada brought to my attention a number of oil-on-canvas paintings by this talented furniture artist. The works, circa 1938, are nicely composed renderings of mountain ranges and landscapes in northern New Mexico and Colorado. This new knowledge of Tejada as another WPA artist who worked with more than one medium contributes another piece of evidence to support the idea put forth that these artists have been "Sin Nombre" for too long.[67]

It is lamentable, though not surprising, that the work of these Hispano artists and their countless and virtually unidentified students has gone unrecognized for so long. As varied and widespread as their art was, the research presented here only scratches the surface. Hopefully, future studies will recover the works and New Deal–era experiences of additional artists, including Arturo Martínez y Salazar of Taos (1911–1986), Eloy Chávez of La Ciénega, the Chupadero masters, and, of course, las artistas de Taos.

Through their participation and creative contributions, Elidio Gonzales, Abad Lucero, George Segura and Domingo Tejada embodied the essence of the WPA art programs' mission: art for everyman (or, as was the case of the Roswell ladies' lounge, art for everywoman!). Their masterful works evoke Southwestern artistic traditions and ambiance in federal and state buildings, educational institutions, hotels and private homes. Although they served (and in many cases still serve) a utilitarian function, they need to be considered first and foremost, works of art; significant contributions to the New Deal artistic legacy.

Notes

1. Holger Cahill to Donald Bear, 4 February 1936, FAP Office of the National Director, Correspondence with State and Regional Offices, 1935–1940, Record Group (hereafter RG) 69, National Archives, Washington, D.C. (hereafter NA).

2. As a supplement to other field research for this work, I frequented antique stores and flea markets in Albuquerque, Santa Fe, and Taos between fall 1994 and spring 1998. In print advertisements, many dealers and proprietors listed "WPA Furniture" among the types of objects they sold. Pine furniture during the 1930s through the 1950s and carved in a New Mexican style is often labeled as "WPA furniture," even if it was made after 1943 or created in the vocational schools. The application of the umbrella term has been attributed, in part, to the complexities involved in researching this time period, and also to the widespread use of the designs from the "Blue Books" across New Mexico.

3. Carmella Padilla and Donna Pierce, "Fine Spanish Colonial Furniture: Then and Now," *Spanish Market: The Magazine of the Spanish Colonial Arts Society, Inc.* (July 1994), 10–13.

4. Regarding art history, furniture is usually referred to as a component of "decorative arts." However, decorative arts usually means the applied arts (ceramics, glass, metalwork, textiles, and furniture) situated within a domestic setting. Examples of New Mexican furniture were made for public buildings and funded by the various arts-related programs of the WPA. The furniture made by Hispana and Hispano artists during the New Deal era must be re-examined as a fine art form because it followed in the metaphorical footsteps of the Arts and Crafts and Bauhaus movements, both of which addressed design reform. The Arts and Crafts movement focused on re-creating vernacular design that had been overshadowed by industrialization while the central aim of the Bauhaus was to unite all arts and erase differences between artist and craftsperson. Works from both of these movements are often looked upon as "high" art.

5. Donald Bear to Holger Cahill, 28 January 1936, FAP Office of the National Director, Correspondence with State and Regional Offices 1935–1940, RG 69, NA.

6. "Points of Interest in the Department of the Interior Building" (n.d.), WPA Section of Fine Arts of the Public Buildings Administration of the Federal Works Agency, Miscellaneous Vertical Files, National Museum of American Art/National Portrait Gallery Library, 1.

7. "What Work Means to those Who Might Have Been Condemned to a Dole—W.P.A. and American Craftsmenship [*sic*]," extension of remarks of Representative H. Jerry Voorhis (Calif.), House of Representatives, 14 February 1938, Congressional Record, 75th Cong., 3rd Sess.

8. "Description, Items of Cost and Number of Workers on Seven Projects For New Mexico," attached to letter from Donald Bear to Holger Cahill, 10 February 1936, New Mexico Correspondence with State and Regional Offices, 1935–1940, RG 69, NA, 2.

9. *Spanish Colonial Furniture Bulletin* (Santa Fe: New Mexico Department of Vocational Education, 1935), 1.

10. Ibid.

11. Ibid., 3.

12. Ibid.

13. During my research, I was shown the well-used and highly coveted copy Abad Lucero used. The "Blue Book" owned by George Segura was copied with the permission of Segura's widow, Rose, in October 1994 by Richard E. Ahlborn for the Collections of the National Museum of American History, Smithsonian Institution, Washington, D.C.

14. Irving Rusinow photographs, RG 83-G, Records of the Bureau of Agricultural Economics, Prints: Agricultural Economic Activities, 1911–1947, National Archives Still Pictures Branch, College Park, Maryland (hereafter NASPB).

15. Marta Weigle, ed., *Hispanic Villages of Northern New Mexico: A Reprint of Volume II of the 1935 Tewa Basin Study with Supplementary Materials* (Santa Fe: The Lightning Tree Press, 1975), 71.

16. *Spanish Colonial Furniture Bulletin,* 1.

17. "Description, Items of Cost and Number of Workers on Seven Projects For New Mexico," I have intentionally chosen to include lists of objects within the text of this work rather than footnote them. Due to the fact that information on Hispana/o WPA artists and their works is so difficult to track down, I believe these lists are important primary research tools, much like colonial church inventories and wills, and that they will provide clues for future research and scholarship.

Artist Abad Lucero remembers working on the library furniture project and creating one of the large library tables. Interview with author, 15 August 1997, Albuquerque, N.Mex.

18. "New Work for Idle Hands," Works Progress Administration Information Service Files, RG 69, NA, 6.

19. Weigle, ed., *Hispanic Villages of Northern New Mexico,* 65.

20. Lea Rowland to Ellen S. Woodward, 2 July 1936, WPA Central Files, RG 69, NA.

21. "Willow and Rawhide Furniture," report in WPA Central Files, 1935–44, RG 69, NA.

22. "Many Races Contribute to WPA Handicraft Project," Division of Information Service, RG 69, NA, 4.

23. Radio Script No. 1 for Mary Margaret McBride (by Frazier [?]) titled "Vocational Handicrafts," Information Service, RG 69, NA, 5.

24. Text on exhibition photos, negatives 12638 and 12617, RG 69, NASPB.

25. "Spanish Colonial Furniture," summary attached to letter from Lea Rowland to Ellen Woodward, 2 July 1936, WPA Cultural Files, box 1934, RG 69, NA.

26. A number of visitors to the *Sin Nombre* exhibition at the Museum of International Folk Art (MOIFA) in Santa Fe identified Eloy Chávez from a previously unidentified photograph, neg. no. RG69N12118–C, found in the NASPB.

27. Text on back of photograph of doors, old neg. no. PX 53–227 321, from WPA file, CCC New Mexico, Franklin Delano Roosevelt Library and Museum, Hyde Park, New York.

28. Civilian Conservation Corps, *Official Annual 1936: Albuquerque District 8th Corps Area* (Baton Rouge, La.: Direct Advertising Company, 1936), 25.

29. Ibid., 59.

30. Ibid., 60.

31. Interview with Abad Eloy Lucero, 15 August 1997, Albuquerque, N.Mex.

32. William Wroth, ed., *Hispanic Crafts of the Southwest* (Colorado Springs: The Taylor Museum of the Colorado Springs Fine Arts Center, 1977), 101.

33. A number of the WPA/FAP and NYA instructors were often reassigned or on temporary assignment between art centers and vocational schools. Abad Lucero and Domingo Tejada, two of the other prominent furniture and wood artists, are examples.

34. Interview with Eliseo and Paula Rodríguez, 11 December 1996, Santa Fe, N.Mex.

35. Russell Vernon Hunter to Domingo Tejada, 3 November 1937, Roswell Museum Art Center Institutional Archives, Roswell, New Mexico. (hereafter Roswell MACIA). William Wroth also mentions that Gonzales worked for the WPA/FAP "in Roswell and Santa Fe, making furniture for the Gallup Courthouse." *Hispanic Crafts of the Southwest,* 101.

36. Wroth, *Hispanic Crafts of the Southwest,* 101.

37. *Sun and Adobe: Photographs by Jean Rodgers Oliver* (Old Albuquerque, N.Mex.: Revilo Press, 1955).

38. Hispanic Heritage Wing, Project Records, MOIFA.

39. William Wroth, "The Hispanic Craft Revival in New Mexico," in Janet Kardon, ed., *Revivals! Diverse Traditions, 1920–1945: The History of Twentieth-Century American Craft* (New York: Harry N. Abrams, Inc., and the American Craft Museum, 1994), 83–93, 274n1.

40. Interview with Abad Eloy Lucero, 15 August 1997.

41. Ibid.

42. Ibid.

43. Ibid. Emma Lucero remembers getting paid $39 for two weeks at a time working for the NYA.

44. Ibid.

45. "Vocational School Makes Fine Furniture," unidentified newspaper article dated 21 October 1950. Collection of Marcella Falvey. Santa Fe, N.Mex.

46. I am deeply indebted to Richard Ahlborn, curator in the Division of Cultural History, National Museum of American History, Smithsonian Institution, Washington, D.C., for generously sharing his research on George Segura with me.

47. Valda Cooper, "Three R's at El Rito," *New Mexico Magazine* (September 1945), 16–17, 33–37.

48. Text on the back of photograph of the bench, box 20, WPA Photographs RUS-SEV, Archives of American Art, Smithsonian Institution, Washington, D.C. (hereafter AAASI).

49. Russell Vernon Hunter to Holger Cahill, 3 March 1936, Correspondence with State and Regional Offices, RG 69, NA.

50. Rose Trujillo Segura, interview notes by Richard E. Ahlborn, 21 October 1994, Division of Cultural History, Spanish-American Division Files, National Museum of American History (hereafter SADF).

51. Leo Trujillo to Richard Ahlborn, 28 March 1991, Division of Cultural History, SADF.

52. Rose Trujillo Segura, interview notes by Richard E. Alhborn, 21 October 1994, SADF.

53. Many thanks to the Tejada family who provided the birth and death dates for Domingo Gusmán Tejada.

54. Interview with Abad Eloy Lucero, 15 August 1997.

55. Sylvia Loomis interview with Roland Dickey, 16 January 1964, AAASI, p. 12 of transcript.

56. Robert B. Sprague to Russell Vernon Hunter, 24 February 1938, Roswell MACIA.

57. Robert B. Sprague to Russell Vernon Hunter, 4 April 1938, Roswell MACIA.

58. Untitled newspaper article, *Roswell Daily Record,* 7 June 1939, Roswell MACIA.

59. Loomis interview with Roland Dickey, 16 January 1964, AAASI, p. 19 of transcript.

60. "Specifications of the Interior Furnishings of the Roswell Museum," 10 May 1938, Roswell MACIA, 1.

61. Roland F. Dickey, *New Mexico Village Arts* (Albuquerque: University of New Mexico Press, 1970), 70.

62. "The Roswell Museum," *El Palacio* vol. XLIV, nos. 7–9 (16–23 February through 2 March 1938), 59. One of the original La Fonda benches is still in use at the Palace of the Governors in Santa Fe.

63. Robert B. Sprague to Russell Vernon Hunter, 10 March 1938, Roswell MACIA.

64. According to Tejada family members, José Moíses Tejada (1919–ca. 1991) worked for the CCC and taught furniture-making in the Clovis, New Mexico area, which is close to Roswell. Interview with Jo Ann Tejada Lerma, Pluma Louise Gonzales, and Loren Tejada, 1 August 2000, Santa Fe, N.Mex.

65. Lucy Lepper Shaw (director, NYA Educational Camp for Girls, Capitán, N.Mex.) to Robert B. Sprague (Roswell Museum), 21 February and 14 April 1938, Roswell MACIA.

66. Joy Yeck Finke to Thomas C. Parker (assistant national FAP director), 19 July 1938, WPA Central Files, 1935–1944, RG 69, NA.

67. My eternal thanks to Loren and Vikki Tejada for sharing their family history and paintings with me.

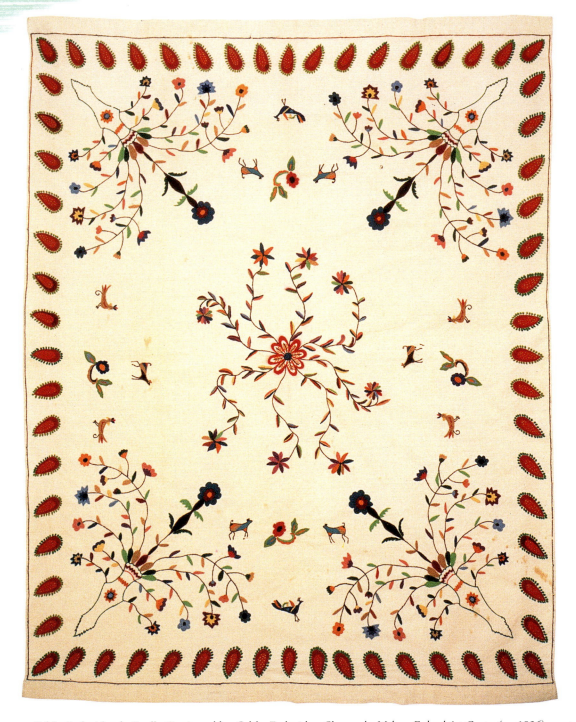

Colcha Embroidery by Estella García and her Colcha Embroidery Class at the Melrose Federal Art Center (ca. 1936),
cotton and yarn, Federal Art Project, Melrose, New Mexico. Gift of Mr. and Mrs. Robert H. Martin, Museum of
International Folk Art, a unit of the Museum of New Mexico, Santa Fe. (A.1986.467.1) Photo by Blair Clark.

CHAPTER FOUR

Fabric Arts Weaving an Artistic Legacy

FABRIC ARTS WERE ALIVE AND WELL during the New Deal era and the WPA. Home-spun fever swept the United States and was an important contributor to the post-industrialization "revival" movements at this time. As a result of this widespread interest, art forms such as drawn work, embroidery, lace-making, and weaving flourished during the depression, adding richness of texture to difficult times. Fabric arts were so integral to American identity nationwide that references to them were often used as a metaphor by which to pull the United States together during those difficult times. President Franklin Delano Roosevelt illustrated this in one of his speeches:

> We of the United States are amazingly rich in the elements from which we weave a culture. We have the best of man's past on which to draw, brought to us by our native folk and folk of all parts of the world. In binding these elements into a national fabric of beauty and strength, let us keep the original fibres [*sic*] so intact that the fineness of each will show in the completed handiwork.[1]

The various WPA arts projects picked up on Roosevelt's metaphors, and strongly emphasized fabric arts in its programs. Nowhere was this more apparent than in New Mexico and southern Colorado, where art forms such as weaving and colcha embroidery already had a long history that evoked a sense of place and identity.

As part of the national examination of "domestic handicraft" and its accompanying marketing possibilities, Alberta G. Redenbaugh, a consultant hired by the WPA, conducted a "craft survey" in which she listed a

number of WPA programs, items each produced, and future potential for marketing the items. In Region Eight, which included Colorado and New Mexico, she listed the weaving project that produced hangings and rugs in Trinidad, Colorado as having seven looms. This program engaged in spinning, weaving, and dyeing of native wool with local plants. The San Luis, Colorado project also had seven looms and produced rugs out of hand-spun and naturally dyed wool. Based in the courthouse, the Pueblo, Colorado project had ten looms and used both commercial and native dyes to create rugs and hangings. It also produced luncheon sets (tablecloths and napkins) and tennis nets. The Colorado Springs project, located in the high school building, had eight looms and produced rugs from commercial yarns. In Taos, New Mexico, the University Center (Harwood) focused on weaving and embroidery, and created rugs and draperies using native wool.[2]

In terms of marketing possibilities, Redenbaugh felt that the Colorado projects were very promising. She commented that:

> The most outstanding craft offered by Colorado is wool weaving. The units at Trinidad and San Luis are dyeing native wool, using for the most part native dyes, and spinning and weaving rugs, which because of the quality of the work and the beauty of the color and design, are outstanding. They are commercially saleable, although the prices will probably be high.[3]

In contrast, at the time of her survey, Redenbaugh felt that New Mexico had no "real handicraft project," but had "lots of indigenous handicrafts," and mentioned that in Taos, "in addition to homespun and wool rugs, hangings embroidered with colcha embroidery are finding some sale."[4]

Fortunately, Redenbaugh was partially wrong in her account of the success of the New Mexico fabric arts. Weaving became a profitable industry for the state during the depression. Tourism fueled interest in handmade goods and art with a "Spanish" or Mexican flavor and, as a result, a number of weaving businesses started up in the Santa Fe area during the 1930s. One such retail and production outfit was Burro Weavers. The business concentrated on hand-woven neckties for men but also produced scarves, handbags, and cloth. One article described the activities of the shop:

> And today, the Burro Weavers carry on the old tradition. Native Spanish-American descendants of the early master weavers now ply their looms in the workshop at 228 Don Gaspar and assure the future of this ancient craft which reaches back through the centuries in New Mexico.[5]

At Burro Weavers, one could visit the "Loom Room" and "see native weavers turn natural colors into textile art."[6]

The hand-woven tie market, spurred on by Burro Weavers and many other companies that included Tewa Weavers and Rio Grande Weavers, became so important to New Mexico's economy during this period that by 1945 it was referred to as an "industry" in the research study, *New Mexico's Future: An Economic and Employment Appraisal,* compiled by the Committee for Economic Development. At the time, nearly 22 percent of those engaged in manufacturing in New Mexico were employed in textiles. The report elaborated on the industry and the artistry:

> But, in Santa Fe, the fabrics are hand-loomed; the looms powered by sturdy limbs. Then the goods are fashioned and cut and sewed into wearing apparel and accessories of various kinds. Properly illustrated in colors that show the artisan's skill and artistry, this apparel finds ready acceptance and sale in the markets in the United States.[7]

There were many other weaving shops in New Mexico,

most of which were located in and around Santa Fe. All employed Hispana and Hispano weavers who created saleable products out of a traditional art. The Southwestern Master Craftsmen store, located on Palace Avenue across from the art museum in Santa Fe, advertised fine wool and mohair rugs as "hand woven with real vegetable dye as they were made hundreds of years ago."[8] A 1938 advertisement for Preston McCrossen's Santa Fe tie business reads: "New Ties From Old Looms" and states that "with the beautiful colors of the New Mexico scene as inspiration, the plant is producing hand-woven fabrics surpassing any ever developed."[9]

> One advertisement for Webb Young, Trader, read: Years ago New Mexican natives erected crude looms, twirled their yarn from long-haired sheep, and produced a material that today recaptures its charm in modern apparel. Thus developed the Handwoven, Hand-tailored Tie. Its striking pattern and perfection of workmanship brought instant success. Today I offer you the Southwest's greatest gift—a man's gift—distinctly individual—the Handwoven Tie![10]

This last advertising quote provides some idea as to how Hispana and Hispano fabric artists were perceived and the evolving role their traditional cultural arts played. One result is the absence, especially of women, in WPA-era documentation. More problematic is the fact that the owner of Webb Young, Trader was James Young, a future member of Nelson Rockefeller's staff in the Office of the Coordinator of Inter-American Affairs.[11] Through this government office, Young would work on cultural programs to enhance neighborly relations with the Spanish-speaking countries south of the border. At the same time, he continued to develop his Santa Fe tie business and could only refer to the ties created by Hispana and Hispano weavers as "Hand woven by the mountain people of New Mexico."[12] Despite the demeaning nature of such advertisements, department stores in the eastern United States were purchasing and selling the ties as fast as they could be made, leading indirectly to an appreciation for the hand-woven qualities of this art form.

An article done by the Federal Writers' Project for the New Mexican edition of the American Guide Series stated that because of the popularity of the hand-woven items, the demand far exceeded the supply:

> Weaving again has become a highly perfected art; at no time have the standards of workmanship been lowered to meet the demand and the craftsmen in the villages of New Mexico are again producing their woven materials of handspun, vegetable dyed yarn which is equal to the best of the former period.[13]

With the proliferation of Hispano and Hispana weavers producing ties and other works for tourism and eastern department stores, it may be postulated that there were a large number of weavers, both men and women, trained by tie companies and vocational schools. But as has been pointed out, these talented artists were hired as "laborers" and received little recognition for their skill and talent.

Native Market

The Native Market and El Parián Analco employed a number of artists to weave and embroider items for sale in these stores. In addition, artists demonstrated their skills inside the stores for the benefit of curio shoppers. A number of historical photographs show Native Market weaving booths draped with handspun skeins of wool.

Through Native Market records and the research efforts of Sarah Nestor in her book, *The Native Market of the Spanish New Mexican Craftsmen in Santa Fe, 1933–1940* published in 1978 by the Colonial New

Tillie Gabaldón (Stark, 1919–1979), Colcha Embroidered Pillows (note signature on lower right pillow, 1930–1969), cotton, wool, natural and commercial dyes, Santa Fe, New Mexico. Spanish Colonial Arts Society, Inc. Collection on loan to the Museum of New Mexico, Museum of International Folk Art, Santa Fe. Photo by Blair Clark.

Tillie Gabaldón (Stark), early 1970s, Santa Fe, New Mexico. Photo courtesy of Cecil F. Stark Jr.

Mexico Historical Foundation, the names of many of the Native Market artists have been uncovered. Deolinda Baca created colcha embroideries and did some weaving. Margaret Baca was a weaver. Tillie Gabaldón (later Gabaldón Stark) learned dyeing and spinning of natural wool in the Santa Fe store. She also did colcha embroidery and was an active participant in the resurgence of interest in this art form. Gabaldón Stark often signed her first name to her pieces and added an embroidered morning glory as her trademark. Doña María Martínez and her daughter Atocha Martínez carded and spun wool for yarn. Dolores Perrault (later Montoya) from the State Department of Vocational Education not only acted as artistic and purchasing consultant to the Native Market, she also carded and spun wool for the store. Two Hispanos, Valentín Rivera and David Salazar (cousin of Abad Lucero), also wove for the Native Market store. Other Native Market artists spun their

wool and created their works to sell in their homes. A number of the Native Market fabric artists, including Max Ortiz, went on to collaborate with and teach in the vocational school system and in various WPA-supported programs.

Vocational Schools

The interrelationship between the Native Market store and the vocational school system strengthened the impact of fabric arts throughout the state during the 1930s and 1940s, which, as strong as it was, remains missing from existing documentation. A large number of the state's vocational schools, including those in Chupadero, Puerto de Luna, San José, and Taos offered spinning, dyeing, weaving, and colcha embroidery classes. The 1935 *Tewa Basin Report* mentioned weavers in a number of towns. Unfortunately, despite the enormous number of artists mastering these skills in vocational classes, few have been identified.

Crisóstoma "Chris" Luna (ca. 1950s). Photo courtesy of Marcella Falvey, Santa Fe, New Mexico.

Crisóstoma Luna (1902–1997), Jerga Shawl (ca. 1930s), wool, Vocational School, Taos, New Mexico. International Folk Art Foundation Collection, Museum of International Folk Art, a unit of the Museum of New Mexico, Santa Fe (FA.1998.34.3). Photo by Blair Clark.

Crisóstoma "Chris" Luna (1902–1997)

Chris Luna wove traditional hand-dyed Rio Grande–style blankets in geometric designs based directly on designs from the "Blue Books" produced and distributed by the New Mexico State Department of Vocational Education. She also wove *jergas,* a type of utilitarian floor covering also used for cushions and blankets. Her daughter Marcella remembers that her mother later stopped weaving and transformed her fabric skills into crocheted and drawn work pieces. Luna perfected her art under the direction of Dolores Perrault Montoya at the Taos Vocational School. Although her work has been collected by museums, only a few examples have been identified. Two Rio Grande–style pieces are in the collection of the Taylor Museum of the Colorado Springs Fine Arts Center. A jerga shawl, exhibited at the American Craft Museum in New York City from 1994 to 1995 is now in the collections of the Museum of International Folk Art in Santa Fe. Luna was married to Máximo L. Luna, the Taos Vocational School furniture artist and teacher. Her sister, Margaret Herrera (Chávez), was a painter.

Dolores Perrault Montoya (dates unknown)

Dolores Perrault Montoya, a fabric artist and weaver, is largely responsible for the teaching and perpetuation of these fabric art forms during the New Deal era. In addition to her art direction and purchasing position at the Native Market store, she authored the "Vegetable Dyes Bulletin," first issued in January 1934, while teaching both spinning and weaving in Taos. The bulletin contained valuable information on the sources for dyes and the techniques used in coloring natural wool. The bulletin's forward included the opinions of the State Department of Vocational Education about the future of weaving and the fabric arts:

> The only hope the hand craftsman has in competing with the machine is to produce

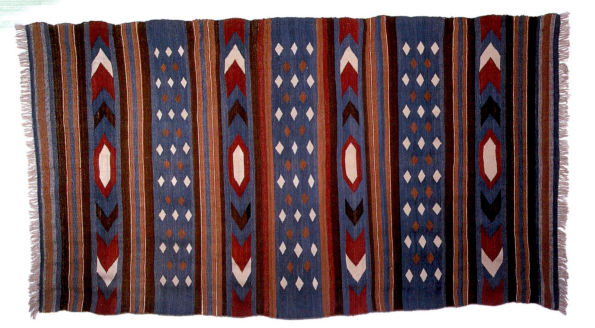

*Crisóstoma Luna (1902–1997), Rio Grande Weaving (ca. 1939), handspun wool and
vegetable dyes, probably Taos Vocational School, Taos, New Mexico. Collection
of the Taylor Museum of the Colorado Springs Fine Arts Center.*

an all hand-made article which will be superior in quality and, above all, he must make use of the advantage he has in being able to produce articles of individuality.[14]

The "Vegetable Dyes Bulletin" was used all around the state in the vocational schools, Native Market, and retail stores, as well as in various arts-related programs of the WPA.

WPA Weaving Projects

As Alberta Redenbaugh's survey noted, the WPA had active weaving projects in New Mexico and southern Colorado. Although the art in both states was the same in technique and design, the San Luis Valley in Colorado received more recognition in print for the quality of art produced by Hispana and Hispano weavers on the project. Comments such as

"Spanish-American workers at San Luis, Colorado, are carding, dyeing and spinning raw wool into rugs of exquisite Spanish-Colonial design," were common.[15] When the weaving project was mentioned in reports, articles, press releases, and other WPA documentation, careful attention to traditional techniques was always the focus:

> In Colorado, a neighboring state, along with the weaving of rugs, are being developed several other skills, those of dying and designing. The state report tells of washing the raw wool, drying it, carding it, right on the project, spinning it into hanks and weaving it into rugs, four by six feet. These rugs are highly colored with native dyes, many of which are natural dyes, made from insects and roots, which are collected from the countryside. This process, too, is done on the project. Original designs

and color harmonies are obtained by following old Spanish Motifs. This was part of the work carried out under special supervision.[16]

Oftentimes, the accounts provided by the WPA information service were even more detailed about the project—but never about the artists:

In Colorado, surplus wool is being transformed on the WPA handicraft projects into woolen blankets. Since all of the work is done on the project it may be interesting to review the process.

The first step in working the wool, after it has been sheared, is the cleaning. Since wool varies as to its grease content it is necessary to spread it out in the sun from ten to twenty days in order to allow the grease to evaporate. Then a thorough beating with slender willow poles, cut from a nearby thicket, fluffs it and shakes out most of the dirt. A further step in making the wool ready to be carded, is pulling it apart by hand.

In the carding process, simple hand cards are used. Carding parallels the fibers of the wool so that it lends itself readily to being spun. The spinning is usually done with a malacate, a small stick about a foot high, with a wooden disk three inches from the bottom. For heavy yarn a simple spinning wheel is used.

After being spun the yarn is made into skeins and washed thoroughly in order to clean it of all grease before dyeing. Dyeing with vegetable dyes requires a mordant and alum is the usual one. Among the herbs and flowers used are hierba de la piedra, chamise, dahlias, cedar, apple bark, red onion skins, and wild cherry roots as well as many others.

Of the eight looms in operation on the Colorado projects, six are Spanish Colonial and two are Navajo.[17]

The explicit detail describing the techniques recovers "lost" knowledge and provides important information about both the Spanish-inspired weaving process from beginning to end, and sources for the natural dyes. Even the Spanish words for weaving implements were documented. Such attention to detail overshadows the identities of the artists, who were seen as laborers engaging in crafts, which consequently makes the recovery of the fabric artists even more difficult.

In her 1979 article, "Spanish-Americans, their Servants and Sheep: A Culture History of Weaving in Southern Colorado," Marianne L. Stoller mentions that some "forty people" worked on the San Luis weaving project started by G. Madden Jones in 1935, that was later supervised by Gladys Robinson between 1938 and 1940. According to Stoller, "Mrs. J. J. Lovato of Viejo San Acacio acted as consultant," because she was the only older artist still weaving in the area.[18] Stoller identified three more women (Faustina Bernal of San Luis, Mrs. Esquibel of Chama, Katarina Vigil of San Luis), and two men (Alberto Casías and Ben Vialpando) as participants in the WPA weaving project in San Luis during the late 1930s.[19]

Although this work focuses on Hispana and Hispano artists of the New Mexico WPA, I have included details about artists on the San Luis project, because the Colorado town is not far from the New Mexico border. It is plausible, as often was the case with the WPA art programs, that some artists may have gone south to nearby Costilla, New Mexico, to help initiate and work on the WPA weaving project there. Also because of geographical proximity, the names of the two projects may have been confused by federal employees back east who were unfamiliar with Spanish names. To add to the confusion, the town of

"Shop of a Spanish American WPA Weaving Project" (1939), Costilla, New Mexico. Photo by Russell Lee for the Farm Security Administration, courtesy of the Library of Congress, neg. no. LC-USF-34-34287-D.

San Luis is located in Costilla County, Colorado. One account mentions the Costilla County project:

> The inspiration for the design of the rugs, blankets and draperies which are woven on the WPA project in Costilla County, Colorado for the new courthouse which is being built there now, is being furnished by some antique Spanish pieces in the Denver Art Museum. These museum pieces are fine examples of Spanish colonial style with antedated Indian and Mexican Navajo [sic] designs. The same designs are drawn to scale for the present day rugs. The same colors are also obtained.[20]

Costilla, New Mexico

The WPA weaving project in Costilla receives little mention in extant WPA documentation. However, thanks to Russell Lee, one of the talented members of the Farm Security Administration (FSA) photography corps, the artists and the works of the Costilla weaving project have been at least visually recorded.

In September 1939, Lee photographed the small, single-door adobe building that housed the project. The sign in the window of the small workspace reads, "WPA Craft and Weaving shop." Lee also took many images of the interior of the shop and three images of the artists and their WPA supervisor. Although black-and-white film in many ways does not do the art justice, the intricate patterns and high quality of weaving do emerge from the photographs. Woven vests, belts, rugs of various sizes in the Río Grande blanket style, as well as jergas, can be seen in Lee's photos. Project artists also made rag rugs.

Lee's series of images also documents natural dyes such as indigo, nitric acid, powdered alum, bark, burdock root, cochineal, and walnut husks that were used on the wool.[21] The dye sources depicted in the photographs are similar to those mentioned in the detailed account of the San Luis project. The non-industrialized processes of carding, spinning, and skein-making is also documented. The photos indicate the presence of two large Spanish treadle looms. A little over three years later, another FSA photographer, John Collier, would also take a picture of the Costilla Plaza. This series of photos has been previously reproduced in a number of publications. Despite the careful attention to detail regarding the process of weaving at the Costilla project, Lee never identified the Hispana artists featured in his images. In July 1999, with the help of Santera Arlene Cisneros Sena, her mother Elsie Martínez Cisneros, and two *tías* (aunts) from Costilla, Celsa Quintana and Otilia Martínez, the Costilla weavers were finally provided names and long-overdue recognition. Many thanks to the four detectives who identified the artists as Mary Sedillo (project supervisor), Beatríz Váldez, Belesandra de Herrera and Ramoncita Quintana.

The WPA weaving projects were not limited to the northern portion of New Mexico or southern Colorado. Weaving was taught to both children and

adults throughout New Mexico's WPA art programs. In Melrose and Roswell, children were taught on small hand-held looms. Adults and advanced students worked on large Spanish looms—at least one of which was built by Domingo Tejada, the furniture artist from Roswell.

The majority of the students who learned to weave through the New Mexico WPA arts-related programs were women. Ironically, in colonial and territorial New Mexico, men are credited with doing most of the weaving.[22] All of the fabric arts, including colcha and drawn work, were seen by WPA administrators merely as "women's work" for home use. They were often considered an extension of the WPA sewing-room projects and other "domestic science"-related activities:[23]

> In New Mexico, a state where household employment was formerly the only type of work open to women, they are now being taught on the handicraft projects, learning hand spinning of yarn and the weaving of that yarn into yarn goods, bed spreads and many useful articles for the home.[24]

Max Ortiz (dates unknown)

Max Ortiz, a native of Peña Blanca, taught weaving at the Melrose Federal Art Center. He was probably related to the Ortiz family, whose members were well-known in the early part of the twentieth century for their weaving skills. An undated newspaper article that was written sometime after the Melrose Gallery opening on June 22, 1938, states that Max Ortiz had been in the weaving business for four years, and that he "is from a Native Market in Santa Fe and goes from one project to another."[25] Prior to his employment on the FAP, Ortiz wove textiles for both Native Market and El Parián Analco. In the children's classes at

"WPA Weaving Project Supervisor (identified as Mary Sedillo) Displaying Some of the Articles Made" (1939), Costilla, New Mexico. Photo by Russell Lee for the Farm Security Administration, courtesy of the Library of Congress, neg. no. LC-USF-34231-D.

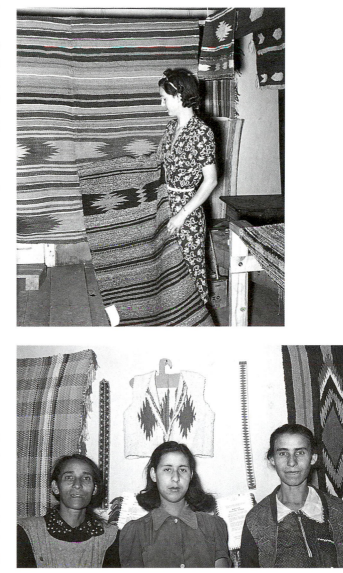

"Spanish American Women Members of the WPA Weaving Project" (1939), from left to right: Beatríz Váldez, Belesandra de Herrera, and Ramoncita Quintana, Costilla, New Mexico. Photo by Russell Lee for the Farm Security Administration, courtesy of the Library of Congress, neg. no. LC-USF-34-34232-D.

"Spanish American Woman (identified as Beatríz Váldez) Weaving Rag Rug at a WPA Weaving Project" (1939), Costilla, New Mexico. Photo by Russell Lee for the Farm Security Administration, courtesy of the Library of Congress, neg. no. LC-USF-34289-D.

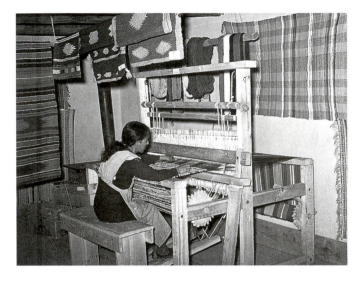

"Ingredients for Dyeing Wool used at a Works Progress Administration Weaving Project. They are Indigo, Nitric Acid, Powdered Alum, Bark, Burdock Root, Cochineal and Walnut Husks" (1939), Costilla, New Mexico. Photo by Russell Lee for the Farm Security Administration, courtesy of the Library of Congress, neg. no. LC-USF-34228-D.

Melrose, Ortiz taught the necessary artistic skills on the small looms that were made on site in the Art Center's wood shop. The inscription on the back of a photograph that depicts artists making the looms reads: "Textile design is an essential activity at a community art center. These boys in the wood-working class at Melrose, New Mexico, are making looms for use in their WPA art center."[26]

Weaving was not the only fabric art taught under the auspices of El Diablo a Pie. Colcha embroidery and drawn work were also taught through WPA art projects in New Mexico. The various forms were often taught on the same projects and became interwoven in the documentation. A major proponent of applying artistic skills to more than one textile art form was the NYA. The reasoning behind such a fabric art focus was that the NYA had a large number of female participants.

Camp Capitán

The NYA girls' camp in Capitán, New Mexico was extremely successful in teaching fabric arts to its enrollees. Girls who participated in the camp developed a catalog of art works with pieces that could be ordered. The catalog, which lies in the depths of Record Group 69 in the National Archives, is hand colored in pencil and carefully detailed. It should be considered a work of art in its own right. It contains actual hand-woven fabric swatches for items such as ties and belts. Woven dress and suit fabric in basket weave, diagonal weave, herringbone, and tweed available in any desired color could be ordered at $5 per yard. Scotch Plaid or Clan McBeth [*sic*] patterns were somewhat more expensive at $6 per yard. Woven *boleros* (vests) were also available in "any desired combination of color" for $3. Scarves and purses, including the "Chimayo" purse, ranged in price from 60 cents to $2 and were also available in "all wool and any color combination."

Baby blankets in "all wool Shetland" and luncheon sets in "Perle Crochet Cotton" could be ordered in the customer's choice of colors. Hand woven rag rugs, cotton rugs, and bath mats in "modernistic patterns" were also for sale in the Camp Capitán catalog.[27]

Other pages in the catalog detail the different colcha items available. Spanish embroidered blouses in white cotton broadcloth or muslin, made with round or square yokes and long or short sleeves and detailed with colcha embroidery, ranged in price from $7.50 to $15. Twenty-inch aprons, in white or colored cotton, with colcha design on either hem or top band, sold for $3. Belts and purses could be ordered in the customer's choice of colors at a cost of $10. Colcha-embellished handkerchiefs with hand rolled edges were priced at $.50. Bolero vest jackets combined colcha on linen or cotton and could be ordered in white or other colors for the sum of $5. Finally, luncheon sets that included a 36-inch by 54-inch tablecloth and four 16-inch napkins of linen or Osenberg material were priced at $7.50 and up. The colcha designs utilized at Camp Capitán included floral and vegetal motifs, birds and animals, and even images of "sleeping" Mexican figures and donkeys.[28]

Young women artists from the NYA programs also embroidered and wove many other examples of WPA fabric arts for state and federal buildings in New Mexico. The girls from the NYA program in Roswell were responsible for the artistry involved in the creation of the stage curtain for the Roswell Federal Art Center, which was described as:

> A curtain hand embroidered with the Maximillian double eagle designe [*sic*], as shown on the cover, adds to the effectiveness of the room. The embroidery was done by National Youth Administration workers, under art project supervision.[29]

The stage curtain was comprised of two panels, one 10' x 9' 6" and the other 10' x 10' of a "loosely woven whip-cord type of material, with muslin lining."[30] Both curtains were planned to cost $50 and to incorporate colcha stitch in the following design:

> both with running border along bottom edge composed in each case, of 4 Maximillian eagle designs, with narrow decorative crosses separating each design and all appliqued to the curtain. Curtains composed of loosely-woven whip-cord type of material, with muslin lining.[31]

A photograph of the NYA class working on this colcha curtain at the Roswell Federal Art Center appeared in the September 5, 1938 issue of *Time* magazine.[32] The image, selected to illustrate the Roswell Federal Art Center as a WPA success story failed to identify the artists. In May 1999, the class instructor was identified by Mary Ellen Sheehee of Santa Fe as Amelia B. Martínez (formerly Baca). Sheehee spotted the previously unidentified photo on the invitation to the *Sin Nombre* exhibition and recalled that Martínez and her own mother had been close friends and together had run the WPA cooking school in Santa Fe. Despite the persistent efforts of Teresa Ebie, former curator of paintings and registrar at the Roswell Museum and Art Center, the curtain, last seen in photographs from the 1950s, remains unaccounted for.[33]

The rug in the ladies' lounge of the Roswell Federal Art Center was also created by NYA artists. It was described in the grand opening program as coming from the "National Youth Administration looms at Los Lunas."[34] The work was originally envisioned as "one hand-loomed rug—55" by 80"; white warp with ¾" red stripes 3" apart; light pink woof."[35]

The attention to detail, and the variety of fabric arts objects made through NYA projects in New Mexico, supports the theory that there were many

more Hispana artists working in a variety of fabric arts mediums than current literature has led us to believe. Not only did these artists create works, as exemplified by the Camp Capitán catalog, but they marketed them as well. Perhaps future research on these Hispanas will uncover additional artistic and economic contributions to the New Deal legacy.

Colcha

As demonstrated by the Camp Capitán catalog, the art of colcha embroidery received great attention in the art programs of the WPA at both the state and national levels. New Mexico WPA officials sent a number of designs along with supplementary research material to the National IAD offices in Washington, D.C.:

> With this shipment I am sending a bulletin, "New Mexico Colonial Embroidery," published by the New Mexico Department of Vocational Education. The text will give data on the stitches, for the embroidery shown in our color renderings. Most of the designs in the bulletin are from the collection of one member of our State Advisory Art Committee. You will find an example of this embroidery among the articles sent to Washington, for the Phillips Memorial Exhibit.[36]

The *Index of American Design* included many colcha designs in its final edition as did the *Portfolio of Spanish Colonial Design.* As a result of the attention this art form received, examples of colcha work were exhibited in museums, department stores, and federal art centers across the country during the New Deal era.

Specific attention to this art form may have resulted because of its beauty and history. Colcha embroidery was somewhat elevated above perceived utilitarian applications of weaving. This separation of the art forms occurred in part because of the cultural status of colcha. The perception of embroidery as a measure

of gentility and Spanish nobility was written about by the New Mexico WPA Writers' Project:

> The Spanish women disdained spinning, considering it Indian work. That regard has prevailed to the recent revival of the arts, in communities clinging to a last vestige of aristocracy, and considerable persuasion on the part of the revivalists was necessary. Among the old women, expert spinners were known to disacknowledge their ability; but when younger women began to spin, the older ones, loathe to be outdone, often brought their skill from hiding. It is likely that this art of embroidery was practiced less professionally than weaving and was part of the education and activity of many women of the leisure class. The process is generally spoken of as *Colcha,* which means bedspread, as most of the pieces were for that use. There were some altar clothes however.[37]

The colcha stitch is thought to be originally from Spain. It retained much of its original artistic elements with strong Moorish, Asian, and indigenous aspects thrown in. It was often the art of the upper and middle classes and it was used for decorative pieces and religious articles such as altar cloths. During the WPA, it was re-fashioned into these same items, as well as into theater curtains and furniture upholstery.

True colcha embroidery was done with hand-dyed and hand-spun yarn. Although it is not stated in available documentation, it seems plausible that the various *colcheras* of the WPA art programs learned master dyeing and spinning techniques in addition to the artistry of the colcha stitch. The colcha stitch is long and thick; another small stitch secures it in the middle. A chain stitch is used for borders and other design elements such as flower stems. The patterns—typically floral motifs, birds, animals, and zigzag designs—

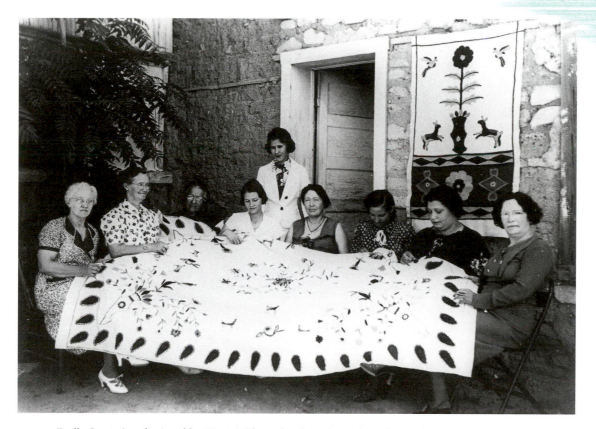

Estella García (standing) and her WPA Colcha Embroidery Class at the Melrose Federal Art Center (ca. 1936).
The fourth artist from the left has been identified as Rita Rodríguez Chávez. Melrose, New Mexico.
Museum of New Mexico Photo Archives, MNM no. 90204.

were usually drawn onto the cloth first and then filled in with the colcha stitch.

One unattributed WPA colcha piece in particular was often featured in photographs. It was square in shape and approximately the size of a card table and it featured two birds at the top with a small floral motif between them. Directly below the birds were three flowering plant images, and below these are four images of deer-like animals, four outlined leaves follow, and the bottom of the piece is stitched with a vine and vegetal pattern. The range of design elements suggests that this well-exhibited piece was a sampler. Among the numerous venues in which it appeared was the industrial exposition section of the WPA's *Little Forum Exhibit* at Bloomingdale's Department Store in New York City, during the 1939 New York World's Fair. The work was exhibited next to what appear to be smaller samplers of weavings or napkins and hand towels, and a tin sconce by Eddie Delgado. The same piece of colcha had been previously exhibited at the January 1938 WPA show at the National Museum.

Estella R. García (dates unknown)

Estella García is one of the few Hispanas mentioned in Federal Art Project documentation. Although few details of her life have emerged from the written record, her artistry, teaching, and supervisory skills at the

Melrose Federal Art Center were obviously worthy of mention, then and now.

García was hired on the Federal Art Project to teach colcha embroidery. Given the historical associations of embroidery with gentility and Spanish nobility, colcha benefited from a somewhat elevated status in the realm of New Mexican fiber arts. This was especially true for the work of García's Anglo and Hispana students in the WPA. Their colcha work was highly praised by WPA state and national officials and it was featured in numerous national New Deal art exhibitions that included such venues as Bloomingdale's Department Store in New York City.

The members of the Melrose colcha project were quite prolific. García's students designed and produced a number of embroidered masterpieces for the various WPA showcases around the state. Among these were large theater curtains for Melrose High School, Carrie Tingley Hospital (then in Truth or Consequences), and the Albuquerque Community Playhouse (now the Albuquerque Little Theater). The dynamics of the colcha project were described in the following words:

> It was kind of a cooperative project. Wherever there were groups of women who could do Colcha embroidery and were on relief, why they would do one of these designs. I think that maybe there were eight of these designs that were done in Colcha and then appliquéd on to the stage curtain.[38]

The curtain created for the Albuquerque Community Playhouse was "sixteen yards of the same repeat design." The stage curtains and accompanying wall hangings for the auditorium were done in "Spanish Colonial colcha method and design" and took fifteen "workers" to make them for a total cost of $825.[39] The finished hand-stitched art received widespread national attention and were featured in a number of WPA photos and museum exhibits. They were loaned to exhibition venues back east and only returned after a long series of letters from the director of the New Mexico Federal Art Project. Despite the attention given to these work in the 1930s and despite the efforts to have them returned to the state, the Albuquerque Playhouse curtain and its companion pieces remain missing.

García and her students also designed and created wall hangings and samplers to enhance New Deal–era government buildings in New Mexico. Examples of these can be seen in the backgrounds of the historical photographs taken of the project. Colcha-embroidered seat coverings for chaise lounges, settees, and chairs were also made for Melrose High School and the Albuquerque Community Playhouse in addition to other WPA projects around the state.

To date, only one of García's class members has been identified. Thanks to Ernestine Rodríguez, Rita Rodríguez Chávez (seen in one the photos wearing a white blouse) of Santa Fe was one of the members of the Melrose colcha class.[40] While many of the artists in García's class remain *sin nombre,* one of their collaborative works has been identified. With the aid of historical photos, a large and elaborately designed piece was discovered in the collections of the Museum of International Folk Art. The piece, donated in the 1980s, is the one featured in a group shot of the Melrose embroidery class taken soon after the center opened in June 1938. In the photo, the embroidery is unfinished. Red paisleys form a bright red and green border around the piece. In each of the four corners, a vase-like image holds sprays of flowers and leaves with a central blue flower pointing toward the middle of the material. What seem like traditional colcha designs and patterns is challenged in the center elements, where García's colcheras have unleashed their artistic palette and created eight stems with leaves and blooms in non-traditional color combinations. It seems plausible that

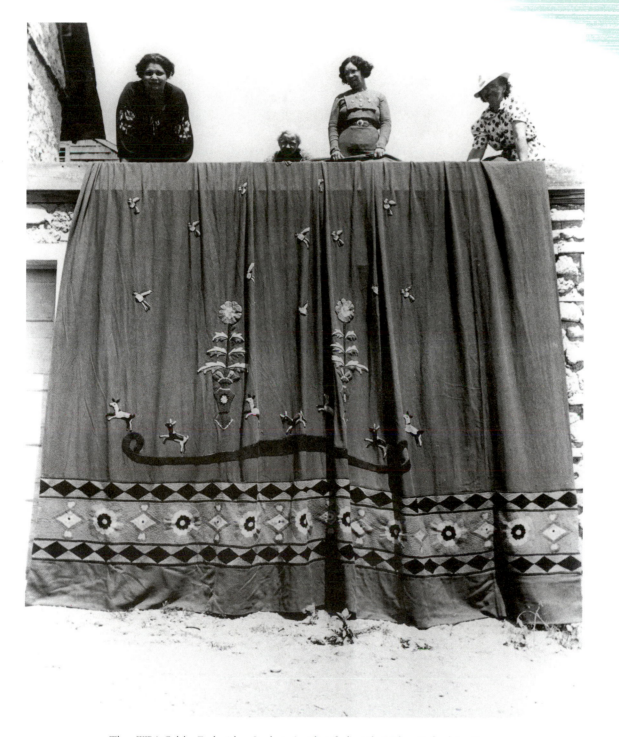

*Three WPA Colcha Embroidery Students (unidentified) at the Melrose Federal Art Center
with Carrie Tingley Curtain (ca. 1936), Federal Art Project, Melrose, New Mexico.
Photo courtesy of the Museum of New Mexico Photo Archives, MNM no. 9025.*

each of the eight students in the photo was allowed to create her individual signature branch.

The absence of Estella R. García, her students, and identified examples of their works from New Deal–era records attests to the perception that the work of women textile artists was considered at that time to be "craft" and thus not worthy of art historical consideration. Nonetheless, the work of these Melrose fiber artists traveled the nation and enhanced federal state buildings in New Mexico. In fact, their contributions to public art are indeed worthy of notice.

Numerous other examples of WPA colcha art exist that enhanced government buildings around the state during the New Deal. Other works that, through further research, may be attributed to García or her students, include the seat cushions and backs for the two straight-backed chairs made by Domingo Tejada for the Roswell Federal Art Center. The colcha work on the pair of chairs was lavish and ornate, filling the whole space with the distinctive stitch in shades of orange, tan, and yellow. The backs of the chairs sported a central rosette-shaped medallion with a lion in the center. Alternating bird and floral motifs surrounded the lion. Both chairs were sent to New York City for exhibition in the WPA art building at the 1939 to 1940 World's Fair. A number of letters document the difficulty the New Mexico FAP encountered in ensuring the chairs' return from fair officials.

Embroidered seat covers for the chairs in the Roswell Art Center's ladies' lounge may also have been made in Melrose by García and her class. In addition, they may have been responsible for executing the colcha motifs designed in blue and gold by Russell Vernon Hunter for a set of office furniture created for Governor Clyde Tingley in the capital buildings in Santa Fe. These works await positive identification. A settee with the same colcha design was last seen in the legislature rooms around 1958.[41]

The Women's and Professional Division of the WPA in New Mexico also held classes in colcha. The work done on these projects followed designs found in the vocational system's "Blue Books" and the Division's own body of design research. The latter was described in the following excerpt from a project report:

One of the most interesting parts of the New Mexico project work at the present time is the arrangement whereby original textile designs based on Southwest tradition are being drawn to be turned over to the women's professional division for uses in sewing projects, making drapes, hooked rugs and other things of general usage.[42]

In April 1938, "three pieces of colcha embroidery" loaned by the Santa Fe offices of the Women's and Professional Division were mailed to Oklahoma City for an exhibit in Washington.[43]

Drawn Work

The third fabric art form taught through the WPA art programs in New Mexico was the now rarely mentioned "Mexican" drawn work.[44] This form required the artist to pull threads, in cotton or linen cloth, in order to create lace-like designs. Actual lace patterns were often the inspirational source. One writer described the history and terminology (including the Spanish words) of the art form:

In New Mexico, picturesque work is being done on the handicraft projects where the workers are making Spanish drawn work, which is called "Randa."

The name "Randa" means "Drawn Work." This handicraft was brought to Key West from Cuba by native cubans [sic] when they settled in Key West many years ago. Similar work is done in the Bahamas, but it is done mostly on thick paper. The work, however, shows up

most beautifully when done on Linen [*sic*], much as Warandol De Hilo, Holan De Hilo and Cutre de Hilo. This real Spanish material is to be preferred to irish [*sic*] linen because it is more closely woven. It is also advisable to use real linen thread.

The drawn work is done on a little cushion (*almohadilla*) about 20" long and 6" wide. The work is pinned on so that the threads will stay taut. The tighter the threads can be kept, the more beautiful the work will be. The most essential thing in making Spanish drawn work is counting the threads. It is most important in order to complete a perfect pattern.

Randa De Pie means that the work is done with all the threads pulled lengthwise. However, a variety of patterns can be worked on it by pulling from two to four threads each way and forming little blocks. Surcido means darned. This pattern can be made to form baskets, roses, butterflies, heads, etc. Galleticas, meaning crackers, is the pattern liked mostly by tourists; still it is one of the simplest to make.[45]

Few other WPA-era documents reference this art, but Genevieve Chapin, a writer for the FWP in New Mexico, did refer to this "needle work" tradition in Clayton, New Mexico:

> Working in still different fabric we find another artist in the person of Mrs. Fannie Potter who lives two doors east of First on the South side of Walnut Street in Clayton. Mrs. Potter, who is a native of Old Mexico, specializes in fine Spanish needlework and has worked at her chosen art since early childhood. She received most of her training from her mother, later perfecting her work during five years spent in the Convent school at Aguas Calientes in Old Mexico. Now, she, in turn, is passing on her skill to her young daughter Susie, who works with her and acts as her interpreter.
>
> The skillful fingers of these two Spanish women have many beautiful works of art to their credit—mostly Mexican drawn work, Italian cut work and embroidery. One can scarcely realize the infinite patience and exactitude that has directed these women in the setting of these beautiful stitches.
>
> Besides the pieces she has made for herself, Mrs. Potter has given private lessons for some fifteen years. During the past three years she has had a W.P.A. teaching project for needlework in Clayton. During this teaching work numerous films have been made of her work. She sells to many out of state points and has donated several valuable pieces to different churches.[46]

At this point, despite thorough research, the names of Fannie Potter and her daughter Susie are the only names of Hispana artists to appear in documentation. That they have been recorded at all may have to do with the perceived class distinction of the racial identification of the artists as "Spanish" and their art as "needlework." Another account also mentioned these two artists:

> Mrs. Fannie Potter of Clayton, is teaching a class of about twenty pupils the art of fine Spanish needlework, the class being a public works art project.
>
> Mrs. Potter is a descendant of Spanish nobility, a daughter of the federal army officer, general Jose [*sic*] Garcia Conde. She was educated at St. Vincents Academy at Aguas Calientes, Mexico, and it was at this convent that she perfected the art of needle work.
>
> The pupils of this needle work class are very enthusiastic workers, and Mrs. Potter has

the distinction of being always able to create a deep interest in her work so that her class varies little in enrollment.[47]

Additional names of Hispanas who created drawn work for the WPA remain unrecovered and attributed examples of this art form are rare. Nevertheless, drawn work received regional and national FAP and WPA recognition. Examples of "Mexican" drawn work and lace done in Arizona and New Mexico were exhibited at the National Museum (now the Smithsonian) in Washington, D.C. from January 10 through January 30, 1938.[48]

As hard as it has been to uncover information on Hispana and Hispano artists of the WPA in New Mexico, the most difficult aspect has been trying to uncover the names of Spanish-speaking artists who created the intricate woven and embellished art forms of colcha embroidery, drawn work, and weaving during the New Deal era.

Despite the lack of names, an intricately woven picture of Hispana and Hispano fabric artists, along with their works, emerges from the archival collections. As previously discussed, a number of visual clues exist through pictures taken during the New Deal by photographers such as Russell Lee and John Collier. The images of the WPA *tejadores/as* (weavers) and colcheras, who for the most part remain unnamed, do document their existence and participation in the federal art programs and the perpetuation of these women's arts.

One example of this visual archival recovery process is that of Evangelina López.[49] Russell Lee took a picture of her in Chamisal. He titled it "Spanish-American Woman doing needle work. Many of the homes in this section show the love of the Spanish-Americans for colorful decoration." The photo shows López using the colcha stitch to design an eagle, among other decorative elements. She is sitting in a rocking chair that includes an example of drawn work with cherubic figures and elaborately patterned borders draped over its back.[50]

Another Lee photograph of López shows her standing by a painted homemade adobe *alacena* (wall cupboard). The top leaf-shaped nichos are backed with colcha-embroidered floral and bird designs. The doorway to the left of the alacena shows the corner of a homemade lace curtain with tassels.

An additional series of photographs by John Collier in January 1943 feature another Hispana fabric artist, Maclovia López, demonstrating her spinning and sewing skills. She was married to the mayordomo of Las Trampas, Juan Antonio López.[51] In addition to spinning and sewing, she also wove. López, who died in 1967, could read and write English, and she also taught briefly at the Las Trampas school.[52] At this time it is not known whether she participated in the WPA or the vocational school system or whether her art was sold through retail outlets.

The fabric arts made by Hispana and Hispano artists in the WPA were the essence of a deeply rooted authentic American expression. Despite the active arts programs in New Mexico, the "Spanish Colonial" art forms of colcha embroidery, weaving, and lace-making arts were not accorded the same attention as the fabric arts created in "American Colonial designs" by artists on the east coast of the United States. Furthermore, as a direct result of their utilitarian "craft" status and the fact that that they were, for the most part, created by women, the finely woven, textured, and embellished work received little art historical consideration during the New Deal era. Today, most of the examples found in public and private collections are attributed to artists "unknown."

Notes

1. Alberta G. Redenbaugh; FDR cited in "Mrs. Redenbaugh's Craft Survey," WPA Central Files, 1935–1944, n.d. (possibly post–1938), Record Group (hereafter RG) 69, National Archives, Washington, D.C. (hereafter NA), 1–2.

2. Ibid., 8.

3. Ibid.

4. Ibid., 8–9. It is not clear what exactly Redenbaugh meant when she claimed that New Mexico had "no real handicraft project." At the time she conducted her survey, the WPA and vocational school programs were going strong. The programs and art produced in the New Mexico projects was similar (if not the same) to that of the southern Colorado projects. She may have been referring to marketing possibilities or perhaps that was the way she felt.

5. Russell Vernon Hunter Papers (loaned by Mrs. H. Gilbert Fincke), n.d. (circa 1939), microfilm roll 3028, Archives of Amercian Art, Smithsonian Institution, Washington, D.C. (hereafter AAASI).

6. Ibid.

7. E. L. Moulton, *New Mexico's Future: An Economic and Employment Appraisal* (Albuquerque: Committee for Economic Development, Bernalillo County, N.Mex., 1945), 101.

8. "Handbook of Old Santa Fé [*sic*]: Guide to Taos and the Indian Country of the Rio Grande" (Santa Fe: Edward Sullivan Advertising, 1938), inside front cover.

9. Ibid., back cover.

10. Ibid., 2.

11. James W. Young to Charles Hapgood, New York, 17 June 1941, Charles Hapgood Papers, AAASI. According to the letter, Young joined the OCIAA in the fall of 1940.

12. Label on the back of hand-woven tie made for Webb Young, Trader. Collection of the author.

13. *The WPA Guide to 1930s New Mexico,* reprint edition of *New Mexico: A Guide to the Colorful State* by the WPA Federal Writers' Project and published by Hastings House in 1940 (Tucson: University of Arizona Press, 1989), 165.

14. "Vegetable Dyes Bulletin" (Santa Fe: New Mexico Department of Vocational Education, 1935), 1.

15. Radio Script No.1 for Mary Margaret McBride (by Frazier [?]), titled "Vocational Handicrafts," Information Service, RG 69, NA, 4.

16. "The Revival of an Old Craft: For Linens and Domestics," WPA Division of Information Service Primary File 1936–1942, box 73, RG 69, NA, 2–3.

17. "Reviving American Handicrafts," n.d., WPA Information Service Primary File 1936–42, RG 69, NA, 4.

18. Marianne L. Stoller, "Spanish-Americans, their Servants and Sheep: A Culture History of Weaving in Southern Colorado," *Spanish Textile Tradition of New Mexico and Colorado,* comp. and ed. Nora Fisher (Santa Fe: Museum of New Mexico Press, 1979), 48.

19. Ibid.

20. "The Revival of an Old Craft: For Linens and Domestics," 3.

21. These materials are listed on the official caption of Lee's photograph. U.S. Department of Agriculture Farm Security Administration, neg. no. LC-USF34-34228-D.

22. Further investigation may uncover exactly when this colonial New Mexican male-dominated art form became inclusive. I suspect it has to do with the division of labor during hard times. For example, during the depression many Hispano males had to travel out of state to work. Additionally, men were away during World Wars I and II. While men were gone, Hispanas were at home carrying out daily activities that included art.

23. The State of New Mexico and Roman Catholic Church in Peñasco sponsored a "domestic science" class for girls in the Peñasco area. With the support of the vocational school system, nuns taught young Hispanas various forms of needlework.

24. "The Revival of an Old Craft: For Linens and Domestics," 3.

25. Undated newspaper article, but the headline reads, "Melrose Smallest Town in United States to Have Federal Art Center; Visited By Many," box 8 of 8, Holger Cahill Papers, AAASI.

26. Photograph, box 5 of 8, Holger Cahill Papers, AAASI.

27. "Catalogue Girl's Camp NYA Capitán, New Mexico," WPA Central Files, box 1935, RG 69, NA.

28. Ibid.

29. "Roswell Museum Spring River Park, Roswell, New Mexico: A Special Commemorative Reprint on the Occasion of Our 50th Anniversary, 1937–1987" (originally printed by Leland Trafton and CCC printing students), 4.

30. "Specifications of the Interior Furnishings of the Roswell Museum," Roswell Museum and Art Center Institutional Archives (hereafter Roswell MACIA), 4.

31. Ibid.

32. *Time* magazine, 5 September 1938, 35.

33. Interview with Teresa Ebie, 17 October 1997, Roswell, N.Mex.

34. "Roswell Museum Spring River Park, Roswell, New Mexico," 6.

35. "Specifications of the Interior Furnishings of the Roswell Museum," 10 May 1938, Roswell MACIA, 6.

36. Lea Rowland (state WPA administrator) to Kathleen Calkins (director of Research Index of American Design), 3 June 1936, Central Correspondence Files 1935–1944, RG 69, NA.

37. William Pillin (?), untitled manuscript on Spanish-colonial arts and crafts in New Mexico for the WPA American Guide Series, WPA File 329, New Mexico State Records Center and Archives (hereafter NMSRCA), 12.

38. Sylvia Loomis interview with Joy Yeck Finke, 9 January 1964, AAASI, p. 11 of transcript.

39. "Description of Items of Cost and Number of Workers on Seven Projects for New Mexico," report attached to letter from Donald Bear to Holger Cahill, 10 February 1936, FAP Office of the National Director, RG 69, NA.

40. Ernestine Rodríguez of Santa Fe provided this valuable (and long awaited!) information to me. According to Mrs. Rodríguez, Rita Rodríguez Chávez was married to Tony Chávez, who was a weaver. Personal communication with Rosalía Triana, 25 January 2000.

41. Sylvia Loomis interview with Roland Dickey and Joy Yeck Fincke, 16 January 1964, Albuquerque, N.Mex., Oral History Collection, AAASI, p. 21 of transcript.

42. "Federal Project Seen as a National Art School by the Regional Director, D. J. Bear" (n.a.), *Santa Fe New Mexican,* 17 December 1937.

43. Nancy Lane (director of the New Mexico WPA Women's and Professional Division) to Ellen Woodward (assistant WPA administrator), 6 April 1938, box 1935, WPA Central Files, RG 69, NA.

44. "The Revival of an Old Craft: For Linens and Domestics," 3.

45. "Reviving American Handicrafts," 6.

46. Genevieve Chapin, "Unusual Industries," New Mexico Federal Writers' Project, 25 July 1936, WPA File no. 238, NMSRCA; also cited in Marta Weigle, *Women of New Mexico: Depression Era Images* (Santa Fe: Ancient City Press, 1993), 84.

47. Carrie L. Hodges, "Art—Northeastern New Mexico," 21 March 1936, WPA File no. 155, NMSRCA, 2.

48. Flora G. Orr, "Skilled Work Shown in Relief Ranks," *Washington Star,* 9 June 1938.

49. Lee did not identify López when he took the pictures. López was identified later in a compilation of Lee's photographs edited by William Wroth, who traveled to Peñasco and Chamisal to interview community members in an attempt to identify the photographer's subjects.

50. Photograph by Russell Lee (July 1940), taken for the United States Department of Agriculture Farm Security Administration, Library of Congress neg. no. LC-USF34-37107-D.

51. Carl Fleischhauer and Beverly W. Barannan, eds., *Documenting America, 1935–1943* (Berkeley: University of California Press in association with the Library of Congress, 1988), 294–311. This work features a number of photographs of the López family.

52. Nancy Wood, *Heartland New Mexico: Photographs from the Farm Security Administration, 1935–1943* (Albuquerque: University of New Mexico Press, 1989), 113–14.

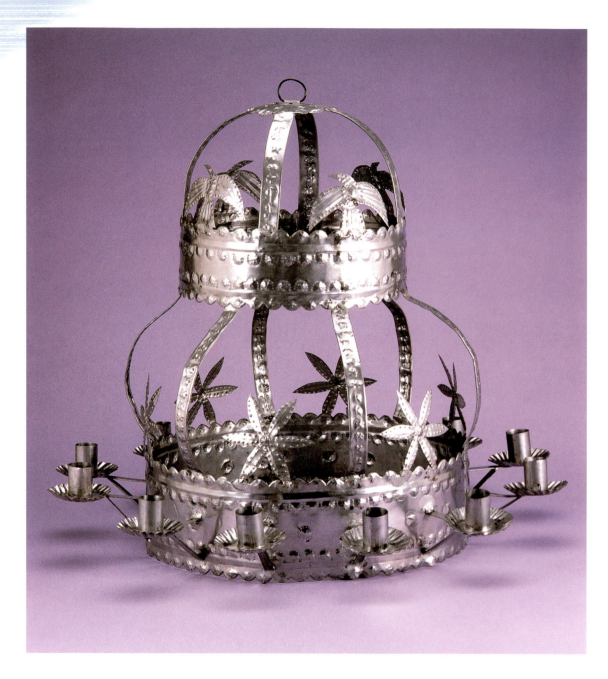

Francisco Delgado (1858–1936), Chandelier (ca. 1930s), tin, Santa Fe, New Mexico.
Museum of International Folk Art, a unit of the Museum of New Mexico, Santa Fe
(A.1991.2.2). Photo by Blair Clark.

CHAPTER FIVE

Masters of a Different "Canvas"

Mixed Media in El Diablo a Pie

MIXED MEDIA HAS BEEN DEFINED AS "Art of the twentieth century which combines different types of physical materials."[1] If this definition is to be taken literally, then Hispana and Hispano artists of El Diablo a Pie in New Mexico must be considered masters of mixed media art. In addition to those discussed in the accompanying chapters, iron, tin, glass, and straw were among the other media with which Hispana and Hispano artists created masterpieces for New Deal art programs. That the majority of these works were utilitarian and decorative should not keep them from art historical consideration. They are not "handicrafts," but rather integral artistic manifestations of cultural identity.

Hispana and Hispano artists have created art forms from everyday objects and natural materials long before it was the a trendy thing to do. Innovative artistic traditions emerged by applying one artistic medium to another. Elaborate tin art developed from discarded food cans during the time of American occupation in the mid-1800s. Hispano artists recast the throwaway metal into frames, mirrors, sconces, boxes, and nichos. The works were patterned with embossed and scored designs. As this art form developed, the tin was combined with glass, mirrors, paint, wallpaper, and gift wrapping, thus becoming a distinctly American art.

The same held true with straw embellishment of wood forms. The straw appliqué tradition had been around since the time of colonial settlers but it underwent an innovative and transformative artistic process during the first half of the twentieth century through the artistry of Eliseo Rodríguez, Paula Rodríguez, and Ernesto Roybal. Intricate and meticulous designs fashioned completely out of straw fibers were applied onto wooden crosses, sconces, nichos, and furniture. Since the colonial era, the straw reflected candlelight in churches, chapels, and homes, shimmering like gold.

As far as government support is concerned, mixed media arts were considered worthy of inclusion in exhibitions and documentation, but only as "handicrafts" or "metal work." Yet, tin and straw, known as the poor man's silver and gold respectively, were among the most ingenious and creative art forms in New Mexico.

Metal Arts

Native Market and the Vocational Art Classes

The Native Market and El Parián Analco sold tinwork, much of which was made by an artist named Pedro Quintana, a jeweler who made exquisite filigree. He inherited his artistic talents from his father, Alejandro. Brice Sewell, director of the State Department of Vocational Education, apparently encouraged the younger Quintana to learn how to create tin art, and Quintana mastered it. He created candlesticks, candelabras, frames, and nichos, and he often demonstrated his skill in the Native Market store.[2]

It is unclear how many schools had tinwork projects in New Mexico's New Deal–era vocational education system. Máximo Luna, the principal of the Taos Vocational School, doubled as a tinwork teacher. This is not surprising because often vocational school teachers would expand their duties and teach more than one art form. Luna was also from a family of Taos jewelers who specialized in silver and filigree; he was thus trained in metal arts as well as in furniture.[3] Tinworks created under his instruction included a number of chandeliers that graced the Harwood Foundation in Taos when it was first built in 1937.

The art of ironwork was also taught in the vocational school system, often in conjunction with tinwork or woodworking classes. Written information about this art form is scarce in WPA-related archival collections, but a number of photographs document the many as yet unnamed artists and their works. One depicts an artist from La Ciénega, near Santa Fe. The accompanying text reads: "Cienega-New Mexico-Vocational Education-Wrought Iron Work, used on the finished Spanish type furniture."[4] Two other photos, both filed under the category "Handicrafts," show ironwork artists engaged in projects. The New Mexico locations, works, and artists are otherwise unidentified. One image shows a group of younger artists creating detailed furniture adornments and donkey figures out of iron and tin.[5] The second image documents three Hispano artists doing ironwork on an anvil.[6] To date, only two New Deal iron artists have been identified.

Moíses Aragón (b. 1916)

Designer and artist Moíses Aragón was hired by colleague Abad Lucero to teach ornamental iron and tinwork at the Taos Vocational School. From 1935 to 1940, he also worked with Taos-area WPA furniture artists Máximo Luna and Elidio Gonzales. Aragón adorned their creations with hand-forged hardware in tradition-al "Spanish Colonial" designs. In addition to furniture accessories, Aragón created lamps, chandeliers, and curtain rods out of tin and iron. These works, and others by the artist, graced buildings such as the Harwood Foundation, the San Fernando Hotel, and the San Fernando Tavern in Taos, New Mexico.

When World War II began, Aragón redirected his artistic talents and began to teach pattern-making and foundry work in addition to his furniture classes in local schools and colleges. One of his classes, made up of twenty-one boys and thirteen girls, outfitted two hundred dormitory rooms, each with a carved chest, chair, dresser, and bed. Aragón moved to San Francisco, California in 1942 and contributed to the war effort by designing and building ventilation systems in local shipyards.[7]

Pete García (dates unknown)

Little has come to light regarding the other identified iron work artist, Pete García, who was hired by the FAP to create the iron railings for the orchestra pit, staircases, and lounge area in the then Albuquerque Community Playhouse.[8] An amount of $140 was requested to pay him and another "worker" to make the following:

Decorative Iron work: Railing around Orchestra Pit, in Albuquerque Community Playhouse

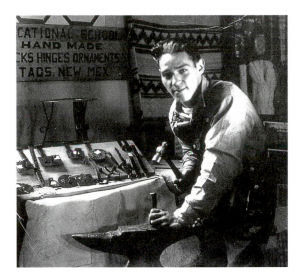

*Moisés Aragón in his Studio (ca. 1930s), Taos, New Mexico.
Photo courtesy of the Aragón Family.*

[Albuquerque Little Theater], to be executed
from working drawings made from architect's
sketches. Incidental pieces such as grills, fini-
als, etc. hardware rocks, etc. Iron rods for side
curtains.[9]

Although no identified photographs of García have
been located to date, parts of his work have been found
in the collections of the Albuquerque Little Theater.

National Youth Adminstration (NYA)

The National Youth Administration supported many
tin and metal work classes across the state. The catalog
created at the NYA girls' camp in Capitán featured
"TinCraft [*sic*]." Among the items offered were: smok-
ing stands (20" high) for $1.50; concha-type belts of
"various shapes and designs" for $.50 to $41.00; ash-
trays for pipes or cigarettes for $.15 to $.35; boxes for
cigarettes, pins, or makeup in different designs and sizes,
sold for $.50 to $2.00; wall-mounted match boxes for
$.75; and trays ranging in size and price from $.50 to
$4.00. A customer could also order picture frames or
mirrored frames in "Spanish or Modernistic Design"

in a variety of shapes and sizes, many of which were
based on *New Mexico Tin Craft,* another "Blue Book"
compiled by the New Mexico State Department of
Vocational Education. Tin nichos, described as "lovely
settings for your favorite saint with a small platform
for a candle," sold for $2.00. The catalog also fea-
tured sconces and lanterns that could outfit a candle
or electricity, bookends in "Spanish or Modernistic"
design, storm lights, lamps, silent butlers, firescreens,
crosses with glass, candlesticks and candelabras, flower
pots with flowers, and Christmas ornaments.[10]

Another NYA tin project, directed by Carmen
Espinosa, was taught in Santa Fe. The artwork was
created with materials purchased by the local histori-
cal society. Although their exact whereabouts have yet
to be identified, the following works, created through
the project, were later donated to the Museum of New
Mexico by the historical society:

> Tin santo case
> 2 Tin work crosses
> Tin work cross
> Tin frame around photograph
> > of wooden crucifix
> Tin frame around small picture of St. Francis
> Round tin work frame with photograph
> Tin frame with photograph
> Tin frame with picture of Virgin
> Tin ornamental cross[11]

Francisco Delgado (1858–1936)

Francisco Delgado is one of the more recognized
Hispano artists of early twentieth-century New
Mexico. His status is partially due to a frequently pub-
lished photograph by T. Harmon Parkhurst taken of
him in his Santa Fe workshop circa 1935.[12] The image
not only depicts the artist in his creative surroundings,
but also provides a visual record of the depth of his
tin and mixed media work, including framed mirrors,

chandeliers, candlesticks, lamps, lanterns, sconces, crosses, and nichos.

One of Delgado's first jobs was in a hardware store where he was "appropriately placed in charge of the sheet metal department."[13] In their trailblazing book, *New Mexican Tinwork 1840–1940,* Lane Coulter and Maurice Dixon, Jr. state that Delgado was listed in the 1910 Santa Fe census as a merchant.[14] For many years, he was the head stenographer in the United States Land Office and later became chief registrar. In 1929, Delgado retired from federal and state government and returned to his merchant/artist life in his Canyon Road shop. In the early 1930s, Delgado also worked for the Spanish Colonial Arts Society shop in Santa Fe's Sena Plaza.

He is listed in the final Public Works of Art Project Report along with the painter and muralist Esquípula Romero de Romero of Albuquerque and sculptor José Dolores López of Córdova as among the participating artists of the PWAP.[15] The report listed his street address as 503 Canyon Road in Santa Fe; the same location from which Delgado ran his colonial antique shop.

A portion of the tin art Delgado created for the PWAP has yet to be identified in the program's records.

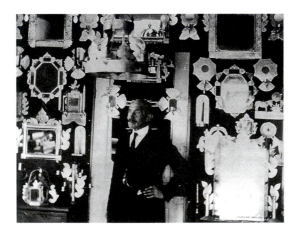

Francisco Delgado in his Studio (ca. 1935), Santa Fe, New Mexico. Photo courtesy of Angelina Delgado Martínez.

A large quantity of art was created for several buildings in and around Santa Fe. Among the recorded work Delgado completed during the six-month existence of the PWAP between 1933 and 1934, were eleven chandeliers and five lanterns for the state museum in Santa Fe.[16] The work was described by contemporary WPA writers in the following manner:

> While tin candle sticks, sconces and candelabra were in use earlier they became increasingly popular after the American occupation when the native learned to transform a surplus of empty tin cans into things of beauty with the aid of tin snips and punches. Mr. Delgado's work for the Old Museum is characteristically in keeping with the building.[17]

While the references to the "state museum" and the "old museum" may imply the original buildings of the Museum of New Mexico, the Fine Arts Museum, and the Palace of the Governors, the works in question may actually be some of the lighting fixtures still in use at the Laboratory of Anthropology which, at the time, was home to the PWAP offices. Until more documentation is uncovered, the exact location, description, and identification of Delgado's work remains unknown.

Francisco Delgado was also an important collector of historical tin art. He was one of the first to recognize its beauty and artistic qualities as not solely for utilitarian or devotional service. His own work within this artistic tradition was inspired by the historical antecedents that comprised his collection. From historical photographs and the few identified pieces in the Museum of International Folk Art's collection, it is still difficult to thoroughly discuss Delgado's individual style. However, there are a few distinctive elements that distinguish his work from his contemporaries. His careful use of embossing, stamping, and scoring produced exquisite designs on the tin background. The fine execution of these

Ildeberto "Eddie" Delgado (ca. 1950s), Santa Fe, New Mexico. Photo courtesy of Angelina Delgado Martínez.

motifs suggests that the artist was a patient man who enjoyed his work. In the creation of his art, Delgado also incorporated elements from his historic collection and created his own style. He was fond of birds, crescents, floral motifs, and pendants that usually manifested themselves as additional embellishments either soldered onto or "spraying" from a central geometric-shaped frame. Inspired by the "Valencia Red and Green Tinsmith," Delgado also accented details in his work with red and green paint.

His death in 1936 came at a time when the Federal Art Project in New Mexico was just taking off, but his artistic legacy was picked up and maintained by his son, Ildeberto, who became the pre-eminent tin artist of the WPA.

Ildeberto "Eddie" Delgado (1883–1973)

Ildeberto "Eddie" Delgado, Francisco Delgado's son, is the only artist who worked with traditional techniques and mixed media materials who was mentioned often in WPA records. He was born in Santa Fe and during his youth worked as a grocery clerk and

in the lumberyard. He also ran Delgado's Curio Shop, the family business, in the late 1920s. By 1937, he was creating art out of tin and selling it at El Parián Analco.[18]

During the era of Native Market and the Federal Art Project, tin art became a popular item for retail stores. Roland Dickey remembered being approached by a retailer for help with ordering tin:

> During the days when we were putting out a lot of craft work on the art project a man from the Merchandise Mart in Chicago came and looked me up not at the office but at home one weekend, and he wanted me to be the intermediary between some tinsmiths like Eddie Delgado in order to produce lots of little tin things for them to sell in their shop. But I couldn't quite convince him that nobody in New Mexico went on a time clock and that if Eddie wanted to make tin candlesticks, for instance, he'd do them like mad, but if he wasn't in the mood he wouldn't. And so I couldn't guarantee him any supply. He went away shaking his head. I don't think he ever quite understood what I was trying to tell him.[19]

Nonetheless, two examples of Delgado's work, a candle sconce and a lantern, were exhibited in the 1939 WPA *Little Forum Exhibit* at Bloomingdale's Department Store in New York City.[20]

Eddie Delgado's intricate tin creations graced many federal buildings and WPA projects in New Mexico.[21] A number of examples are still in use in their original locations at the now Albuquerque Little Theater, the Roswell Federal Art Center, the National Park Service building in Santa Fe, and the officer's club at Cannon Air Force Base. Delgado's

Ildeberto Delgado (1883–1973), Exit Sign (1936), tin, glass, and oil paint, Works Progress Administration, Santa Fe, New Mexico. Collection of the Albuquerque Little Theater, Albuquerque, New Mexico. Photo by Blair Clark.

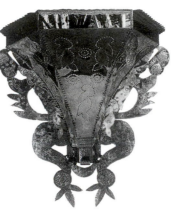

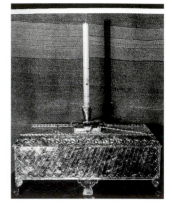

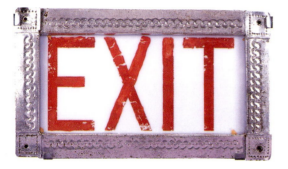

Ildeberto Delgado (1883–1973), Wall Sconce (1936), tin, Works Progress Administration, for the Albuquerque Community Playhouse (Albuquerque Little Theater). E. Boyd Files 49 937, Museum of International Folk Art, a unit of the Museum of New Mexico, Santa Fe.

Ildeberto Delgado (1883–1973), Tin Candle Holder (1936), Works Progress Administration, for the Albuquerque Community Play-house (Albuquerque Little Theater). E. Boyd Files 50 943, Museum of International Folk Art, a unit of the Museum of New Mexico, Santa Fe.

work was well documented and photographed during the WPA.

An outstanding example of his art—a tin frame with birds that holds the reverse painting on glass by Eliseo Rodríguez—was mentioned briefly in a previous chapter. Rodríguez's rendering of a Cristo crucificado was originally set in an octagonal frame and encircled by eight additional small reverse painted panels of floral designs. Eight tin arches with attached embossed circles were soldered to the glass panels. Eight birds posed on the outside of the frame. This frame is Delgado's almost identical interpretation of a circa 1870 frame made by the "Mora Octagonal Workshop." Judging from existing photos, the only difference between the two pieces would be those that resulted from differing tool quality and tin weight. Delgado's version was widely exhibited around the state and the country. It was also featured in an exhibition of santos by FAP artist Juan Sánchez at the Federal Art Gallery in Las Vegas, New Mexico.

As it was for many of the other Hispana and Hispano artists already discussed, the Albuquerque Community Playhouse, built with WPA funds in 1936, was the foremost public showcase for Delgado's tin art. For this project, he created a collection of works that displayed a number of combined styles and that incorporated innovative designs. It has not been entirely ascertained whether Delgado designed these unusual pieces himself or whether FAP administrator Russell Vernon Hunter or project architect John Gaw Meem sketched the designs for him. A number of the works were composed of recombined traditional tinwork design elements but departed from extant historical examples. These works included candy or fruit dishes, combined candleholders and flower vases, and uniquely shaped single candlesticks. If future research indicates that the creative mind behind these designs was indeed Delgado's, then his work must be reinterpreted to address such innovation within this artistic tradition. If he was following designs done by

administrators and architects, then the dynamics of this relationship must be explored further and would substantiate the amount of artistic control Hispana and Hispano artists could exercise in WPA programs. Either way, WPA/FAP administrators were obviously impressed by the results of Delgado's work since there are numerous official photographs of different tin objects; still, they are found under the WPA category of "Arts and Crafts: Metalwork."

Delgado's tin masterpieces were also exhibited frequently in WPA/FAP venues across the country. Although no photographs of the objects have yet been identified, three of his pieces, a "Painted Sconce—Double Eagle," "Sconce with Bird," and "Sconce with Bird Atop," were sent to Washington to be exhibited at the Museum of Modern Art.[22] The Double Eagle sconce was described as a "reproduction." Although numerous pieces made in New Mexico in the nineteenth century also included the double eagle, the original source for Delgado's piece was documented as "found near Albuquerque, New Mexico and probably came from Mexico."[23] The two sconces with birds were described as copies "from old designs in a tin shop of Eddie Delgado's father."[24]

Lighting fixtures were among the more utilitarian pieces Delgado made for the Albuquerque Community Theater. Two "workers" and a total amount of $414 were requested to create the following:[25]

Lighting fixtures: 1 large chandelier, wall sconce for auditorium, foyer chandeliers, portal lights, in tin from Spanish-Colonial design. Exit lights—lights in women's lounge and club rooms.[26]

The larger works included at least five tin wall sconces for the theater proper, two of which are still mounted on either side of the stage. They are bold and angular, almost funnel-shaped or cone-like in appearance. Emerging from the walls, they have a

"Spanish Colonial" art deco appearance and are reminiscent of lighting fixtures in old movie theaters. The central cone is edged with ornately stamped tin finials and tendrils. The top of the sconce has reverse painted glass panels and a serrated lip that opens to emit light. Some time in the past, someone painted over two of the sconces but they have since been restored.

Other tin lighting fixtures for the theater included a chandelier with six light bulb sockets. Its star-shaped base hung from the ceiling of the Playhouse's upper lounge.[27] A tin chain hid electrical wires. A punched tin lantern that also incorporated a hanging chain to camouflage the electrical cord was used for stairway lighting.[28] Two small table-sized single candlesticks also appear to have been equipped with electrical wiring.[29] Among the non-electric lighting fixtures were two tall freestanding single candlesticks for the lobby.

The innovative and unusual works that Delgado created for the Playhouse's public areas also included a tin dish with rolled rim "petals" and leaf supports at the base, and an elaborate three-tiered tin "candle and flower holder" that resembled a fountain. The latter held four candles and had ample space for large flower arrangements.[30] Another unique piece Delgado did for this project was a rectangular-shaped candle holder, shaped like a tissue box. It was broad at the base, and sported reverse-painted glass panels at the top. In the center of the lid was a single *bobeche*, (candleholder). Finally, in a contemporary twist on modern necessities, the artist made at least two tin-trimmed exit signs for the theater's lobby and public areas.

In addition to his innovative designs, Delgado also made traditional tin art pieces for the Albuquerque Community Playhouse. Two large freestanding crosses were featured in photographs of the lobby. He did elaborate tin and glass nichos for the project; they are among Delgado's more ornate works. The largest nicho was rectangular in shape with three crescents soldered

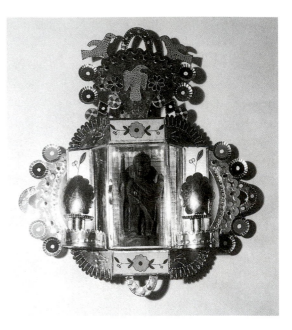

Ildeberto Delgado (1883–1973), Nicho (with FAP sculpture by Patrocinio Barela, 1936), tin and oil paint, Works Progress Administration, for the Albuquerque Community Playhouse (Albuquerque Little Theater). E. Boyd Files 211 5502, Museum of International Folk Art, a unit of the Museum of New Mexico, Santa Fe.

to each side. The floral rosettes and bird motifs were all detailed and painted. Rather than the traditional lunette, the nicho is topped with a fan-like basket motif with a bird in the center. Two birds rest on either side of the basket handle. From available photographs it appears as if this nicho was also used as a candle holder, since there are three candle fixtures at its base.

A pair of smaller nichos is similar to the first in that they are all done in the style of the Valencia Red and Green Tinsmith.[31] They evoke this style because of elaborate detailing that includes stamped and embossed designs and paint (probably red and green although it is difficult to determine from photographs) to enhance particular motifs such as petals and rosette centers. The parameters of the twin nichos are completely filled and layered with soldered, stamped, painted, and embossed elements. Because of this intensely baroque quality (and the development of new techniques), these works are far more elaborate than their nineteenth-century counterparts. Each of the nichos had two candle holders on the outside of the glass-enclosed case. Glass panels that were reverse-painted with bold flowers were attached to both sides of each work. A similar fanned basket and birds adorned the tops. Both may have originally housed bultos by Patrocinio Barela.[32]

Ildeberto Delgado also created all the FAP tin art for the other major New Mexico–style art showcases in Roswell. The art center and museum listed the following works requested for the project:

Office:

One central three-light tin chandelier; 15" high, 10" on tri-cornered sides; 2" x 9" mirror inserts; 9" tin chain supports light from 8½" ceiling plate; all parts decorated by punched designs.

One 4-sided 12" high tin lantern; 4" x 5" glass sides supported from 6" x 13" wall plate on 8" bar; equipped with toggle switch; all parts decorated by punched designs.

One round sconce, single light, 15" diameter; rooster and star border; six mirror inserts forming oriental cross; equipped with toggle switch.[33]

Gallery:

3 tin chandeliers with concealed flood lights, and six lights on 1' extended arms; 18" x 4,' supported on 2' 8" [*sic*] brass chain; hexagonal shape with 6 glass inserts 4" x 10" on each side; 14" tubular crown with 6 tin decorative vanes attached to upright supports; 6 decorative vanes supporting light arms. Parts decorated by punched designs.[34]

One tin lighting fixture in center of stage ceiling; 14" x 12" x 6"; 4 decorative tin vanes;

Ildeberto Delgado (1883–1973), Nicho Lunette (ca. 1936), tin and oil paint, Works Progress Administration, Santa Fe, New Mexico. Collection of the Albuquerque Little Theater, Albuquerque, New Mexico. Photo by Blair Clark.

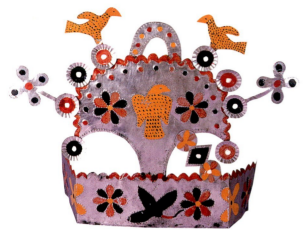

light arranged to flood back of stage, as well as sides.[35]

Foyer:

One tin ceiling fixture with four funnel-shaped reflectors pointed to the for [*sic*] corners; all parts decorated with punched tin designs.

Name plate 1½" by 4" were also made for the four sculpture bust [*sic*] in the foyer as well as one each for the Ladies [*sic*]and Gentlemen's lounges.[36]

Ladies' Lounge:

2 tin sconces—single light, 18" x 11," punched decor, each equipped with toggle switch.

Picture—hand painted flower design on glass 2" x 5," in 3/16" tin frame, surmounted by 2' serrated-edge tin lunette, with two small decorative, punched vanes, attached to the sides.

Central lighting fixture—hexagonal—5¾" x 5" tin shade, supported one inch beneath round, scalloped-edge ceiling plate, 3 glass inserts with combed white paint design, 3 glass inserts with flower design.[37]

Two tin tie-backs were also specified for the "Sahara cloth" curtains in the Roswell ladies' lounge.[38] To date, only the three chandeliers in the gallery hang where they were originally installed. The other Delgado works are still missing.

The third large FAP project Delgado did was the National Park Service Southwest Regional Headquarters building in Santa Fe. This WPA- and CCC-built edifice, now a national historic landmark because it is the largest extant adobe-constructed office building, features many tin and glass light fixtures still inside the building and outside on the patio. Among the works are sconces, lanterns, and chandeliers, all with electrical wiring. The New Mexico School of Mines in Socorro was another recipient of Delgado's federally funded FAP art. Although the work has yet to be located, archival documentation states that a unique tin candelabra for four candles/bulbs was one of the pieces created.[39]

Among the non-WPA-funded art Delgado produced were tin chandeliers for the Santa Fe Gas building. In 1944, he made another group of at least six large tin chandeliers and some other fixtures for the officers' club at Cannon Air Force Base.[40] The chandeliers were inundated with lattice work. Pendants, shaped like the tear drops on crystal chandeliers dangle from each of twelve arms. Small tin stars and a larger mirrored sun hang from each larger piece. A 1944 photograph shows Delgado creating parts of the chandeliers, while the base engineering officer and Russell Vernon Hunter observe.

After World War II, Delgado continued his art. According to Joy Yeck Fincke, the FAP work strengthened his career:

> Eddie Delgado was a tinsmith and he had been doing tinsmith work for a long while, but he got many more commissions after his work was used on the art projects.[41]

In the 1950s he made tin wall sconces for the restored San Miguel Chapel in Santa Fe.[42] Delgado and his daughter Angelina made lighting fixtures for "an ancient Albuquerque building restored as an Old Town restaurant."[43] He also applied his artistic skills to a different medium, creating his own molds to make plaster of paris images and figures.[44]

Oddly, a 1958 article in *Santa Fe Scene* makes no mention of Delgado's work for the WPA. Even at this late date, the *Scene* grappled with the idea of tinwork as fine art. The article suggests that because Delgado's art received recognition from museums, it should be accorded some type of artistic status:

> Wherever there are more than several artists collected, there are controversies, of course, and whether or not tinsmithing can be classed as one of the true arts, unobtrusive Eddie Delgado isn't inclined to ask—or answer—but his handicraft has been officially recognized in Santa Fe where his works are on display in the art gallery of the state museum.[45]

Ildeberto Delgado's daughter, Angelina, and granddaughter, Rita Younis, continue the family's artistic traditions. The two work in tin using the same punching and scoring tools Francisco and Ildeberto used.

Felix Guara (dates unknown)

Another tin artist mentioned in WPA documentation is Felix Guara, who is listed as the maker of a "mirrored frame with Indian bird."[46] According to one WPA document, the frame was "copied from the original in the Applegate Collection in Santa Fe, but there are many other ones in the vicinity."[47] To date, no other mention of Guara, nor a photographic image of this piece, has been located. The "Mirror Frame with Indian Bird" was featured with two of Ildeberto Delgado's sconces in an exhibition of "Spanish-Colonial Craft Items" at the Museum of Modern Art in Washington, D.C.[48]

Unattributed tinwork from various WPA arts-related programs still decorates many New Deal–era buildings in New Mexico and resides in the state's museums. Tin lamps still hang from the ceilings of some of the WPA-funded state fair buildings in Albuquerque. A number of other tinwork pieces were made for various WPA/FAP projects around the state. A selection of FAP tinwork was loaned to the McKinley County Courthouse in Gallup.[49] A tin-and-glass nicho (perhaps by Ildeberto Delgado), was featured in a number of photographs in an exhibition at the Federal Art Center in Las Vegas. It was recently found in the collections of the Museum of International Folk Art in Santa Fe.

Straw Appliqué

The art of straw appliqué was repopularized during the New Deal era through retail venues such as Native Market and WPA-sponsored art projects and vocational schools. One contemporary account described the re-emergence in the following words:

> One of the most fascinating means of decorative embellishment was the use of straw laid on a coat of pitch. Used on chests and crosses, its golden scheme made a splendid contrast with the blackness of the pitch. Little of the craft has been revived, except recently at the Spanish-American Normal School at El Rito and on the New Mexico Federal Art Project.[50]

Although at the time not many artists worked in this medium, straw work was planned for statewide inclusion in many of the WPA/FAP showcases, including the Albuquerque Community Playhouse and the Roswell Federal Art Center. In a letter describing some of the research and submissions to the *Index of American Design*, Lea Rowland, the New Mexico WPA administrator, wrote:

> I also hope to use in this theater some of the

Eliseo José Rodríguez (b. 1915) with his Cristo Crucificado *(1998), Santa Fe, New Mexico. Museum of International Folk Art, a unit of the Museum of New Mexico, Santa Fe. Photo by Blair Clark.*

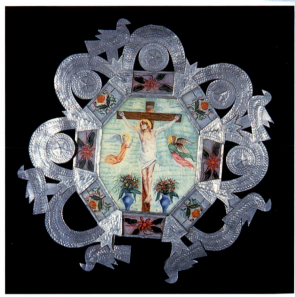

Eliseo José Rodríguez (b. 1915), Cristo Crucificado *(1936), oil on glass, tin frame by Ildeberto Delgado, Federal Art Project, Santa Fe, New Mexico. Gift of the Historical Society of New Mexico to the Museum of New Mexico, Palace of the Governors, Santa Fe, New Mexico. Photo by Blair Clark.*

straw inlay work, as shown in the candle sconce. This craft is particularly appealing to me. I know of but one person in the state who has done it recently, a boy of twelve or fourteen years. The examples of this work are extremely rare. I have been of the opinion that it was done in imitation of marquetry.[51]

No actual written or pictorial record of the straw inlay with appliqué sconces that were made for the Albuquerque Community Playhouse has been uncovered, but the art form was used on the backboard of the large sitting bench made for the theater's lobby. It also appeared on the outside of a *vargueño* (writing desk) that graced the theater's ladies' lounge. According to one document, the straw "inlay" on the furniture was applied by furniture artist George Segura and his students.[52]

The striking trastero, or standing cupboard, that Domingo Tejada made for the office at the Roswell Museum and Federal Art Center also shows the incorporation of this art form into large FAP works. The trastero featured "straw 'inlay' on upper panels of doors and on upper half side of panels, with maltese cross pierced designs interspersed."[53] The inclusion of this mixed media application on larger pieces such as trasteros helped to create an aesthetic acknowledgement of its importance as an art form.

Eliseo José Rodríguez (b. 1915)

I briefly explored the mastery of straw appliqué in an earlier chapter with regard to artist Eliseo Rodríguez, who was the instrumental force in placing it back among contemporary forms of Hispano art. However, few of the artist's WPA-funded works have been identified. One of Rodríguez's FAP pieces, "Wood Cross with Straw Inlay," was completed on May 15, 1938 and valued at $5. It was given to the Museum of New

Eliseo José Rodríguez (b. 1915) San Juan Bautista (1998), oil and glass, tin frame by Don Cash, Santa Fe, New Mexico. International Folk Art Foundation Collection, Museum of International Folk Art, a unit of the Museum of New Mexico, Santa Fe (FA.1998.36.1). Photo by Blair Clark.

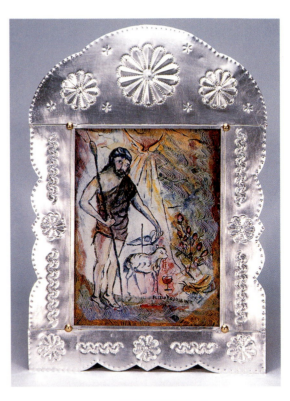

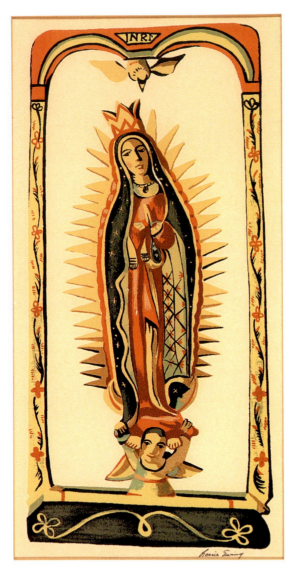

Eliseo José Rodríguez, Paula Rodríguez, and Louis Ewing, Virgen de Guadalupe (late 1940s–early 1950s), silk-screen print, Santa Fe, New Mexico. Private collection. Photo by Blair Clark.

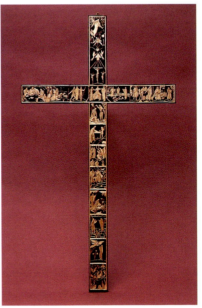

Eliseo José Rodríguez (b. 1915), Life of Christ (1981), straw, wood, and paint, Santa Fe, New Mexico. Museum of International Folk Art, a unit of the Museum of New Mexico, Santa Fe (A.1986.565.2). Photo by Blair Clark.

Mexico on January 14, 1943 when the FAP ceased its operations.[54]

During the WPA, the majority of Rodríguez's straw appliqué was done in geometric and floral designs based on older examples in museum and private collections, only a few of which he was able to study at the time. It wasn't until after the WPA came to an end that both Rodríguez and his wife, Paula, developed their powerful narrative style by depicting religious figures, santos, and scenes from the Bible out of small pieces of straw. The figurative renderings were applied to crosses, boxes, panels, and frames. Variations of color and shine in the straw served as the artist's palette and allowed for perspective, depth, expression, and motion. Thus, Rodríguez's formal training and painterly perspective brought this art to a new level; and, in an even greater sense, defined it.

Rodríguez was a recipient of the Santa Fe Mayor's Award (1999) and the New Mexico Governor's Award for Excellence and Artistic Achievement (1980). Additionally, he has been named a Santa Fe Living Treasure. In 1989, both Eliseo and Paula were awarded the Spanish Colonial Arts Society Master's Award for lifetime achievement. Examples of his straw appliqué art are located in the collections of the Albuquerque Museum, the Museum of International Folk Art in Santa Fe, the Taylor Museum of the Colorado Springs Fine Arts Center, the National Museum of American History at the Smithsonian Institution, and in many other national and international museums.

Paula Rodríguez (b. 1915)

Originally from Rowe, New Mexico, Paula Gutiérrez (Rodríguez) is an unsung hero of WPA art. Although she was not involved in an official capacity with the New Deal art programs, she played a pivotal role in the development of straw appliqué during this era. At the same time, she raised seven children.

Plaque Honoring Eliseo José Rodríguez, Fine Arts Museum, Santa Fe, New Mexico. Photo by Blair Clark.

When the FAP asked her husband Eliseo to research and create a straw appliqué process based on colonial prototypes, Paula was studying and experimenting with him every step of the way, transforming the traditional geometric patterning into a powerful narrative. It was she in addition to her husband and family friend, artist Louie Ewing, who experimented with the serigraphy process. Rodríguez remembers printing not only the silk-screen religious images for Santa Fe's Laboratory of Anthropology but also community posters in the couple's garage. That these two artistic achievements have been largely overlooked in relation to the New Deal era speaks to the role of women in this sociocultural climate. Rodríguez was and is an artist, but her name does not appear on the official FAP rolls.

Her works have a distinct style and she has received many individual honors and joint awards that she shares with her husband. Examples of her mastery

Eliseo José Rodríguez (b. 1915), Portrait of Paula Rodríguez *(1942), oil on canvas, Santa Fe, New Mexico. Collection of the artist. Photo by Blair Clark.*

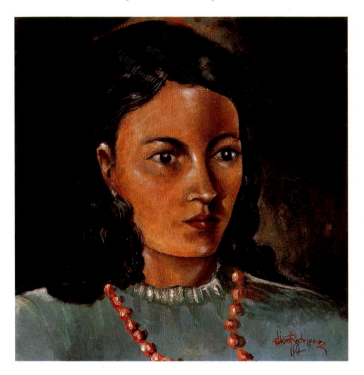

Paula Rodríguez in front of Portrait of Paula *(by Eliseo Rodriguez), June 6, 1999 at the opening reception of* Sin Nombre *at the Museum of International Folk Art. Photo by Tey Marianna Nunn.*

are in the collections of the Museum of International Folk Art, the Spanish Colonial Arts Society, and museum and private collections in Europe. Currently, one of her large straw appliquéd crosses is on exhibit in the U.S. Embassy in Madrid, Spain. Like her husband, she is also a past recipient of the New Mexico Governor's Award (1980), the Santa Fe Mayor's Recognition Award for Excellence in the Arts (1999), and she has been named a Santa Fe Living Treasure.

Together, Eliseo and Paula Rodríguez have kept an important cultural art form from disappearing. In doing so, they have forged a legacy of artistic beauty and perseverance. Their daughter Vickie is also an award-winning straw appliqué master. Daughter Yolanda learned the art form and apprenticed with her mother under an apprentice grant from the National Endowment for the Arts. Four of the Rodríguez's grandchildren—Gabriel, Jessica, Marcial, and Monica—are also accomplished artists in this medium.

Ernesto José Roybal (1914–1998)

Although his name does not appear frequently in official WPA documentation, a number of straw appliqué works created for the Federal Art Project have been attributed to Ernesto José Roybal of Pojoaque, New Mexico.

One example, a straw appliquéd plaque he made in 1938, is in the Colorado Collection of the University of Colorado at Boulder. The plaque, modeled after a colonial piece, features a cross mounted on a stepped pedestal with a smaller cross on either side. A serrated border and other stylized motifs complete the appliqué work. In his master's thesis on WPA artist Juan Sánchez, Tom Reidel includes an illustration of the plaque as well as the rendition of the same plaque that was executed for the *Portfolio of Spanish Colonial Design.* The watercolor depiction was copied directly from Roybal's original work.[55] Ernesto Roybal is also

Ernesto Roybal (1914–1998), date unknown, California.
Photo courtesy of Victoria Sosaya.

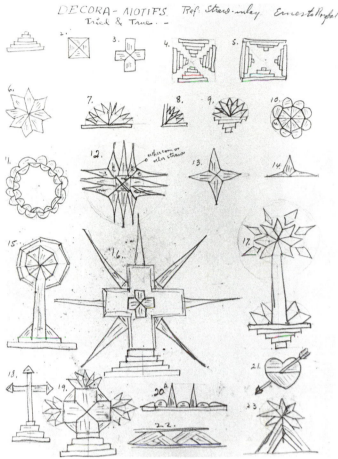

Ernesto Roybal (1914–1998), design page,
(ca. 1937), pencil on paper, New Mexico.
Photo courtesy of Victoria Sosaya.

listed as one of the artists and colorists on the *Portfolio* project. It is not known whether he actually did some of the watercolor work, or if he was being credited for his creation of the original piece. However, according to his family, he did paint with watercolors throughout his life.[56]

Another of Roybal's works, described as a "Wood Block with Straw Inlay Design," was completed on July 15, 1939 at a cost of $1. It was given to the Museum of New Mexico by the WPA at the close of the art project on January 14, 1943 but remains unidentified within the museum's collections.[57] Will Wroth included one of Roybal's appliquéd crosses in his essay, "The Hispanic Craft Revival in New Mexico."[58] The work, from the private collection of Joy Yeck Fincke, former assistant to state FAP director Russell Vernon Hunter, features a modern and bold straw design.

A straw appliqué cross in the collection of the Museum of International Folk Art has also recently been identified as Roybal's work. The back of the work has a penciled inscription that reads "FAP." The floral design elements are similar to those on the plaque at the University of Colorado and the cross pictured in Wroth's article. This work is unique within the traditional art form in that the straw appliqué designs have been applied to natural wood rather than to a black surface. Original sketches for this and other examples of Roybal's work are his family's collection.

The Museum of International Folk Art in Santa Fe has another straw appliqué WPA/FAP work that remains unattributed. The wooden nicho, a copy of a nineteenth-century piece, is painted a deep navy blue. Both the façade and the sides are embellished with

Ernesto Roybal (1914–1998), Untitled Painting (date unknown), watercolor on paper, New Mexico. Photo courtesy of Victoria Sosaya.

Ernesto Roybal (1914–1998), Santa Cruz (ca. 1937–1940), straw and wood, Federal Art Project, Pojoaque, New Mexico. Gift of the Historical Society of New Mexico to the Museum of New Mexico, Museum of International Folk Art, Santa Fe (A.4.53.1). Photo by Blair Clark.

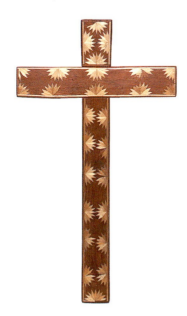

straw appliqué in the exact pattern of the original. To date, no one, including Eliseo Rodríguez, has been able to identify the artist who created this work.

During World War II, Roybal, as did so many other trained artists and Nuevomexicanos, moved to California and worked in the shipyards in Oakland, San Francisco, and Los Angeles.

The mixed media works of tin, metal, and straw appliqué artists are a visual narrative of the struggles and experiences of Hispanos in New Mexico. Adaptation, creativity, and innovation have created art forms worthy of inclusion in the American art canon. The baroque detailing, embellishment, and patterning on the surfaces of everyday objects transformed the pieces into art accessible to everyone. The combination of various mediums to develop an art style is powerful testimony to Hispano aesthetic sensibility. These artists are no less true artists than their painting and sculpting counterparts. They are simply masters of a different "canvas."

Notes

1. Edward Lucie Smith, *The Thames and Hudson Dictionary of Art Terms* (London: Thames and Hudson, Ltd., 1993), 122.

2. William Wroth, "The Hispanic Craft Revival in New Mexico," in Janet Kardon, ed., *Revivals! Diverse Traditions: The History of Twentieth Century American Craft 1920–1945* (New York: Harry Abrams, Inc., Publishers in Association with the American Craft Museum), 89.

3. William Wroth, ed., *Hispanic Crafts of the Southwest* (Colorado Springs: Taylor Museum of the Colorado Springs Fine Arts Center, 1977), 105.

4. Accompanying text to photograph, negative number RG 69-N 11656-C, Record Group (hereafter RG) 69-N, National Archives Still Picture Branch, College Park, Maryland (hereafter NASPB).

5. "Tin and Iron Wrought Work, New Mexico," negative number RG 69 MP, box 4, #3, RG 69, NASPB.

6. "Tin and Iron Wrought Work, New Mexico," negative number RG 69 MP, box 4, #1, RG 69, NASPB.

7. The author is indebted to Debbie Brehm, the granddaughter of Moíses Aragón, for providing this information in April 1998.

8. Shipping receipt for FAP Project photographs from New Mexico sent to Thomas C. Parker (deputy director, WPA Art Program), Washington, D.C., 2 January 1940, Correspondence with State and Regional Offices, RG 69, National Archives, Washington, D.C. (hereafter NA).

9. "Description, Items of Cost and Number of Workers on Seven Projects for New Mexico," report attached to letter from Donald Bear to Holger Cahill, 10 February 1936, Office of the National Director, Correspondence with State and Regional Offices, RG 69, NA.

10. "Catalogue Girl's [*sic*] Camp NYA Capitán New Mexico," circa 1940, box 1935, Central Files, 1935–1944, RG 69, NA.

11. Historical Society Collection Acquisition File Cards, Palace of the Governors, Museum of New Mexico, Santa Fe, N.Mex., (hereafter MNM).

12. Photograph of Francisco Delgado, negative number 71180, MNM.

13. The article "Eddie Delgado Creative Artisan," contains some information about Eddie's father Francisco Delgado. *Santa Fe Scene,* 8 March 1958, 5.

14. Lane Coulter and Maurice Dixon, Jr., *New Mexican Tinwork 1840–1940* (Albuquerque: University of New Mexico Press, 1990), 145.

15. PWAP Report of the Assistant Secretary of the Treasury to Federal Relief Administrator, 8 December 1933-30 June 1934, WPA Division of Information, RG 69, NA, 77.

16. "Names of Artists and Craftsmen," n.d., Laboratory of Anthropology Collections, MNM. An additional handwritten notation of "45" is written next to the numbers of the objects.

17. "The Spanish American Craftsmen," n.d., WPA File no. 155, New Mexico State Records Center and Archives (hereafter NMSRCA), 26.

18. Coulter and Dixon, Jr., *New Mexican Tinwork,* 147.

19. Sylvia Loomis interview with Roland Dickey, 16 January 1964, Santa Fe, New Mexico, Archives of American Art, Smithsonian Institution, Washington, D.C. (hereafter AAASI), p. 8 of transcript.

20. Accompanying text to photograph of exhibition, negative number RG 69-N 10295, "Handicrafts," RG 69, NASPB.

21. Throughout WPA documentation, Ildeberto is referred to as "Eddie," a simpler and anglicized version of Ildeberto. Such was also the case with many of the WPA Hispano artists such as Patrocinio "Pat" Barela, Pedro "Pete" Cervántez, and Santiago "Sam" Matta.

22. Russell Vernon Hunter to Mildred Holzhauer, 28 March 1939, WPA Central Files, RG 69, NA.

23. Ibid.

24. Ibid.

25. Although he died in 1936, the second "worker" on the tin project for the Albuquerque Community Playhouse may have been Delgado's father, Francisco. See William Wroth, "The Hispanic Craft Revival in New Mexico," 239.

26. "Description, Items of Cost and Number of Workers on Seven Projects for New Mexico," report attached to letter, Donald Bear to Holger Cahill.

27. Shipping receipt for FAP project photographs from New Mexico to Thomas C. Parker.

28. Thomas C. Parker to James J. Connelly, 9 December 1939, Central Correspondence Files, 1935–44, RG 69 651.313, NA.

29. A photograph of the candlesticks shows cords protruding from their bases. In WPA Photograph Collection, box 6, AAASI.

30. Images of both pieces—the dish and the candle/flower holder—are in the WPA Photograph Collection, box 6, AAASI.

31. The work of the Valencia Red and Green Tinsmith dates from 1870 to 1900. See Coulter and Dixon, Jr., *New Mexican Tinwork,* for concise coverage of the other nineteenth-century examples as well.

32. A photograph from the Museum of New Mexico Photo Archives shows a sculpture by Barela inside the glass compartment of the nicho. Negative number 90212, MNM.

33. "Specifications of the Interior Furnishings of the Roswell Museum," Roswell Museum-Federal Art Center, 10 May 1938, Roswell Museum and Art Center Institutional Archives (hereafter Roswell MACIA), 1.

34. Ibid., 3.

35. Ibid., 4.

36. Ibid., 5.

37. Ibid., 6.

38. Ibid.

39. Photograph in the WPA Photograph Collection, box 6, AAASI.

40. There may have been eight chandeliers. Personal communication with Kathy Flynn, Assistant Secretary of State for New Mexico, March 1996. The officers' club has been remodeled and the location of all eight works has not been determined.

41. Sylvia Loomis interview with Joy Yeck Fincke, 9 January 1964, Albuquerque, New Mexico. AAASI, p. 19 of transcript.

42. Coulter and Dixon, Jr., *New Mexican Tinwork,* 147. Coulter and Dixon, Jr. note that they got this information from the Santa Fe Directories, 1925–45. The tin sconces are still in the chapel.

43. "Eddie Delgado Creative Artisan," in *Santa Fe Scene,* 8 March 1958, 7. Family members recall that the restaurant was La Placita, which still faces Old Town's plaza. To date, it has been difficult to get additional information from the restaurant's owners.

44. Ibid., 4.

45. Ibid.

46. Mildred Holzhauer to Russell Vernon Hunter, 25 May 1939, WPA Central Files, Office of the National Director, Correspondence with State and Regional Offices, box 53, RG 69, NA.

47. Russell Vernon Hunter to Mildred Holzhauer, 28 March 1939, WPA Central Files, Office of the National Director, Correspondence with State and Regional Offices, box 53, RG 69, NA.

48. Ibid.

49. Joseph A. Danysh (regional FAP director), to Thomas C. Parker, 27 June 1939, Correspondence with State and Regional Offices, RG 69, NA.

50. William Pillin, "Spanish-Colonial Arts and Crafts in New Mexico," 12 January 1938, WPA file no. 300, NMSRCA, 6.

51. Lea Rowland to Kathleen Calkins (director of Research, *Index of American Design*), Washington, D.C., 3 June 1936, Central Correspondence Files, RG 69, NA.

52. Shipping receipt for FAP project photographs sent from New Mexico to Thomas C. Parker, 2 January 1940. See furniture chapter for more information on the work of George Segura.

53. "Specifications of the Interior Furnishings of the Roswell Museum," 10 May 1938, Roswell MACIA.

54. Collection accession data card for object number B 88/11, Palace of the Governors, MNM.

55. Figures 3.7 and 3.8 in Thomas L. Reidel, "'Copied for the W.P.A.': Juan Sanchez, American Tradition and the New Deal Politics of Saint Making" (Master's thesis, University of Colorado, 1992), 75.

56. Personal communication with Victoria Sosaya and Priscilla and Eleanor de Roybal, June 1998, Santa Fe, N.Mex.

57. Accession data cards for object B 87/235, Palace of the Governors, MNM.

58. Wroth, "The Hispanic Craft Revival in New Mexico," 91.

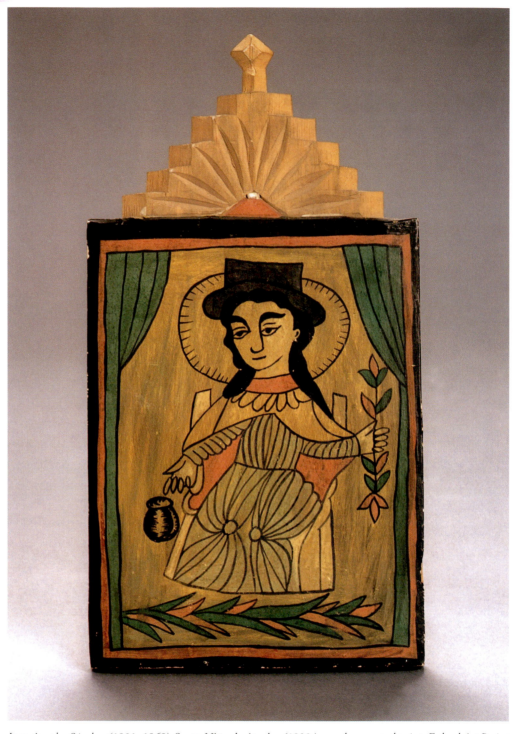

Juan Amadeo Sánchez (1901–1969), Santo Niño de Atocha *(1930s), wood, gesso, and paint, Federal Art Project, Colmor, New Mexico. WPA Project Purchase Colorado Collection, CU Art Galleries, University of Colorado at Boulder, photo © Colorado Collection, CU Art Galleries, University of Colorado at Boulder, by Larry Harwood.*

CHAPTER SIX

Sculptors and Santos

WITH THE EXCEPTION OF PATROCINIO BARELA the Hispano sculptors of the WPA art projects have been overlooked in the enormous body of work focusing on the santero tradition and New Mexican religious art. The absence of information suggests that Hispano sculpture, especially religious sculpture, disappeared completely from the art historical record between the 1880s, when the railroad arrived in New Mexico, and the post-Chicano awakening of contemporary santero art. It is alarming that such an integral component of the artistic and cultural life of the United States, and the artists who created these three-dimensional and relief works, could remain missing from the literature for so long.

Further information about Hispana and Hispano artists who worked within the broader time span between 1850 and 1950 is greatly needed. Although outside the scope of this work, some of the issues that require re-examination and reinterpretation deal with what could be referred to as the "Plaster Statue Myth." This is an almost universal idea that the Hispano population of New Mexico only wanted newly manufactured plaster statues, and used them to replace all of their beloved and venerated religious sculptures during this time period.[1] The perceived result of such collecting behavior is that the sculptors and painters of New Mexican religious images stopped creating. In reality, veneration of plaster sculpture, as well as mass-produced religious prints, did happen. However, a complete and total substitution never occurred, nor did Hispano artists completely stop sculpting and painting. Information on this time period is simply more difficult to find because attention was focused (and records kept) on Native Americans, their culture, and their art. Future research will help recognize many of the Hispana and Hispano artists who worked during this era. In an effort to provide a departure point for such research, this chapter will discuss a number of individuals, born well before the turn of the century, who mastered the art of sculpting santos during these lost years and who, for a time, created art for the WPA.

The lack of acknowledgment of Hispano WPA sculptors is largely because of the perception that religious sculptures created under the auspices of the United States government were simply examples of government art, and not authentic products of spiritual creativity by New Mexican sculptors and santeros.[2] Many of the artists were directed to make copies of colonial or "antique pieces." To WPA administrators and the art world at the time, Barela was the only original talent—a "true primitive"—who was a New Mexico native. Those who were so-called "copyists" were thought to have no inherent talent or originality. In her 1963 notes recorded for the Archives of American Art, E. Boyd commented on the perceived difference in artistic talent and meaning:

> Original work by Patrocinio Barela was deservedly featured in national exhibits. However, the deliberate encouragement, without critical reservation, of the poor copying of old santos by Santiago Mata [sic], Juan Sanchez [sic], Emilio Padilla and other artisans has left a long trail of poor stuff behind it, and into the present.[3]

Although they were directed to produce copies, the sculptors and santeros of El Diablo a Pie, including Matta, Sánchez, and Padilla, did indeed inject aspects of their own artistry and creative vision into the projects. While the sculptural "copies" created by Matta and Sánchez were meant to be historical reproductions of colonial originals, their individual artistic styles can be distinguished. Matta's fondness for texturing is evident in almost all of the clothing elements on his bultos while Sánchez's works indicate a smoothness of line and form. The carved reliefs of Emilio Padilla evoke a muralistic approach with regard to composition. Despite the obvious individual styles, the artists were all considered to be reproducing other works rather than creating original sculptures. As a result, their art was not completely embraced, with only a few exceptions:

> Probably the nicest items awaiting allocation at the present time are the santos and bultos carved in wood and painted by New Mexican artists in the manner of the earliest artists to come to "New Spain." San Miguel is there, various holy ninos [sic] and suffering Cristi. One enchanting little lady, her lips set in a line that show glistening white teeth, is discovered to be the patron saint of neurotica (quite at home in Santa Fe no doubt.) One carved panel honors Our Lady of Guadalupe in traditional design.[4]

At the same time that Matta, Sánchez, and Padilla were sculpting, a number of artists, not traced directly to the WPA, were also creating both wood and stone works with religious and secular themes during the PWAP and FAP years. They, too, received little artistic recognition. Only when they produced secular works did they warrant attention, albeit in patronizing tones. Artist Pablo Archuleta displayed his work at the Santa Fe Fiesta and received the following review:

> A display that attracted universal attention was the stone work of a very old Spanish man, Pablo Archuleta of Moses. The bust of Roosevelt was his masterpiece and has an artistic value.
>
> Mr. Archuleta does not pose as an outstanding sculptor, for he is absolutely untaught and works for his own pleasure and gratification. He uses native stone for his work, and his tools are hand made and very crude. His work is a marvel to all.[5]

The 1935 *Tewa Basin Study* mentioned one artist in Trampas who was a "fair wood-carver who averages some $15 per month on the sale of his work."[6] In San Luis, Colorado, an area better known for its weaving, a number of woodcarvers and sculptors worked:

We have recently discovered that we have in our Manual Training Class at San Luis a Spanish man of rare ability as a wood-carver. One may find in this man's home many interesting articles that he has made. Many of these have been made in the class shop. The teacher of this class can do this work and is doing a considerable amount of it at the present. One can readily see that in a class of this type much is being done toward the reviving of a nearly lost art of the Spanish people, the art of wood-carving.[7]

As previously mentioned, the Federal Art Project became extremely interested in reproducing the "authentic" New Mexican art form known as santos. "Santos" was an all-encompassing term that referred both to three-dimensional sculpture, or bultos, and one-dimensional painted or gesso relief renderings on wooden boards, called retablos. Art works were thoroughly researched and every attempt was made to use traditional materials and techniques. As was often the case with the WPA fabric arts, more attention was paid to the images and techniques than to the artists. The following example demonstrates this perception:

> I think the bultos and santos should have flannel sack made for them, otherwise they will be scratched by excelsior and other packing materials. You may be prepared to find these somewhat marred as the materials used are not at all permanent. We have been using the old method of finishing these with jaspe and egg, and the result is a convincing point as to the bad condition of the originals here.[8]

Indeed, the FAP exhibited the bultos around the state and the country in an effort to share the uniquely New Mexican artistic representations with America. Sculpture by New Mexican Hispano artists was exhibited at many of the nation's federal art centers

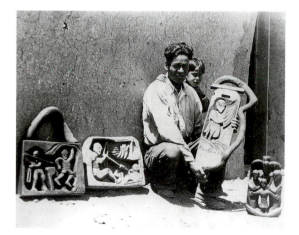

Patrocinio Barela and his son Luis (1936), Taos, New Mexico. Photo courtesy of E. Boyd Files 40 715, Museum of International Folk Art, a unit of the Museum of New Mexico, Santa Fe.

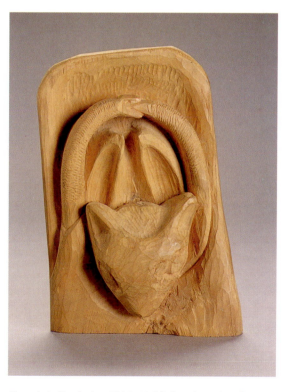

Patrocinio Barela (ca. 1900–1964), Bat *(1938), cedar, Taos, New Mexico WPA Project Purchase, Colorado Collection, CU Art Galleries, University of Colorado at Boulder. Photo © Colorado Collection, CU Art Galleries, University of Colorado at Boulder, by Larry Harwood.*

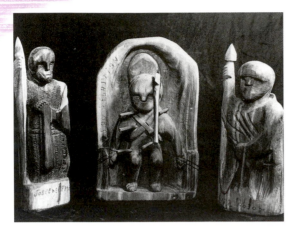

Patrocinio Barela (ca. 1900–1964),
Saint Sebastian Flanked by Two Soldiers (1938),
cedar, Federal Art Project, Taos,
New Mexico. Photo courtesy
of the National Archives,
neg. no. RG-69-AG-309
(Sculpture is in the
collection of the
Portland Art Museum).

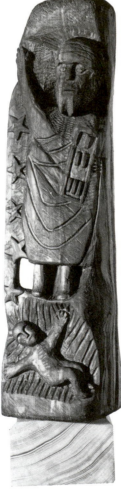

Patrocinio Barela
(ca. 1900–1964),
Ten Commandments
(1930s), wood,
Federal Art Project,
Taos, New Mexico.
Photo courtesy
of the National
Archives, neg. no.
RG-69-AG-999.

and galleries. Other venues included MoMA, the WPA building at the 1939–40 World's Fair, Howard University in Washington, D.C., and the de Young Museum in San Francisco. Additional examples were allocated to venues around the country. On March 4, 1939 "sculpture and woodcarvings" were sent to the Denver public school district.[9]

Patrocinio Barela (circa 1900–1964)[10]

Patrocinio Barela is the Hispano artist most often mentioned throughout WPA documentation. During the New Deal era, this Taos sculptor received national attention through exhibitions and the personal interest of FAP officials Russell Vernon Hunter and Holger Cahill. Barela was the first Hispano artist of the period to achieve national recognition and the first Taos artist of any ethnicity to be collected by MoMA.[11]

Barela was born in Bisbee, Arizona around 1900, to parents of Mexican descent. His mother died when he was a child and, by 1908, his father Manuel had moved Patrocinio and his brother, Nicolás, to the Taos area. Manuel Barela worked as a sheepherder and gradually became well-known as an "herb doctor." Patrocinio left home around the age of eleven and worked in Colorado and elsewhere as a day laborer and migrant worker. He returned to the Taos area in the early 1930s and married Remedios Josefa Trujillo y Vigil. He lived most of the rest of his life in Cañon, just outside of Taos.

In 1931, shortly after his marriage, Barela began to carve his evocative and mesmerizing wood sculptures. A popular account relates how Barela's career began when he either repaired the arm of a santo, or watched a friend repair a santo. This event in Barela's life inspired him to make his own santos, mostly from single pieces of wood so that parts such as appendages would not break off.

As the New Deal programs took effect, he applied

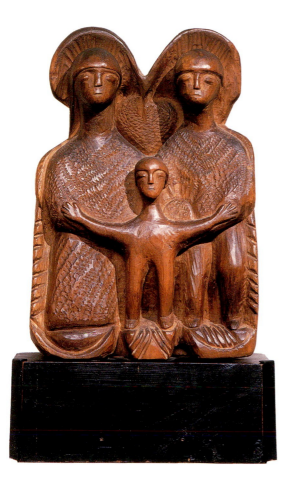

Patrocinio Barela (ca. 1900–1964), Holy Family *(February 1936), cedar, Federal Art Project, Taos, New Mexico. Franklin D. Roosevelt Library, Hyde Park, New York. Photo by Blair Clark.*

In the wood carving by Patrocino [*sic*] Barela, showing an over door panel decoration of the Twelve Apostles is well exemplified the native talent of our Spanish-American wood carvers, and suggests that much interesting architectural decoration could be introduced in our New Mexican homes by its use. He has also some very good bultos. Barela proves that he is a true artist in that he prefers to do his work at a lesswage [*sic*] than he could receive working on a road project. He is a real primitive and does not have to strive for an effect. It is hoped that he may always retain this primitive simplicity that many sophisticated artists try unsuccessfully to achieve.[13]

Barela's sculptures rapidly caught the attention of FAP administrators outside of New Mexico. In September 1936, seven of the following eight works—*Hope or the Four Stages of Man, God the Father, The Ten Commandments, Twelve Apostles, The Coronation of the Virgin, Heavy Thinker, Holy Family,* and *Santo Niño*—were featured in an exhibition titled *New Horizons of American Art* held at MoMA.[14] The sculptures were well-received and Barela was hailed by both the New York art world and critics, and suddenly catapulted into the national artistic limelight. Acclaimed by the press, he was called a "true primitive" and a "naïve genius." *Time* magazine called him the "discovery of the year."[15] MoMA issued its own release about the "New Mexican Teamster Art Sensation" and described him as an "early Romanesque sculptor strayed out of the eleventh century into the twentieth, to find his place in the Museum of Modern Art with a group of works larger than any other artists represented."[16]

for federal relief. A social worker went to his house on a required follow-up interview for his relief application and saw his work. After purchasing two pieces, the worker showed the sculptures to Russell Vernon Hunter, who was so taken with the sculptures that in 1935 he signed Barela on to the FAP. Except for the "18-month furlough release" when he left to go harvest potatoes in Colorado, Barela created art for the FAP until the program ended.[12]

In the Spring of 1936, a number of his sculptures and reliefs were exhibited at the Museum of Fine Arts in Santa Fe. One relief in particular caught the attention of Federal Writers' Project writer Ina Sizer Cassidy:

Across the country, the *San Francisco News* picked up on the press release and supplied their own article, "Laborer Becomes Sensation as Wood Carver":

> Fortunately, Pat does not know that he has strayed from the 11th Century into the 20th. He lives his primitive life in Taos Canyon, close to the people he has always known. The dreams of his mind are obeyed by his fingers and his knife, and pieces of mountain cedar become saints and angels.[17]

Other reviews likened Barela's work to African wood sculpture, Easter Island statues, early Christian reliefs, and Henry Moore sculptures. It was even said that Henry Moore had some of Barela's work in his own collection.[18] At one point, Harry Hopkins, FDR's right hand man and chief administrator for the WPA, was so taken by the aforementioned *Holy Family* after seeing it at the MoMA exhibition that he personally requested it for his office in Washington, D.C.[19] Later, on a trip through Santa Fe, Hopkins asked to meet with Barela.[20] The *Holy Family* is now in the collection of the Franklin Delano Roosevelt Library and Museum in Hyde Park, New York.

Not long after the MoMA exhibition, art dealers began contacting FAP administrators in Washington, D.C. and Santa Fe about representing Barela in galleries. Hunter and Cahill both felt the need to protect him from these dealers. Among the large quantity of correspondence between the two men are a number of letters that discuss Barela's "naïveté." However, one letter gives him more credit than the others:

> Pat has had several requests of a similar nature, and he is both skeptical and reluctant—perhaps wise, because I think he is more aware of the status of his stuff than we might believe. To one request he stated: "The lady better come out and see them. If I bought a pair of shoes I'd want to see them first."[21]

During the New Deal era, the nationwide attention Barela got became so intense that even Hollywood wanted to promote this "primitive artist." In a 1960s interview, Joy Yeck Fincke, Hunter's assistant, commented on Tinsel Town's interest:

> Then there was an article about Pat Barela in *Time Magazine* and then Hollywood got on it. They decided that they would make this spectacular thing about this secluded woodcarver and we had a terrible time keeping him from that. . . . So, we really had to protect him. He was awfully childlike. Not stupid, but just naïve and childlike.[22]

Like the Hollywood anecdote, this quote demonstrates how Barela was treated by his Anglo patrons and how they perceived his inability to function in a "civilized" society.

In 1939, Barela's *Life* was exhibited in the contemporary art building at the World's Fair in New York. The work was the only sculpture out of thirty-one works selected by the New York World's Fair governing committee for purchase. The committee included such notable art experts as Holger Cahill, Juliana Force (Whitney Museum of American Art), A. Conger Goodyear (MoMA), Harry B. Wehle (Metropolitan Museum of Art), and Laurance P. Roberts (Brooklyn Museum of Art). Once it was purchased, it was immediately donated by the fair to the University Museum in Philadelphia.

Throughout the New Deal, his works were exhibited in many other venues that included the M. H. de Young Museum in San Francisco and the Portland Art Museum in Portland, Oregon. Aesthetic factors contributed greatly to Barela's acceptance as a modern artist. His undulating natural wood sculptures appealed particularly to the modernist "fine art" sensibilities in vogue at that time. Primitivism was all the rage and artists like Picasso and Matisse intentionally tried to

Patrocinio Barela (ca. 1900–1964), Horse and Rider *(1950s), juniper, Taos, New Mexico Museum of International Folk Art, a unit of the Museum of New Mexico, Santa Fe (A.1992.87.2). Photo by Blair Clark.*

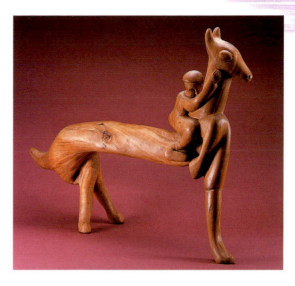

incorporate true "primitive" characteristics into their work. At the time Barela was sculpting, "primitive" art was considered the epitome of the avant garde. The term was, and still is, used to refer to art created by untrained artists and children or work that is not derived from anything. Application of this Eurocentric term implied the art of the "other" and, in terms of modern art, meant specifically the art of non-western cultures. The contemporary art climate categorized Barela as a "primitive" artist. His sculpture straddled the "high" and "low" art border and he was simultaneously seen as both a "folk" and a modern artist. Descriptions of the artist and his work, such as "Patrocino [*sic*] Barela—modern primitive—wood carver," reflected this juxtaposition.[23]

His work, carved out of local woods that included juniper and cedar, was extremely introspective.[24] Barela's creative themes usually dealt with life, family, inner struggle, religious imagery, and morals. Although English was his second language, Barela described many of his works in his own words for exhibition texts and other descriptions of his pieces. Perhaps the most poignant is one that accompanied his *Hope or the Four Stages of Man,* in the MoMA exhibition. It is reproduced here with all grammar and spelling as it appears in the original:

> Man lives four different kinds of life in his life—when he is a boy and when he is a man, and then middle man and then old man. And those have been my ideas to carve a bulto to show the life of man in these carvings.
>
> Man is born and created by laws of nature and so he born all by himself and then he hope for the hope he has been waiting. Then comes

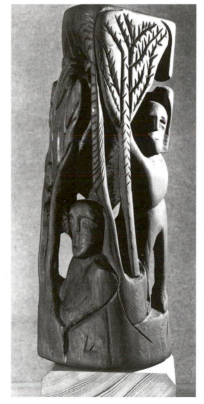

Patrocinio Barela (ca. 1900–1964), Hope or The Four Ages of Man *(1930s), wood, Federal Art Project, Taos, New Mexico. Photo courtesy of the National Archives, neg. no. RG-69-AG-1000 (Sculpture is in the collection of the Portland Art Museum).*

number two which means it is a son which has been reproduced by him and is only half the man he should be, but then after, he grown to be a man and that means number three. Number two and three make a complete man and he grows like the tree that is by his side—large and strong in life full of happiness and full of hope. But then comes number four—that man is growing older and he has gone through life. He has work and struggle and now he is old, tiresome, and weak.

Same way with the tree by his side. He older, his branches and leaves have fallen, his beauty gone. So tree only appears to be a pole or a bare post. The trees have grown in the same way of man. When the tree that is carved near the bulto number four there is no more hope so that the life of the tree died and there was no more beauty. Nothing left but bare branches. That was my idea. So under those way I carved the following bulto to show the different parts of a man's life.[25]

Early in 1942, as the United States headed into World War II, the FAP became the Graphic Section of the War Services Division and the artists were directed to explore and create only war-related themes. Barela took on the assignment and created a series of seven (at least) dramatic bas relief panels featuring guns, military tanks, soldiers, airplanes, aircraft carriers, the American flag, and even a map of Tokyo Bay. In January 1943, Russell Vernon Hunter was "disbursing project materials." He wrote to Holger Cahill, now chief of the Cultural Section of the War Services Division about Barela's war-related art that is now on permanent loan to the National Museum of American Art:

Some weeks ago I suggested to Pat Barela that he turn his production thoughts to war situa-

tions. We now have about a dozen carvings done on this subject, one of which is the finest piece that he has done, I think.[26]

As he did with FAP painter Pedro Cervántez Hunter took a great deal of credit for his "discovery of Pat Barela." According to Joy Yeck Fincke, "Certainly he would have been a complete unknown had he not been discovered by the art project."[27] It seems unlikely that without Hunter's interest, Barela would have gone through life without any sort of recognition. A number of Taos artists and shopkeepers collected and sold his work early in the artist's career. Since Taos was such a well-known artistic and literary center, sooner or later, someone would have pushed Barela into a larger arena. At one point he worked on Mabel Dodge Luhan's house in Taos. According to Taos businessman Harold Street, it was Luhan who encouraged Barela to make larger and bolder pieces.

Barela's art has defied exact categorization. His sculptural works do transcend pigeon-hole classification of what is New Mexican Hispanic religious sculpture. Nor do they fit easily into other European constructs of Romanesque and Primitive Modern art. Barela was unaware of art world trends. Rather, he sculpted vital images out of his own need for artistic expression. His works visually narrate his own thoughts and struggles. Formed and yet unformed, Barela's advice, beliefs, dreams, expectations, and ideas emerge out of wood with unexpected twists and turns. Natural knotholes, for example, become knees, mouths, and pipes. While much of his imagery is recognizable, many figures and shapes and the stories behind them remain unnamed. Some of the text Barela kept to himself.

Patrocinio Barela continued to carve until his tragic death in October 1964, the result of a fire in his studio. His works are in the collections of The Albuquerque Museum; the Franklin Delano Roosevelt Library and Museum in Hyde Park, New York; the Harwood

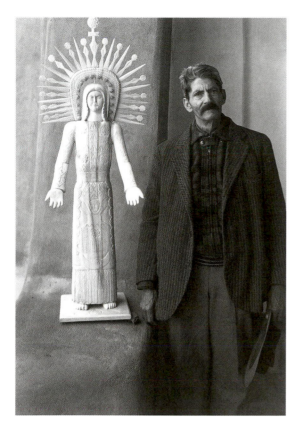

recovered and embraced. A poster that featured a 1989 portrait of Barela by Edward Gonzales was the image that was chosen for the National Association of Chicana and Chicano Studies (NACCS) conference in 1990. In 1996 and 1997, a traveling exhibition of Barela's art presented a selection of forty sculptural works. The exhibition accompanied the release of Edward Gonzales and Thomas Witt's book, *Spirit Ascendant.* In 1999, Vicente Martínez, a curator at the Millicent Rogers Museum, organized another exhibit of Barela's work titled *Barela: Recordando un Artista del Pueblo* (Remembering a Village Artist) which was designed to bring Barela's work back to the *gente* (people). In addition to serving as an inspiration to many Chicano/Hispano/Latino scholars and artists, Patrocinio's legacy lives on in the artwork of his grandchildren and great-grandchildren.

José Dolores López (1868–1937)

José Dolores López, a farmer from Córdova, began his artistic career making furniture. His father was a carpenter who passed the tools of the trade to his son. The younger López mastered the skills needed to create chairs, chests, nichos, cabinets, corner cupboards, and screen-door frames and his furniture was often painted in bright colors. López's other works included crosses for grave markers, coffins, corbels, boxes, and towel racks.

In the 1920s, Frank Applegate "discovered" López and his ornately detailed work, and strongly encouraged him to leave his art unpainted.[28] Later, Applegate and Mary Austin encouraged López to make religious images. So, rather than using color as a means for artistic expression, López began texturing his bultos and "clothed them with carving" rather than fabric or paint.[29]

Foundation Museum at the University of New Mexico; Howard University; the Kit Carson Historic Museum; the Martínez Hacienda; the Millicent Rogers Museum in Taos; the Museum of Fine Arts in Santa Fe; the Museum of International Folk Art in Santa Fe; MoMA; the National Museum of American Art; the Panhandle-Plains Museum in Canyon, Texas; the Portland Art Museum; the Roswell Museum and Art Center; the San Francisco Museum of Modern Art; Taylor Museum of the Colorado Springs Fine Art Center; the University of Arizona Museum of Art; the University of Colorado at Boulder; University Museum in Philadelphia; and in many private collections.

In recent years, Barela's work has been recognized again for its contributions to the wider category of Chicano and Latino contemporary art. He is the first of the Hispana and Hispano WPA artists to be

José Dolores López (1868–1937), Abe [sic] del Paraíso (ca. 1933), aspen, Public Works of Art Project, Córdova, New Mexico. Collection of the Taylor Museum of the Colorado Springs Fine Arts Center, on permanent loan from the United States Government. Photo by Blair Clark.

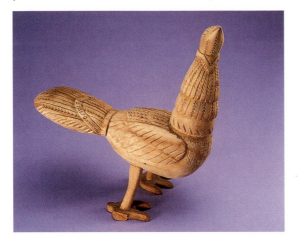

The finely chip-carved details distinguish López's work from other artists at the time. His utilization and application of such meticulous embellishment may have been the result of his knowledge of filigree jewelry.[30] As a result of his style, he is generally considered to be the founder of the Córdovan tradition of carved natural wood.

Applegate and Austin were among the founding members of the Spanish Colonial Arts Society, the cultural entity that started Spanish Market and continues to sponsor it today. When Spanish Market first began in 1926, it was held in conjunction with the Santa Fe fiestas in September. López participated in many of the earlier markets. One small article in the *Santa Fe New Mexican* had this to say about the artist:

One of the most remarkable things ever seen in the Spanish Fair, in the patio of the art museum, is the Adam and Eve group by Jose Dolores Lopez [*sic*], the wood carver of Cordova [*sic*], a high type of primitive art, which greatly impressed all visitors. The display also includes a group of Joseph and Mary

and other biblical scenes, with many quaint carved animals, leaf-necklaces and other speciments [*sic*] of the woodcarver's genius.[31]

The use of terms such as "primitive" and "quaint" once again provides a glimpse of the cultural context in which Hispano sculpture was viewed in 1932.

López also created a number of sculptures for the PWAP.[32] Although the PWAP was short-lived and functioned only for some six months in 1933 and 1934, he sculpted two exquisite works during that time. One of the PWAP works, *Our Lady of Light,* is perhaps his most famous. The sculpture is finely patterned and conveys both a bold and delicate presence. The halo (or crown) exemplifies López's use of intricate motifs. The other piece either created for the PWAP, or purchased with PWAP funds, was *Adam and Eve;* it included a tree with the infamous serpent. Again, López's meticulous application of small carved details is evident in the leaves of the tree and foliage. The inscription at the tree's base, carved in both Spanish and English, reads "The Tree of Life of the Good and Bad." Both works are in the collection of the Taylor Museum of the Colorado Springs Fine Arts Center. López may have made an additional work for the WPA. An undated PWAP roster of "Artists and Craftsmen" lists López as a "woodcarver" who was paid to do a total of three pieces, two of which were still in Washington at the time the roster was compiled.[33]

Jesse Nusbaum, state PWAP director, discussed López and his work in an interview with Sylvia Loomis:

One of the fine things we had was done by the famous old woodcarver at Cordova [*sic*], and I never saw a man more pleased in my life. He had done several things but his best carving was a very elaborate one of the Garden of Eden and the Tree with Adam and Eve . . . this was José Dolores López. And when he got the carving finished he brought it down here

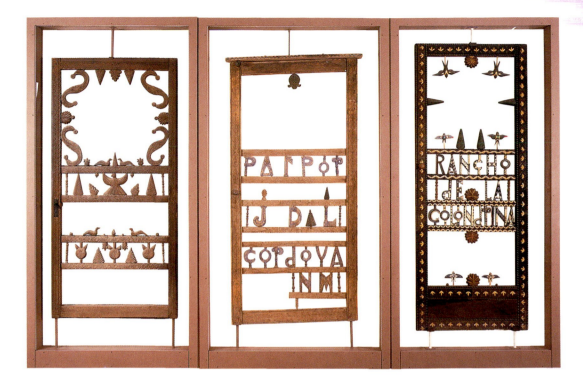

José Dolores López (1868–1937). From left to right: Carved Door (1929); Main Door to the Artist's Home (late 1920s); Door from Rancho de las Golondrinas (ca. 1930), Córdova, New Mexico. Left door in Spanish Colonial Arts Society, Inc. Collection on loan to the Museum of International Folk Art, a unit of the Museum of new Mexico, Santa Fe. Center door in the Fred Harvey Collection of the International Folk Art Foundation, Museum of International Folk Art, a unit of the Museum of New Mexico, Santa Fe (FA.1975.24.1). Right door gift of Bill and Julie Dougherty, collection of the Museum of International Folk Art, a unit of the Museum of New Mexico, Santa Fe (A.1997.55.1). Photo by Blair Clark.

in an old car to the Park Service and he said he wanted the President to see it.[34] FDR and his wife Eleanor did see López's *Our Lady of Light* and *Adam and Eve* in the PWAP exhibition held at the Corcoran Gallery of Art in Washington, D.C. from April 24, 1934 to May 20, 1934. López's religious sculptures received a somewhat confused and mixed reception. Jesse Nusbaum commented:

> When the people back East tried to write about some of this primitive art—Like Lopez' carving out of white cedar wood—we had some pretty bad stories on that. They didn't understand it.[35]

Easterners perhaps did not understand López's sculptural representations or, by extension, the ethnic identity of the artist who created them. In the Corcoran exhibition, López and his work were categorized under Indian Arts and exhibited alongside pottery by María and Julian Martínez as well as with paintings by Pablita Velarde and Tonita Peña.[36]

The same case of "mistaken identity" occurred later in another Washington, D.C. exhibition. The 1937 Rural Arts Exhibition held on the patio of the U.S. Department of Agriculture building also demonstrated the confusion with which Hispano artists were viewed at that time. The caption on the back of one of the official exhibition photos of *Our Lady of Light* found

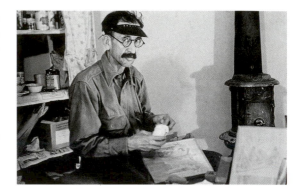

in the Library of Congress reads "Religious Figure made by Indian." José Dolores López's name is not on it.

In 1983, Belisario R. Contreras, the Chilean-born New Deal art scholar, interpreted and described *Our Lady of Light*. He mentioned that sculptor López was interested in folk mythology and expressed the Hispanic-Indian culture in this work. Contreras wrote:

> Lopez [*sic*] imparts an exotic, baroque quality to his *Our Lady of Light*, particularly in the motif of an elaborate headdress with its illuminated lightrays [*sic*]. The decorative designs—angel, moon, and flower—are repeated throughout the long robes of the figure.[37]

In 1935, the *Tewa Basin Study* referred to López as a woodworker and emphasized the commercial importance and artistic quality of his art: "the best money in the village is made by a woodworker, whose work has become quite famous. This man is working on an art basis, however, and is undoubtedly somewhat of a genius in his line."[38] Another New Mexican account, which also discussed López's work, listed José Dolores López as a "sculptor" and described its artistic merit:

> A native wood carver. At present one of a few and perhaps the last of the Santo makers. These Santo makers traveled all over the state in the days when hand carved and painted images of the saints were appreciated. His Garden of Eden is one of those startling things hard to place artistically, while somewhat naïve it is neither old or modern—it just is.[39]

López was not only an enormously talented sculptor and artist. He was a deeply spiritual man and a member of the Penitente Brotherhood. He was intimately involved with his community in Córdova. Later in his life, López was described by fellow Córdovan resident, Lorin Brown of the Federal Writers' Project:

> Don José was tall and slender, with the assurance and poise of the born gentleman. His were finely molded features with black intensely compelling eyes surmounted by a high forehead above which iron gray hair swept back in a thick and well-combed pompadour. The fine, sensitive mouth of the artist was framed by the points of a thin mustache. Long lines running from the sides of his aquiline nose to his chin accentuated the lean, tapering face. His complexion was a light brown from much exposure to the sun and rain. Lines at the corner of his eyes bespoke a man of understanding with a sense of humor.[40]

López died in 1937 from injuries he suffered in an automobile accident. He left behind an artistic legacy and a new, contemporary Hispano artistic tradition.

Santiago "Sam" Matta (dates unknown)

Little is known about Santiago Matta, a sculptor and fourth-generation santero who learned his art from family members.[41] Some say he was not Nuevomexicano, while others say he was a native of Río Arriba County. In either case, he was much older than many other artists and workers when he began work with the FAP.[42]

Santiago, or "Sam," Matta was hired by the

Museum Extension Project, a WPA component of the FAP to produce "copies" of colonial santos.[43] In terms of his style, the majority of his bultos and retablos were polychrome. However, he also created a number of carved relief panels in natural wood, both painted and unpainted, including *St. Jerome,* which is in the Museum of International Folk Art in Santa Fe. A New Deal–era article in the Museum of New Mexico's *El Palacio* magazine announced the completion of a large group of polychrome sculptures for the Museum Extension Project:

> The work of carving the "Santos" of New Mexico by Sam Matta is now completed. This set will comprise two rotating exhibits. The individual labels and descriptions are being written and the exhibit will go on the circuit starting with Carlsbad the latter part of May. A future article in *El Palacio* will be devoted entirely to this very interesting expression of New Mexican art.[44]

Another *El Palacio* article appeared three months later and elaborated on the artistic qualities of the pieces:

> In all there are twenty copies in uniform size, good examples of the more conspicuous New Mexican Santos, done free-hand, using the characteristics of the original only as a guide for style. They are being used to compose two rotating exhibits for the branch museums.[45]

The first group of traveling santos included San Ysidro, Nuestra Señora de Dolores, San Francisco, La Santísima Trinidad, San Gabriel, El Santo Niño de Chimayó, San Pedro, San Cristóbal–Offero, Nuestra Señora de Guadalupe, and Crucifixión.

Group two included another Guadalupe, a Nuestra Señora, La Conquistadora, San Antonio de Padua, San Pascual [*sic*], San Miguel, San Rafael, Santiago, La Sagrada Familia on their flight into Egypt, and another representation of Christ on the Cross.[46]

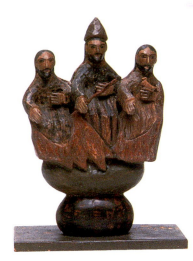

Santiago Matta (dates unknown), Holy Trinity *(1939), hardwood, gesso, and paint, Works Progress Administration, Museum Extension Project, Santa Fe, New Mexico. Gift of the Historical Society of New Mexico to the Museum of New Mexico, Museum of International Folk Art, Santa Fe. Photo by Blair Clark.*

Santiago Matta (dates unknown), San Francisco *(1939), hardwood, gesso, and paint, Works Progress Administration, Museum Extension Project, Santa Fe, New Mexico. Gift of the Historical Society of New Mexico to the Museum of New Mexico, Museum of International Folk Art, Santa Fe. Photo by Blair Clark.*

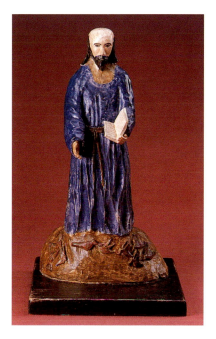

Out of the twenty sculptures, only five have been located. These are San Ysidro, San Francisco, La Santísima Trinidad, Nuestra Señora de Dolores, and one of the Crucifixions. These five works are in the collections of the Museum of International Folk Art in Santa Fe. A sixth work, one of the two Vírgenes de Guadalupe sculpted for the Museum Extension Project, was only recently identified in the collections of the Palace of the Governors, the history museum on the Santa Fe Plaza.

Completed May 16, 1939, Matta's twenty FAP sculptures traveled in two groups around the New Mexico museum circuit to all sorts of venues, like the Carlsbad Municipal Museum.[47] The works remained in each museum "for a period of time sufficient to enable the people of the community to see and study an art that is New Mexico's own."[48]

Despite the fact that Matta used original colonial santos as "style guides" for his own WPA art, the excellent quality of his polychrome sculptures was not noted as often as were the works of his FAP colleagues Patrocinio Barela and Juan Sánchez. E. Boyd often criticized Matta's "reproductions" and those of other artists who were paid to reproduce colonial originals and create didactic versions of the santos. However, she hailed the artistic quality and originality of his other works:

> One of the men so engaged was Santiago Mata [sic], a native of Rio Arriba County. Although his efforts to copy old painted santos left much to be desired, he had an innate ability to carve. His original compositions in wood or stone followed the patterns of earlier New Mexican santeros.[49]

Perhaps Matta's creative talent was curbed because he was required to make specific sculptures. He found it difficult to "copy" santos, but when he was allowed to work in his own style and utilize his own subject

Santiago Matta (dates unknown), Nativity (ca. 1930s), limestone, Santa Fe, New Mexico. Collection of the Museum of International Folk Art, a unit of the Museum of New Mexico, Santa Fe. Photo by Blair Clark.

matter, Matta's artistry became worthy of remark. In a 1964 oral interview, Boyd commented positively on Matta's skills outside of official WPA work: "Incidentally, while working on his own he did some quite interesting original things in the field of 20th century folk sculpture. His copies make you weep, and he was most prolific."[50]

Upon completion of the twenty WPA santos, Matta was again hired as an artist on another WPA/FAP Museum Extension Project. For this project, he carved the Stations of the Cross. The reliefs, created on unstained wood panels, were originally framed with bold smooth wooden frames that displayed crosses on top. Matta finished the first and second stations in February 1940.[51] The entire series of the stations, sans frames, is now in the collections of the Museum of International Folk Art.

Again expressing his own artisic preferences, Matta carved religious images in stone, and his works are reminiscent of relief sculpture. Carved into the backs or bases of most of these sculptural works are the words "Trabajo de Mano por S. Matta."[52] Among his known New Deal relief works are El Velo de Verónica (Veronica's Veil), dated between 1937 and

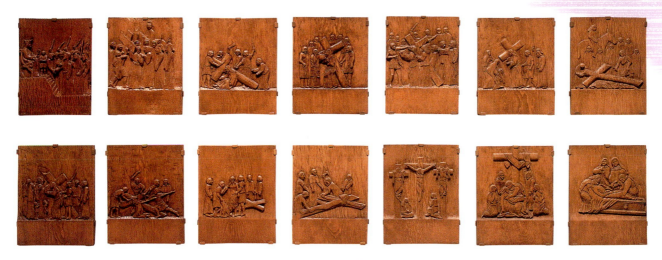

Santiago Matta (dates unknown), Stations of the Cross *(1940), hardwood, Works Progress Administration,*
Museum Extension Project, Santa Fe, New Mexico. Gift of the Historical Society of New Mexico
to the Museum of New Mexico, Museum of International Folk Art, Santa Fe. Photo by Blair Clark.

1941, *Crucifixion,* and *Nativity. Veronica's Veil* is now on permanent display in the Hispanic Heritage Wing at the Museum of International Folk Art. The two other works are in the museum's other collections. Matta's stone works are intricately executed and indicate an intimate knowledge of the type of stone he chose. His *Crucifixion* is a provocative stone relief with delicate yet bold details. Christ's facial features are finely sculpted, as are his ribs, fingers and feet. The entire crucifixion scene emerges from the stone, but somehow remains a fixed part of the base. The effect is similar to Barela's wood sculptures whose figures both emerge and retreat into their wooden surroundings. Matta's artistic mastery of different media is evident when the stone Crucifixion is compared to one of his wood sculptures of the same subject matter. The polychrome bulto demonstrates the same careful attention to detail. Christ's draped body against the cross is realistically portrayed. Christ's face and ribs are sculpted in exquisite detail, conveying his physical pain.

Recently, new information has come to light that Santiago Matta was also a painter. At least one of his

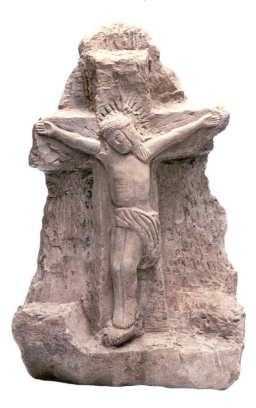

Santiago Matta (dates unknown), Crucifixion *(ca. 1930s), limestone, Santa Fe, New Mexico. Collection of the Museum of International Folk Art, a unit of the Museum of New Mexico, Santa Fe. Photo by Blair Clark.*

Santiago Matta (dates unknown), Untitled Landscape *(ca. 1930s), possibly hand-mixed pigments on board.*
Collection of Matilde Garcia Archuleta. Photo by Blair Clark.

oil-on-board northern New Mexico landscapes has been identified in a private collection. The painting's owner, who knew the artist, recalled that he often mixed his own paints and pigments.[53]

It seems likely that Santiago Matta may have been the same Santiago Mata [*sic*], an informant for Lorin Brown, a bilingual researcher and writer for the New Mexico FWP. Brown worked for the PWA and the NRA prior to his FWP service. He met "Santiago S. Mata" in Santa Fe, who was probably Santiago Matta. The artist was an active member of La Liga Obrera de Habla Español (League of Spanish-Speaking Workers) at the time.[54] La Liga was a newly formed labor movement that had chapters in many smaller Nuevomexicano villages.[55] Matta may have been the source for the FWP's story of *El león y el hombre* (The Lion and the Man) that Brown collected in September 1938.[56]

Emilio Padilla (1913–1970)

Emilio Padilla was born in Springer, New Mexico and moved to Santa Fe as a child. According to one account, he had "been a carver since the time he could pick up a knife."[57] At the age of fourteen, he began formal art training with Howard Kretz Coluzzi, an artist and muralist. Painter Eliseo Rodríguez remembers working with Emilio Padilla in the WPA/FAP art studios in Santa Fe.[58] The two artists may have studied together at the Santa Fe Art School since Rodríguez was also a student of Coluzzi's prior to the FAP. It was Coluzzi who provided Padilla with a letter of introduction to Mary Austin. She in turn facilitated his introduction to the local PWAP administrators.[59]

Among the works that Padilla created for the WPA, one piece in particular—a large relief of St. George—received special attention in a number of minor articles:

Emilio Padilla (1913–1971), Don Diego de Vargas
*(1934–1936), pine, Public Works of Art Project
and Federal Art Project, Santa Fe, New Mexico.
Coronado State Monument, a unit of the Museum
of New Mexico, Santa Fe. Photo by Blair Clark.*

*Emilio Padilla (ca. 1960), Santa Fe, New Mexico.
Photo courtesy of Margarita Padilla Lyngen.*

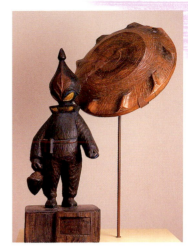

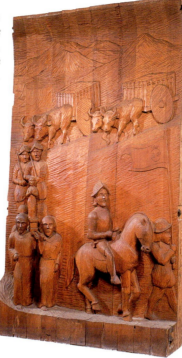

Emilio Padilla (1913–1971),
Aropeighertzipog *with his*
Flying Saucer *(1964), redwood,
Santa Fe, New Mexico. Collection
of Nino and Nancy Padilla.
Photo by Blair Clark.*

A young man not overly competent as a wood carver, but Mary Austin inspired him to carve a St. George in high relief for the Old Museum in Santa Fe. For want of more time the project is languishing at the moment. Neither he nor Mary Austin knew what it meant to carve a built up block of wood one by four by six feet. It will be completed eventually and take its place as an expression of native crafts.[60]

It appears that this work was created under both PWAP and FAP funding. In PWAP records, Padilla is listed as carving a "Large wooden panel, 6 ½' by 3' 8" x 1' which was to be completed "on [his] own time" and then was to be "placed in the NM Museum Santa Fe."[61] Furthermore, the high relief of "Saint George" may have been misidentified in the article. Instead of a carved image of "Saint George," the work may be Padilla's sculpted depiction of Diego de Vargas and his second occupation of Santa Fe in 1695. In 1936, the comple-

tion of this work, "produced under the public works of art project and works progress administration," was announced in *The Western Artist:*[62]

A gifted young native sculptor, Emilio Padilla of Santa Fe, has completed a wood sculpture of the reconquistador, Don Diego de Vargas.

The relief is on a block of New Mexico pine.[63]

The clay model of the carved work began January 18, 1934.[64] Padilla was 23 years old when he completed the Vargas relief that was "executed on a block of New Mexico pine, one foot thick, four feet wide, and six and a half feet high" and was completed in March 1936.[65] Despite support from Howard Coluzzi and Mary Austin, Padilla was not categorized as an artist on the PWAP. Instead, according to the following account, he was placed in a lower artistic bracket. He even had to pay for his own studio space for the Vargas relief project:

Padilla entered into art as a profession during

the low point of the depression, when most of the artists in the country were just barely scraping out an existence on tiny project checks issued by the government under its Public Works Administration. Padilla got on the program, in its lowest bracket and completed his gigantic wood carving in a studio he rented in one of the houses on the south side of the Alameda—where the State Park Commission is located now. The government paid him $16.00 a week while he was working on it.[66]

Although the Vargas relief was completed in 1936, two years after the PWAP ended, Padilla's name and address (827 Palace Avenue in Santa Fe) are listed in the final PWAP report released in June 1934.[67] The report also lists the number of works completed for the project, including "2 wood carvings" and "4 sculptures."[68] At least two of these were *Our Lady of Light* and *Adam and Eve* by José Dolores López. Padilla may have created an additional three works for the program.

Upon completion, Padilla's large relief panel, (then sponsored by the Historical Society of New Mexico), was installed in the wall of the D.A.R. room, just left of the entrance to the library at the Palace of the Governors.[69] Mary Austin is credited for suggesting a historical theme and for selecting the location for the piece.[70] At the time it was created, the work was described as having been executed in a technique bearing "close affinity to that of old woodcarving done in the early days of New Mexico."[71] The subject matter and visual narrative were also mentioned:

The young sculptor has shown the figure of De Vargas on horseback after passing the Franciscans, who are bearing the image of "Nuestra Senora de la Conquista," about to pass the flagbearer. Directly behind the representatives of the church are two soldiers, symbolizing Spain's military power, followed by oxen and oxcarts, the most extensively used mode of transportation in De Vargas' day.[72]

In the sculpture, Padilla visually conveys the expanse and terrain Vargas and his party crossed as they traveled through what was then the northern frontier of New Spain. Such distance and landscape is rendered completely in wood but is similar in composition to the historical murals of the American scene that were simultaneously applied to the walls of state and federal buildings in the United States. Padilla's sense of artistic perspective (and his formal training) is evident in his placement of the exquisitely carved figures of Vargas, the priests, the soldiers, and even the oxen. The texturing of the *carreta* (cart) wheels portrays a sense of movement and pageantry.

In the early 1950s, the Vargas relief was removed from the wall and kept in the Palace of the Governors' courtyard for several months. It then disappeared for a number of years, and at one point was even thought to have been burnt by a museum guard. In 1954, the artist noticed that the work had been removed, and he launched a campaign to recover it and reinstall it in its original location. A flurry of legal activity followed. Padilla asked for access to the work and demanded to know what had happened to it. After a number of visits to the museum and after receiving no response from museum staff, he retained a Santa Fe law firm, McKenna and Sommer, to back up his request.[73]

The Vargas piece had suffered "considerable deterioration," after it was eventually located in one of the Museum's storage areas.[74] Padilla apparently offered to restore the work and perhaps regain ownership. Because of the complexities involved with the government-sponsored arts and property rights, letters were written by Museum of New Mexico administrators to Holger Cahill and Dorothy Miller at MoMA

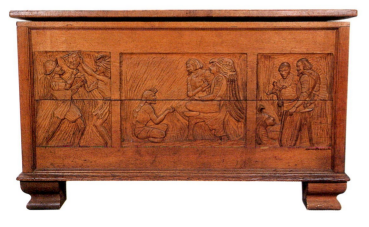

Emilio Padilla (1913–1971), Carved Caja (1930s), pine and cedar, Santa Fe, New Mexico. Gift of Filmore and Janet Rose in memory of Dorothy Alfson who commissioned this work to the Museum of International Folk Art, a unit of the Museum of New Mexico, Santa Fe (A.1999.39.1). Photo by Paul Smutko.

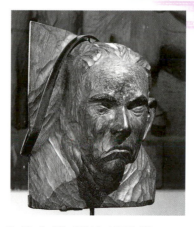

Emilio Padilla (1913–1971), Vincent van Gogh *(ca. 1960s), redwood, Santa Fe, New Mexico. Collection of Thane Padilla. Photo by Blair Clark.*

in an effort to determine who had legal ownership of the piece. To date, the piece is still in the collections of the Museum of New Mexico.

During his FAP career, Padilla also carved three-dimensional religious-themed sculpture. E. Boyd mentioned that Padilla created replicas of colonial pieces like his contemporaries, Santiago Matta and Juan Sánchez. Although not yet positively identified, a bulto of San Ysidro in the collections of the Museum of International Folk Art may be Padilla's work. The piece was used for a long time as a museum prop; it is labeled as such on the underside of the base. The rounded shape of San Ysidro's head and of the angel are similar to the sculpted figures in the Vargas relief. In addition to his large carved relief panels and his three-dimensional sculptures, Padilla may also have carved Stations of the Cross for the Museum Extension Project, for the Museum of New Mexico. A WPA photograph from the National Archives shows a young artist carving one of the stations. Santiago Matta was an old man at the time, so the artist may have been Padilla. If it is indeed Padilla, the whereabouts of Stations of the Cross are unknown.

According to his son Nino, Padilla was "an artist by trade and completed many sculptures and carvings but found it necessary to take other jobs in order to make a living."[75] Padilla continued to sculpt during his lifetime. By 1954, he was reapplying his artistry as a draftsman for the New Mexico State Highway Department.[76] He also continued to try to get his Vargas masterpiece reinstalled in Santa Fe. Nino Padilla stressed these convictions in a statement regarding the history of the piece:

> This piece of art belongs in Santa Fe in the Palace of the Governors and I will do whatever it takes to get it back in its rightfull [*sic*] location. It was my father's request and the public should have the piece back in the Capital City where it bears significance.[77]

No documentation has been uncovered to suggest that Padilla was given permission to restore his own work. In 1983 his son restored the work, which is currently on exhibit in the visitors' center and museum at the Coronado State Monument in Bernalillo, New Mexico.

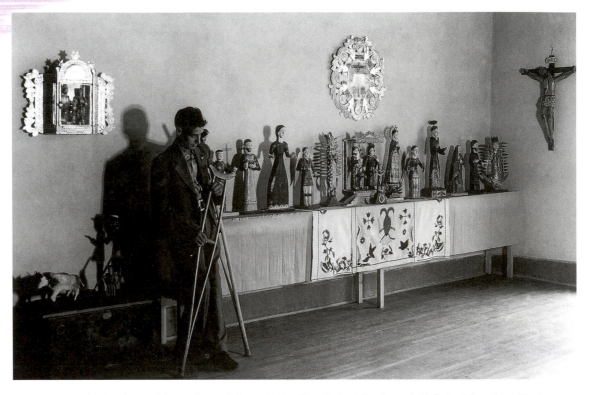

Juan Amadeo Sánchez with his work on exhibit at the Las Vegas Federal Art Center (1936), Las Vegas, New Mexico.
E. Boyd Files 97 2157, Museum of International Folk Art, a unit of the Museum of New Mexico, Santa Fe.

Juan Amadeo Sánchez (1901–1969)

Juan Sánchez received substantial mention, but far less critical attention, than his FAP colleague, Patrocinio Barela. Unlike the latter, Sánchez was not given the freedom to create his own works. Instead he was hired as a copyist and earned his government salary by carving and painting replicas of colonial New Mexican religious sculpture. His santos, both retablos and bultos, were specifically created to be exact replicas of existing colonial examples found in museum and private collections and eventually in northern New Mexico churches and chapels.

Sánchez was born in Río Pueblo, a community near Taos, and grew up in Colmor, New Mexico, a small town situated on the Colfax and Mora county lines.[78] At the age of twelve, he was the victim of a malicious prank instigated by other boys. He was locked in a box with the lid nailed shut for hours. This episode affected him for the rest of his life because he developed rheumatism as a result of the confinement. The rheumatism led to a severe partial paralysis.

His disability also affected how his sculpture and painting skills were perceived. Rather than completely acknowledging his artistic talent, the media and WPA administration considered Sánchez a rehabilitation case rather than a talented artist. Russell Vernon Hunter often took pride in acknowledging his discovery of Sánchez's talents and for helping him deal with his handicap through art. As a combined result of these circumstances, it was difficult for Sánchez's art to receive the recognition it might have were he not disabled.

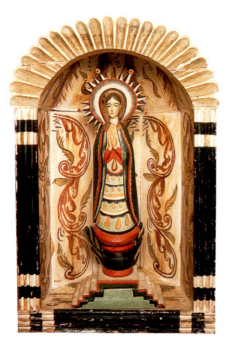

Juan Amadeo Sánchez (1901–1969), Nuestra Señora de la Luz en Nicho *(ca. 1939), wood, gesso, and paint, Federal Art Project, Colmor, New Mexico. Gift of the Historical Society of New Mexico to the Museum of New Mexico, Palace of the Governors, Santa Fe. Photo by Blair Clark.*

In describing his visit to the new San Miguel Federal Art Center in Las Vegas in September 1937, Holger Cahill provided an example of how the FAP portrayed this artist:

> Among their work is a group of Santos by a Project artist named Juan Sanchez [*sic*] who is an interesting rehabilitation case. Seriously crippled from his early childhood, Mr. Sanchez [*sic*] has had a very difficult time of it, and during recent years has been tried out with indifferent success on a number of W.P.A. projects. He seems to have found himself in making a sculptural record of the old New Mexican santos, a very interesting form of votive sculpture, and he appears to be most happy in his work, and improving all the time.[79]

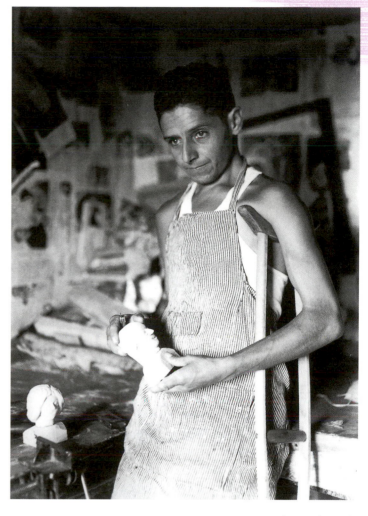

Juan Amadeo Sánchez in his Studio (ca. 1930s), probably Colmor, New Mexico. E. Boyd Files 90 199, Museum of International Folk Art, a unit of the Museum of New Mexico, Santa Fe.

Juan Amadeo Sánchez (1901–1969), Santa Librada *reverse side (1938), pine, gesso, and paint, Federal Art Project, Colmor, New Mexico. Gift of the Historical Society of New Mexico to the Museum of New Mexico, Museum of International Folk Art, Santa Fe. Photo by Blair Clark.*

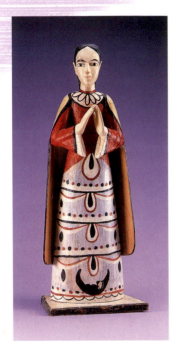

Juan Amadeo Sánchez (1901–1969),
La Inmaculada (1940), wood, gesso, and paint,
Federal Art Project, Colmor, New Mexico.
Gift of the Historical Society of New Mexico to the
Museum of New Mexico, Palace of the Governors,
Santa Fe (10751/45). Photo by Blair Clark.

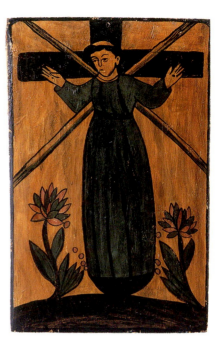

Juan Amadeo Sánchez (1901–1969),
San Felipe de Jesús (late 1930s), wood, gesso, and
paint, Federal Art Project, Colmor, New Mexico.
Gift of the Historical Society of New Mexico to the
Museum of New Mexico, Palace of the Governors,
Santa Fe (10747/45). Photo by Blair Clark.

Joy Yeck Fincke also commented on the combination of Sánchez's disability and "craftsmanship":

> Juan had an affliction of his spine and he was not able to bend. One of his family drove him around and they fixed kind of a leaning board in the car. When he got out of the car he walked on crutches, but he was an able craftsman and he did some marvelous examples of these old santos.[80]

The reproduction of colonial religious imagery was somewhat problematic. It raised many issues about appropriation, authenticity, and the desire for the ancient, if only in copies. The reproductions were meant to be used for secular purposes in traveling exhibitions both locally and nationally, and in museums in WPA buildings such as the Roswell Federal Art Center (now the Roswell Art Museum). Sánchez took on the responsibility for the creation of religious reproductions for state and federal buildings with grace and artistic sensitivity. He was always careful to sign his name to the backs of his retablos or the bottoms of his bultos. He often included the words "Copied for the WPA." Sánchez traveled to churches and chapels all around northern New Mexico to find sources for his FAP work:

> The santero is completing a nicho from the Taos Church which should be included, and it is a matter of getting through the snow to get it. He is now at Trampas, where the best of old things are, and he also has some others which should be included.[81]

Sánchez used the traditional techniques of Spanish Colonial New Mexican art in his work. He carved his own boards and applied gesso before painting the images on the retablos. His three-dimensional sculptures, or bultos, were also gessoed before he applied paint mixed from Alabastine dry colors, egg yolk, and water.[82]

Sánchez made over a hundred pieces of art for the FAP.[83] Examples from this large body of work were exhibited in New Mexico and around the country. As

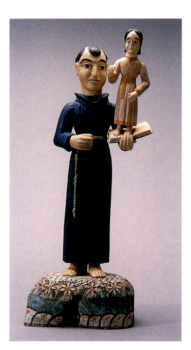

Juan Amadeo Sánchez (1901–1969),
San Antonio y el Niño Jesús *(late 1930s),*
Federal Art Project, wood, gesso, and paint,
Colmor, New Mexico. Gift of the Historical
Society of New Mexico to the Museum of New
Mexico, Museum of International Folk Art,
Santa Fe. Photo by Blair Clark.

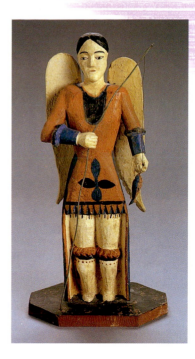

Juan Amadeo Sánchez (1901–1969), San Rafael,
Archangel *(1937), Federal Art Project, wood,*
gesso, paint, Colmor, New Mexico. WPA Project
Purchase, Colorado Collection, CU Art Galleries,
University of Colorado at Boulder, photo ©
Colorado Collection, CU Art Galleries, University
of Colorado at Boulder, by Larry Harwood.

one might surmise, sculptures and retablos exhibited in Santa Fe received a lot of attention from area artists and writers. After viewing one exhibition by project artists, Alfred Morang wrote:

> The Santos by Juan Sanchez are remarkable in form and a kind of half-submerged power that rings far truer than could any obvious stressing of emotional intensity. This artist seems deeply interested in his material and either consciously or subconsciously makes constructive use of limitations.[84]

A large exhibition of Sánchez's work was held in Las Vegas, New Mexico at the San Miguel Federal Art Center. A series of official FAP/WPA photographs were taken of the exhibition and of the artist standing next to the exhibition. These were the same works Holger Cahill saw at the center in September 1937. The exhibition also included Eddie Delgado's tinwork and Eliseo Rodríguez's reverse painting on glass. Amidst the other works, Sánchez's sculptural grouping of the Holy Family is installed in Delgado's tin nicho.

Among Sánchez's known FAP bultos are *Immaculate Conception* (July 1939), *Immaculate Conception* (1940), *Jesús Nazareno* (June 6, 1937), *Nuestra Señora de la Luz en Nicho* (ca. 1939), *San Francisco* (ca. 1939), *Saint Gertrudes* (March 1942), *San José en Nicho* (ca. 1939), and *San Juan* (August 1938). All are in the collections of the Palace of the Governors. The San Juan bulto was loaned to the Denver public schools and also used in the art reference collection until the 1980s.[85] The work has been returned to the Museum of New Mexico.

The Museum of International Folk Art also has a number of Sánchez's religious sculptures including *San Ysidro, San José,* and *San José y el Niño Jesús.* The *San Ysidro Labrador,* with plow and oxen, was completed May 15, 1937. A photograph features this work in a nicho with two other retablo-like images hanging from the back of the nicho.[86] As evidenced by the official FAP information card attached to the base

of the sculpture, *San José y el Niño Jesús* was completed in 1942, and may have been one of his last FAP works. The figure of the Niño is missing. From archival photos, it is known that he also sculpted *San Acacio, San Rafael,* and a *Santa Bárbara with Tower.* Sanchez's *St. Peter* is a copy of the nineteenth-century sculpture by José Rafael Aragón, which at the time it was "copied" resided in the church in Córdova.[87]

Sánchez also painted a prolific number of retablos for the FAP. His *San Miguel Archangel* dates from the late 1930s. It was painted after a San Miguel retablo attributed to the school of Rafael Aragón (1840–1870). Other works include *Christ on the Cross/El Cristo Crucificado, San Antonio* (June 15, 1938), *San Felipe de Jesús* (took 4½ hours to complete),[88] *San Ramón Nonato* (April 1938), *Santa Librada* (April 1938), *Santa Rita,* and *Our Lady of Sorrows* (July 15, 1938).[89]

At least six of Sánchez's bultos and two retablos that the FAP gave to the Museum of New Mexico in 1943 were discarded in January 1953, possibly by E. Boyd, because they had "disintegrated" or were in "poor" condition.[90] The bultos included a large *Cristo crucificado* (completed March 1937), *Nuestra Señora de las Conzojas* [sic] (completed September 1937), *San Acacio* (completed in 1941), *San Antonio* (completed June 1, 1937), *San Juan (Baptist) with bowl* [sic] (completed June 15, 1938), and *San Roque.* The retablos included a large *Nuestra Señora de Guadalupe* and *Queen of Heaven.* Both of these were completed in 1942 at a cost of $25 each.[91]

Sánchez also carved elaborate nichos for many of his santos. He "copied" a large nicho from the original in the Ranchos de Taos Church in November 1938.[92] Another intricately carved nicho was patterned after one in the Truchas church. The nicho originally held the bulto of La Inmaculada Concepción. The *bulto en nicho* traveled around the U.S. as part of the exhibition circuit. During its travels, the large nicho was temporarily lost in transit for approximately a month between September and October 1941.[93]

In his 1994 Master's thesis on Juan Sánchez, Tom Reidel challenged the idea that he merely copied original art works. Reidel demonstrated how Sánchez's work deviated from colonial santos in many ways. The artist often added a detail or element, subtly changed the colors or background, or stylized flowers. During the WPA, Sánchez did not receive critical acclaim. Because his works were commissioned as copies, they could only be considered as such and thus were not dealt with as original art.

His *Cristo Crucificado* retablo is a reproduction of a work by Pedro Antonio Fresquís, also known as the Truchas master (1749–1831). Sánchez's rendition is taller and thinner than the board on which Fresquís painted his image. Sánchez stylized the flower arrangements on either side of Christ and also changed the border. His artistic changes were subtle and utilized many elements within the New Mexico santero tradition. Sánchez's changes went unnoticed by WPA administrators. As more colonial sources are located, further art historical analysis will substantiate the incorporation of Sánchez's own stylistic elements into his pieces. Until this takes place, however, his works can be distinguished from those of, say, Santiago Matta, whose sculptures were much smaller. Sánchez's sculptured and painted works indicate a careful attention to detail, especially in the delicate facial expressions of the santos and gessoed folds of their clothing. Furthermore, Matta preferred to texture the clothing on his figures while Sánchez utilized more painted details in order to convey the same patterns and draping.

In addition to his carving and sculpting abilities, Sánchez is also listed as one of the artists on the *Portfolio of Spanish Colonial Design.* According to Reidel, Sánchez painted some of the actual *Portfolio* plates,

but "it is impossible to determine which ones."[94] Sánchez may also have been one of the many water-colorists who received outlined *Portfolio* plates to hand-color and fill in or he may actually have rendered some of the original designs for which E. Boyd was given credit. It is possible that examples of his sculptured and painted works were copied and used for illustrations for the *Portfolio.*

Strangely, Sánchez did not consider himself a santero. Although he was a very religious man, he believed that his creations were appreciated more for their artistic and historical significance than for their religious qualities. Still, he was aware that he was perpetuating colonial history and Hispano culture when he reproduced the religious imagery of New Mexico. In an unpublished paper, he wrote:

> Even though I have to deal with some physical disabilities, God has granted me the ability to reproduce this old Colonial art, and I live in hopes that my work may be kept for many centuries, so that future generations may see what colonial-New Mexican santos were.[95]

A 1966 *New Mexico Magazine* article referred to Sánchez as "one of the few santeros left in New Mexico."[96] The article also stated that after spending six years traveling around and studying and copying bultos and retablos for the Federal Art Project, Sánchez settled down and took special orders in his Raton, New Mexico studio. He sold his work via stores in Chimayó, Santa Fe, and Taos. An example of his later work can be seen in the *nacimiento* (nativity) purchased in the 1960s by Alexander Girard, a well-known folk art collector. Girard's enormous collection was given to the Museum of International Folk Art in Santa Fe. Until recently the nacimiento was inexplicably stored with the Polish collection at the Museum of International Folk Art. It is now housed with the rest of Sánchez's work in the museum's collection area.

Juan Sánchez continued to make retablos and bultos until his death in Raton in 1969. His known polychrome sculpture and other works are in the collections of the Museum of International Folk Art and the Palace of the Governors in Santa Fe, in the Raton museum, the Taylor Museum of the Colorado Springs Fine Arts Center, the University of Colorado at Boulder, the Denver Art Museum, and the Roswell Museum and Art Center. Some of his pieces are in private collections.

The contemporary art of Nuevomexicana/o sculptors and santeras/os is not a recent art movement. It is deeply rooted in the expressive natural and organic forms of Patrocinio Barela, the intricately detailed works of José Dolores López, and the polychrome and relief sculptures of Santiago Matta, Emilio Padilla, and Juan Sánchez. Without the artistic talents and efforts of these, and many other New Deal–era artists, the art of colonial and contemporary New Mexico would not intersect.

Notes

1. I have coined the term "Plaster Statue Myth" in an effort to call attention to the common belief that people stopped producing santos and retablos after the 1880s with the arrival of the railroad. I believe, as do many others, that there was an overlap in these artistic traditions from 1880 to the so-called "revival" period. Future research will help to restore this period of Nuevomexicano art history as well.

2. In the last few years, scholarly work on Hispano WPA sculptors has begun. Thomas Reidel's research has been overlooked because it is in thesis form. Reidel was one of the first researchers to recover a portion of this misplaced component of American art history. In researching his thesis, he conducted oral interviews and contacted living relatives of Juan Amadeo Sánchez. The full citation for this work is Thomas L. Reidel, "'Copied for the W.P.A.': Juan A. Sánchez, American Tradition and the New Deal Politics of Saint-Making" (Master's thesis, University of Colorado, 1992). *Spirit Ascendant: The Art and Life of Patrociño Barela* by Edward Gonzales and David L. Witt, (Santa Fe: Red Crane Books, 1996), is the other work that deserves recognition. Gonzales, a Chicano artist from New Mexico, and Witt, of the Harwood Museum in Taos, pooled their research on Barela and co-authored a retrospective of his life and work. Their book, (and Reidel's thesis), is the first in-depth scholarly work devoted entirely to Hispana or Hispano artists who worked for the WPA.

3. E. Boyd, "Notes from E. B. Notebook on FAP Job," 6 November 1963, E. Boyd Papers, Archives of American Art, Smithsonian Institution, Washington, D.C. (hereafter AAASI), 2.

4. "Doña Tarabilla in Santa Fe," n.d., miscellaneous newspaper article in the Vernon Hunter Clippings, 1940–1960, AAASI. Due to the incomplete description, it is difficult to ascertain which works, if any in this account, have been identified and attributed. A number of pieces (mentioned later here) by Santiago Matta, Emilio Padilla, and Juan Sánchez are in the collections of the Museum of New Mexico, Roswell Museum and Art Center, and the Taylor Museum of the Colorado Springs Fine Arts Center.

5. Carrie L. Hodges, "Art—Northeastern NM," 21 March 1936, WPA File no. 155, New Mexico State Records Center and Archives, Santa Fe, New Mexico (hereafter NMSRCA). Unfortunately, to date, the bust of Roosevelt has not been located. Existing photographic images indicate that some Hispano WPA sculptors (Juan Sánchez and Patrocinio Barela) carved representations of other famous Anglo figures including George and Martha Washington.

Barela also created images of Russell Vernon Hunter and George Washington. Both are pictured in Gonzales and Witt's book, *Spirit Ascendant.*

6. Marta Weigle, ed., *Hispanic Villages of Northern New Mexico: A Reprint Volume II of the 1935 Tewa Basin Study with Supplemetary Materials* (Santa Fe: The Lightning Tree Press, 1975), 204.

7. "Excerpt for Colorado Narrative Report," 20 August 1936, WPA Information Service, Vocational Handicrafts, Record Group (hereafter RG) 69, National Archives, Washington, D.C. (hereafter NA).

8. Russell Vernon Hunter to Mildred Holzhauer, 10 November 1938, box 53, FAP Office of the National Director, Correspondence with State and Regional Offices, WPA Central Files, RG 69, NA.

9. Joseph A. Danysh to Thomas C. Parker, 27 June 1939, Box 53, FAP Office of the National Director, Correspondence with State and Regional Offices, RG 69, NA.

10. Although the theory has been put forth that Patrocinio's name should have been spelled "Patrociño" with a tilde over the "n" and no "i," the Barela family continue to spell his name as Patrocinio.

11. This observation was made by artist Edward Gonzales in *Sprit Ascendant* and in a panel discussion at the New Mexico Art History Conference in Taos in October 1996. Gonzales and Witt also reiterate throughout their book that Barela was the first "Mexican American" artist to achieve a high degree of national recognition.

12. Russell Vernon Hunter to Holger Cahill, 2 January 1940, box 1931, May 1941–Feb. 1942, WPA Central Files, RG 69, NA.

13. Ina Sizer Cassidy, "WPA Artists Display at Santa Fe Art Museum," *The Reporter,* WPA for New Mexico, April 1936, box 1935, WPA Central Files, RG 69, NA, 21.

14. "List of Sculptures," Holger Cahill Papers, "Exhibitions," AAASI.

15. "Relief Work," *Time,* 21 September 1936, 42–43.

16. "New York Hails Barela Wood Carvings," *El Palacio,* vol. XLI, no. 14–16 (1936), 84.

17. Emilia Hodel, "Laborer becomes Sensation as Woodcarver," *San Francisco News,* 3 October 1936.

18. Gonzales and Witt, *Spirit Ascendant,* 50.

19. Russell Vernon Hunter to Harry L. Hopkins, 30 October 1936, box 1919, 1935–44, WPA Central Files, RG 69, NA.

20. "New York Hails Barela's Woodcarvings," 83–84.

21. Russell Vernon Hunter to Holger Cahill, 2 January 1940.

22. Sylvia Loomis interview with Joy Yeck Fincke, 9 January 1964, Albuquerque, N.Mex., AAASI, p. 9 of transcript.

23. "List of Taos Artists," Holger Cahill Papers, box 4 of 8, AAASI. For additional reading on the definitions of "primitive" in terms of art and culture, see Colin Rhodes, *Primitivism and Modern Art* (London: Thames and Hudson, 1994) and Marianna Torgovnik, *Gone Primitive: Savage Intellects, Modern Lives* (Chicago: University of Chicago Press, 1991).

24. Gonzales and Witt provide a thorough explanation of the local woods in and around the Taos area. See *Spirit Ascendant,* chapter three, 178n13.

25. Russell Vernon Hunter, "Concerning Patrocinio Barela," in *Art for the Millions: Essays from the 1930s by Artists and Administrators of the WPA Federal Art Project,* ed. Francis V. O'Connor (Greenwich, Conn.: New York Graphic Society, Ltd., 1973), 96.

26. Russell Vernon Hunter to Holger Cahill, 8 January 1942, box 1924, WPA Central Files, RG 69, NA. The letter is dated 1942 but it was probably written January 8, 1943. The typist may have forgotten to implement the new year in the date. The letter also mentions the possibility that some of these works may have been allocated to the "Santa Barbara Museum." In the May 1996 publication by the United States General Services Administration (GSA), WPA Art Work in non-Federal Repositories does not list any of Barela's sculptures in the Santa Barbara Museum of Art's entries.

27. Loomis interview with Joy Yeck Fincke, 9 January 1964, N.Mex., p. 19 of transcript.

28. For an excellent and thorough treatise on José Dolores López and the effects of his "discovery," see Charles L. Briggs, *The Woodcarvers of Córdova, New Mexico: Social Dimensions of an Artistic "Revival"* (Albuquerque: University of New Mexico Press, 1989). Briggs was one of the first scholars to directly address the intricacies of Anglo-Hispano artistic and cultural interactions during the early part of the twentieth century. Briggs stated that "The profound effect that outsiders' discovery of José Dolores exerted on the development of the industry renders them major actors in the artistic drama and merits brief description" (p. 44).

29. Unpublished and undated article possibly by Mrs. Meredith Hare, titled "José Dolores López: The Wood Carver of Córdova," Holger Cahill Papers, AAASI, 4.

30. Charles L. Briggs, *The Woodcarvers of Córdova, New Mexico,* 31.

31. *Santa Fe New Mexican,* Tuesday, 6 September 1932, 1.

32. In his book (1989), Briggs states that "the Lópezes were never employed by the F.A.P. Nevertheless, several of José Dolores's more ambitious pieces were purchased with Federal Art Project funds, and both his and George López's works were exhibited in traveling shows in the U.S. under the sponsorship of F.A.P. director Holger Cahill. Charles L. Briggs, *The Woodcarvers of Córdova, New Mexico,* 86. This author would like to note that López's works were not exhibited by the FAP but rather by the PWAP, which functioned before the FAP was in existence. See especially "National Exhibition of Art by the Public Works of Art Project," Exhibition Catalog, WPA Misc. Vertical Files, National Museum of American Art/National Portrait Gallery Library, Smithsonian Institution, Corcoran Gallery of Art, Washington, D.C., 1934.

33. "List of Craftsmen and Artists," PWAP, Collections of the Laboratory of Anthropology, Museum of New Mexico, Santa Fe, n.d. (probably sometime between late 1933 and the end of 1934), 2. The works mentioned that were in Washington were most likely *Our Lady of Light* and *Adam and Eve,* and may have been the objects exhibited at the Corcoran.

34. Loomis interview with Jesse L. Nusbaum, 12 December 1963, Santa Fe, N.Mex., AAASI, p. 14 of transcript.

35. Ibid., 14. In contrast to Barela's sculptural works with their smooth clean lines and surfaces, the ornately patterned and carved figures López made were indeed unique to the establishment art worlds which, at the time, were focused on the "primitive" art of Africa, Easter Island, Oceania, and Mesoamerica. López's baroque but delicate adornment provided a different style.

36. "National Exhibition of Art by the Public Works of Art Project," (Washington, D.C., Corcoran Gallery of Art, 1934), 14.

37. Belisario R. Contreras, *Tradition and Innovation in New Deal Art* (Lewisburg, Pa.: Bucknell University Press, 1983), 95–96.

38. Weigle, Marta, ed., *Hispanic Villages of Northern New Mexico,* 107.

39. "The Spanish American Craftsmen," n.d., WPA File no. 155, NMSRCA.

40. Lorin W. Brown, *Hispano Folklife: The Lorin W. Brown Federal Writer's Project Manuscripts* (Albuquerque: University of New Mexico Press, 1978), 207.

41. "Branch Museum News: Santos on Exhibit," *El Palacio,* vol. 46, no. 7 (July 1939): 163. If what the article stated was true and Matta was indeed a fourth-generation santero, then members of his family were creating sculpture before, during, and after New Mexico became a territory.

42. Ibid.

43. Matta's name frequently appears in different versions and spellings in WPA documentation: Santiago Matta, Sam Mata, and Santiago Mata are all used in reference to this artist. He often signed his works "Trabajo de Mano por S. Matta."

44. "Branch Museum Program," *El Palacio,* vol. 46, no. 5 (May 1939): 108.

45. "Branch Museum News: Santos on Exhibit," 163.

46. Ibid., 164.

47. The date May 16, 1939, appears on photographs of the bultos in the WPA Photograph Collection, AAASI.

48. "Branch Museum News: Santos on Exhibit," *El Palacio,* vol. 46, no. 7, (July 1939): 165.

49. E. Boyd, *The New Mexico Santero* (Santa Fe: Museum of New Mexico Press, 1972 reprint), 23.

50. Loomis interview with Elizabeth Boyd, 8 October 1964, AAASI, transcript.

51. Image and text in WPA Photograph Collection, Microfilm roll 1168, AAASI.

52. Santiago Matta Vertical File, Museum of International Folk Art Library, Museum of International Folk Art, Santa Fe, N.Mex.

53. I'm deeply grateful to Teresa Archuleta Sagel and her mother, Matilde Archuleta, for bringing this important information to my attention. It adds a whole new dimension to Matta's work and supports the point that he was indeed a talented "fine" artist.

54. Brown, *Hispano Folklife in New Mexico,* 19.

55. Santiago Mata and Santiago Matta may indeed be one and the same, since before Lorin Brown went to work on the Writers' Project, he worked for approximately a year and a half for Brice Sewell of the State Department of Vocational Education. Brown's job was to help hire artists for some of the vocational schools near Santa Fe. See Brown, *Hispano Folklife of New Mexico,* 19.

56. Brown, *Hispano Folklife of New Mexico,* 129.

57. Dave Weber, "Arts and Artists," *Santa Fe New Mexican,* Sunday, 27 June 1954.

58. Interview with Eliseo and Paula Rodríguez, 19 March 1997, Santa Fe, N.Mex.

59. "Interesting Woodcarving in Museum," *El Palacio,* vol. 40, no. 22–24, (June 1936), 121.

60. "The Spanish American Craftsmen," n.d.,

61. "List of Craftsmen and Artists," PWAP, Collections of the Laboratory of Anthropology, Museum of New Mexico, Santa Fe (hereafter MNM), 2.

62. "With the Artists," in *The Western Artist,* vol. no. 3/4, (June 1936): 10.

63. Ibid.

64. "Interesting Woodcarving in Museum," 121.

65. Ibid.

66. Weber, "Arts and Artists."

67. Public Works of Art Project, "Report of the Assistant Secretary of the Treasury to Federal Relief Administrator, December 8, 1933–June 30, 1934" (Washington, D.C.: United States Printing Office, 1934), 78.

68. Ibid.

69. "Interesting Woodcarving in Museum," 121.

70. Ibid.

71. Ibid.

72. Ibid.

73. "Memorandum for the record," 29 June 1954, initialed DSK for the Museum of New Mexico, Files of the Coronado State Monument, Bernalillo, New Mexico (hereafter FCSM).

74. Boaz Long (museum director in Santa Fe), to Holger Cahill (MoMA), 16 August 1955, FCSM.

75. Handwritten statement by Nino Padilla, 31 May 1983, FCSM.

76. "Memorandum for the record," FCSM.

77. Handwritten statement by Nino Padilla, FCSM.

78. Tom Reidel, "New Deal Saint-Making: Juan A. Sánchez and the Federal Art Project," paper presented at the New Mexico Art History Conference, 1 November 1996, Taos, New Mexico, 4. My heartfelt thanks to Tom Reidel for graciously supplying me with a copy.

79. Holger Cahill memo to Mrs. Woodward regarding field trip to the Pacific Coast, 11 September 1937, Holger Cahill Papers, AAASI, box 10 of 10, 2.

80. Loomis interview with Joy Yeck Fincke, 9 January 1964, Albuquerque, N.Mex., AAASI, p. 14 of transcript.

81. Russell Vernon Hunter to Mildred Holzhauer, 10 November 1938.

82. Juan A. Sánchez, "My Reproductions of New Mexican Santos," Appendix A in Reidel, "'Copied for the W.P.A.,'" 135.

83. Russell Vernon Hunter to Florence Kerr, (assistant WPA commissioner), 10 March 1942, WPA Central Files, RG 69, NA. The letter includes a "survey of our accomplishments in New Mexico." Under the category of sculpture the survey lists "Fifty pieces of wood-carving by Patrocino [sic] Barela" and "One hundred reproductions (painted bultos) of saints of the Spanish-Colonial hagiocracy [sic], made by Juan Sanchez."

84. Alfred Morang, "WPA Art Projects Disclose Many Persons with Talent," miscellaneous newspaper article, 24 May 1940, microfilm roll 3028, Vernon Hunter Clippings, AAASI.

85. Federal Art Project Information Label from bottom of bulto, object number 10052/45, Collection of the Palace of the Governors, MNM.

86. E. Boyd Vertical Files, Museum of International Folk Art, Santa Fe, N.Mex.

87. William Wroth "Hispanic Craft Revival in New Mexico," in Janet Kardon, ed., *Revivals! Diverse Traditions 1920–1945 : The History of Twentieth Century American Craft* (New York: Harry N. Abrams, Inc., Publishers in association with the American Craft Museum, 1994), 93.

88. Information written on back of work, object number 10747/45, Collection of the Palace of the Governors, MNM.

89. The retablos listed here are in the collections of the Museum of International Folk Art and the Palace of the Governors. Both entities are units of the Museum of New Mexico in Santa Fe. *Santa Rita* took six and a half hours to complete.

90. Accession Record Data Cards, Palace of the Governors, MNM. In February 1998, Diana De Santis, curator at the Palace of the Governors and Robin Farwell Gavin, curator at the Museum of International Folk Art, identified the handwriting on the data cards as E. Boyd's.

91. Accession Record Data Cards, Palace of the Governors, MNM. The *Cristo Crucificado* was 37 ½". It was completed at a cost of $50. *Nuestra Señora de las Conzojas* [sic] was 22" and was completed at a cost of $5; *San Acacio* was 21" and cost $10; *San Antonio* was 18" and cost $5; *San Juan with Bowl* was 20" and cost $15; and *San Roque* was 18" high and cost $10.

92. Label and date written by Juan A. Sánchez on the top left side of nicho, which is in the collections of the Palace of the Governors in Santa Fe.

93. Series of letters between Russell Vernon Hunter, Walter M. Kiplinger, and James J. Connelly, 9 September 1941, 16 September 1941, 24 September 1941, and 1 October 1941, box 53, FAP Office of the Director, Correspondence with State and Regional Offices, WPA Central Files, RG 69, NA.

94. Reidel, "New Deal Saint-Making," 5.

95. Juan A. Sánchez, "My Reproductions of New Mexican Santos," unpublished paper in the collection of Sánchez's niece, Mary Ellen Ferreira. Full text cited in Reidel, "'Copied for the W.P.A.'"

96. "People and Places," *New Mexico Magazine,* (June-July 1966), 37.

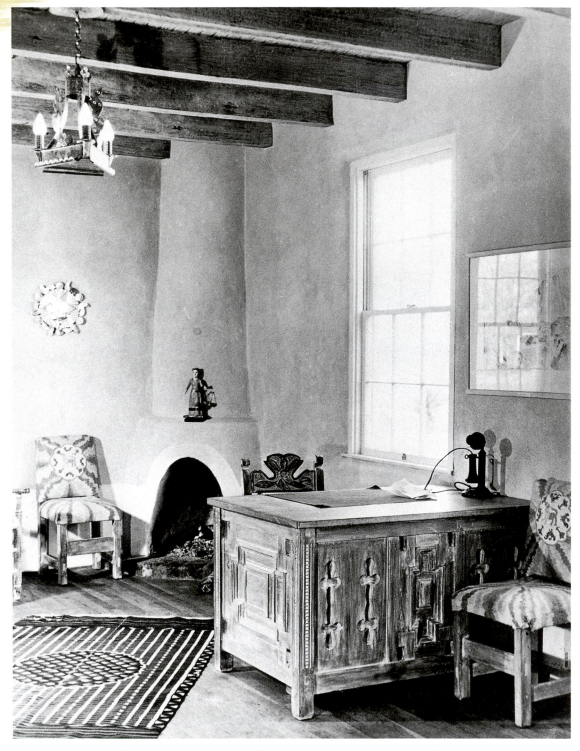

*Roswell Federal Art Center's Main Office (ca. 1937), Roswell, New Mexico. Photo courtesy
of the Archives of American Art, Holger Cahill Papers, Smithsonian Institution.*

American art is a highly varied one,

using as it does the cultures of many peoples.

If properly managed and encouraged,

it is on a threshold of a new highly successful era.[1]

Conclusion

WHEN THE FEDERAL ART PROJECT ENDED in March 1942, its activities transferred to the Graphic Section of the War Services Division. From October 1942 to April 1943, the final incarnation of the FAP fell under the direction of the Graphic Section of the Division of Program Operation. During this time all art projects not related to U.S. military services ceased operation. The closure included the FAP, the *Index of American Design*, museum exhibitions, and "decorative art and craft work" not specifically requested by defense agencies.[2] The artistic aspects of the WPA tried to adapt to the changes. The new directive prompted Russell Vernon Hunter to issue a memo that stated:

> When the Federal Art Project started under WPA, it was the policy to give creative workers all possible leeway in assignments. Every attempt was made to secure assignments suitable to their temperaments, and to allow them to work where most convenient for them.

Hunter continued: "The strictly creative work has already been curtailed, and we are trying to redirect all Art Unit work into channels of need in War Service."[3]

In New Mexico as in the rest of the nation, the various art programs were dramatically curtailed as they began to engage in only war- and defense-related activities. In Albuquerque, the large lithography and printing program began to produce war-related posters in Spanish that were then distributed throughout the state as well as in Texas, California, and Puerto Rico. Across New Mexico, officers' clubs on military bases were decorated and furnished. Hunter left the New Mexican FAP and with Eddie Delgado and Eliseo Rodríguez went to Clovis to help create usable art for the officers' club at Cannon Air Force Base. Delgado made all the tin chandeliers and Rodríguez, along with some other artists, constructed the wooden furniture for the space.[4] To a limited extent, the re-directed art program provided art classes for soldiers as leisure-time activities to enhance morale. As the various arts-related components began to shut down, decisions were made regarding what to do with government-funded art works. In April 1943, the Central Allocation Unit in Chicago began assigning FAP works to public institutions and museums, usually at only the cost of shipping. As a result, many works by Hispana and Hispano artists including Patrocinio Barela, Pedro Cervántez, and Edward Chávez ended up in public and private collections across the country.

Esquípula Romero de Romero (1889–1975), Devotion
*(ca. 1932), oil on panel, Albuquerque, New Mexico.
Collection of John Dillon Fillmore, Santa Fe.
Photo by Blair Clark.*

The majority of Hispano artists who had partici-
pated in the WPA served their country during World
War II, in one form or another. They adapted their
artistic skills to war-support techniques such as drafting
and repair work. They served as soldiers and support
staff. Aesthetics also played a roll in job assignments.
Abad Lucero repaired aircraft while painter Edward
Chávez carried out his duty by recording his war ex-
perience through his artistic medium. Hispano artists
of the WPA joined hundreds of other Nuevomexicanos
in defending their country. So successful were they
that the army was prompted to comment: "They have
fallen in on an equal plane with the English speaking
men and more than hold their own."[5]

The New Mexico State Department of Vocational
Education also shifted its focus to wartime activities.
Those Hispanas and Hispanos who had begun the
program learning wood-working, tinwork, and
weaving were put to work applying those skills to
wartime purposes. In Las Vegas the vocational pro-
gram at Highlands University trained students to
make machine parts. WPA workers like Candido
Martínez, Manuel García, Rosendo García, Vidal
Bustos, Lucio Crespin, George Maes, Gabriel
Montoya, M. Madrid, and Eloy Castillo applied their
skills with lathes and solder to create joint bearings,
nuts, and bolts.[6] Beginning in late November 1941 and
continuing through early 1943, hundreds of
Hispanos trained by the vocational schools were
bussed to southern California by the WPA. Some were
transferred to Seattle, Washington, to share their
skills with the defense industry. Southern California
needed trained and skilled men immediately and the
Hispano vocational school students provided much-
needed support. A semi-monthly activity report
dated December 31, 1942 indicates that the New
Mexican Division of Training and Re-employment
of the WPA assigned 165 men and 66 women to
vocational training in welding, aircraft riveting, and
metal machine operating. Although she (or they) re-
mains unidentified, the likelihood of at least one "Rosa
the Riveter" among this group of trainees exists. Fu-
ture research into the transition programs will recover
additional names and provide an idea as to how many
artists adapted their skills to war industry–oriented
vocational programs in New Mexico, which received
no funding after January 30, 1943.[7]

Upon their return to New Mexico after the war,
most of the Hispano WPA artists went back to non-
arts-related jobs in order to earn money, as the pro-
grams allowing them to utilize their artistic skills were
no longer available. Esquípula Romero de Romero,

the painter and muralist once accused of abusing the color "Russian Blue," started an outdoor sign business and later became a builder in Albuquerque. George Segura, the artist who created the stunning furniture for the Albuquerque Community Playhouse, became a dentist in Santa Fe. Eliseo Rodríguez, the painter, muralist and straw appliqué master, went to work for Southwest Master Craftsmen, a furniture company in Santa Fe. He also supervised cabinet-making courses at Agua Fría Vocational School at Saint Michael's College in Santa Fe. Pedro Cervántez, the highly praised painter, went to work painting signs in Clovis. The impact of WW II on the careers of these and other Hispana and Hispano WPA-era artists is an avenue for future research.

Exclusion did occur and was, for the most part, unintentionally perpetuated by the Anglo-oriented national and local WPA administrators and art world. Despite their attempts to help and "rehabilitate" the native Hispano population through the teaching and encouragement of "crafts," the WPA administration, with their attitudes toward Hispano art, successfully kept Hispana and Hispano WPA artists from full inclusion in American art history. Additionally, the perceptions about the ethnic identity of native Spanish-speakers in New Mexico is indicative of cultural misunderstandings imposed by Eurocentric expectations and that contributed to exclusion. The Hispano population was "problematic" for many easterners who weren't entirely convinced that Hispanas and Hispanos had achieved the necessary degree of Americanization to warrant social and artistic equality. Finally, the very fact that Hispano artists of the WPA worked for federal programs removed the grand perception by authorities that theirs was indeed true art. Rather, it was thought by many to be art created within a certain time frame in exchange for a paycheck. Many national critics felt that art produced

Esquípula Romero de Romero (1889–1975), José Miguel, Domingo Pueblo Indian *(1930), oil on canvas. Private collection. Photo by Blair Clark.*

under these circumstances could not truly be creative art created by a "fine artist." Rather, these were untrained government workers off the streets putting paintbrush to canvas for the first time in exchange for a "dole."

That Hispana and Hispano artists were left out of regional and national accounts of federally sponsored art activities during the New Deal era cannot be ignored. These "other" WPA artists participated in large numbers, and created masterworks of American art. Those whose work was accepted within the parameters of Eurocentric artistic sensibilities, such as Patrocinio Barela and Pedro Cervántez, enjoyed brief acclaim. The artists who worked with "traditional" artistic techniques and mediums were relegated to "artisan" status. With very few exceptions, all have been erased from art historical memory and cultural histories.

Hispana and Hispano artists did not just create art for the WPA; they produced masterpieces for a number of New Deal–era federally funded programs with arts components, including the Civilian Conservation Corps (CCC), the Public Works of Art Project (PWAP), the Federal Art Project (FAP), and the National Youth Administration (NYA). These artists created not only what were considered to be the "traditional" Hispano art forms of furniture, fabric arts, and mixed media, they also painted on canvas and on walls, and sculpted bas reliefs and statuary. Furthermore, these masterworks were produced during a historical period of heightened appreciation of what was uniquely American and must therefore be re-categorized as American art. No longer can these works be dismissed as "handicrafts."

Artistic traditions and aesthetic training differ culturally. Some artists are taught in classes, others are taught by masters in their families. Fine techniques and expertise are conveyed, regardless of training. Today, Hispana/o, Chicana/o, and Latina/o artists still find difficulty placing their art within the categorical hierarchy that Eurocentric mentality and concepts dictate. Historically, scholars and curators from outside the culture have dictated what is "fine" and what is "folk." In an effort to collapse these categories, contemporary artists have embraced and intentionally incorporated traditional and popular artistic elements into a variety of mediums. As a result, contemporary Hispano, Chicano, and Latino art continues to be excluded and misinterpreted in museums and galleries and the artists are again missing from art and cultural history.

The same modus operandi was more difficult to achieve within the social and cultural constraints of the New Deal. Hispano and Hispana artists had to follow rules in order to receive any sort of recognition for their work. Nevertheless, in doing so through various mediums, they documented their artistic and cultural heritage. The mission statement of the national WPA arts programs, "Art for the People by the People," applies directly to the federally funded projects by Hispana and Hispano artists. That they were considered to be mere makers of "copies" or "reproductions" does not justify their absence from American art history. Most, if not all, did not have creative freedom. They were guided and "encouraged" to work from colonial originals and schematic drawings adapted from colonial and territorial styles. But even when these WPA artists were "copying," such as in the case of Juan Sánchez, their individual styles emerged. Despite all attempts to limit the vision of these artists to that which would reconstruct a Spanish colonial past, their distinct artistic and creative talents could not be suppressed. Never did they simply follow patterns. Instead, they worked within imposed boundaries and restrictions. Their artistic techniques were of the highest quality and expertly rendered. The fact that Russell Vernon Hunter and other administrators and architects exerted creative power and quality control over these artists needs to be examined further, but should in no way contribute to the perception that these artists were any less than artists. "Folk" art and "handicraft" are inadequate terms for their works; they were and are artists of the highest caliber. Their creations are American art.

While many examples of this New Deal art still exist scattered in museum and private collections, many of the artists who created them have died. Their legacy, however, lives on in the creative minds of contemporary Chicana/o, Hispana/o, and Latina/o artists of New Mexico and the rest of the country. Artwork inspired by the same patterns, designs, and subject matter, continued to be produced in schools, homes, and studios long after the official demise of the WPA. The artistic talents of the Hispana and

Hispano artists of El Diablo a Pie have provided the grounding for Santa Fe–style furnishings that seem ubiquitous now. All of the known artists who are still living continue to work with the same artistry and skills that they brought to the various federally funded arts programs of the New Deal era.

Since the 1960s and the Chicano movement, contemporary Nuevomexicana/o artists have begun to reclaim and acknowledge the legacy left by the Hispana and Hispano artists of the New Deal. In 1979, the oil-on-canvas work, rather than the straw appliqué, of Eliseo Rodríguez was chosen for the poster that advertised a pivotal art exhibition organized in 1979 by La Cofradía in Santa Fe.[8] More recently, contemporary artists like Edward Gonzales have been directly inspired by the work of their WPA predecessors. Among many works, Gonzales painted an image of Patrocinio Barela, which was first used on a poster that announced the National Association of Chicana and Chicano Studies (NACCS) Conference held in Albuquerque in 1990. More recently, in 1995, Gonzales incorporated Barela-like figures of the Holy Family into his illustration of a nativity scene for Rudolfo Anaya's children's book, *The Farolitos of Christmas*. Anaya himself is considered one of the forefathers of the Chicano literary movement in New Mexico.

From this point forward, New Mexican, Chicano, Latino, and American art history must be inclusive of these artists. Their social and artistic contributions should be recognized. Art history will expand and be enriched with the Hispana and Hispano artists of El Diablo a Pie. These men and women are the link between colonial and contemporary histories and artists. They must be accorded equal recognition, fully embraced, and formally affirmed as American artists. It's time.

Notes

1. Alberta G. Redenbaugh, "Mrs. Redenbaugh's Craft Survey," box 419, WPA Central Files, 1935–44, Record Group (hereafter RG) 69, National Archives, Washington, D.C. (hereafter NA), 16.

2. "War Services Cultural Program," no author, 20 February 1942, Holger Cahill Papers, Archives of American Art, Smithsonian Institution, Washington, D.C.

3. Russell Vernon Hunter to All Project Workers Art Unit, Works Progress Administration Inter-Office Correspondence, War Services Sub-division, 19 March 1942, Roswell Museum and Art Center Institutional Archives.

4. Interview with Eliseo and Paula Rodríguez, March 1997, Santa Fe, N.Mex. At least six of the chandeliers still exist. At this time, the current whereabouts or descriptions of the furniture are unknown.

5. *Spanish Speaking Americans in the War: The Southwest.* (Washington, D.C.: Office of the Coordinator of Inter-American Affairs, n.d.), 3.

6. "WPA Trainees at New Mexico Highlands University," 8 May 1942, Las Vegas, New Mexico, box 1924, WPA Central Files, RG 69, NA.

7. James J. Connelly (New Mexico WPA state administrator) to William J. Easton, 26 January 1943, box 1924, WPA Central Files, RG 69, NA.

8. La Cofradía is an early group of Hispano and Chicano artists, mostly from northern New Mexico. The selection of Rodríguez's image for the poster is significant for a number of reasons, not the least of which is the fact that posters have become an integral creative expression for the Chicano movement as an important artistic vehicle that reaches more people.

Bibliography

Primary Sources: Archives and Art Works

The Albuquerque Museum, New Mexico

Center for Southwest Research Collections, Zimmerman Library, University of New Mexico

Denver Art Museum, Colorado

Franklin D. Roosevelt Presidential Library and Museum, Hyde Park, New York

Harwood Museum of the University of New Mexico, Taos

Historical Society for Southeast New Mexico, Roswell

Las Vegas Museum and Historical Society, New Mexico

Las Vegas Public Library, New Mexico

The Library of Congress

Museum of International Folk Art Library and Collections, Museum of New Mexico, Santa Fe

The Museum of Modern Art, New York City

Museum of Fine Arts Library and Archives, Museum of New Mexico, Santa Fe

National Archives and Records Administration, Washington, D.C.

National Hispanic Cultural Center of New Mexico

National Museum of American History, Division of Community Life

The National Park Service, Southwest System Support Office, Santa Fe, New Mexico

New Mexico Highlands University, Thomas C. Donnelly Library

New Mexico State Records Center and Archives

Palace of the Governors, Photo Archives and Library, Museum of New Mexico, Santa Fe

New Mexico State Library, Santa Fe

The New Mexico State University Library, Las Cruces

The New Mexico State University Museum, Las Cruces

Oklahoma City Art Museum, Oklahoma

Panhandle-Plains Historical Museum, Canyon, Texas

The Portland Art Museum, Oregon

The Raton Museum and Archives, New Mexico

Roswell Museum and Art Center, New Mexico

San Francisco Museum of Modern Art, California

The Sheldon Memorial Art Gallery, University of Nebraska at Lincoln

Still Picture Unit of the Special Media Archives Services Division, National Archives at College Park, Maryland

Smithsonian Archives of American Art

Smithsonian National Museum of American History (Records in the Division of Community Life)

Taylor Museum, Colorado Springs Fine Arts Center, Colorado

University of Colorado, Department of Fine Arts Collection

University of New Mexico Art Museum and Archives, Albuquerque

University of New Mexico Archives, Albuquerque

Oral Interviews

Herminio Córdova and Gloria López Córdova, September 1994, Santa Fe, New Mexico; December 1997, Santa Fe, New Mexico

Teresa Ebie, October 1997, Roswell, New Mexico

Abad and Emma Lucero, August 1997, Albuquerque, New Mexico

Eliseo and Paula Rodríguez, December 1996, Santa Fe, New Mexico; March 1997, Santa Fe, New Mexico

Articles and Books

Arellano, Anselmo F. "Las Vegans and New Mexicans during the Spanish American War, 1989." In *Las Vegas Grandes on the Gallinas 1835–1995.* Las Vegas, N.Mex.: Editorial Teleraña, 1985.

Arellano, Anselmo F. and Julián Josué Vigil, eds. *Arthur L. Campa and the Coronado Cuarto Centennial.* Las Vegas, N.Mex.: Editorial Telaraña, 1980.

"Arts of the Southwest." *El Palacio* 34, nos. 15–16 (1933): 126.

Balderrama, Francisco E. and Raymond Rodríguez. *Decade of Betrayal: Mexican Repatriation in the 1930s.* Albuquerque: University of New Mexico Press, 1995.

Bermingham, Peter. *The New Deal in the Southwest, Arizona and New Mexico.* Tucson: University of Arizona Press, 1980.

Biebel, Charles. *Making the Most of It: Public Works in Albuquerque during the New Deal 1929–1942.* Albuquerque Museum History Monograph. The Albuquerque Museum, 1986.

Biles, Roger. *A New Deal for the American People.* DeKalb, Ill.: Northern Illinois University Press, 1991.

Boke, Richard L. "Roots in The Earth." In *The New Mexico Quarterly Historical Review* 11, no. 1 (February 1941): 25–36.

Boyd, E. *The New Mexico Santero.* Santa Fe: Museum of New Mexico Press, 1972. Reprint.

Briggs, Charles L. "To Talk in Different Tongues: The 'Discovery' and 'Encouragement' of Hispano Woodcarvers by Santa Fe Patrons, 1919–1945." In *Hispanic Crafts of the Southwest.* Ed. by William Wroth. Colorado Springs: Taylor Museum of the Colorado Springs Fine Arts Center, 1977. Pp. 37–51.

—————. *The Wood Carvers of Córdova, New Mexico: Social Dimensions of an Artistic "Revival."* Albuquerque: University of New Mexico Press, 1989.

Brody, J. J. *Pueblo Indian Painting: Tradition and Modernism in New Mexico, 1900–1930.* Santa Fe: School of American Research Press, 1997.

Brown, Lorin W. *Hispano Folklife of New Mexico: The Lorin W. Brown Federal Writers' Project Manuscripts.* Albuquerque: University of New Mexico Press, 1978.

Burma, John H. *Spanish-speaking Groups in the United States.* Durham, N.C.: Duke University Press, 1954.

Bustard, Bruce I. *A New Deal for the Arts.* Washington, D.C.: National Archives and Records Administration in association with the University of Washington Press, 1997.

Cahill, Holger. *New Horizons in American Art.* New York: Arno Press, 1969. Reprint.

Campa, Arthur Leon. *Spanish Folkpoetry in New Mexico.* Albuquerque: University of New Mexico Press, 1946.

Cassidy, Ina Sizer. "Art and Artists in New Mexico: Home Arts and Crafts." *New Mexico Magazine* 17, no. 5 (May 1939): 26–27, 46–47.

—————. "Art and Artists of New Mexico: Adventures in Tin." *New Mexico Magazine* 15, no. 8 (August 1937): 28, 56.

Civilian Conservation Corps. *Official Annual. . . . 1936, Albuquerque District 8th Corps Area.* Baton Rouge, La.: Direct Advertising Company, 1936.

Coan, Mary W. "Handicraft Arts Revived." *New Mexico Magazine* 13 (February 1935): 14–15.

Coke, Van Deren. *Taos and Santa Fe: The Artist's Environment, 1882–1942.* Albuquerque: University of New Mexico Press, 1979.

Comfort, Charles, ed. "Eddie Delgado—Creative Artist." Taos Recordings and Publications, 1976.

Contreras, Belisario R. *Traditional Innovation in New Deal Art.* Lewisberg, Pa.: Bucknell University Press, 1988.

de Cordova, Lorenzo. *Echoes of the Flute.* Santa Fe, N.Mex.: Ancient City Press, 1972

Coulter, Lane and Maurice Dixon, Jr. *New Mexican Tinwork, 1840–1940.* Albuquerque: University of New Mexico Press, 1990

Crews, Mildred, Wendell Anderson, and Judson Crews. *Patrocinio Barela: Taos Woodcarver.* Third edition. Taos, N.Mex.: Taos Recordings and Publications, 1976.

Curtin, Leonora F. "Back to Tin—An Ancient Craft." *Touring Topics* 24, no. 9 (September 1932): 22–23.

Delpar, Helen. *The Enormous Vogue of Things Mexican: Cultural Relations between the United States and Mexico, 1920–1935.* Tuscaloosa: University of Alabama Press, 1992.

Deutsch, Sarah. *No Separate Refuge: Culture, Class, and Gender on an Anglo-Hispanic Frontier in the American Southwest, 1880–1940.* New York: Oxford University Press, 1987.

Dickey, Roland F. *New Mexico Village Arts.* Albuquerque: University of New Mexico Press, 1940. Reprint, 1970.

Edmonson, Munro S. *Los Manitos: A Study of Institutional Values.* New Orleans: Middle American Research Institute, Tulane University, 1957.

Eldredge, Charles C., Julie Schimmel, and William H. Truettner. *Art in New Mexico, 1900–1945: Paths to Taos and Santa Fe.* New York: Abbeville Press, 1986.

Espinosa, Carmen. *New Mexico Tin Craft.* Santa Fe: New Mexico State Department of Trade and Industrial Education, 1937.

————. *Spanish Colonial Painted Chests.* Santa Fe: New Mexico State Department of Trade and Industrial Education, 1937.

Federal Art Project. *Portfolio of Spanish Colonial Design in New Mexico.* Santa Fe: Works Progress Administration, 1937.

Fleischhauer, Carl, and Beverly W. Bannan, eds. *Documenting America, 1935–1943.* Berkeley: University of California Press in association with the Library of Congress, 1988.

Fisher, Nora, ed. *Spanish Textile Tradition of New Mexico and Colorado.* Santa Fe: Museum of New Mexico Press, 1979.

Flynn, Kathryn A., ed. *Treasures on New Mexico Trails: Discover New Deal Art and Architecture.* Santa Fe: Sunstone Press, 1995.

Forrest, Suzanne. *The Preservation of the Village: New Mexico's Hispanics and the New Deal.* Albuquerque: University of New Mexico Press, 1989.

Gibson, Arrell Morgan. *The Santa Fe and Taos Colonies: Age of the Muses, 1900–1942.* Norman: University of Oklahoma Press, 1983.

Goldwater, Robert. *Primitivism in Modern Art.* Rev. ed. Cambridge, Mass.: Harvard University Press, 1986.

Gonzales, Edward, and David L. Witt. *Spirit Ascendant: The Art and Life of Patrociño Barela.* Santa Fe, N.Mex.: Red Crane Books, 1996.

Gonzales, Phillip B. "The Political Construction of Latino Nomenclatures in Twentieth-Century New Mexico." *Journal of the Southwest* 35, no. 2 (summer 1993): 158–272.

González, Nancie L. *The Spanish-Americans of New Mexico: A Heritage of Pride.* Albuquerque: University of New Mexico Press, 1969.

Griswold, Lestor. *Handicraft.* 8th ed. Colorado Springs: Out West Printing and Stationery Co., 1942.

Hazleton, Jayne M. *The WPA Collection of the Oklahoma City Art Museum.* Oklahoma City: Oklahoma City Art Museum, 1996.

Hougland, Willard. *Santos: A Primitive American Art.* New York: Jan Kleijkamp and Ellis Monroe, 1946.

Houser, Nellie. "The Spanish American Normal." *New Mexico School Review* 17, no. 6 (1938): 24.

Howard, Kathleen L., and Diana F. Pardue. *Inventing the Southwest: The Fred Harvey Company and Native American Art.* Flagstaff, Ariz.: Northland Publishing and the Heard Museum, 1996.

Johansen, Sigurd. *Rural Social Organization in a Spanish-American Culture Area.* Albuquerque: University of New Mexico Press, 1948.

Kalb, Laurie Beth. *Crafting Devotions: Tradition in Contemporary New Mexico Santos.* Albuquerque: University of New Mexico Press in association with the Gene Autry Western Heritage Museum, 1994.

Kalfatovic, Martin R. *The New Deal Fine Arts Projects: A Bibliography, 1933–1992.* Metuchen, N.J.: Scarecrow Press, Inc., 1994.

Kardon, Janet, ed. *Revivals! Diverse Traditions: The History of Twentieth Century American Craft.* New York: Harry N. Abrams, Inc. and the American Craft Museum, 1994.

Kutsche, Paul, ed. *The Survival of Spanish American Villages.* Colorado Springs: Colorado College, 1979.

Lamadrid, Enrique R. "Cultural Resistance in New Mexico: A New Appraisal of a Multi-Cultural Heritage." *Spanish Market Magazine* 4 (July 1991): 24–25.

———. "Ig/Noble Savages of New Mexico's Silent Cinema 1912–1914." *Spectator, The University of Southern California Journal of Film and Television,* 1992: 12–23.

Landes, Ruth. *Latin Americans of the Southwest.* New York: McGraw-Hill Inc., 1965.

Loomis, Charles P., and Loomis, Nellie H. "Skilled Spanish-American War Industry Workers from New Mexico." *Applied Anthropology* 2, no.1 (1942): 33–34.

Lowitt, Richard. *The New Deal and the West.* Bloomington: Indiana University Press, 1984.

Lucie-Smith, Edward. *The Thames and Hudson Dictionary of Art Terms.* London: Thames and Hudson Ltd., 1993. Reprint.

Martínez, Reyes N. "The Weaver of Talpa," *New Mexico Writers' Project.* Unpublished Manuscript. History Division, Museum of New Mexico, Santa Fe.

Mauzy, Wayne. "Santa Fe's Native Market." *El Palacio* 40, nos. 13–15 (March–April 1936): 65–72.

McCrossen, Helen Cramp. "Native Crafts in New Mexico." *The School Arts Magazine* 30, no. 7 (1935): 456–58.

McDonald, William F. *Federal Relief Administration and the Arts: The Origins and Administrative History of the Arts Projects of the Works Progress Administration.* Columbus: Ohio State University Press, 1969.

McKinzie, Richard D. *The New Deal For Artists.* Princeton, N.J.: Princeton University Press, 1973.

McWilliams, Carey. *North From Mexico: The Spanish-speaking People of the United States.* New York: Monthly Review Press, 1961. Reprint.

Melosh, Barbara. *Engendering Culture: Manhood and Womanhood in New Deal Public Art and Theater.* Washington, D.C.: Smithsonian Institution Press, 1991.

Meltzer, Milton. *Violins and Shovels: The WPA Arts Projects.* New York: Delacorte Press, 1976.

Metcalf, Eugene W., Jr. "The Politics of the Past in American Folk Art History." In *Folk Art and Art Worlds.* Ed. John Michael Vlach and Simon J. Bronner. Logan: Utah State University Press.

Moulton, E. L. *New Mexico's Future: An Economic and Employment Appraisal.* Albuquerque Committee for Economic Development, Bernalillo County, New Mexico, 1945.

Nanninga, S. P. *The New Mexico School System.* Albuquerque: University of New Mexico Press, 1942.

Nestor, Sarah. *The Native Market of the Spanish New Mexican Craftsmen: Santa Fe, 1933–1944.* Santa Fe: The Colonial New Mexico Historical Foundation, 1978.

A New Deal for Public Art: Murals from the Public Art Programs. New York: The Bronx Museum of the Arts, 1993.

O'Connor, Francis V. *Federal Art Patronage 1933 to by Larry Harwood 1943.* College Park: University of Maryland Art Gallery, 1966.

———. *Federal Support for the Visual Arts: The New Deal and Now.* New York: New York Graphic Society Ltd., 1969.

O'Connor, Francis V., ed. *The New Deal Art Projects: An Anthology of Memoirs.* Washington, D.C.: Smithsonian Institution Press, 1972.

———, ed. *Art for the Millions: Essays from the 1930s by Artists and Administrators of the WPA Federal Art Project.* Greenwich, Conn.: New York Graphic Society Ltd., 1973.

Oles, James. *South of the Border: Mexico in the American Imagination, 1914–1917*. Washington, D.C.: Smithsonian Institution Press, 1993.

Padilla, Carmella M. "Patrociño Barela, Expressionist Carver." *El Palacio* 101, no. 3 (winter/spring 1996–97): 38–43, 50–51.

————. "Eliseo and Paula Rodríguez: Straw Appliqué Masters Merge Marriage and Art." *Spanish Market Magazine* 10, no. 1 (1997): 30–35, 53.

Padilla, Carmella, and Donna Pierce. "Fine Spanish Colonial Furniture: Then and Now." *Spanish Market Magazine* 10, no. 1 (July 1994): 10–13.

Pierce, Donna, and Marta Weigle, eds. *Spanish New Mexico: The Spanish Colonial Arts Society Collection*. Santa Fe: Museum of New Mexico Press, 1996.

Pike, Fredrick B. *FDR'S Good Neighbor Policy: Sixty Years of Generally Gentle Chaos*. Austin: University of Texas Press, 1995.

Powell, Philip Wayne. *Tree of Hate: Propaganda and Prejudices Affecting United States Relations with the Hispanic World*. Vallecito, Calif.: Ross House Books, 1985.

Public Works of Art Project. *National Exhibition of Art by the Public Works of Art Project*. Washington, D.C.: Corcoran Gallery of Art, 1934.

Quirarte, Jacinto. *Mexican American Artists*. Austin: University of Texas Press, 1973.

Rebolledo, Tey Diana, and Teresa Márquez, eds. *Women's Tales from the New Mexico WPA: La Diabla a Pie*. Houston: Arte Público Press, 2000.

Rhodes, Colin. *Primitivism and Modern Art*. London: Thames and Hudson, Ltd., 1994.

Robertson, Edna, and Sarah Nestor. *Artists of the Canyons and Caminos: Santa Fe–The Early Years*. Salt Lake City, Utah: Peregrine Smith, 1982.

Rosenzweig, Roy, ed. *Government and the Arts in Thirties America: A Guide to Oral Histories and Other Research Materials*. Fairfax, Va.: George Mason University Press, 1986.

Ross, Patricia. "The Craft of Tinwork." *Contemporary Arts of the Southwest* 1, no. 2 (January–February 1933): 2.

Sagel, Jim. "Eliseo Rodríguez." Program for Feria Artesana, Albuquerque Convention Center, 27–28 August, 1983.

Sánchez, George I. *Forgotten People: A Study of New Mexicans*. Albuquerque: University of New Mexico Press, 1996. Reprint.

————. "New Mexicans and Acculturation," *New Mexico Quarterly Review* 11, no. 1 (February 1941): 61–68.

————. *Supplement to Forgotten People: Community Education in Taos County, A Critical Review and a Proposal*. Albuquerque: Zimmerman Library, University of New Mexico, January 1940.

Santa Fe Visitor's Guide. Santa Fe: Santa Fe Chamber of Commerce and the Santa Fe New Mexican Publishing Corp., 1931.

Schackel, Sandra. *Social Housekeepers: Women Shaping Public Policy in New Mexico, 1920–1940*. Albuquerque: University of New Mexico Press, 1992.

Sewell, Brice H. "A New Type of School." *New Mexico School Review* 15, no. 2 (1935): 49.

————. " New Los Lunas Vocational School Building." *New Mexico School Review* 15, no. 5 (1936): 6.

————. "The Old Skills are Again Being Practiced in Mora Valley." *The New Mexico School Review* 16, no. 1 (1936): 21.

————. "Vocational Education Adjusts its Program to Meet New Needs of Industry." *New Mexico School Review* 17, no. 6 (1938): 26.

————. "Why Vocational Education?" *New Mexico School Review* 14, no. 6 (1935): 7.

————. "Fine Furniture—Handmade." *New Mexico Magazine* 17, no. 5 (May 1939): 27.

Simmons, Marc, and Frank Turley. *Southwestern Colonial Ironwork*. Santa Fe: Museum of New Mexico Press, 1980.

Spanish American Dance Tunes of New Mexico: WPA, 1936–1937. San Cristobal, N.Mex.: Cantemos Records, 2000.

"Spanish Arts: Wood Carving Group." *El Palacio* 33, nos. 11–12 (1932): 120.

Spanish Colonial Furniture Bulletin. Rev. ed. Santa Fe: New Mexico Department of Vocational Education, April 1935.

Spanish Speaking Americans in the War: The Southwest. Washington, D.C.: Office of the Coordinator of Inter-American Affairs, n.d.

Taggett, Sherry Clayton, and Ted Schwarz. *Paintbrushes and Pistols: How the Taos Artists Sold the West.* Santa Fe: John Muir Publications, 1990.

Taylor, Lonn, and Dessa Bokides. *New Mexican Furniture 1600–1940: The Origins, Survival, and Revival of Furniture Making in the Hispanic Southwest.* Santa Fe: Museum of New Mexico Press, 1989.

Threads of Culture: Photography in New Mexico, 1939–1943. Santa Fe: Museum of Fine Arts, 1993.

Tireman, Loyd S., and Mary Watson. *A Community School in a Spanish-Speaking Village.* New York: Arno Press, 1976. Reprint.

Torgovnick, Marianna. *Gone Primitive: Savage Intellects, Modern Lives.* Chicago: University of Chicago Press, 1990.

United States General Services Administration. *WPA Artwork in Non-Federal Repositories.* Washington, D.C.: GSA Public Building Service, Cultural Affairs Division, Fine Arts Program, May 1996.

Vlach, John Michael, and Simon J. Bronner. *Folk Art and Art Worlds.* Logan: Utah State University Press, 1992.

Walmsley, Myrtle. *I Remember, I Remember Truchas the Way it Was 1936–1956.* Albuquerque: Menaul Historical Library of the Southwest, 1981.

Weigle, Marta, ed. *Hispanic Villages of Northern New Mexico: A Reprint of Volume II of the 1935 Tewa Basin Study with Supplementary Materials.* Santa Fe: The Lightning Tree Press, 1975.

———, ed. *Two Guadalupes: Hispanic Legends and Magic Tales from Northern New Mexico.* Santa Fe: Ancient City Press, 1987.

———, ed. *New Mexicans in Cameo and Camera: New Deal Documentation of Twentieth-Century Lives.* Albuquerque: University of New Mexico Press, 1985.

———, ed. *Women of New Mexico: Depression Era Images.* Santa Fe: Ancient City Press, 1993.

Weigle, Marta, and Kyle Fiore, eds. *New Mexico Artists and Writers: A Celebration, 1940.* Santa Fe: Ancient City Press, 1982.

Weigle, Marta, Claudia Larcombe, and Samuel Larcombe, eds. *Hispanic Arts and Ethnohistory in the Southwest.* Santa Fe: Ancient City Press, 1983.

Weisberger, Bernard A., ed. *The WPA Guide to America: The Best of 1930s America as seen by the Federal Writers' Project.* New York: Pantheon Books, 1985.

White, John Franklin. *Art in Action: American Art Centers and the New Deal.* Metuchen, N.J.: Scarecrow Press, Inc., 1987.

Williams, A. D. *Spanish Colonial Furniture.* Milwaukee: The Bruce Publishing Company, 1941.

Wood, Nancy. *Heartland New Mexico: Photographs from the Farm Security Administration, 1935–1943.* Albuquerque: University of New Mexico Press, 1989.

Workers of the Writers' Program, Music Program and Art Program of the Works Projects Administration in the State of New Mexico. *The Spanish-American Song and Game Book.* New York: A.S. Barnes and Company, 1942.

"WPA Art Work Shown in Museum." *El Palacio* 40, nos. 16–18 (1935): 92–94.

The WPA Guide to 1930s New Mexico: Compiled by the Workers of the Writers' Program of the Works Projects Administration in the State of New Mexico. Tucson: University of Arizona Press, 1989. Reprint.

Wroth, William. "New Hope in Hard Times: Hispanic Crafts Are Revived During Troubled Years." *El Palacio* 89, no. 2 (1983): 23–31.

———. "The Hispanic Craft Revival in New Mexico." In *Revivals! Diverse Traditions: The History of Twentieth Century American Craft 1920–1945,* ed. Janet Kardon. New York: Harry N. Abrams, Inc. and the American Craft Museum, 1994.

Wroth, William, ed. *Furniture from the Hispanic Southwest.* Santa Fe: Ancient City Press, 1984.

———, ed. *Hispanic Crafts of the Southwest.* Colorado Springs: Taylor Museum of the Colorado Springs Fine Arts Center, 1977.

———, ed. *Weaving and Colcha from the Hispanic Southwest.* Santa Fe: Ancient City Press, 1985.

———, ed. *Russell Lee's FSA Photographs of Chamisal and Peñasco, New Mexico.* Santa Fe: Ancient City Press and Taylor Museum of the Colorado Springs Fine Arts Center, 1985.

Unpublished Manuscripts, Papers, Theses and Dissertations

Applegate, Frank. "Spanish Colonial Arts and Crafts." T. M. Pearce Papers, University of New Mexico General Library, Albuquerque, n.d.

De Clercq, Suzanne Marie. "Santa Fe, New Mexico: A Geography of Arts and Crafts." Master's thesis, University of Minnesota, 1971.

Gaither, James Mann. "A Return to the Village: A Study of Santa Fe and Taos, New Mexico as Cultural Centers, 1900–1934." Ph.D. diss., University of Minnesota, 1957.

Pickens, William Hickman. "The New Deal in New Mexico, 1926–1938." Master's thesis, University of New Mexico, 1971.

Reeve, Kay Aiken. "The Making of an American Place: The Development of Santa Fe and Taos, New Mexico as an American Cultural Center, 1889–1942." Ph.D. diss., Texas A&M University, 1977.

Reidel, Thomas L. "'Copied for the W.P.A': Juan Sanchez, American Tradition and the New Deal Politics of Saint Making." Master's thesis, University of Colorado, 1992.

———. "New Deal Saint-Making: Juan A. Sanchez and the Federal Art Project." Paper presented at the New Mexico Art History Conference, Taos, New Mexico, 1 November 1996.

Sachs, Lucinda Lucero. "Clyde Tingley's Little New Deal for New Mexico: 1935–1938." Master's thesis, University of New Mexico, 1989.

Spurlock, William Henry. "Federal Support for the Visual Arts in the State of New Mexico." Master's thesis, University of New Mexico, 1974.

Stiver, Louise I. "The Role of the Laboratory of Anthropology in Federally Supported New Deal Programs: 1933–1943. Paper presented at the University of New Mexico, Summer, 1989. Filed with the office of the Museum of New Mexico registrar.

Stoller, Marianne L. "The Early Santeros of New Mexico: A Problem in Ethnic Identity and Artistic Tradition." Paper presented at the annual meeting of the American Society for Ethnohistory, Albuquerque, 9 October 1976.

Newspapers and Periodicals

Albuquerque Journal

Albuquerque Tribune

Amarillo Globe-Times

El Faro (WPA paper)

La Herencia del Norte

Las Cruces Sun-News

Las Vegas Optic

New Mexico Examiner

New Mexico Magazine

El Palacio

The Reporter (WPA publication)

Roswell Daily Record

Santa Fe New Mexican

Santa Fe Scene

The Santa Fean

Spanish Market Magazine

The Sunshine State Builder (WPA publication)

Taos News

Western Artist

Index